EXPRESSIONISM IN ART

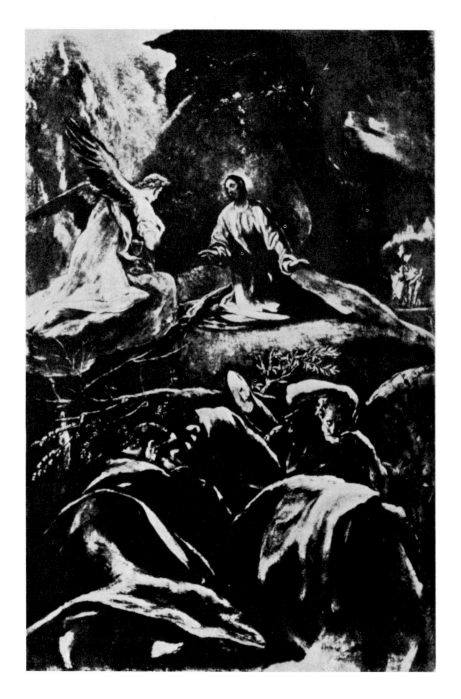

The Agony in the Garden, by El Greco.

EXPRESSIONISM
IN ART

BY SHELDON CHENEY

REVISED EDITION
WITH 210 ILLUSTRATIONS

LIVERIGHT

NEW YORK

59418

2.98765432

SBN: 87140-530-X (clothbound)
 87140-033-2 (paperbound)
Library of Congress Catalog Card Number: 79-131276

MANUFACTURED IN THE UNITED STATES OF AMERICA

PREFACE

MANY artists and students will face a new essay on Modernist art with the sort of impatience manifested by John Marin. I had asked for photographs of his paintings.

"What!" he exclaimed. "Another damn book?"

Contemplating the burden of recent works in this field, I too am impelled to ask why I—who once reformed and wrote no books for seven years—should now offer a volume about Expressionism.

My reason, I think, was this. There are books enough serving as introductions to Modernism, recounting its early history and paving the way to the first glimmers of understanding. But there is, in English, no book pretending to *analysis* of the characteristic elements in Expressionist art.

Eleven years ago I wrote a frankly introductory work. Therein I was concerned to break down prejudice against "the new art." I was trying to remove the blinders placed by academic teaching over the eyes of the average citizen, was hoping to pry open, a little, the too tightly closed mind of the student and observer.

In those days, in the early 'Twenties, Modernist art was on the defensive. One broached the subject with apologies and explanations. One took up arms self-consciously, even heroically, under the barrage of writings laid down by academic critics in defense of what is now obviously "the old art." The whole subject of Modernism was surrounded by an atmosphere of battle, with the radicals on the challenging side. The introductory and apologetic books, my *Primer* and the variously admirable works of Wilenski, Bell and Eddy, belong to that earlier time, when the public was unconvinced and the Moderns a beleaguered minority.

Today conditions are reversed. If the battle is to continue, it is

< vii >

the conservatives who find themselves on the defensive, who must sue for an audience. Expressionism—if you will allow me the word probationally—is widely accepted, studied, even respectable.

In this book, therefore, if I am wise, only minor effort will be expended to convince the reader that radical Modern art is logical and inevitable. I shall take for granted open-mindedness, if not a practiced appreciation of old and contemporary Expressionist works. After some clearing of the ground, and the establishing of definitions, I shall explain, so far as my present understanding serves, the special means by which artists are accomplishing a return to essentially expressive and creative art. I plan to describe technical methods, report theories, and sketch so much of the social background as may seem to have characteristic influence upon advanced practice.

My first aim is to aid the student in opening the way to understanding and enjoyment. I hope, in addition, that practicing artists will find the book clarifying; though I want no one to seek herein a *formula* for creative accomplishment. True Expressionism goes deeper than that.

The book is at once my most independent and personal expression upon art, and a confession that I have no original theory of Modernism. Even while relying upon my own reactions to and study of living art works, I can claim no originality for the explanations and analyses set forth; and certainly I make no pretense to omniscience in any part of the vast field surveyed. I have merely collated more recorded opinions and expositions than any earlier writer, and I am attempting a digest in readable form, along the line of my own "seeing."

The skeleton of the book is that of a course of "lectures"—a rather pretentious word in the circumstances—prepared in 1932 for discussion-groups at my briefly existent *School for Open-Mindedness*, in Berkeley, and repeated informally that year at art schools in the neighborhood. Teaching, in my case, is a give-and-take affair, and I think my students brought me as much knowledge and

< viii >

new understanding as I imparted to them. The whole book, indeed, reflects a view of creative art that has developed in a series of contacts with students and practicing artists. Parts of the material have been "talked out" with Joseph Sheridan and Glenn Wessels, painters, and with my nephew, Warren Cheney, sculptor. All of these, moreover, have put at my disposal unpublished articles or notes, for which I hereby express gratitude and admit indebtedness.

By far my largest debt, however, is to Professor Hans Hofmann. It was study of his two articles in *The Fortnightly*, doubtless, and the reading of a part of his unpublished work on *Creation in Form and Color*, that crystallized in its present form my "theory of plastic orchestration," elaborated here in the chapters on Picture-Building. I had already incorporated ideas of Albert Gleizes, Dr. Barnes and others into a framework of theory which I was placing before my fellow-students; but Hofmann's exposition of the formal part of the Expressionist synthesis seemed to me clarifying beyond any previous statements. References to these and other sources will be found in the footnotes on the following pages.

I wish to make acknowledgment also for courtesies extended by many artists and galleries in connection with the illustrations. I owe thanks particularly, for groups of photographs, to Alfred Stieglitz (prophet and early leader in the field we are entering), A. E. Gallatin, Pierre Matisse, Adolph Lewisohn, The Weyhe Gallery, The Downtown Gallery of New York City, and the California Palace of the Legion of Honor and the Adams-Danysh Gallery, San Francisco. In other cases I hope that the specific acknowledgment under the reproductions will seem sufficient token of appreciation, to those many who generously co-operated to make the set of illustrations representative and full. Three of the larger museums have been particularly helpful in offering the use of illustrations from their collections: the Art Institute of Chicago; and the Metropolitan Museum of Art, and the Museum of Modern Art, New York.

A more indefinable but heavier debt is owing to two individuals: J. B. Neumann has been generous with gathered material, both

< ix >

factual and photographic; and Martha Candler read the manuscript, and made invaluable suggestions leading to corrections and rewriting. To both I am sincerely grateful.

I started the writing of the book under a more particular title—since discarded—*Expressionism in Art: The First Fifty Years*. This was phrased to suggest a truth too often overlooked: although Expressionism is commonly considered so young that its only possible merits lie in the fields of novelty and undirectioned experiment, the "movement" can be traced, in several arts, through the course of a full half-century. In the early 'Eighties Cezanne already had retired from Paris and Impressionism to Provence and to painting for the sake of plastic rhythm and emotional realization; and in the later 'Eighties Gauguin and van Gogh spent memorable productive months together at Arles, and Rousseau was sending his first strangely different works to the exhibition halls. Daumier earlier had been packing his paintings with a sort of structural organization just now being recognized as a variant achievement of the typical Modernist expressive form.

Cezanne of course is recognized as prophet and first master by all Expressionists (whether they admit the label or not); and the other four helped to lift the new movement to the importance of a world-shaping revolution. While these events were occurring in France, Sullivan in Chicago was laying the foundation of a new world architecture, actually creating the first expressively Modern buildings. And in San Francisco a girl named Isadora Duncan was practicing those dances which, by example, were to revolutionize another art. In the theatre Craig and Appia were to follow soon with their disruptive insurgent theories. Not only in its roots but in many aspects of its practice, Expressionism goes back a half century.

I realize that I am using the term Expressionism to cover these several phenomena at a time when it is still bitterly challenged by those who would give it a pathological and a German significance. My reasons are too varied for treatment in a preface: they will have a chapter later, under the title "Why Expressionism?" But I may

< x >

usefully summarize my thought here: I believe Expressionism to be the name history will assign to the development in art that began with Cezanne in painting, with Sullivan in architecture, with Duncan in dancing, with Craig and Appia in the theatre. It seems to me the only term exact enough to describe alike the works of Cezanne and Picasso and Orozco and Wigman and Wright and Lehmbruck; even while broad enough to embrace the varied contributions of the so-called Post-Impressionists, Fauves, Cubists, Functionalists, Purists, etc.

But it is for the book itself to explain what Expressionism is: how the artists now arrive at a more intense expressiveness (instead of simulating aspects of nature, or echoing Greek architectural idioms), and what it is that they express. In all reverence I may say, God help me!

<div align="right">S. C.</div>

< xi >

Note on the Revised Edition, 1948

This is a revised edition of a book written almost fifteen years ago. I have received more letters from artists commending the work than in regard to any other writing of mine. Much as I should have liked to attempt a complete rewriting, in the interest of greater simplification, I have had to admit that a clear, effortless exposition of the subject is probably beyond me. The artists who have written to me, and the many favorable reviews, seem to warrant the present reprint, which carries, incidentally, twenty new illustrations, along with numerous text corrections and added footnotes.

The vogue at the moment seems to be for extremely simple art books, of the nature of "Morons Can Draw" or "How to Paint without Knowing How." Expressionism as a subject hardly admits elementary treatment of that sort. The chapters on Picture-Building, a relatively mysterious activity, are really the heart of my volume. It is chiefly on their account that I offer the book again, to artists and students, and to laymen who are willing to make a persistent and perhaps difficult effort toward comprehension.

I have resisted the temptation to add a paragraph on art in the Atomic Age. Nor have I trimmed my original chapter on socially conscious art, chiefly about Communism, though the word "Communism" has come to have sinister connotations not felt fifteen years ago. My broad, even idealistic use of the word was perhaps sufficiently guarded even then, through disavowal of political or party attachment.

"Expressionism" as a name identifying the main current of creative art in the 20th century has steadily gained adherents among artists, writers and museum people. This is still one of the very few books in the language that try to explain why the name applies.

Westport, Connecticut S. C.

July, 1948

< xii >

CONTENTS

< xiii >

LIST OF ILLUSTRATIONS

< xv >

< xvi >

< xvii >

< xviii >

< xix >

< xx >

< xxi >

< xxii >

EXPRESSIONISM IN ART

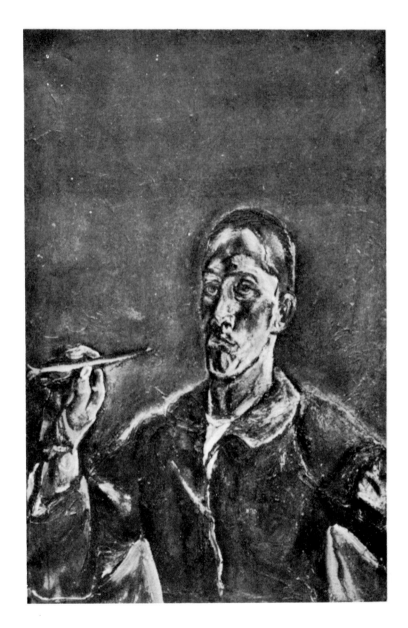

Self-portrait, by Oskar Kokoschka.
(By courtesy of J. B. Neumann.)

CHAPTER I

THE scientists speak of a beginning in chaos; though there may have been, then as always, an eternal order which the time-counting human mind cannot comprehend. The picture of an initial chaos, at any rate, then at a first apprehensible moment a movement toward order, an integration—this picture may afford the most vivid backcloth for any appearance of the still mysterious figure, art.

This is how it would be: Chaos. Then somewhere in unorganized infinitude a clot of atoms, an integration of forces: next, emerging design, ordered movement, form. Finally a rough stabilization of the physical universe, as men of today, within limits, know it: stupendous nebulae and galaxies, millions of light years in extent, within a controlled complex of movements, orbits, weights and tensions. A physical machine-universe, kept "running" by prodigious burnings, radiation, condensation, motion: a continual cosmic transforming of energy. And at the other end of the scale, each physical atom existing by virtue of infinitesimal wave-spurts of that same energy.

Off in the remoter distances of one galaxy, one among millions, exists a not very important star, the Sun, and pendant to that a tiny ball of burned-out ash known as the Earth. Ultimately and unaccountably the life-spark is on Earth, the beginning of vital evolution—and of all man's mysteries of being, experiencing, creating. Rudimentary plants appear and lift crowns toward the sustaining

< 3 >

Sun. Living creatures evolve, adapt, become complex. Millions of years later, man has emerged, recognizably. For further aeons he is man-animal, while that master tool, intellect, grows, functions ever more clearly, points the way to ultimate conquest of all that is on Earth. Deeper, a link with the Universe-Self, unlike the intellect in being knowable only by experience and intuition, the Spirit has its separate, sometimes rapturous, existence.

Linked with Spirit, with creation, with beauty beyond explanation, is the thing men call art. As the spiritual vision of man develops, as the Spirit flames—at times almost to control over intellect and life—artistic effort is born, aesthetic understanding and enjoyment are extended.

No one "knows" what the spiritual is, whence wells up the divine apprehension, the creative impulse and expression. No more can anyone write assuredly of the aesthetic. But there it is: art, the impulse toward it, creative or appreciative, its "works" and the satisfaction or rapture they afford. And men are curious about it.

Now it is not usual to begin a book concerning the arts with a confession that there still is mystery about the subject: a baffling fog which the searchlights of reason fail to penetrate. One is expected rather to lay down a definition on the first page, and stick to it through thick and thin, as guide to interpretation and as final refuge from questioning. It is perhaps a sign of our modernity that we recognize the cloudiness, that we distrust such easy aphorisms as those guiding our immediate ancestors. "Art is imitation," they said, and lapsed into the practice of shallow imitative illustration. Or "Beauty is truth," and interpreted truth as photographic simulation or moral lesson.

We—you as reader impelled to seek understanding of a change that has obviously occurred in all common paths of art, and I as

< 4 >

explorer, having gone ahead in an effort to mark a main road—we shall be wary of too-tight definitions and too-limiting formulas. You will not ask too exact a report. I shall not pretend that I am setting down a precise sheet of directions or a permanent chart. We shall proceed as befits those who know that there are mysteries still not to be cleared by exercise of the human intellect, or by spiritual apprehension at its present pitch and intensity.

The art mystery has immeasurably deepened within the quarter-century. For the practice of the arts has epochally moved, in our time, away from the obvious, superficially real, and demonstrable, toward values not observable, imitable or reasonable. Artists and explainers alike look for the key to the secret in the realms of intuition, intimation, creation, expression. If we are even tentatively to consider Expressionism, we are compelled to renounce the shallowly bright truths and easy enjoyments of Victorian Realism, and to admit that we have climbed, in our search for more satisfying aesthetic enjoyment, into regions intellectually mysterious, perhaps explainable only as mystic. The most creative artists of our time have led the way, and we can object only if the sensitive ones among us fail to experience a sharper aesthetic response.

It is, moreover, meet that we should proceed for a time without too many fast-set guide posts, because our whole temper, as Moderns, impels us to resist the ideas of setness, limitation and finality. In short, we believe in evolution—and not alone in our conception of biology. We recognize, if we are wise, that all living philosophy has been profoundly influenced by the enunciation of the doctrine of evolution. Life is change, growth; institutions are passing means toward change; art and the spiritual life of which it is a part— expression and experience—are never more than an accompaniment of a stage attained by man along the way, geared to his compre-

< 5 >

hension, which is ever enlarging. Thus no matter how much we may learn about art in one era, there will be uncertainty about its next direction. Even as we attempt to measure one flower, there will be unaccountable life-stuff flowing, and changed environment, to shape another and different blossoming. There is no absolute in matters of art.

Nonetheless it is my business here to find what of immediate certainty there may be within this mystery. It is my duty to discover what rock islands may exist at the point in the current now reached by man. We do not pretend to begin at the heart of the mystery, pontifically, and work outward. We can, however, push from certain known points, inward, toward the hidden center. By bringing clear what has happened, in the name of art, at different times, and then noting by comparisons the changed direction, the tangent intent, the different enjoyment, we may find clues to understanding.

UNDERSTANDING BY CONTRAST

Art has arrived, at various periods in man's history, as formal expression. At other periods it has been, instead, imitational activity. It happens that there is between the present Expressionist practice and the immediately preceding imitational art, a contrast so striking that even a superficial study of the one in relation to the other affords light toward a main path of the present Modernism.

If one can see, for what it was, the shallow, literal, imitative painting and sculpture and architecture of the Victorian period, just before the current outpouring of Expressionist works; if one can place 19th Century art in relation to the rigidly institutionalized society, the materialistic and academic philosophies, and the intel-

< 6 >

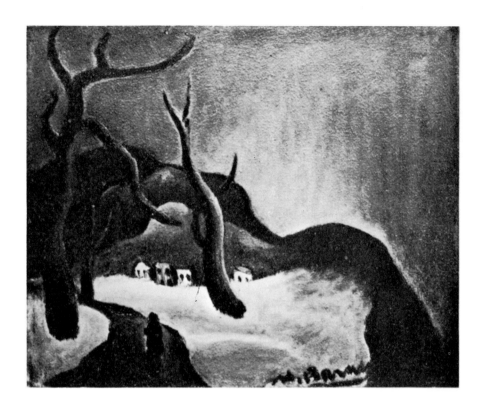

Four Houses, by Matthew Barnes. (Photo by Ansel Adams, by courtesy of Joseph A. Danysh Galleries.)

lectualized cultural structure of which it was a part: then one has the perfect contrast to all that the Modernist artists are striving for.

The literalism and dogmatism of bitterly divided Christian sects, the superficiality of "scientific" philosophy, the tendency to pigeon-hole and label every object, action and impulse, these characteristics of the times, as well as the actual photographic surface art, go some way, as opposites, to explain the almost fanatic devotion of the Expressionists to intuitional and mystic values, and formal "unnatural" expression. The Landseers, Bouguereaus, Sargents

< 7 >

and Besnards among painters, the Baryes and Saint-Gaudens of sculpture, and the Eclectic historic-imitative architects, all belonged to the age of set-mindedness, of imitational molds-for-art. Cezanne and Lehmbruck and Sullivan belonged to some later era: partly to the period of revolutionary confusion and birth, between two ages, partly to an emerging new world.

Just before Expressionism, indeed, there was a crystallization of living and of art into approved and recognized molds. Morals were codified, a rigid model for living was set up, every activity of man was charted, and sanctioned or forbidden. Realistic minds settled, assertedly for all eternity, what art is, canonized Raphael and Donatello and Gainsborough, embalmed standard examples in tomb-like museums, and formed academies to perpetuate the true faith and protect the orthodox.

The Modern considers all such codifying and canonizing futile and limiting. He is as certain of evolution in art as in organic life. He points out that in spite of all the damming tactics of schools, academies and critics, the flood of Expressionism has swept over the Western world, so changing practice that the devotees of trans-fer-from-nature art cry out that beauty is destroyed, nature vio-lated, chaos come again. Of the works of visual art flowing into the exhibition galleries today, three-fourths are of such nature that in 1890 they would have been turned away from all doors as having nothing to do with finished art. Similarly, to the cultured Eclectics of 1870-1930, Modernist architecture is barren of beauty, nakedly awkward, and utterly un-understandable as art. So great is the revolution immediately behind us.

The artists themselves, impelled by forces totally overlooked by Victorian criticism and practice—forces impossible to codify and difficult to detect—have changed not only the outward aspect of the

< 8 >

arts, but men's understanding of the reasons for art activity, and of the essential thing that the observer experiences as art.

Whether we are yet ready, or not, to employ the word Expressionism, we cannot escape the conclusion that the Western world's interest in and attitude toward the arts have shifted epochally since Cezanne saw a vision beyond Impressionism, since Duncan flung away the ballroom slippers which for generations had confined the art of the dance to variations of Louis XIV ballet-interludes, since Sullivan dared to design functionally.

EVOLUTION AND OUR TIME

If one grants vital evolution—and who does not among educated people?—how can one avoid realization that all that *is* changes? Everything material, from nebulae and stars to chairs and human bodies, exists by virtue of movement, change. Beyond the immediate physical-chemical transformation there is the longer progressive movement, which might be called chain-growth. The intellect too changes, grows, age after age (though obviously it is commonly utilized to only a fraction of its occasionally glimpsed powers). Within our time, indeed, new knowledge of the brain has been uncovered, and men foresee controlled growth, with unprecedented mental achievement. Expression of the spiritual life of man has been a shifting current; though in the failure to understand the march of evolution, every great religious establishment has tried to stop the flow, to set up final laws, only to be swept down in time.

Art too changes, assumes new outward appearances, presupposes man's finer sensitivity and enlarged capacity for aesthetic experience. The senses that thrilled to Monet's color harmonies, fixed from nature's tenderest fleeting aspects, and the mind that ah'd

< 9 >

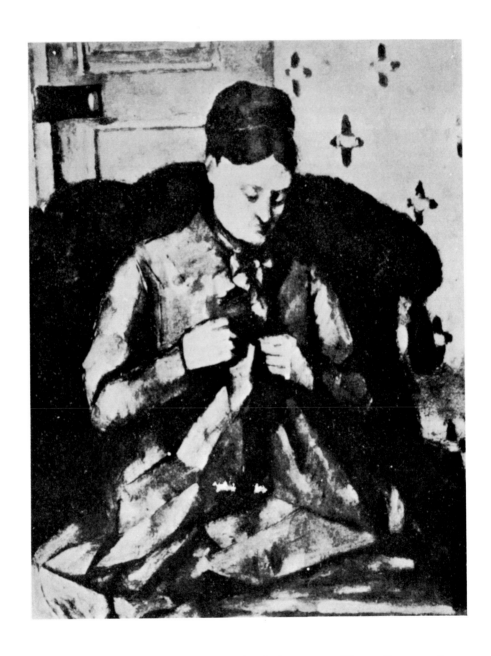

Portrait of Madame Cezanne, by Paul Cezanne. (From *Cezanne,* by Julius Meier-Graefe.)

over Sargent's uncanny exposures of character and dashing portrayal of clothes and bric-a-brac, are stilled, in a later time, when some inner faculty of the observer responds to the plastic dynamics, the universal architectonics of a painting by Cezanne. Educated men should accept as natural this growth of human-aesthetic faculties, and the accompanying deeper current of creativeness in art practice: a creativeness triply expressive, in the current outpouring, as I shall try to show, and amply warranting the name Expressionism.

It is part of my thesis, then, that Expressionism represents a new stage reached in art's upward climb: that it is the art proper to the present-day expanding world, and rightly different from the art of the tight-bound 19th Century society. As represented in its early phases, by the Expressionist experiments that we see, so various, so confusing, on all sides of us, it is the art born of the struggle between two worlds, of the death-confusion of an expiring civilization, and of the birth-pains of a different human society. The works we may mark as finest, noblest, intensest, in the Modernist achievement, as the most revelatory, may be found fully worthy of man's increased artistic expressiveness in the world as it will next be stabilized—a world still vague in its outlines because man is entering into it in utmost confusion.

Let us not fool ourselves into believing that that world either will be a final one. The current of change will flow strong again, after a period of ebb, other unforeseen changes will follow, another society and another art will eventuate: perhaps an art never fixed in paint or stone or sound, but created and at once enjoyed within the one creator-enjoyer's faculties. But it is enough for us, today, that we understand the living art of this our time, and of the age opening before us. If we are alert and living, we shall desire to

< 11 >

know the achievement, and to enjoy the revelations, of the fully living, fully creative artists of these exciting Nineteen-Forties.

When the student sees art thus, fitted into the evolutionary scheme of things, subject to the influences of evolutionary change in surrounding life, and creatively evolutionary in its own right, he has established a perspective very useful in evaluating Expressionism.

TRADITION AND MODERNISM

Evolution implies change *within a continuity*. The main portion of this book will be concerned with change, growth, the differences; the remainder of this chapter, and the next, however, will have to do with continuity, with the tradition of art practice and theory, with the immediate historic background against which the phenomenon Expressionism discovers itself.

It is likely that nothing of artistic impulse and understanding that is once born into the world is completely lost in times after. Just as physical man carries about, along with his directly useful parts, a strange assortment of survivals from his periods of growth, ears related to fish-gills, a stub of a tail that he can't even wag effectively, a vermiform appendix, etc.—as well as a consciousness stored (though not "normally" to be tapped at will) with everything he has ever seen or heard, upon a lower foundation of racial inheritance—just so, the contemporary art stream carries along surviving elements from all the epochs of man's adventuring among the arts.

Certain characteristics—even the most creative and revealing— may be obscured for a time; as occurred during the long reign of Realism. A scientific and imitative spirit brought to the surface of the current, in Renaissance times, a mirror-like art, bright with

< 12 >

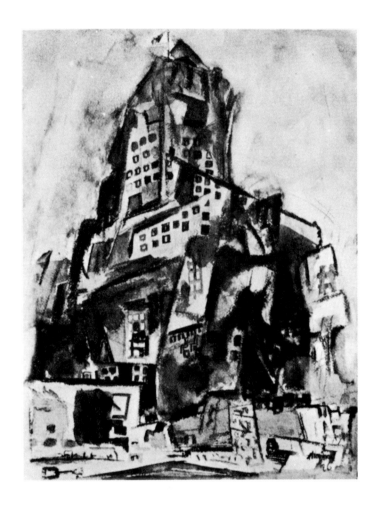

Lower New York, by John Marin. (By courtesy of
An American Place.)

easily understood transfers from nature's storehouse of beauty;
and men were satisfied, forgetting an inheritance of more profound
aesthetic discernment.

Even in that time, however, El Greco could refuse to be swept

< 13 >

with the surface current, could carry on a more intensely creative tradition, and add to it from his own rich and expressive genius. And at the very moment, three centuries later, when the Realistic achievement was touching the ultimate point in refinement and technical effectiveness, another genius, Cezanne, guessed the shallowness of contemporary art, perceived some of the glories that had been obscured, and set to work to recover the main tradition of creativeness, fusing it, within his own vision, with the color-brilliancy learned out of his own time.

The world is quick to label Cezanne a revolutionary, because his practice was so widely divergent from that of his contemporaries. In the longer view he is the historic evolutionary figure, picking up the forgotten main tradition: continuing, from a new start, the solid classic art-expression that lasts through the ages. Just so with Sullivan, the initiator of a new architecture, but first of the Moderns to link with the giant creator-builders of the past. In these figures tradition and Modernism meet. A temporarily forgotten heritage is recovered; at the same time a new release initiated.

Therein is the whole answer of the "radicals" to the academicians who cry out that Expressionism negates history, presupposes destruction of the entire treasured achievement of past artists. The Moderns instead, even while claiming a new intensity of creativeness, born partly out of the patterns of these times, point out that their practice links with the deeper tides of the art of the past; that it is only the weak photographic-ornamental art of the 17th-19th Century period that they violently oppose and scornfully ridicule.

The conservative critics, nurtured on Victorian sentimental Realism, clinging to a distorted Aristotelean dictum—"art is imitation" —and seeing no deeper than an intellectual-sensuous appeal, totally

< 14 >

overlook the characteristic abstract, emotional and pictorial-formal values in Modernist art, and gird at the surface distortion, the "unnatural" aspect of it. They believe that their battling is in defense of the main tradition. But it is, I believe, they, the conservative critics, and the surface-nature artists for whom they battle, who will be judged by history to have been out of line. It is the Expressionists, rather, who are the true traditional artists. For *the evolution of art, in the historic view, is along a path of creativeness.*

As art evolves, the "works" changing, and man's perceptive faculties growing, along the path men call tradition, it is the newly expressive bursts of activity that mark progress. Realistic-photographic and selective-Realistic painting, and historic-imitative architecture, wherein creative values were almost totally obscured, are now seen to have marked the pause between evolutionary spurts. Modernism brings art back to the vital tradition. I realize that I must, in order to make this clear to the reader, prove ultimately that the Expressionists have introduced substantially new elements into art—even while they were returning to the main ages-long stream of creativeness.* But here I wish only to note that Expressionism, far from being merely an attempt to "attract by novelty," is claimant to the right of main succession, in the purple line. Incidentally, if the reader still is employing the word "radical" as a term of reproach, he should look up its essential meaning: "from the foundation," "connected with the root."

* Chapters VI to XI, roughly, embody my attempt to explain the joining-on process, and to identify the formal values that are new—or perhaps it should be phrased, the understanding that is new. Expressionism is newer as theory than in practice; for in various historic eras, artists achieved, perhaps intuitively, values that critics of today term Expressionistic. Examples will be noted particularly in the chapters on Picture-Building. Note too the book's frontispiece.

< 15 >

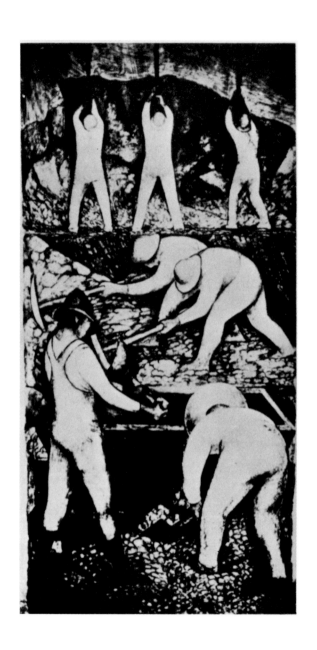

Gold Mining: Mural painting by Diego Rivera.

The Moderns, indeed, go to man's past reverently. They recognize the life of the ages as soil from which contemporary art takes nourishment. But they ask that recorded history be fairly rewritten, with less emphasis on the near-barren era (as regards the visual arts) since the Renaissance, and more attention to originally expressive ages. Claiming creativeness as a principle, they damn 19th Century society for lacking or subordinating creative ability, for enthroning imitativeness, and for setting up models and molds for the eternal confinement of art. Even if the molds had been more elastic and better chosen, they could have been useful in only the most transitory and incidental way. The Expressionist recognizes a tradition, but not molds, of creativeness.

Let the student, then, turn to the historic ages freely, for enlightenment, for understanding of the ways in which the creative spirit came to flower at various times and places. Let him cultivate the ability to search the past, and to find works of art moving and intense in relation to the life of their own times. Enjoyment of ancient Chinese paintings, and the Sienese Primitives, and El Greco and the Mayans, will afford him a sense of identification with the great art stream of the past, the stream that comes unaccountably from the original source of life; and that mystic identification will aid him to express with deeper insight and in quintessence the life-currents of this his own time. But never should he copy, or fix himself within the limits of a past achievement in art, whether negro-primitive, Chinese, pre-Raphaelite, or shallow Victorian.

If someone come, in defense of the academicians, saying that their understanding and practice evolve too, are in the ascending scale, let the student not be misled. Their activity has only a reflective relationship to living art, is not a part of it. It will be pointed out that whereas forty years ago the academies were fight-

< 17 >

ing and excluding Impressionism, in favor of the more naturalistic and frankly literary-romantic painters of an earlier time, today their exhibitions are given up almost *in toto* to the belated Impressionists. To them this spells progress. It is, rather, a way of keeping the grave decently decked. It is the dead hand of Victorianism reaching forward in an attempt to forestall further change or creation. The academicians merely have altered the molds, forty years after invention has passed. They believe in final molds as before: but public opinion has forced a readjustment. They still suspect and exclude tangent art, art creative in its own time.

Revolutionary evolution is always accomplished by marginal groups, by minorities suspect among the ruling majority. Each new band of innovators finds the world encumbered with the litter of a dead past. But the Moderns today find the road to acceptance doubly obstructed: not only are the works of the dead all around, but the dying hand holds grimly to those instruments which should serve as guides to advancement, to progressive living, to new life. I refer at the moment to museums and the printed word.

OBSTRUCTIONS: PSEUDO-TRADITION AND THE MUSEUMS

Long ago I wrote at some length about mis-education of the eye and understanding, as a determining factor in closing the average mind against Modernist art. A false conception of art *as illustration* was developed in one's school years: by the pictures and statues in classroom and home, and by the actual illustrations (properly literary and Realistic) in popular magazines. By these agencies the young student or casual observer is led, as a matter of course, to evaluate a work of art by the degree of its likeness to nature. Casts from the late Greek or Roman statues, penny

< 18 >

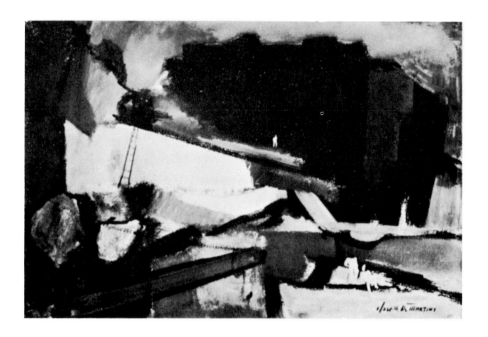

The Quarry Pool, by Joseph de Martini. An illustration of the Expressionist effort to render the picture plastically alive and unified. A near-abstraction, but without denial of nature. (By courtesy of the Addison Gallery of American Art, Phillips Academy, Andover.)

prints after all the carefully photographic painters, from Raphael and Murillo to J. G. Brown and Sargent, magazine covers by Maxfield Parrish and Harrison Fisher, and colored "masterpieces of modern painting" as chosen by the editors of the women's periodicals, more particularly for the saccharine Christmas issues—these form the bulk of the school and home repertoire of art: afford the contacts by which youth shapes its conception of what art is.

To me it seems clear that this pushing forward of illustrative works in various forms, in place of creative art, is a chief reason

< 19 >

why any deeply expressive painting puzzles or repels the student at first meeting; and I urge the reader to be sure that he has brought clear in his own mind the all-important distinction between Realistic-illustrative activity and truly creative art. But now let us go farther: considering the case of the student who is not wholly satisfied with the home and school offering, who turns to the two instruments that should serve to break down the obsession with obvious photographic art—the museums and the art-history books.

Both fail him. The academicians choose the pictures that shall be shown to him in the great treasuries of art works, and they determine the names of artists and the modes of art that shall be exalted to him as reader of history. The Modernist finds his way to acceptance blocked, so far as may be in an inevitably changing world, by mis-education in the early school years, mis-education by the museums, and by distortion and suppression in the commonly circulated text books. Since we are considering the relationship of Modernism to tradition, let us pause a little over these obstructions, lest they continue to confound those who wish to approach Expressionism with an open and unconfused mind. Discrimination, and rejection of nine-tenths of what is offered as masterly art, must precede immediacy of vision and independence of judgment.

In recognizing the extraordinary material progress made by their museums, Americans have been, perhaps, too blind to the perversion of function commonly developed. The grander institutions, while acquiring princely materials for display, housed in palatial buildings, have slipped over from being art museums in the stricter sense, to being historical-cultural museums.

Among the several obvious faults in such institutions—which include overcrowding of exhibits, grandly elaborate or coldly tomb-like buildings (dwarfing the art within, rendering intimate enjoy-

< 20 >

ment of the exhibits impossible), and confusion of function—this lack of directive conviction is most significant to us as students of Modernism. The curator is scholar, antiquarian, teacher. Insofar as he considers it his business to deal with living art, he turns for advice to the academies. He meets art always forty years behind the times. The student is led to believe that original and vital art is here treasured and shown for his benefit. But when actually creative work is included, in the vast pageant of samples of everything ever manufactured anywhere in the name of art, it is lost in oceans of secondary stuff. The point of view of the selectors, in regard to what is creative, is always a generation out of date, and is timidly all-inclusive.

A vivid instance of the influence of the academies is to be found in the newspapers as I write. In a mid-western city a two-million-dollar museum building is being dedicated. Ample provision is made for the purchase of paintings, out of the eleven-million-dollar endowment. But the directors are prohibited from buying any work of art *if produced by an artist dead fewer than thirty years.*

Thus the dead hand lingers on to discourage creativeness and hinder growth. Creation in a certain time would seem to presuppose a fitness of the work to the aesthetic-responsive faculty of the observer bred in that time. Yet here is a munificent gift limited to works of past generations.*

Average folk have become so accustomed to considering the museums purely historic and antiquarian in function, as tombs-

* It is possible to add, in 1948, that the museum situation has changed conspicuously for the better in the fourteen years since the paragraphs above were written. Opportunities now exist for the student to see modern paintings in most large American cities. Similarly the textbooks of art are no longer so biased and inadequate as in 1934. It seems well, however, to retain the passages about the museums here, and the criticisms of textbooks a few pages forward, because there is abundant room for improvement still, in both matters.

< 21 >

for-art, with usually a mortuary solemnity of aspect in both architecture and exhibits, that the incident does not deeply shock them. But the Modernist, believing that a new intensity of creativeness is being achieved, and certain that an epochal revolution has occurred in men's understanding of the distinction between intensely living and secondary art, sees serious danger in these historic institutions masquerading as the chambers and exemplars of true art.

Already the Modernist has crystallized another ideal, of the art museum for these times, the museum living up to the implication of its name, "Place of the Muses": a place colorful, intimate, unified, giving back an aesthetic response, rather than instructing the mind. But only a Modern conception of what essentially constitutes creative art, expressive art, can lead to inspired and unified design of the collections and galleries. The Expressionist believes that the modern art museum, like the modern work of art, can afford sustained aesthetic pleasure, a consistent experience of art—as does a symphony program or a theatre production—related to creative practice and appreciation in this our own time.

It will be in order, when that is achieved, to take down the present motto over the proud museum portals: "We show everything." It will be necessary to sweep out, into frankly historical-cultural museums, the clutter of secondary, impotent, reproductive stuff. Living art will be the basis of art-museum design, as living expression is at the heart of the practice of the Modern artist.

In that day the curators and academicians will not use the public galleries in their business of canonizing artists and schools forty years after they have been at their intensest significance. The dead hand will no longer stay the living. Meantime let the student not be blinded by the sacro-sanct air and gilded framework of the museum displays. Let him realize that they are based on 19th Cen-

< 22 >

tury conceptions and molds. The dealers' galleries are still the likelier places for study of art that is vital; though one must discriminate there too. To come back to the starting point of this digression, the academicians control the museums, and they not only are laggards in the evolutionary advance—they even fight the Modernists from the rear.

MODERNIST ART AND HISTORY

When we turn to published annals of the past, we find that the historians too have betrayed us. The art-history books, like the museums, are designed with no conviction as to what creative art essentially is; and in general—since they were written in the Victorian era—they glorify the artists and schools that achieved a neat illusive art, the tasteful sentimental-natural and romantic painters, and the smooth naturalistic sculptors. They are concerned especially with the types of art from which the 19th Century molds were patterned: notably late Greek Realistic sculptures, Renaissance Italian painting (more especially that of the period after the discovery of scientific anatomy and natural perspective, which largely nullified the form-values achieved by the "Primitives"), the flashy British portrait painters, and the various forms of romantic and photographic 19th Century French art.

To the Modern this obsession with the shallow imitational products of uncreative ages is misleading and unfortunate. He prays for the coming of an historian who will begin with a passionate belief in the creative and expressive elements as fundamental, who will relegate illusion-art to its secondary place, and tell the main story in terms of the works of greatest creative intensity. Notable reversals would result from such an approach. Chinese painting,

< 23 >

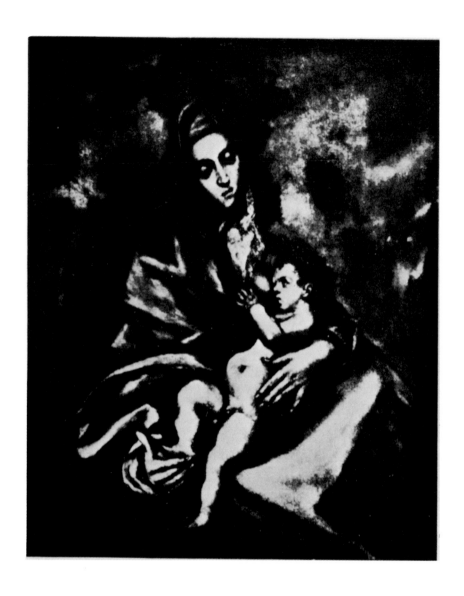

Madonna and Child, by El Greco. Illustrating typical "distortion" of natural aspects, for expressive-formal intensification. (From *Domenico Theotocopuli El Greco*, by August L. Mayer.)

Persian miniature painting, Primitive drawing and painting, from the cave artists to the Italo-Byzantine development, and many periods of primitive sculpture, even to the contemporary African negro figures, early Chinese sculpture—all these would come into increased appreciation. Fading back into lesser prominence would be the recently popular physical-culture exhibits of the later Greeks, such "safe" masters as Raphael, Veronese, Murillo and the entire "British School," and 19th Century favorites from the polished Neo-Classicists and dreamy Romanticists to the gross-feeding Realists and spineless Impressionists. In short, the Expressionist asks for a revision of recorded history, on the basis of a fresh conception of what constitutes vital art, in order that the student may no longer be infected with the obsession that "Art is imitation."

In analyzing existent art-histories, we should find, no doubt, as much insidious propaganda and wilful distortion as in those now discredited "patriotic" history books out of which my generation—schooled in the opening years of the 20th Century—learned the record of men and nations on earth. There was wilful discrimination, and "interpretation" of fact, to make out my country, its ideals and its leaders, pre-eminent. Military victories were glorified, defeats minimized—or forgotten—and the *status quo* shamelessly bolstered. Presidents, kings, generals, patriots, churches, constitutions, were inordinately extolled. As all this fabrication and falsifying was done for the home-land and womanhood and Christianity, there was only negligible criticism of it, or challenge. One belonged within the tight-set system of which it was a part. One accepted, patriotically, without question.

Histories of art seem to have been written almost as servilely, with propagandist bias—and by people ignorant of the profound values of plastic order and dynamic rhythm which the Moderns

< 25 >

believe basic. Academicians, church painters, flatterers and photographers were glorified. Easily understood surface-art from the past was paraded as immortal. National pride was properly served. Even today there is not a published history of art which the Modern will recommend without apologies, reservations and warnings.

That the Expressionist movement already has had strong influence upon world opinion, outside circles ruled by the historians, is obvious. El Greco has been elevated to supreme desirability and widespread recognition, though he was not considered worthy of mention in Reinach's *Apollo: An Illustrated Manual of the History of Art throughout the Ages*, or in Goodyear's *A History of Art*—two Victorian works still standard at public libraries and schools. The popular thousand-page *Outlines of the History of Art* by Lübke did better, according him a single line. As late as 1923, H. B. Cotterill wrote, with special reference to "the origins and evolution of European art," *A History of Art*, in two fat volumes, and dismissed El Greco with a slighting paragraph. But today collectors search the markets for even the least intense works by this "master," and clear their walls for these obviously Expressionistic prizes. Less dramatic reversals in ranking, due to "discoveries" by the Modernists, may be illustrated in the resurrection of Daumier as a painter (after his near-obscuration, as a mere cartoonist), and in the canonization of William Blake and of Albert Ryder.

In a larger view, it is obvious that the museum curators and the historians alike will be forced hereafter to study negro sculpture, Chinese paintings and Mayan-Amerindian developments—not to forget individuals like El Greco, Daumier and Hans von Marées—as belonging integrally in the classic stream of art evolution. Where art lives, the radicals have overturned rankings, brought forward forgotten creative artists, changed the approach to world

< 26 >

art. But let the student beware still of published histories; or at least let him form his own conception of creative values, before he reads. Much current confusion exists because recorded history fixes in the student mind a theory of and approach to art utterly disrelated to living practice and advanced thought upon the subject.

The current Modernism must persist a little longer as radicalism, before it is accepted officially as in the tradition: before it yields up the name "Modernism" to some later development. Evolutionary progress brings Expressionism daily closer to that time when it will be standard in practice, and a touchstone for judging the creative past. Popular education, museums and historians still dissent: but it becomes more obvious every day that they are the dissentients, a diminishing group, on a side road.

< 27 >

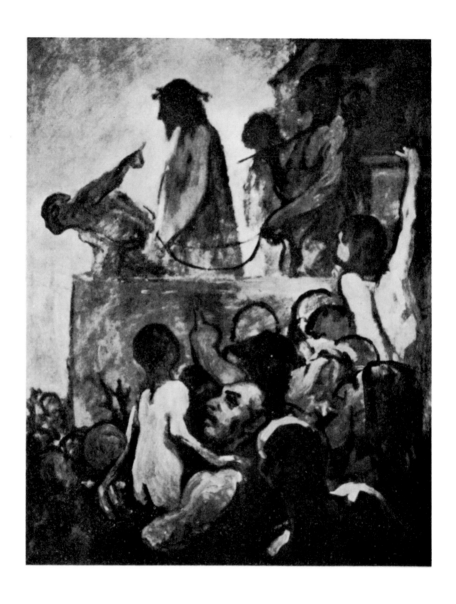

Ecce Homo, by Honoré Daumier. (Photo by courtesy of the Museum of Modern Art, from original in the Folkwang Museum, Essen.)

CHAPTER II

J UST what was it that typical painters and architects and sculptors were doing when Cezanne and Sullivan and Lehmbruck emerged to initiate their contributive revolutions: breaking down the dams which had been erected across the historic streams of progress?

The art of painting offers the neatest illustration of the shift from Realistic practice to Expressionist practice. The change is most cleancut, most typical, most illuminating; and the works of the earlier period are surprisingly innocent of the values especially prized by the Moderns.

Painting in the 19th Century was, as a whole, overwhelmingly Realistic. In my definition—each new writer must frame his own, so muddied are the critical waters—Realism is that type of art concerned with transcribing, without noticeable distortion of surface aspects, the beauties, picturesqueness or other "interesting" values of observable nature. Realism thus includes a considerable group of schools: from Naturalism—with every hair of the beard separately depicted—to the widely variant Romantic and Neo-Classic developments, which were characterized, until recently, as at the very pole from Realism.

Thus the so-called "Classic" art of David and Ingres and Prud'-hon (and in sculpture Canova) seems in longer perspective essentially Realistic, because, in illustrating "ideal" and legendary scenes, with meticulous smoothed-down technique, the artists still

< 29 >

never departed from what could be seen on the surface of nature with the eye. In the search for flawless beauty they arrived at mechanical and effeminate refinement and dry rhetoric, that are at the far extreme from the truly Classic, in the root sense. They were concerned, to be sure, with nature as seen through the scholarly books of Greek and Roman history—but it *was* nature transcribed.

I include the Romanticists likewise among the essential Realists: they sought exotic far-off nature, or they poetically fuzzed up the edges of nature near at hand; but they never departed from a substantially photographic objective view, never distorted or re-arranged surface likeness, in a search for expression and order—never dreamed that art was other than interpretive imitation. From Delacroix with his melodramatics to the Barbizon painters in their misty or glamorous woods, there is a wide range of Romantic "interpretation"; but seldom a detail that could not have been picked up with the camera-eye, sharply or fuzzily focussed.

Along with the Naturalist-Realists, the Neo-Classic-Realists and the Romantic-Realists, there were the groups more commonly termed just plain Realists—painters devoted to nature but too selective to warrant the Naturalist label, and neither coldly idealistic nor yearnful for far-away places and exotic variants from nature's types. Stemming from Courbet, they flourished up to the time when Impressionism capped the progress toward refinement of surface transcription. Within this range one finds the sentimental anecdote-painters, the *genre* painters, the flattering portrait painters, and the purveyors of the charms of the nude, from the hothouse and twilight variations to the straight physical-culture display.

(The definition of Realism is not a point of cardinal importance here: we need not agree absolutely on a permanent terminology before getting on with our study. If you prefer to hold to earlier

< 30 >

conceptions of Realism, considering it opposed to Romanticism and Classicism, you need merely grant me, tentatively, that *beyond* such distinctions there exists a more fundamental division: between formal-expressive or Expressionist art on the one hand, and, on the other, grouped Realism, Romanticism and pseudo-Classicism, all bound within a servility to observed natural detail.)

Within Realism many are the varieties: many the efforts to lift the type out of the category of heightened photography. Attempts are made to render Realism significant, during the 19th Century, by idealizing nature, by serving patriotism or God, by offering escape into vicarious experience, into life as discovered by the artist in parts of the world inaccessible to the ordinary citizen. Attempts are made to build up its importance by pushing technique to a new brilliancy of surface appeal: as in the brushwork of Sargent, or the amazing meticulousness of Meissonier, or the soft-focus poetizing of Carrière. New tricks of composition are achieved, a new posteresque independence of casual detail, new ways of framing and balancing the main motive; and certainly there was gained at this time final intellectual knowledge of mechanical perspective and of physical anatomy. But—summarizing it from the later viewpoint—as long as art remains primarily illustration, as long as its business is considered to be transfer to the canvas of beauty or picturesqueness seen in outward nature, or the telling of a story in nature's objective materials, it is Realism, and to the modern mind more shallow than art that begins with a search for order, form, revelation, expression.

Impressionism as a variety of Realism demands more specific notice. In its scientific advance it put new potentialities into the hands of the later rebels; in its pushing of the Realist search to the last point of accurate surface transcription from nature, it hastened recognition of the shallow character of all Realistic art.

< 31 >

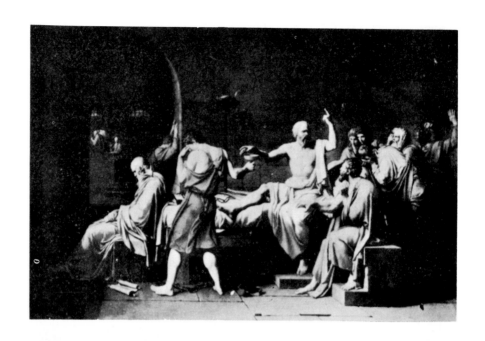

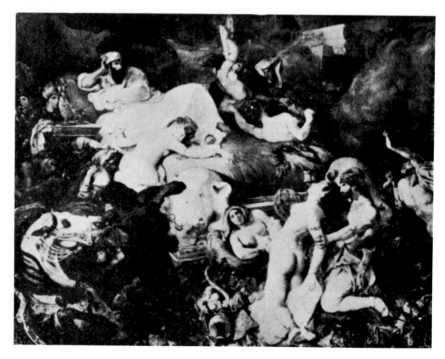

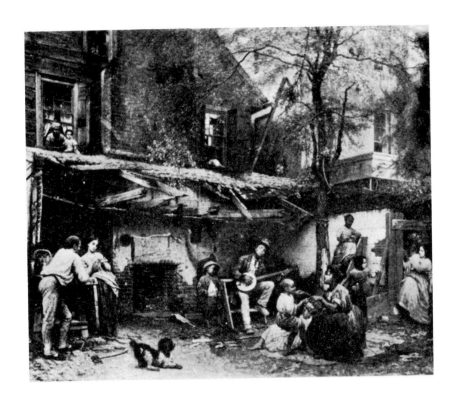

Three types of art here classed within the Realistic method, as distinguished from Expressionism. Opposite, above, The Death of Socrates, by David: illustrating the Neo-Classicism of a century ago, with legendary subject matter and "refined" technique, but pictorially hard, dry and shallow, and camera-exact in detail. Below, The Death of Sardanapalus, by Delacroix: an example of 19th Century Romanticism, full of natural movement but plastically disordered; exotic in subject but photographic in detail. Above, on this page, Old Kentucky Home, by Eastman Johnson: an example of Realistic exactness glorified for its own sake, as unashamed Naturalism, without understanding of pictorial-plastic aims. All of these, whether marking escape into idealistic-Classic or exotic-picturesque realms or abiding by a familiar sentimental milieu, are held strictly within fidelity to outward Realistic-illusional detail: and so distinguished from Expressionism. (From originals in the Metropolitan Museum of Art, the Louvre, and the Gallery of the New York Public Library.)

Impressionism was concerned with the depiction of fleeting aspects of nature. Story interest was wholly suppressed, and the object as such was subordinated. The surface of nature under light, and the nuances of the component colors in light, became all-important. Structure, depth, organization, were largely forgotten. Art became luminous, hazy, scientifically accurate. That the painters then discovered a new way to make color fresh, alive, brilliant, by juxtaposition of minute strokes, patches and wedges of pigment, was enormously important in the technical advance of painting. But the method was used by the Impressionists themselves for shallow illusional ends.

Thus out of Impressionism the first Expressionist experimentalists were to inherit an incalculably precious asset: a scientific knowledge of color, and with it a pure external colorfulness that belongs essentially to the art of painting. They were to carry on, too, the convention of confessing their brush strokes, no longer smoothing down the pigment to hide the mark of the painter-tool. But the very first revolutionaries were to depart diametrically from the method and "look" of Monet and Pissarro. Whereas the Impressionist aimed at recreating an impression of nature received at one moment of time, in a flash of the eye, the first Expressionist painters returned to a search for order hidden beyond the momentary aspect of nature; and they aimed to fix in the canvas a plastic design, implying movement of the beholder's eye along a carefully designed track of vision. The painter is immediately off on a search for values almost totally absent from typical Impressionist works: values which we may term, tentatively, dynamic structure, plastic rhythm, spatial vitality, formal organization.

< 34 >

Franconia Range—Mist and Rain: Water-color by John Marin. (By
courtesy of Alfred Stieglitz.)

Painting just before Expressionism, then, was the brilliant thin
color wizardry of Monet, Signac, Hassam and Frieseke, mixed with
the heightened photography of Sargent, Besnard, Carrière and
Boecklin. These vied with belated practitioners of all the other
sorts of Realism perfected during the Victorian era: pale Romantics
carrying on the Barbizon tradition, followers of Delacroix discover-
ing new theatrical effects in brighter colors and spotted rendering,
the naked figures of Courbet become more brutal and scientific, or
else warmly poetized by Henner or coldly literalized by Bouguereau.

< 35 >

Art was, through a wide range of variations, illusion, illustration, clever transcription.

In the midst of it came Cezanne, and van Gogh and Gauguin. It was during the flood of painting of those Realistic sorts that the first true revolutionaries appeared. The imitative tide continued, to be sure, for a long time after, and even today its latest flotsam may be seen in the academy exhibits on 57th Street. But in the last quarter of the 19th Century there were those divergent figures: artists who have taken on the stature of giants in the history of painting.

Out of the mid-19th-Century current, himself an Impressionist at first, came the leader Cezanne: out of a group of imitationists, a profoundly creative artist. As the world sees it now, Daumier had earlier achieved a strength of organization that is typically of the Moderns; and soon after Cezanne's defection from the regulars, there stood beside him van Gogh and Gauguin. These are the men who successfully challenged the values, methods and theory of painting as it was practiced by the final Realists, just before Expressionism. (The fact that it was so practiced by the *majority* of conforming "artists," during the first forty years of "the new movement," alongside the increasing stream of creative work, need detain us no longer.)

CONFIRMATION FROM THE STORY OF SCULPTURE

The story of sculpture is not quite so cleancut: the contrast between orthodox Realism and insurgent Expressionism not so suddenly achieved, not so immediately pronounced. To be sure, the art of the sculptor had degenerated through a period of three and a half centuries after Michael Angelo: had been weakly Realistic or frankly ornamental, from Cellini to Barye and Saint-Gaudens.

< 36 >

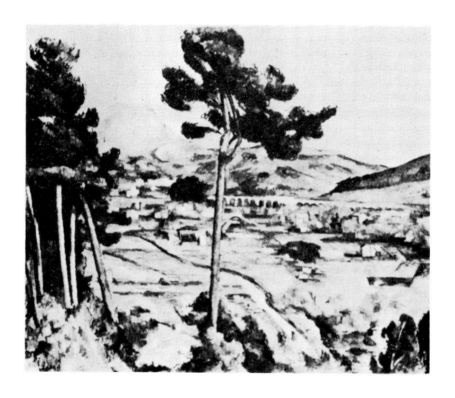

Landscape, by Paul Cezanne. (By courtesy of the Metropolitan Museum of Art.)

Barye may be marked as the type Realist of the Victorian era, photographing in clay the interesting poses of animals, for transfer into more enduring bronze. Saint-Gaudens is the typical illustrator, fixing in monumental compositions subject pieces that would be noble as wash drawings. Neither of these celebrated artists cut his own work in stone—sufficient condemnation, in the mind of the Modern, to exclude them from the roster of great creative sculptors. The art had become something wholly untrue to name, not sculp-

< 37 >

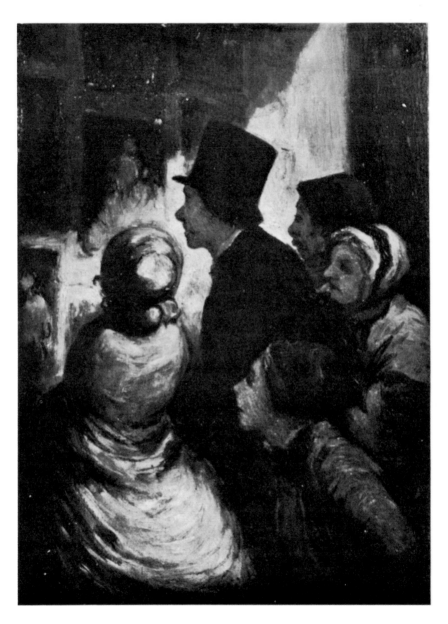

Spectators at the Print Show, by Honoré Daumier. A cunningly organized picture by a master of the plastic or movement element in painting. (By courtesy of the Corcoran Gallery of Art: W. A. Clark Collection.)

tural, but an exercise in modelling, seeking painty effects, obsessed with natural postures and pretty surfaces.

There came, in the midst of the Realistic culmination, no single genius-sculptor of the stature of Cezanne among the painters. Rodin, greatest of the Realists, touched only slightly into a new art: never got clear the distinction between art as illusion of nature, as mirror of the picturesque, and art as primarily expression or revelation. Rodin was, through his middle period, the perfect Impressionist, catching his model at a single moment of time, in a significant attitude, fixing that pose cunningly in stone or clay. He also played up the surfaces of his statues to a brilliant luminosity, rippling his planes with minute variations, affording a sweet evanescent appeal parallel to that of Monet's paintings. But only rarely did he let his inner emotion rule, or permit his "feel for the medium" to dictate paths of improvisation beyond the minor truths of the objective image. He will be known in history as the climactic figure of the Realistic tradition—though he guessed, at the end, that a truer creative art of sculpture was coming. The revolution was to be accomplished by less known artists: Metzner, Maillol, Gaudier, Epstein, Lachaise, Archipenko, and that singular genius whose few works will some day raise him incomparably higher than Rodin: Wilhelm Lehmbruck. These men accomplished a revolution as complete as that in painting, but more gradually.

ARCHITECTURE IMITATIVE AND EXPRESSIVE

Architecture just before Expressionism offers a perfect parallel to the Realism of painting and sculpture. The building art, of course, is never concerned with photography, illustration and illusion. But if those were ends so pursued on their own account

< 39 >

that creative values were largely forgotten, in what were then called the "reproductive" arts, *imitationalism* is the exact counterpart in architectural history. In the one case it is imitation of nature, in the other, imitation of past styles and masters.

Almost from the time of Michael Angelo, architecture had been an exercise in tasteful re-arrangement of re-discovered decorative "motives." During the final quarter of the 19th Century it had become a basic principle of criticism and teaching that all the styles had been invented. The student was trained to take plan and decorative covering from the treasury of the past, and an extraordinary array of books, containing measured drawings of all "masterpieces," was made available to the contemporary designer of architectural veneers. Invention could not go beyond "creative adaptation." The professional architect had been tamed into being an accomplished Eclectic.

During the entire 19th Century, architecture had been Neo-this and Neo-that, with the Renaissance tradition, itself sprung from a Neo-Roman source, barely able to hold its own against revivals of Gothic or Greek or Romanesque. Shadows battled shadows.

Stepping aside from the arena where "the battle of the styles" was being fought, Louis Sullivan in the 'Eighties inquired simply why there could not be an architecture based upon the building materials, the building uses, and the altered ways of human living evident in the machine age. He damned out heartily all renaissances and revivals: all clothing of modern railway stations, meeting houses and office buildings in the garments stripped from Greek temples, Gothic cathedrals and Venetian palaces. And he essayed some buildings in which the materials and uses of the structure actually were reflected in the aspect. He returned the building art to the tradition of creation. He is the grandfather

< 40 >

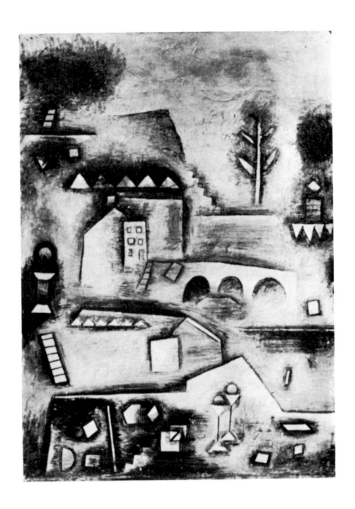

Path of Discovery, by Paul Klee. (By courtesy of J. B. Neumann.)

of the Modern architecture of America and Europe today. His
pupil and co-worker, Frank Lloyd Wright, is more strictly speaking
the father, by reason of richer creative sensibility, and an ability
to fight unscathed through any battle at any odds—to victory, be-
cause the future is on his side. These men, with Berlage in

< 41 >

Holland and Wagner in Austria, initiated the new expressive architecture, which is the exact antithesis of the imitationalism of the Victorian era.

It is not necessary here to seek into all the arts for evidence that practice and theory in the 19th Century were Realistic-imitational: exhibiting values at the very pole from the quality held most precious by the Moderns. I hope to have established sufficiently the point that, in general, art just before Expressionism was un-Expressionistic: uncreative, unoriginal, inexpressive. In literature the lines of revolution begin farther back, and interweave more confusingly with continuing traditional creative practice and with common Realistic activity. There is no suddenly apparent contrast, and there are subtler shadings of imitative and expressive elements. In the theatre, a multiple art, the prophet Craig changes the course of visual stage practice, but the advance is hampered because there are no co-revolutionary playwrights of comparable stature.

In the dance, however, a genius appears, against the typical background of a run-down, imitative and stultifying tradition. She galvanizes the world into attention, and, by example, revolutionizes practice on two continents. It is not so certain that Isadora Duncan carried through to intensest Expressionistic creativeness—Mary Wigman is more typical of the new world—but Duncan ended a centuries-long imitational era: closed a period during which evolution had all but ceased, and initiated a new cycle of creation.

The arts before Expressionism, then, had run a long and varied course within the blinders of Realism and imitationalism. It is necessary to remember the extent to which artists submitted to this limitation, through three centuries: that the graphic work had to

< 42 >

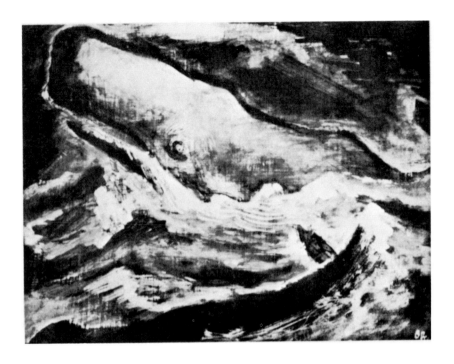

Moby Dick, by Boardman Robinson. (By courtesy of the Kraushaar Galleries, New York.)

give back the illusion of the appearances of nature; that the architect and the dancer had to keep within the limits of what had been done in their professions in the past. Institutionalized education, the museums, written history, still glorify the Realistic painting, the imitative building. But we have come together to study another sort of art—which I hope will be more understandable after this brief glance at what went immediately before.

< 43 >

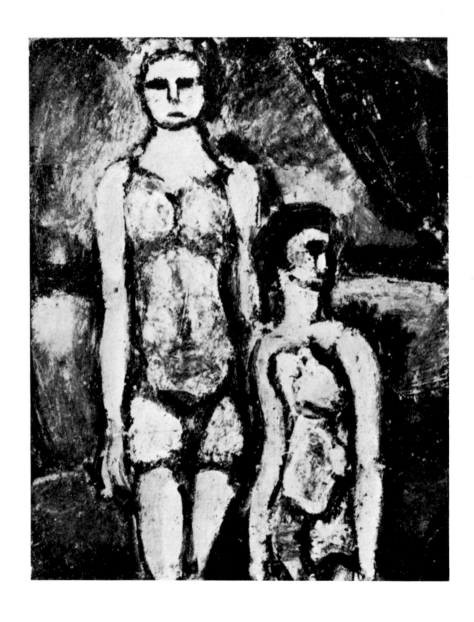

Circus Dancers, by Georges Rouault. Typical abandonment of natural
detail for strong plastic organization. (By courtesy of
Pierre Matisse Gallery.)

CHAPTER III

B ENEDETTO CROCE once opened a book with this definition: "Art is what everybody knows it is." Thus an aesthetician who had spent years wrestling with the subject intellectually, summed up his impatience and his doubts. The statement is far more than a quip. It acknowledges the uselessness of attempting to intellectualize conclusively about art, of trying to explain it literally and reasonably. At the same time it grants that all men feel what art is, intuitively—before they call on the brain to settle whether it is primarily perception or communication, intuition or imitation, content or form, or other of the alternatives which have been endlessly and confusingly debated by the philosophers.

The practicing artist is notoriously contemptuous of the experts who theorize about art; and certainly most of the aestheticians writing today overlook those very qualities or values which the Modernist believes to be the essence of creative work. The case is very much the same as in the realm of speculative philosophy: life itself escapes the philosophers while they are discussing whether it is seeming or being, the reality itself or the perception of it, the while men go on living. The aesthetician is far from being a direct help to either artist or art-lover. In the face of the mystery of creativeness, he has taken refuge in quibbling and abstruse evasion.

And yet we cannot easily and understandingly explore the field of produced art without recognizing some basic "principles." We

< 45 >

cannot advance in a discussion of Expressionism, or any other creative development, without agreeing upon, at the least, a tentative definition. What each student would like to feel, no doubt, is that after reviewing all the standard theories, he has dismissed as many as are outmoded; going on, then, with a few sifted truths that hold good in the light of latest exploration and practice.

It probably does no one any permanent harm to read the books of the learned aestheticians—both the philosophic and the empirical sorts. It is even possible to gain insight thus, if one resolves not to get lost in the disputatious jungles of thought, not to lose one's eyes for seeing, and one's intuitive faculties of enjoyment.

In Croce's works, for instance, the clearing of the ground * is of practical benefit: when he brings art free of the intents of instruction and moralizing, and when he distinguishes the "lyrical or pure intuition" of art from the logical thinking and critical classification of history and natural science. (Much that masquerades as original art, in our museums, is merely illustrative history or nature study.) He also puts back into perspective the earlier systems that aimed at an absolute definition or theory of what art is; he notes that aesthetic is ever growing and renewing, as understanding enlarges. His own first explanation of art as at once *intuition and expression* might afford as likely a starting-point as one could find for a simple book like this, which pretends to record little more than an outside view of one phase of art practice.

* Leo Stein remarks: "The principal service of Croce to aesthetics has been to almost wipe out the subject, while leaving the word. This service is considerable, because aesthetics had been on the whole so enticing and so unprofitable that its removal from the field of practical attention was a real boon." Stein, however, went on to complete his own book, *The A-B-C of Aesthetics*; though he notes in the Preface: "There are no authorities and it is somewhat doubtful whether the subject exists."

< 46 >

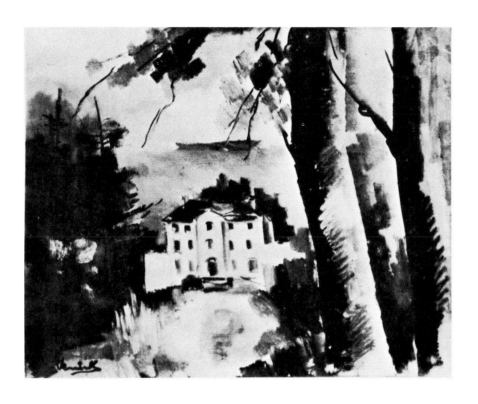

Landscape, by Maurice de Vlaminck. (By courtesy of Adolph Lewisohn.)

It should be emphasized, certainly, that all the elder systems of aesthetics (and some students would include that of Croce), all *a priori* systems, by which laws were laid down for the eternal confinement of art, seem to the Moderns futile. Reasoned canons, based on "the search for perfection"—a search carried on in the natural world—will always be inadequate, in the face of the mysteries and unaccountable reaches of creation. Intellectual concepts of art are necessarily based on observation in the realm of nature and inductive logic; and no amount of study with the sense-equip-

< 47 >

ment and the brain can explain the formal and rhythmic elements in art. The empirical aestheticians, trying to come at the mystery from another side, that of the observer and appreciator—tracing the modes of emotional reaction—are in somewhat better case; but the theory of empathy, of art as stimulation of sympathetic response, seems to many practitioners to leave out more than it takes in. It relates appreciation to a concept of an unchanging ego—as much a limitation as those to be discovered in the "absolute" systems.

The only aesthetician who has attempted, with any show of success, to formulate, in English, a theory specifically applicable to Modernist art, is Herbert Read. He goes largely to the German empirical school for evidence; but he finds in the writings of Bergson (who never treated aesthetics separately) the single statement that he considers broad enough to allow for the phenomena of Modernism.*

For our part, approaching the subject of Expressionism in an effort to clear away obstructions to enjoyment, we too may find

* The student should read a summary of the theories of Croce; he may be considered the end of the old line of aestheticians. His article in *The Encyclopædia Britannica*, 14th edition, is perhaps a better brief statement than any to be found in his books. The quotation at the beginning of the chapter is from the essay translated as *The Essence of Aesthetic*, London, 1921. One has to make allowances for Croce's hostility toward the empirical theorists and their "hopeless attempt." For the other side, see Herbert Read's *Art Now*, New York, 1934. One has to make allowance, in turn, for the author's impatience with Croce; but Read is the most persuasive and readable writer on aesthetics as applied to Modernism. *Art Now* is doubly useful·in having 128 collotype plates of contemporary painting and sculpture. (Too many books on aesthetics can get along without reference to produced art.) Read's terminology seems to me confused and confusing: he attempts exact divisions into groups that are "Subjective Realists," or "Subjective Idealists," etc., but his book is informative and stimulating; and today perhaps no terminology is good outside the volume in which it is used. The student should read also *The A-B-C of Aesthetics*, by Leo Stein, New York, 1927; *Art*, by Clive Bell, London, 1920; Book I of *The Art in Painting*, by Albert C. Barnes, New York, 1928 (second edition, revised and enlarged) ; and *The Modern Movement in Art*, by R. H. Wilenski, London, n.d.

< 48 >

most hope and sustenance in Bergson. The philosophy of change, of which he has been the most eloquent advocate, would seem to offer the only foothold for relating modern art to modern life; and his emphasis on intuition as basic and the mystic as normal, is in line with our study so far. At the moment, an acceptance of the theory of creative evolution—supplemented perhaps by a vague knowledge of the principles of Relativity—will prevent us from offering any definition of art with the expectation that it will prove permanent, absolute or final. We are seeking a means for understanding, in a changing world.

A WORKING DEFINITION

As a basis for discussion to follow, we may start with this:

Art is the formal expression of a conceived image. As an alternative, we might phrase it: *Art is the formal expression of an imagined conception.*

In adopting this definition tentatively, we are not evading the issue as does everyone who explains art as "beauty"; that is merely a transfer of the problem into another unlighted alley. No more do we take refuge in "that which gives pleasure in a special way," or "that which affords aesthetic enjoyment"—evasions both. We are facing the mystery of art with the most definitive words we can find.

But since they still are words, which are inexact, and many notoriously loose, let us try honestly to pin down our meaning as neatly and suggestively as may be—examining each word of the definition for overtones and implications.

Art is the formal expression of a conceived image.

"Formal" carries the implication of order, plan or rhythm in the

< 49 >

expression. It immediately lifts the meaning above imitative functions, beyond art as descriptive, inventorial or explanatory. The Oxford Dictionary defines "formal" first as meaning, "(Metaphys.) of the essence of a thing"—furthering our sense of flight from the casual, natural and ephemeral. There are those who would prefer the phrase "ordered expression" to "formal expression." To this student there seems little difference intrinsically, but "formal" outwardly ties in to the "search for form" which is a main path of Modernist experiment—and talk.

"Expression," as a word, affords another defense against the common conception of art as imitation or interpretation. Croce is careful to free expression from connotations of communication. We need not be so solicitous for a difference: for communication must be a link somewhere in the chain: whether we consider art as complete in the processes within the artist's faculties, with communication a sort of extension, or as the whole chain of processes from conception to appreciation. In either case, "expression" seems the fittest key word in any modern definition of art, because it implies the importance of the processes before the giving-out, of the feeling, the emotion, *personal to the artist*—and is therefore in line with practically all Modernist credos, and the bulk of practice.

"Conceived": this word, in its prime meaning, "become pregnant with, originate," establishes just the point I should like to establish, before going forward to talk about the greater *creativeness* of Expressionist art, as distinguished from Realist. "Conceived" also suggests directness of creation, and overtones of emotion, lyricism, ecstasy.

"Image": used not in the sense of representation or semblance, but as denoting *a production of the imagination given form*. But as some people, timid about abstractions, referring everything pos-

< 50 >

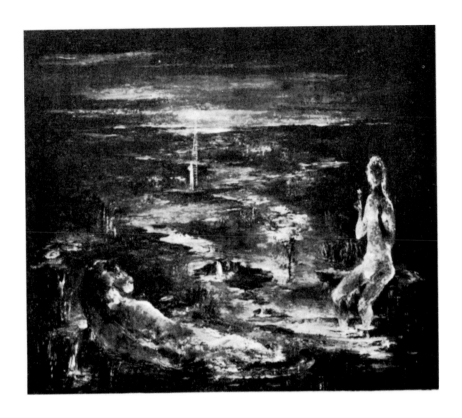

The Garden, by Darrel Austin. (By courtesy of the Perls Galleries, New York.)

sible to sense-images, might find a loophole here, permitting the escape of art back to nature-imitation, I have worded my alternate definition not "conceived image" but "imagined conception," which seems to me a slight weakening of the idea behind "conceived," but safer to some minds in that there is removed the possible likeness-to-nature connotation in "image." (There should be a word with the

< 51 >

implication of concreteness felt in "image," and the intuitional and non-representational sense of "imagination.")

The whole book is in a sense an elucidation—I hope that I am not implying too much!—of this definition. I have recorded earlier my opinion that the contemporary Expressionist movement constitutes partly a return to basic creative art (after a period when men turned to secondary, uncreative imitative activities); and any treatment of a serious phase of art practice, any analysis of a newly expressive or revelatory accomplishment, upon the upward scale, must be shown to come within a definition that embraces Chinese, Greek, Byzantine and other still valid manifestations. In studying Expressionism, in other words, one should begin with a theory basic enough to underlie all creative or primary art; but at the same time one may recognize that the very definition of art is broadened or sharpened by reference to latest achievement.

ART AND ITS MATERIALS

It is obvious, then, that I am trying to frame a definition broad enough to embrace intensely creative art of all past time, and of all sorts, yet a definition shaped somewhat by the conclusions to be drawn from Modernist practice and appreciation.* It is under-

* The hostile reader—there always are such, when Modernism challenges Fundamentalism—will find here an apparent breach in our walls. "First he forms a definition of all art, to which presumably he will reconcile Expressionism, in an effort to bring about its acceptance. Then he admits that he has framed that definition specifically to fit the Expressionist's case! Obviously illogical!" And indeed there is no logic in discussions of creative art: there are no laws to deduce from, nor absolute practice as a starting-point for induction. One throws a little light on the latest phenomena by reference to the main stream of past achievement; one opens appreciation to the latest product, and goes back better prepared to summarize in a definition the essence of past creative effort, in a statement temporarily useful. It is a see-saw effort to let in a little illumination; not an attempt to fix final standards. There seems to me no other method where spiritual and aesthetic values are under discussion. From practice to theory, from theory to practice: and somehow one's understanding widens, one's experience of art deepens.

< 52 >

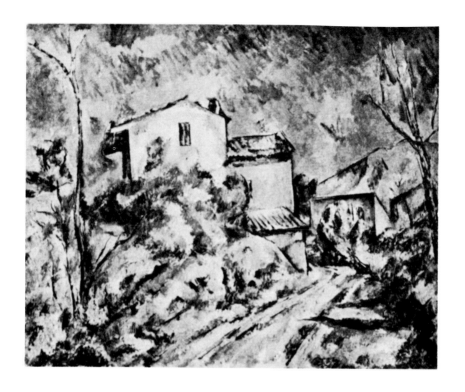

Landscape, by Paul Cezanne. Typical pictorial-plastic treatment, with the medium declared.

standing of the Expressionist achievement, for instance, that leads to the substitution of "expression" for "imitation," "interpretation," etc. The words "illusion" and "representation," common to many earlier definitions, are not included either.

There is, however, one primary lesson artists have learned out of Expressionist experiment and practice, as distinguished from Victorian-Realist, which I have not permitted to influence my wording. It has to do with the importance of the medium: the enormously expressive values to be derived from characteristic use of paint on a two-dimensional field, or stone in the mass, or archi-

< 53 >

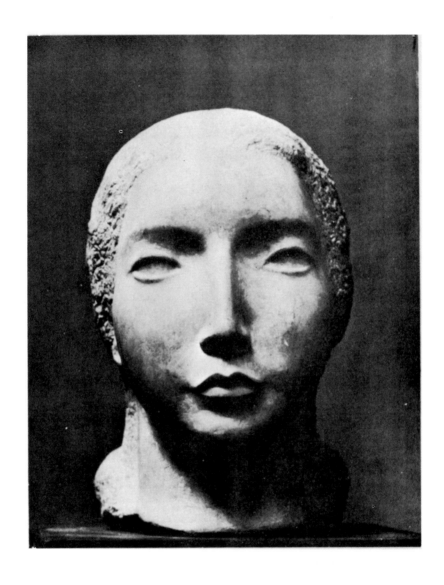

Hilda: Marble sculpture by William Zorach. Typical Expressionist return
to capitalization of the virtues of the stone medium.

tectural steel-and-glass, or movement of actors on a stage. The Modernists have signally capitalized upon the materials and methods particular to each art, have purified the medium: so that the literary values tend to disappear from painting, the plastery-painty values from sculpture, the 19th Century literary-intellectual over-emphasis from the art of the theatre. Expressionism attempts a return to the typically theatrical elements in the stage art, to the stone of sculpture, to the strictly pictorial problems of painting. But the wisdom of his seems to me too elementary to demand recording in a definition of art. Capitalization upon the materials particular to the art in hand can be taken for granted in all intensely creative eras. (During the digression, in the 17th-19th Centuries, from the great tradition, in the seeable arts, men found special delight in sculpture tortured into wash-drawing technique, in anecdote pictures, and in cast iron ornament imitating wood carvings.)

Some of the most understanding of writers on Modernist art stress this matter in their definitions, refusing to consider the sense complete unless the idea of expression is conditioned from the standpoint of material-technique. There is no reason for quarrel with people who prefer to look from a slightly different angle— since we are putting forward no claims to universality or exclusiveness. I may therefore note that my wording might be elaborated thus: *A work of art is the formal expression of a conceived image, in terms of the particular medium employed.*

There is one other word commonly insisted upon, which I have omitted from the basic definition as too obvious: *feeling*. It seems to me patent that creative expression must arise out of feeling or emotion, in any case where conception has occurred, followed by image-forming. But this matter is treated in later chapters: one upon Abstraction, enquiring to what extent the formal image may

< 55 >

exclude the recognizable symbols or materials of objective reality, and one directly upon "Feeling and Meaning." Summaries of the ideas presented in those chapters are included in the numbered paragraphs a few pages forward.

My definition no doubt implies a point of view: it is obviously not worded with the intention of spreading over everything ever done in the name of art. Victorian definitions, like Victorian museums and histories, sometimes suffered from an amiable all-inclusiveness. Here we are definitely disinterested in "art" that is mere transfer from seen nature, that is photography. The emphasis is, instead, on the artist's conception, on essence, on form, on expression; and I take for granted the importance of feeling, and of the potentialities of the medium.

With that emphasis in mind, we shall now enquire whether there is one well-marked main stream of Modernist art. We shall ask whether there is warrant for considering such contributory "schools" as Post-Impressionism, Cubism, Abstractionism, etc., as integral to one current, within one movement. What are the features that characterize the most *typical* Modernist art? If there is such a thing as Expressionism, we should be able to find a certain continuity of experimental endeavor, a like achievement among many artists, a main path of progress—to which, perhaps, the name will prove more appropriate than any other.

THE MAIN PATH OF MODERNISM

I recognize that there are other currents of experiment and advance—and almost innumerable eddies and side-streams—beside the main course I shall now try to chart, roughly. But since I am conductor of the present party of exploration, I shall ask that, for

< 56 >

the moment, the reader follow my tracing of what seems to me the essential Expressionist thing. Some of the lesser currents will be examined later.

In the main, modern Expressionism (regarding, at this time, painting only) may be explained in these few statements.

1. There is an increased precision of thinking in regard to the artist's problem *in relation to his medium*. In painting, this results in an unprecedented respect for the canvas as a two-dimensional field, which, in completion, must have an integrity or unity of its own. The picture frame is no longer a window upon nature, within which a naturally beautiful scene or object is fixed, with or without a measure of selection and interpretation. To preserve the picture field, to endow it with a creative value, which makes it different from nature, is a first aim of Expressionist art.

2. Within the picture the artist arranges certain elements—volumes, planes, lines, colors, textures—in an order determined by a feeling he has experienced, perhaps stimulated by a natural scene, or a memory thereof, or perhaps first stirred at some deeper perceptive source, by an experienced emotion. The order thus achieved, the unified abstract design or plastic architecture of the picture, is of greater ·importance than the surface appearances of natural objects that may be incidental to the design. The achievement of this formal order, as a common attribute of modern painting, is of the essence of Expressionism on the material and compositional side.

3. While obviously it is too early to pronounce judgment on the artists and schools concerned, with any pretense of finality, it seems clear that the main current of Modernism proceeds in a line from Cezanne through the Fauves and the Cubists to the several contemporary groups that are usually explained as "form seeking."

< 57 >

That is, Expressionism has continually fed on the achievements of painters, in various schools, who were willing to sacrifice all else in order to reveal a bit of the precious rhythmic organization, the formal architectonics noted in the paragraph above. Intensest creation, moreover, seems to lie with those artists who differentiate this essential rhythmic-dynamic element from the static compositional values commonly found among the "Old Masters," and even, at times, in recent superficial Realistic painting; the distinction depending upon understanding of plastic orchestration: the correlation of dynamic elements, of tensions and forces set up by volume-space organization, recessive colors, etc. The nearest lucid explanations (for we are deep now in the clouds noted in the first chapter) are those dealing with *movement* in the canvas: meaning not depicted natural movement, but the backward-forward design, the poised or coiled tension-path, the thrust and return and contrapuntal variations of the plastic elements. There are ways of opening the picture, of carrying the attention, of stabilizing the sense of movement, which afford the observer a perception of underlying abstract order, a revelation of a plastic "structure." Some of the commoner means to fixing this movement in the canvas are by superimposed or overlapping planes, by bent planes, by tension of volumes (understood best by reference to the planetary system), by heavy or faint texture, and by manipulation of the forward-coming and receding properties of colors. These several elements are commonly utilized, in conjunction, to achieve not only a main direction of movement in the picture but also an enriching minor counterplay of backward-forward fluctuation.

4. The passionate search of the Expressionists for means to fix the play of movement in the canvas, to reveal the expressive form quality, the dynamic order, has led to increased *abstraction.* There

< 58 >

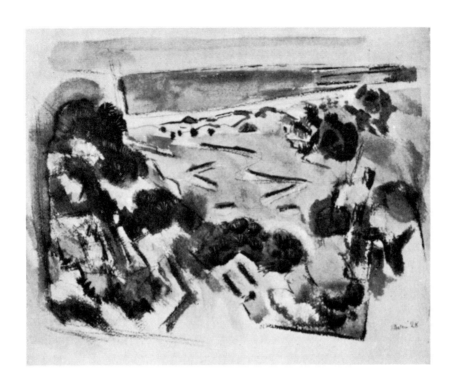

On Morse Mountain, Maine: Water-color by John Marin. Expressive-abstract values displacing illusive and Realistic. (By courtesy of An American Place.)

has been progressive neglect of nature's casual aspects, even what some would call nature's beauty; distortion of natural shapes and textures; and in frequent cases, utter abandonment of recognizable objectivity. Purely abstract relationships have become of greater significance than transfers from nature's storehouse of the beautiful and the "picturesque." It may be stated, indeed, that there are two main divisions of the Expressionist current: one in which the abstract values are sought for their own sake, independent of natu-

< 59 >

ral appearances, or with only incidental relation to the objective world; and one in which a picture ordered with nature's materials and rich in "feeling" contains a supporting skeleton or structure of the abstract, the latter being the more important reason for the picture's existence, aesthetically considered—though there may be a range of over-values, depending upon the nature of the subject, affording human and social interest and stimulation.

5. Implicit in the attempt to achieve a revealing bit of the creative formal order, the abstract architecture in the canvas, there is a universal-mystic significance. An intensely creative abstract work of art, affording an enjoyment that may border upon rapture, links with the mystic's search for personal identification with the rhythm at the heart of the universe, with the consciousness of dynamic order and harmonious progression of the cosmos, beyond time and space. It is not necessary for the reader to accept this statement in order to follow the discussion through following chapters—if he distrusts mystic analogies and speculation in the region of a fourth dimension. Nevertheless, many Expressionist artists are proceeding with a sense of direct connection of abstract values in art with the deeper spiritual aspects of living; and many of the rest of us have found our understanding of Modern art clarified by a study of those contemporary spiritual movements, of both Western and Eastern origin, that attempt to bring the individual soul into conscious identification with the source of all-being. Knowing something of the mystic's conception of the structure and meaning of all that is, we find our faculties better able to identify, and enjoy, the echo of universal-eternal architecture in creative art. The habit of apprehending the infinite in the finite is an aid in seeing through to the picture's abstract core. Art here becomes a sensuous means to revelation of cosmic order. Expressive form, achieved,

< 60 >

opens four-dimensional vistas. (The Modern is here aided and fortified by study of ancient Chinese art, in practice and theory.)

6. The increased precision of feeling in regard to materials and method, the capitalization upon freshly discovered or understood potentialities of color, movement, etc., in relation to the basic picture plane, lead to a new *intensity of expression,* a fullness and vividness typically Modern. This intensity is re-inforced by that other attainment, the plastic orchestration in the picture: the formal order which may be marked by one as mystic revelation, by another as merely mechanistic dynamic rhythm. Besides these factors contributing to the "fullness" of Expressionist painting, the one material, the other rhythmically structural, there is—except in wholly abstract examples—the element drawn from nature or human experience, which cannot yet be charted. It is too soon, it seems to this observer, to attempt to judge how far this "life" element, the reflection of a fullness and intensity of common living, in the machine age, may contribute, in the picture's "content," to the already increased intensity of Expressionist art. Decades from now, historians will be able to look back and estimate the influence: assess the enriching subject values, human and social, in early 20th Century Modernism.

Even today there are critics, holding to literary and moral values in painting but pretending to "sympathy" with the Moderns, who contend that all the achievement since Cezanne has been in the nature of perfecting a shell, into which more inspired artists may in the future pour something significant by way of subject matter. (Thomas Craven opines that the Cubists painted as they did because "they have nothing to say." He adds, writing in 1931, that "in France the more intelligent men . . . are gradually returning to representational art.") Others of us believe that a whole de-

< 61 >

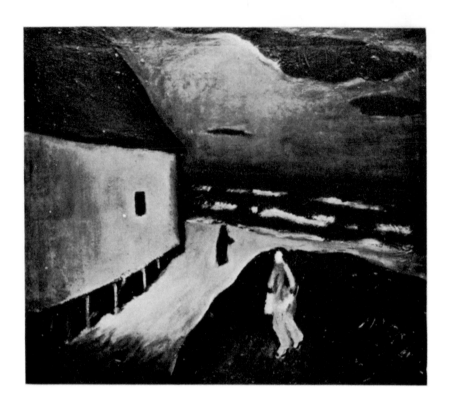

Sea Lyric, by Matthew Barnes. (Photo by courtesy of Joseph A. Danysh
Galleries, from original in collection of Mrs. Sigmund Stern.)

partment of painting—abstract and near-abstract—justifies itself
by the enjoyment afforded without reference to objective nature or
intellectual idea. The compositions of Kandinsky and the near-
abstract "landscapes" of Cezanne, in no sense transcriptions from
nature or comments on subject-matter, yield us pleasure as do the
equally abstract works of Beethoven and Bach.

 In a second range, where objectivity enters in, the core of ab-
stract formal order seems to us the truer source of our enjoyment,
rather than called-up memories of apples, trees, bathers and other

< 62 >

incidental content. In the third range, where compelling subject-matter is indissolubly fused with the formal elements, there simply is not enough evidence to warrant final conclusions. There will be, this observer believes, a development upon the foundation already built by the Modernists, a structure of art more humanly and socially significant, with the satisfying architectonic quality at its core; and as long as that core remains, and the subject elements lend emotional rather than intellectual intensification, it will still be Expressionist achievement. One can only say meantime that the Modern advance so far has been primarily in finding the means to achieve that core, which seems to some immeasurably worth while on its own account; and that there probably will be a further extension toward enrichment with intenser "life stuff." (The more extreme Communists, of course, stand with the old-fashioned critics in insisting upon the first importance of sentimental or intellectual content or message. For them the picture is not significant unless it promotes the workers' revolution. Some of us who believe in the inevitable and just coming of a workers' world, in the widest sense, still admit a value in art separate from propaganda or urge to action. Art with a social "drive" seems to me preferable to most of the product that we have now, with neither abstract values nor social significance: pretty, photographic, sentimental and trivially flattering art, subtly propagandist for the tired world that is passing. But the Communists will come to see that an abstract type of painting is worth preserving on its own account, as music and dance will be preserved.)

OTHER APPROACHES, AND EXCLUSIONS

Now obviously these six statements form a merely *personal* summary of what one observer considers the characteristic values and direction of Modernist art. After, roughly, ten years during which

< 63 >

I have sought for the most expressive, revealing and intense works of contemporary painting, first for enjoyment, then for study and analysis, I have come to the belief that the search for a deeper order in the canvas is the essential mark of today's Modernism; this leading to a conception of the picture as a thing apart from and beyond nature. Next in importance is the conception of that revealing order not merely as a compositional element but as a dynamic value, to be studied and attained in terms of movement, plastic rhythm and tension.

There are other ways of approach to an understanding of the typical thing. Once the point is made that transfers from nature are of only secondary importance, that imitation is giving place to expression—and any representative display of Moderns will suggest as much—one might turn immediately to the question, "What is it that the artist expresses?" The briefest study might lead to this answer: He expresses primarily his feeling for life and order, growing out of his own experience of universal abstract values, perhaps as apprehended from a sense-experience of an object or subject in outward nature; his expression being intensified also by a special mastery of the materials and methods of his art. And indeed, that approach, in turn from the three "sources," in the artist's feeling and imagination, in the subject, and in the materials, will determine the way of our analysis of Expressionist elements in the next chapter.

The reader who knows his "Who's Who in Modernism" will recognize that, in setting down the credo above, I am excluding from the main current several schools and isms which have bulked large in art news during the past thirty years. This is in addition to ruling out, as uncreative, all the streams of Realistic-photographic art: Naturalism, Romanticism, selective-Realism, etc.

< 64 >

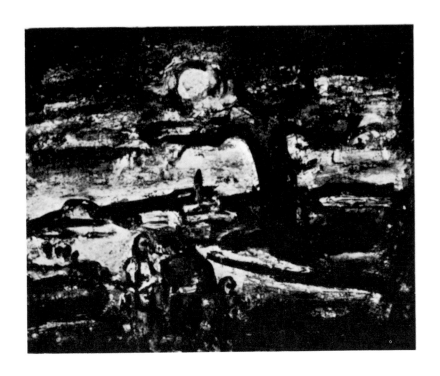

Winter Twilight, by Georges Rouault. (By courtesy of
Pierre Matisse Gallery.)

Thus the following groups claiming the "Modern art" label are
left outside the definition: Futurism, because it ended by being
merely *illustration of movement*, however novel its photography;
Sur-Realism, because in its most characteristic phase it returned to
depiction of the objective, albeit the objects and symbols illustrated
are drawn from the subconscious rather than the surface mind
(though it is to be noted that certain creative members of the Sur-
Realist school have shied away from the Freudian dream-exposing
group, these others being recruits from German Abstractionism,

< 65 >

French Cubism, etc., and better explained with those experimenters); and the devotees of The New Objectivism, because they head straight back toward rearranged photographic Realism. I have thus simplified my task—and I hope that of the reader—because I have come to feel that Expressionism, as the name history will apply to the creative art of this time and the period immediately ahead, is the antithesis of Realism in all its varieties. Although allowing, as noted in statement 6, for the entry of incidental objective values, emotional stimulus and social significance, as contributory, the attainment of dynamic-formal elements, instead of Realistic illusion, is the type-fact of present-day Modernism.

There is something to be said for, or about, this conclusion from another side: the appreciator's. A recognition of abstract values, among those not professional artists, is growing. Perhaps, even, men are coming to a time when this factor in painting will be generally recognized as the prime essential, a touchstone. Our consciousness today is more attuned to it than has been that of any earlier generation, by reason of wider spiritual exploration, clearer understanding of the artist's problem, and increased opportunity to compare the arts of all times and all peoples. It is my belief that as men develop aesthetically and spiritually, in the era now opening, their faculties will be increasingly eager for revelation of the architectonic-universal rhythm, the plastic synthesis. Its guises are various, as discovered in the works of—for instance—Cezanne, van Gogh, Matisse, Picasso, Kandinsky, Klee, Rouault and Marin; but the true Modernist picture is characterized by a value common to the achievement of these artists, and not to be discovered in the works of typical 18th and 19th Century painters.

We are opposed, of course, in our willingness to place a primary importance upon the formal and plastic elements in art, by critics

< 66 >

of the older school, from the Fundamentalist Cortissoz to the "liberal" Craven. Their opposition is based upon the flat statement that they can see no such values, and doubt their existence. (Craven, in a sprightly attack on the Modernists, suggests that the appreciators, far from being humans with broader sensibilities, are those few who consider themselves divinely endowed, but really have shrivelled until their "receptive apparatus is no longer capable of responding to anything but abstractions." He speaks of the Modernists in the past tense—"The Modernists were men of the strongest anti-social propensities"—and he finds Cezanne the only near-master.)

But the swing of informed appreciation toward the form-seeking artists, even to the most abstract, has been evident enough to warrant us in claiming recognition, on the part of perhaps the widest "art public" in history, of formal values. People who can't experience that element simply can't experience a thing common to a large and growing number of their fellow men. These latter ones are ready to stake their faith and a great amount of their study and time upon the existence of a compelling expressive-rhythmic value: believing that it is far more than a self-delusion of a few esoteric wanderers from the normal paths of experience. There is, indeed, something like a landslide among young students of the arts, toward Modernism, and toward recognition of what I have called the formal values of Expressionism.

This all might be put in a nutshell—the beliefs of the Modernists tend to one conclusion: *Things not imitable can be revealed, expressed, presented in another form.*

< 67 >

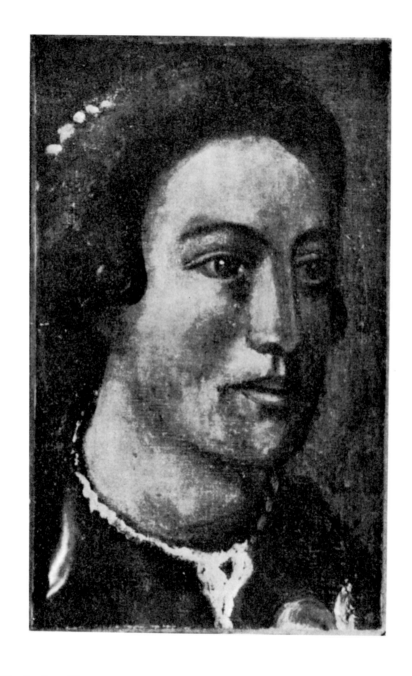

Head of a Young Woman, by André Derain. (By courtesy of the
Museum of Modern Art: Bliss Collection.)

CHAPTER IV

IF I have not lost my way, I have now placed before the reader these basic thoughts: Art inevitably changes, grows, expands into new forms; and tradition marks the main path of progress (Chapter I). Victorian art was the culmination of a progression, or digression, during 350 years, along the lines of Realism and imitationalism; today's Modernism constitutes an utter revolution from Victorian theory and practice. and a return to the creative tradition (Chapter II). Among the multiple currents, eddies and contributing streams of Modernist art, one main direction of advance is discoverable (Chapter III).

If you grant me, on this showing, that there is an epochal revolution, and within it an identifiable main current, it is right to ask: What warrant is there for terming the new creative art "Expressionist"?

In the fifty years since Cezanne and Sullivan effectively started two of the creative streams that have flowed in steadily toward collective Modernism, there has been a welter of confusion over the nomenclature of the subject. The thing must come before the name. Controversy has raged over theory and practice, over the importance of individuals and schools, and over the naming of the main stream. Even today the student who would specifically label the art that is crowding out Realism, if only for convenience in discus-

< 69 >

sion, finds himself attacked and decried. But at the undisputed age of fifty years revolutionary Modernism deserves a recognized name.

The word "Modernism" itself is sometimes insisted upon as sufficient. But if we believe in evolution in art, we know for a certainty that tomorrow's Modernism will be different from today's: that the word can have no lasting historical meaning. It has no character of its own, is only temporal and relative. A century ago, in painting, the current Modernism was Romantic, with the more Modern "Naturalism" already foreshadowed. A half century ago, in the theatre, Modernism was the crusading intellectual Realism of Ibsen (which some universities count Modern still). The label, indeed, has no claim to permanency. If there are any definite characteristics marking off revolutionary art today from Victorian practice, the word is inadequate: a makeshift to be passed on progressively to later generations of innovators.

Similarly "Post-Impressionism" is a relative and negative label, though once useful and expressive. For a time, in the first confusion, it adequately tagged those painters who were pushing beyond current mass-practice. Already it seems to have passed into history, as designation of the very small group of original rebels against Impressionism. The only authoritative place where it is still used in the broadest sense, I believe, is in the pages of *The Encyclopædia Britannica* (14th edition, 1929). It is there praised as a "safe" term, though "Expressionism" is noted as more apt— but unfortunately of German origin!

As to "Futurism," it is the term most often employed—misused —by people who know little about contemporary creative art, except that it puzzles and therefore annoys them. It is another temporal and makeshift label, with no innate character, and is, moreover,

< 70 >

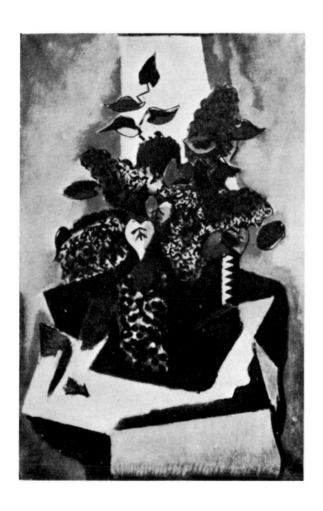

Still Life, by Karl Knaths. (By courtesy of A. E. Gallatin and the Gallery of Living Art.)

the self-chosen tag of a minor but vociferous school of painters and writers. Nor is "Cubism" a possible general designation for Modern art, considering its technical and limited connotations; although the Cubists have made the largest contribution to the main stream, in their experiments and their clarification of theories.

< 71 >

R. H. Wilenski, a leading and widely respected writer on this subject, sums up the main Modern development as "Cubist-Classical," by which he implies that Cubism constitutes the latest creative phase in the great or classical tradition of world art. But the name is rather too clumsy, if not contradictory, to live on definitively. Cubism will bulk large in histories, but as a contributory stream.

It seems to this observer, indeed, that—meaning considered—there are only two current terms possible to criticism and history, as summarizing the Modern movement: "Purism" and "Expressionism." As between the two, "Expressionism" is incomparably the more suggestive.

The antipathy to "Expressionism" as a label comes largely from France. French artists and critics, along with American and British writers trained in Paris, are hostile to a word originally associated with a German school; even though that school was obviously in the main line that began with Cezanne and progressed through Fauves, Cubists and Abstractionists. In a decade, nevertheless, the circulation of the word has widened, outside Germany and France—its significance enlarging too—in a way that argues its appropriateness and expressiveness. It promises, despite Paris, to persist as the label for the typical creative art of the early and middle 20th Century.

Putting aside the external fact that our own "authorities" make increasing use of it,* let us inquire into its appropriateness.

* C. J. Bulliet, in *Apples and Madonnas, Emotional Expression in Modern Art,* rather grudgingly admits that "Expressionism . . . is the best term that has been suggested to give a general idea of the aims of the new men." Helen Gardner, in *Art through the Ages,* notes that "The chief movements that have grown out of the 19th Century, beginning with Cezanne, may be loosely called Post-Impressionism, or as the artists themselves prefer, Expressionism." Frank Jewett Mather, Jr., in *Modern Painting: A Study of Tendencies,* accepts the word in its broadest significance; as does Mary-Cecil Allen in *Painters of the Modern Mind.*

< 72 >

If "Expressionism" is the ultimately right term for the thing this book treats of, it will be true that the word *express* is in some sense a summary of the characteristic elements brought into or restored to art at this time. In a general way the earlier chapters have labored to stress the shift of emphasis from illusion to expression, from imitational aim to expressive aim. The thought was brought to focus at the end of the preceding chapter: "Things not imitable can be revealed, *expressed.*" It is necessary now to explore the expressive elements, analytically.

Just what, it is fair to ask, does the Modern artist express? *What* is revealed in his art, that existed not at all in the average art of the Realistic-Romantic era, or only in very subordinate measure?

There is an element, or a quality or value, sometimes identified as "Form," which may be considered (in a sense and tentatively) the outward crystallization, elusive but vaguely recognizable, of the thing we are here approaching as "expression." Even in the visual arts, we are accustomed to say that form cannot be seen so much as felt. There is still so much of mystery about the ways in which it is achieved and the ways in which it appeals, and so much of wrangling over the question of its existence, that I shall later treat the subject in a chapter cautiously entitled "Attempts to Explain Form." Meantime we are beginning our inquiry farther back, before considering the realization of the quality, in the finished work of art: inquiring what is *behind* the form, beginning with "expression." This inquiry may be divided, arbitrarily, for convenience, into three parts, one concerning the process within the artist's creative faculties, the personal-expression element, one concerning the expression of deeper values or attributes in the subject or object

< 73 >

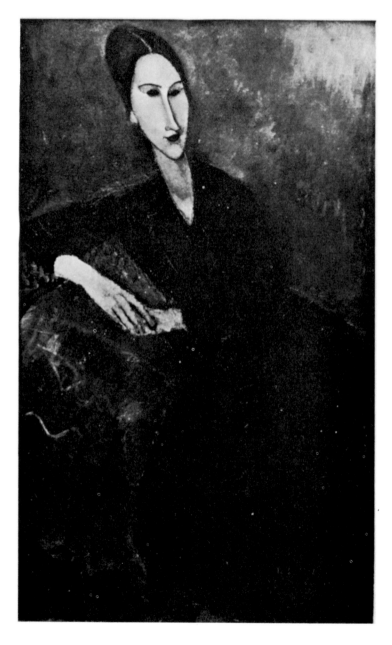

Anna de Zborowska, by Amadeo Modigliani. (By courtesy of the Museum of Modern Art: Bliss Collection.)

(beyond imitable surface aspects), and one concerning the expressible or expressive values of the medium and materials as such.

The first small coteries of artists to whom the name "Expressionists" was applied, in Germany, were attempting to fix in the picture non-representational, non-objective values: "subjective" and formal elements similar to those they had detected in the works of the French Fauves and Cubists, by whom they had been strongly influenced; and to these they added something learned out of the Abstractionism of Kandinsky, one of their own number—he called it soul-expression—and a heritage of intense emotionalism from Edvard Munch. There entered in also, from non-pictorial sources, an emotional intensity coupled with heedlessness of nature, from Strindberg most notably. The German critics settled upon the name "Expressionism" for this group movement "that put more stress on expression of the artist's own feelings than on the objective materials of Realist art."

Certainly if the word was coined to cover the Cubism of Marc, the naïve child-primitivism of Klee, and the dynamic impetuousness of Kirchner, Schmidt-Rottluff, Heckel, Pechstein and Nolde —and these are among the men mentioned in the earliest articles and books—it should be broad enough to denominate the entire creative stream from Cezanne and van Gogh to Rouault, Lurçat, Marin and Arp. The name was invented, indeed, not to suggest a special quality which the Germans had detected in their own radicalism—what the *Britannica* terms "the excessively brutal German contribution"—but to summarize the newly expressive international achievement up to that time. Writers as early as 1919 were treat-

< 75 >

ing the subject under headings that indicate this breadth: "Dynamic Expressionism," "Abstract Expressionism," "Arabesque Expressionism," etc.*

Of the influences out of the French development—as noted by the German critics, in the war years and immediately after—the main current of Cezannism through Matisse and Picasso was doubtless strongest. But van Gogh proved an extraordinary stimulant, and found in Germany first recognition as one of the Masters. Of the less known influences, that of Munch, who had lived long in Germany, giving impetus particularly to the Dresden secessionists, was most potent. But the Swiss Hodler was becoming known, and the works of the 19th Century German "eccentric" von Marees were being re-discovered. It is useless to try to disentangle the threads of these several influences; they all led away from Realism—toward a deepening of expression.

The broad significance of the term Expressionism, as used, could scarcely go farther than it did in 1919, when Herwarth Walden in one of *Der Sturm* publications stated that Impressionism—the final variety of Realism—was only a phase, a vogue, but Expressionism a world movement, of the universal spirit or feeling, linked with Creation. To him the two things were patently Non-Art and Art: nature and expression. He carried the thought over from painting to poetry, music and the other arts. Various writers pushed

* See particularly *Die Deutsche Expressionistische Kultur und Malerei*, by Eckart von Sydow, Berlin, 1919-20. Most of the literature of the subject is still confined to the German language. J. B. Neumann, who has done much to increase American understanding of Expressionism, by exhibitions and lectures, dates the movement, as a recognized international development, from 1911. He held then the first Munch one-man show; and in 1912 there was the great Cologne exhibition which challenged and crystallized understanding in Germany as did the famous Armory Show in this country a year later. The first artist groups to which the Expressionist name was applied were, I believe, *Die Brücke* in Dresden, and the more widely celebrated *Blaue Reiter* in Munich.

< 76 >

the inquiry into other fields, and prepared books on German mediaeval Expressionism, Expressionism in peasant art, etc. What they all were tracing was art as expression of the artist's feelings or imaging, instead of art as illusion or transcription.

It did not escape these early critics, as you see, that "Expressionism" offers the perfect antithesis to the immediately preceding movement, Impressionism. Rudolf Bluemner even went back, in his search for appropriate connotations and explanations, to Thomas Aquinas and Scholasticism. There he found the distinction between *species impressa* and *species expressa:* the one pertaining to material and sinful corporeality, and the other to the angels and the pure human soul. The old objective art—or pretense of art— was to give way to an art freed from materiality: become subjective, expressive. There was, of course, much talk about the mystic element, particularly in abstract Expressionism, and of the individual artist-creator as an individualization of the universal Creator. Of course you and I will have no quarrel with this ranging of the Modernists on the side of the angels.

Some of the earliest summaries prove illuminating still. This one is to be found in Dr. Oskar Pfister's extraordinary psychopathological study, *Expressionism in Art: Its Psychological and Biological Basis:* "The Expressionist objects to the low level of the photographer's camera, reproducing natural colors. The Expressionist wants to reproduce the intrinsic meaning of things, their soul-substance. But this grasping of the intrinsic, i.e., the only genuine reality, is not done through an intellectual study of the external world. . . . From this view-point Impressionism appears as mere surface-art, and therefore a superficial art, a mechanical craft and no art at all. The Expressionist on the other hand creates out of the depth of things, because he knows himself to be in those

< 77 >

depths. To paint out of himself and to paint himself means to reproduce the intrinsic nature of things, the Absolute. The artist creates as God creates, out of his own inner Self, and in his own likeness."

Again Pfister has said that "the Expressionist's world is the Expressionist himself as *the* world." Fritz Burger in 1917 wrote: "The modern picture [aims at] the embodiment of that incommensurable realm which constitutes our innermost Self. . . . It will bring about our enjoyment of the world's inner magnificence, the wonderful abundance and richness of the Creative Power itself." Kandinsky wrote: "That is beautiful which is produced by the inner need, which springs from the soul." And again: "The artist must search deeply into his own soul, develop and tend it, so that his art has something to clothe, and does not remain a glove without a hand."

While we are still exploring this question of the supreme importance of the artist's subjective process, or contribution, in early Expressionism, let me note that two of the writers quoted offer a direct contrast in their interpretations of the source and impulse within the artist. Kandinsky is a mystic and Theosophist, and is himself a creator, with keenest formal sensibility. Pfister is a scientist, psychologist, Realist; he is a skeptic, intolerant of mysticism, and wholly insensible to formal values and aesthetic response. Up to a certain point they see eye to eye, as regards an epochal change that has developed in the arts; their differences beyond are illuminating.

Pfister defines Expressionism as the art of inwardness: but since he recognizes no mystic-creative sources, he must trace back to a psychosis every objective element in the painting. "There are, behind the design planned by the artist-poet, secret personal remi-

< 78 >

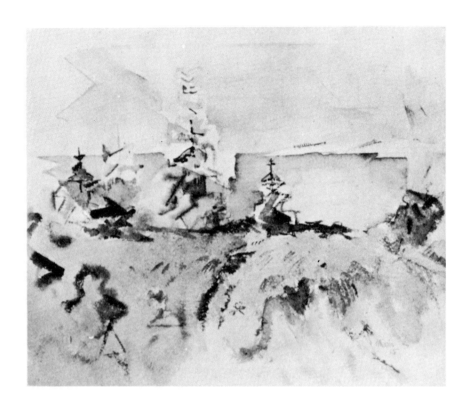

Landscape in Maine: Water-color by John Marin. (By courtesy of the
Art Institute of Chicago.)

niscences and aims which could be found only by Psycho-analysis.
What the artist indicates as its contents is always rationalization.
. . . The deepest meaning . . . is always the self-representation
of the artist's psychical state." Pfister then goes on to the usual
sequential ideas: every artist is a sufferer; "All his pictures con-
tain the fulfillment of secret desires, which are wholly hidden even
from himself"; "Whoever is conscious of a wave of emotion when
looking at Expressionistic works proves thereby that he experiences
the same distress"—a warning to the reader! Ultimately, of course,

< 79 >

Pfister reaches the typical material-scientist's conclusion that **expression** constitutes a psychic discharge. Art is made a funnel for belching up from the subconscious.

Kandinsky, on the other hand, vaults both the subconscious and the upper objective mind, and arrives at a source beyond, in what he frankly terms the soul: art is an expression of the spirituality in man. Kandinsky begins not with distress but with harmony. It would seem to some a fairer starting point for creation. But there are many observers, in this time when men have not outgrown 19th Century materialistic philosophies, who are equipped exclusively for the recognition of Realistic harmony, and cannot respond to Kandinsky's type of art: who therefore lump it with the psychic-discharge sort, and tag it all as "abnormal." Nevertheless the recent trend has been toward acceptance of Kandinsky's general premise.

We shall, in a later chapter, return to the mystic aspect, examining the suggestion that the artists escaping from pre-occupation with objective reality are working toward revealment of the sanest and most beautiful thing to be experienced by man. Meantime we may note that even the later scientists cut under Dr. Pfister's assumption that every expression must proceed from a physical or worldly cause. It is a commonplace of latest scientific philosophy that the physical is only one phase of what is. The most ordinary of terms in the vocabulary of art—design, unity, rhythm, order—imply creative powers not measurable or chartable; and the delving of science into the atom and the nebula have failed to suggest any plausible physical source of first motion or life. Dr. Pfister himself weakens his case when, toward the end of his book, he quotes a remark by Worringer, to the effect that Gothic architecture is a "living document of the lofty hysteria of the Middle Ages." He

< 80 >

would seem almost to indicate that every exceptionally intense work of art is a departure from "the normal." Perhaps the world·is progressing toward attainment of another "normal" than his.

These quotations sufficiently suggest the early revolutionary shift from illusional and imitational art to subjectively expressive art; and the advocates of Expressionism, as the name summarizing constructive Modernism of today, point out that devotion to an inner expressiveness was as much a characteristic urge of Cezanne, Sullivan and Craig—fathers and prophets of the "new art"—as it is a stated objective of many a practitioner a generation later. This is all we need to know, in this chapter, about the subjective element: we are merely establishing that it richly exists—in contrast with the spiritually poor, objective Realism of the centuries immediately preceding. The nature of it, and the methods of presenting it, will afford materials, and controversies for later chapters: treating of its revelation as form, and its significance as feeling and meaning.

GETTING TO THE SOUL OF THE OBJECT

Possibly a purely subjective art would be wholly abstract, without observable relationship to concrete reality. But only a very small part of Modern art is of that sort; though obviously the typical Modernist tends *toward* abstraction, as compared with the Realist confining himself to the surface look of nature.

In other words, the object survives, even though its natural aspect is subordinated, at times distorted. Expressionism is first of all an expression of the artist's own feelings or illumination; but there is also an element of expressiveness of a deeper reality, a hidden essence, in the object (or event) by which his creative faculty has been stimulated. The "inspiration" comes from nature, or memory

< 81 >

thereof, or an observed event; not in a photographic or illusional way, as in the Realist's case, but in some new, doubly expressive equivalent.

The Cubist may claim that he affords an abstract of the apple or the vase or the mandolin player. He has looked not only at the "front" surfaces, which happen to present themselves to the common eye; he has viewed the object from all sides, from front and back, below and above, from without and within. He has sought its essence, not merely its physical aspect under casual light. He reveals this "soul" of the object—let the appearances fall where they may.

"Abstraction" is defined as "an idea stripped of its concrete accompaniments." An "abstract" is the "essence" or "summary." To express this idea or essence or summary, perhaps without resort to nature's casual arrangements, disembarrassed of inconsequential concrete detail, is a first aim of the Expressionist.

There is, I believe, no way of distinguishing exactly between expression of the artist's feelings, as analyzed in the preceding section, and this expression of the deeper values in the object; though there are whole volumes on aesthetics that argue for absolute creation or for perception of nature as the one and only process of creation. The artist expresses something found in the phenomenal world, let us say; but it is the essence, superior to surface reality, only because it breathes relationship to the source of all that is, because it is microcosmic, crystallizing in little the architecture of the universe. That value in the object is hidden from the eyes of ordinary mortals, is detected only by the deeper visioning of the artist. There is, then, no delimiting his experience of it from his feeling over it. He apprehends its universality because his own faculties are extraordinarily attuned to the human-cosmic rhythm.

< 82 >

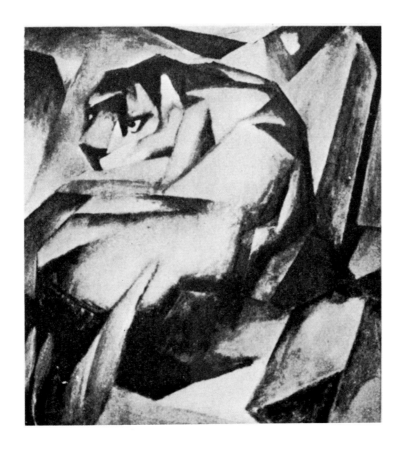

Tiger, by Franz Marc. (From *Expressionismus* by Herman Bahr.)

Expression in his art has found its source at once out of the soul
of the object and out of his own intuitive visioning, out of a reac-
tion and out of subjective feeling. Duncan Phillips entitled one of
his books on modern art, "The Artist Sees Differently," with ref-
erence to this part of the creative process. He had written earlier
an essay under the title, "The Power to See Beautifully."

There is, if you wish to put it that way, a power of mystic pene-
tration, even where nature is concerned; and I think that we are

not laboring the point unduly when we say that expression of what is thus mystically "seen" provides a second warrant for terming Modernist art Expressionistic. What the camera sees can be imitated, depicted: the illusion of it given. The essence can be *expressed*, in other terms.

We might sum up the two kinds of expressiveness by saying that the artist expresses himself, but only when he has been stirred by something apprehended under the surface of nature or life. The two sources are one, if the process is traced back far enough; but in the product, the results may be dissociated and studied separately —as two aspects of expression.

THE EXPRESSIVENESS OF MATERIALS

In the search for an intensity of expression that had been lost by the Realists, the Moderns re-examined the methods and materials of each particular art, and arrived at new understanding of the limitations and capabilities of the several mediums. In some cases they not only recovered values long lost to the world, but, by capitalization upon newly existent materials, such as concrete and steel in architecture, and electric lighting on the stage, added to the intensity and range of expression.

Thus beyond the self-expression of the artist, and the expression of deeper values in the object or model or happening, there is this third sort of revealment which is common to Expressionism. The element of materials and method both shapes the final product by its limitations, and contributes by its special properties to the particular sort of beauty characteristic of the art in hand.

What the Expressionist has recovered is an attitude common to many primitive artists: a sense of directness of expression by the one most capable medium—a loving feel for color on its own account,

< 84 >

or polished wood, or the sensuous overtones of words. During less creatives ages, when imitation gave more delight than creative art, men lost sight of these values out of honest manipulation of materials. It became the fashion to copy the material idioms of one art into the practice of another. The so-called sculptors made plastery compositions with the swishy technique of painting or wash drawing. The painters told stories, or flattered courtiers or millionaires. Clever workmen tortured steel panelling into the semblance of grained wood. Imitational cleverness and transfer of "effects" won the popular and academic hearts. Integrity of medium was forgotten.

Then rose up a van Gogh to revel in color pigment on its own account; a Gaudier-Brzeska to cry out for the mountainous stone-quality in sculpture, damning the "light voluptuous modelling" that had usurped the place of cut-stone art; and a Gordon Craig to demand that the literary men—closet poets and journalists—and the scene-painters be subordinated to the artist of the theatre, who would bring back the typically theatric elements of movement, color, light and revelatory acting.

Expressionist artists speak often of the *purification of the means* of the art: a stripping away of the accretions of insensitive eras, and a sifting of the remaining basic elements for characteristic expressiveness. Isadora Duncan stripped away courtly ornament and literary purpose—as well as masquerade costume—from the dance: purified the art for direct expression of the body in rhythmic movement. Cezanne turned the course of painting from story-telling, photography and sentimental commentary to expression of an artist's feelings in terms of paints and two-dimensional canvas: purified the means and direction of his art. Craig and Appia startled a complacent theatre world by demonstrating that painters

< 85 >

and poets and pulpit-orators were appropriating the stage, blanketing the creative actor under bad pictures, torrents of words and a convention of naturalistic mimicry. They asked that the stage be purified: freed from intruders and returned to the artists of the theatre for *theatrical* expression. The modern theatre movement is sometimes summed up as a return to "the theatre theatrical"—an illuminating suggestion of the importance of an understanding of materials.

We are concerned here with a sort of expression that is instinctive with the artist *after he knows his tools,* after he has come to have a special feel for his materials. Perhaps he seldom thinks about the effects he is achieving specifically out of the virtues of his paint and canvas or chisel and stone: they have become an extension of himself, intuitively used. But the capitalization of the particular capabilities of his medium have put into the product values possible to no other art.

One should be a creative artist to realize the vividness of the artist's consciousness of potential beauty in materials, the poignancy of a sculptor's emotion over a certain quality of stone, or a theatre artist's leap to creative imagining in presence of a new type of stage.

I have so stressed, earlier, the "supreme" importance of the subjective contribution, as a factor in the Expressionist revolution, that the reader might be inclined to underestimate the actual change that has occurred in the attitude toward the medium. Watch the artists themselves, however: they are assiduous in studying their several arts, almost microscopically, for new resources; and conversely, there is a sense of outrage when a fellow artist "violates the picture plane," or fuzzes up the surface of a metal statue with clay-pellet untidiness.

< 86 >

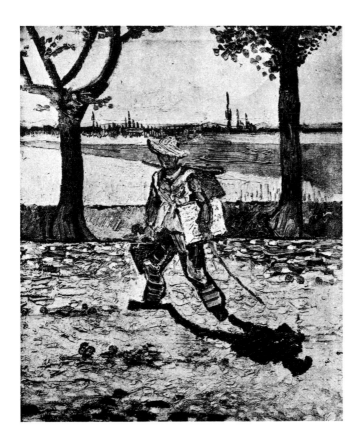

The Artist on the Way, by Vincent van Gogh. The paint as such intensely expressed—plus pictorial organization.

There is more than at first meets the eye in an early slogan of the German Expressionists: "Away from nature—back to the picture." There is an implication of laws of picture-making, distinguishing this art from nature-photography: laws based on the flatness of the canvas and the properties of paints. The picture frame no longer is merely a pleasing border through which a vista is opened upon a fragment of reality. Rather it establishes the

< 87 >

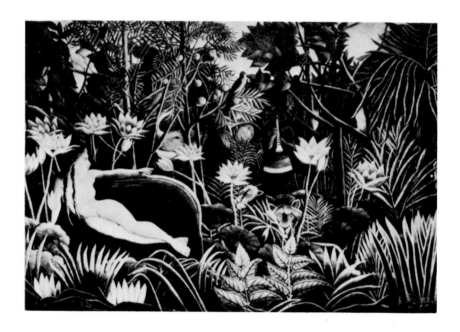

The Dream, by Henri Rousseau. (By courtesy of the Knoedler Galleries.)

boundaries of a picture field, existing under incontrovertible laws. This plane can be violated—for instance, by carrying the eye off the edge, or by "leaving a hole"—only at cost of destroying the pictorial unity, corrupting the plastic rhythm, nullifying expressive form. There is much talk in studios about declaring the canvas, dividing the field, entering the picture, etc., all referring to phases of medium expressiveness.

This is the third, then, of the avenues or sources of that expressiveness which gives purport and significance to the term "Expressionism": after the artist's feelings and his imaging, and after the apprehension of deeper values in "what he takes in for expression," there is this capitalization upon the materials particular to his

< 88 >

art. Though really there is no "after" in the creative process. With the instinctive artist expression is undivided. It is only the miseducated critic and student who must separate the functions, for better understanding.

EXPRESSIONISM—DEFINITION AND SUMMARY

Henri Rousseau loved jungles: not necessarily tropical jungles as they are, but a half imaginative sort, lush, studded with flowers and fruits, designed with plane beyond plane of palm fronds and lotus leaves and sword-like grasses, all bound together in a color mosaic. Rousseau also loved a mistress, and perhaps he dreamed her too into something more than other men would have seen. In 1910 Rousseau painted a picture which is a perfect example of Expressionism at one end of its wide range: naïve subjective expression. He combined his feeling about his mistress and his nostalgic feel for the tropics in a tapestry-like painting. His lady, in a childlike idealization, is placed, nude, on a divan, in the midst of a gorgeous jungle, pleasantly peopled with birds and animals and a dusky piper. The plants and flowers are not botanically correct, and the juxtaposition of parlor sofa and tiger-haunted wilds is one of those distortions of reality distressing to the literal mind. Many people, indeed, fitted in their formative years with blinders shutting out all of art except "normal" transcription from nature, fail to be stirred by this beautiful canvas—except possibly to laughter and ridicule. Rousseau joined two things beloved and real to him in his inner life, and externalized them in expression, in something new in the world, different from nature.*

* I am indebted to J. B. Neumann for this instance. I first heard the work analyzed, as a typical example of Expressionism, at one of his lectures.

< 89 >

Paul Cezanne saw behind each contemplated landscape in his beloved Provence some hint of a cosmic structure, an architectonic rhythm; and he felt in applied paints a structural value and a means to movement—each stroke of the brush could be carefully laid to build the organism, or to turn the movement this way or that.

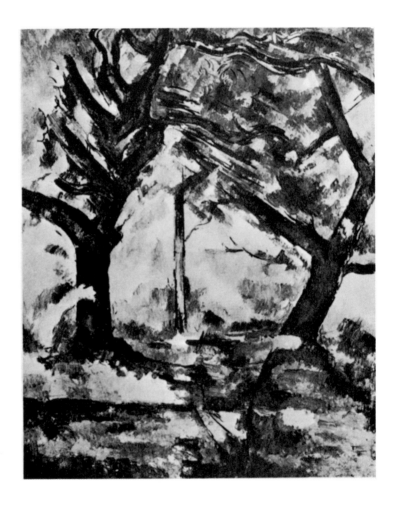

The Big Trees, by Paul Cezanne. (By courtesy of the Knoedler Galleries.)

< 90 >

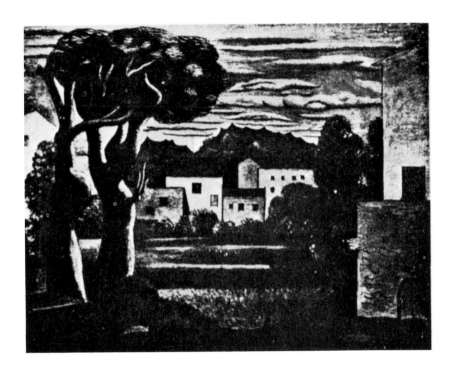

Landscape, by Pablo Picasso. (From *Picasso,* by Maurice Raynal.)

He painted landscape pictures that violate the photographic aspect, distort nature. But in the dynamic organization of forces, in the plastic relationships, in the underplay of controlled planes, Cezanne expressed values absent from painting since El Greco; and he went beyond the Greek in color counterpoint. His canvases are revealment to an intensity unknown in painting before, except in El Greco.

Cezanne is a type Expressionist, over at the other end of the range from Rousseau. It is not so much *personal* feeling that controls here, as cosmic feeling, a consciousness of great impersonal forces underlying the order of the universe—to be revealed, if he

< 91 >

is lucky, through an artist freed from the obsession of "natural-ness." Here, in addition, is an inventive understanding of color as such, of the picture field as an entity with its own laws, of plane arrangement as plastic expression.

It was Cezanne who started the Cubists on their search, and two developments out of Cubism might be shown in example, with Rousseau and Cezanne, as typical phases of Expressionism: in the root sense, of something revealed that was not known to art in the preceding era. The landscape built in flattened and squared forms, by Picasso, exhibits an extraordinary pictorial completeness: it affords a valid satisfaction—gained, I believe, from particularly skillful capitalization upon the capabilities of the painting medium, and very little from elements that might have been photographed in nature. The "straight Cubist" picture by Braque is still further stripped of objective interest, is abstractly expressive, wholly re-moved from ingratiating nature.

Finally, not in the Cubist tradition, but no less a product of the impetus from Cezanne, I am placing here a picture by Kandinsky, which he describes as "soul-expression." It is abstraction absolute.

These all are examples of Expressionism: paintings expressive in ways unrecognized by the Realists and literalists. It seems to this writer that there is no other word that so obviously describes the varied anti-Realistic achievement of contemporary and recent artists: an achievement constituting the main stream of Modern-ism. Therein is the answer to the chapter's title question. It re-mains only to shape our working definition of Expressionism, in the light of this broad expressiveness.

I believe Expressionism to be art in which expressiveness of hidden subjective and formal elements is put before imitation of

< 92 >

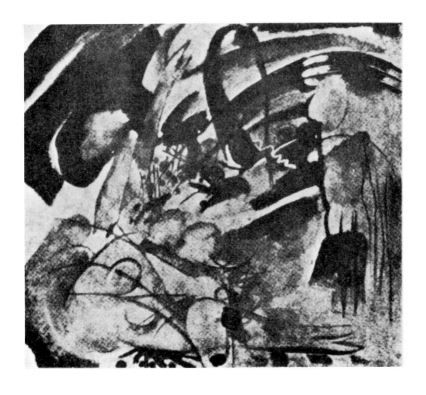

Improvisation 33, by Vasily Kandinsky. (By courtesy of *Der Sturm* Gallery, Berlin.)

aspects of nature or representations of surface life. Where Realism depicts the realities of the concrete world, Expressionism reveals the abstract rhythms or universal structure, sets forth the feelings of the artist, or illuminates the deeper essence of the object or subject, and expresses at highest intensity the values inherent in the medium. Realism offers primarily an illusion of actuality, an inventorial record of things seen outside, or a commentary in "natural" terms. Expressionism stresses instead the artist's imaging powers, however close to or far from nature: his inward penetra-

< 93 >

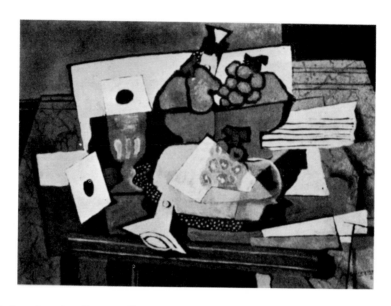

Abstraction, by Georges Braque. (By courtesy of the Phillips Memorial
Gallery, Washington, D.C.)

tion and shaping. In the product, the work of art, Expressionism
gathers these inward impulses, forces and deeper apprehensions
into an expression in which formal organization counts immensely,
where plastic rhythms, structure and thrust and color counterpoint,
enter creatively.

Expressionism is presentative where Realism is representative;
creative where Realism is imitative. From the 19th Century view-
point, Expressionist art often is "distorted," because camera truth
is violated. But the artist claims that he has neglected or distorted
lesser truths only to reveal a greater: for the sake of expressing the
formal values and intensified feeling of an individualized image.

For further evidence, or example, in support of this definition,
one may go to any of the figures commonly called great, among the
artists of the half-century. Here is explanation of the dynamic

< 94 >

geometrics of Cezanne, of van Gogh intensifying sunlight in his painting as no one had ever purveyed (or perhaps felt) sunlight before, or universalizing the Postman; of Seurat organizing his picture space architecturally; of the fresh naively subjective visions fixed in paint by Rousseau; of the decorative-curtain compositions of Gauguin, less dynamic and less "distorted," but no less an arbitrary sensuous arrangement of color planes and volume tensions; of Matisse, escaping all that was literary and photographic in the old painting, to return to naked rhythmic expression, then to decorative organization, to mildly dynamic rhythms fixed in brilliantly harmonious color-structures; of the Cubists, who destroyed nature to re-arrange her planes and colors in more revealing order; of the Abstractionists totally abandoning concrete reality, pushing toward expression of mathematical harmonies and soul states.

< 95 >

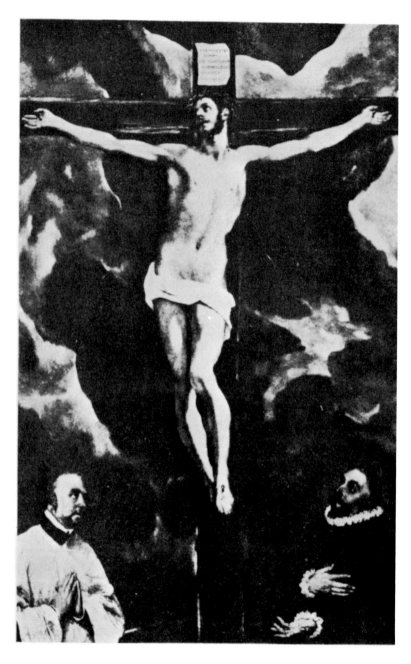

Christ on the Cross, by El Greco. (From *Domenico Theotocopuli El Greco,* by August L. Mayer.)

CHAPTER V

C LIVE BELL calls it "Significant Form." Dr. Barnes calls it "Plastic Form." I have called it "Expressive Form." The aestheticians and intellectualists mostly call it non-existent, and Thomas Craven has implied that it is an imaginary plaything of a few self-deluded esoterics.

Bell started the contemporary discussion of Form in a book entitled *Art*. Citing a number of varied art works. he wrote: "In each, lines and colors combined in a particular way, certain forms and relations of forms, stir our aesthetic emotions. These relations and combinations of lines and colors, these aesthetically moving forms, I call 'Significant Form'; and 'Significant Form' is the one quality common to all works of visual art." He attuned himself to an attribute of art overlooked by the Realists, and he sensitively evaluated historic masterpieces and the works of Moderns by reference to his conception of "the one quality."

Barnes, catching a glimpse of *plastic organization* as a determining element of painting, on the instrumental side, impatiently brushed aside Bell's "system," and offered a more analytic method of appreciation, by understanding and realization of "plastic form." My own modest contribution to the controversy came when I offered the suggestion that "expressive form"—as a term—had the advantage of linking the determinate creative quality with the achieve-

< 97 >

ment of the Expressionists, whom I considered the typical Moderns.

I saw no definitive value in the word "significant," and at that time I was afraid of the word "plastic" as applied to painting—technically it seemed to belong to sculpture, and some of us were passionately sure that the road to salvation lay in a strict confinement of each art within the chest of its own capabilities, uncontaminated by borrowed attributes. The plastic element, moreover, constituted only one part of the formal synthesis.

In any case, today "significant form" survives only in dry intellectual discussion, but the two other terms increasingly serve the practicing artist and the student. "Plastic" has become the commonest designation for the dynamic or "movement" elements in the painting, when talk is along the lines of methods and means; whereas "expressive form" is more in use when there is discussion of a fusion of the formal and the emotional elements.

The attribute form in art is like the unidentifiable quality the lover sees in his beloved. Hollywood is for once more sensible and expressive than most of us, and calls it "It." The materialist lowers it to his own highest thought, and names it "sex appeal." But to the lover it is a distinguishing individual loveliness in the beloved—understandable to all other men who have experienced the quality, who have experienced reasonless love. "And with Love . . . words are of no use, all our philosophy fails—whether to account for the pain, or to fortify against the glamour, or to describe the glory of the experience." So once wrote Edward Carpenter.

Nevertheless quite a few words have been written about love: and not a few are being written about form in art—because it too is a quality being widely experienced, and unexplainable under any other name, if only to be hinted at under this.

< 98 >

Certain it is that critics who claim to see intensely vital and universal values in art since Cezanne, cannot analyze or expound without accepting "plastic form," "expressive form," or some equivalent: which they may prefer to phrase "formal organization," or "rhythmic weight," or a similar still-undefinable term. And certain it is that the student can best approach the work of the several contributing groups of Moderns by asking what it was that each sought *beyond* the values known to Monet and Sargent and Boecklin. For the Expressionist advance has been made largely by schools that might reasonably be called "form-seeking." This is to say that a great number of artists are today setting out to capture and to fix in the canvas a felt quality or value unrecognized in the Victorian and earlier eras, a quality or value still denied by academic painters, by intellectualist critics, and by most admitted aestheticians.

Thus I, having come somehow to a deep enjoyment of El Greco's *View of Toledo* and Cezanne's *Mount Sainte Victoire*, felt in those works a value which I could not explain to myself or others in terms of subject matter, emotion, technique, imagination, composition, or any other of the definitive categories authorized by current criticism. The quality was—as near as I could understand it—the sum of the unidentifiable formal and mystically expressive values in the picture. I studied on for years, going back again and again to the canvases, to see if the thing that had become more memorable, more essential, than any other element, was still there. Finding it, now, a living thing, with vitality increasing as my sensitivity grows, and that it outlasts and outweighs all else, I judge that a label for it will be useful. I accept the least vague offered name, "form."

< 99 >

I try to pin it down a little closer to my own understanding—"expressive form." And immediately I am set upon by a pack of unbelievers, who claim that form is non-existent because they haven't yet seen it.

Half the world of art is sensitive to some such almost hidden, unexplainable quality in the creative painting; the other half fails to apprehend it, and denies existence or sense to it. Let us remember, however, that there are color-blind people, and tone-deaf persons, and materialists who judge that nothing is real that cannot be appraised by the senses reporting to the brain. The intellectuals in art are form-blind; and they are not content to accept their blindness as an absence of sight: they deny and ridicule the "seeing" of those others who detect plastic or expressive form.

We need not spend a great deal of time on the form-blind, though they challenge us continually—some of them even writing books on Modern Art. After all, the best that most men know of life comes by experience, beyond the sensory range. Even our knowledge of material things is scrappy and incomplete, if measured only by the reports of the senses. It is late to be arguing for the existence of mystic elements, when leading scientists of our generation have joined philosophers and spiritual prophets in affirming that the truer life and the animating cause lie beyond anything that is measurable by the physical senses and mind.

Increasing numbers of people, then, *experience* in works of art an aesthetic pleasure beyond anything to be attained by sense and reason; and because those are people who experience and treasure mystic values, in other groves of life, they are willing to speak of the form-experience in art as mystic. The revelation, communion and illumination that come with mystic apprehension—most commonly through art, love, and the religious experience—are for them

< 100 >

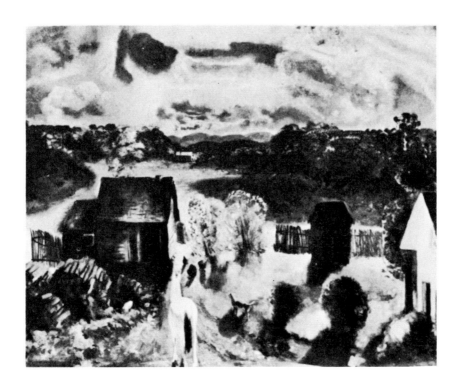

The White Horse, by George Bellows. (By courtesy of the
Worcester Art Museum.)

the realest part of living. That the nature of the experience and
the reality cannot be explained intellectually, that words cannot
compass the full truth, does not nullify the existence or the im-
portance of what we are talking about.

The fight against admission of a hidden or mystic form-value in
art is carried on less by the older aestheticians—so few people read
them any more—than by the would-be "liberal" Realists, or intel-
lectual-materialists. And they tend, as certain phases of Mod-
ernism are progressively clarified—in the essays of Barnes,

< 101 >

Hofmann, Fry, and others—to become tangled in their own terminology. One has the impression that, having made up their minds that their own blindness is the only normal state, they are staggering around in an effort to shut out a light inevitably dawning.*

THE KINDS OF FORM

Let us pause to remind ourselves of the ways in which art was explained, in its service to mankind, before there was this doubtless confusing talk about plastic orchestration and expressive form. Art, of course, was photography, the mirror to nature, for long periods: far longer than the trivial nature of mechanical illustration alone would account for. There were ways in which Realistic or even Naturalistic art might be made to "serve society": when it took on purpose, moralistic, patriotic, etc. The vague thing called sentiment entered in: strongly in the moral-purpose and religious

* It is fair to note, I think, that Thomas Craven, who has made himself the exponent of all that is healthily masculine, physical and intellectual in recent art, while savagely ridiculing those who admit a mystic value, is obliged occasionally to fall back on citing those very excellencies he has denied, almost in the language of the attacked. Thus in *Men of Art* he writes: "How often have we heard artists and critics praising or condemning this picture or that! 'What marvellous form!' 'A master of form!' 'Utterly lacking in form!' And so on." Some pages later, having discovered "the rhythmical interplay of lines and volumes" of Rubens, Craven himself exclaims: "What infinite variety he gave to his volumes! What plasticity! What suppleness of articulation! . . . He had what artists call the profound feeling for form. . . ." Reading Craven's later book, *Modern Art*, one feels again and again that he is on the verge of recognition of abstract or mystic values: that he may have taken the trouble to read Barnes' chapter on "Plastic Form," or other of the explaining writers. But suddenly he throws in a contemptuous bit like this (about Soutine): "About all that can be said of his work is that it indicates some sort of tragic experience—what, I do not know. His art is supposed to be rich in plastic values." Craven is a brilliant writer; but his tragedy seems to be that after he began "debunking" the old art, with gusto and wit, his Victorian training in Realism prevented experience of the creative values in the new. The result is that he tries to destroy creators such as Picasso, Matisse and Rousseau, while glorifying men who are still essentially illustrators such as Benton and Curry. He has nothing less than a phobia regarding abstraction in art; and he narrows form to a technical attainment.

< 102 >

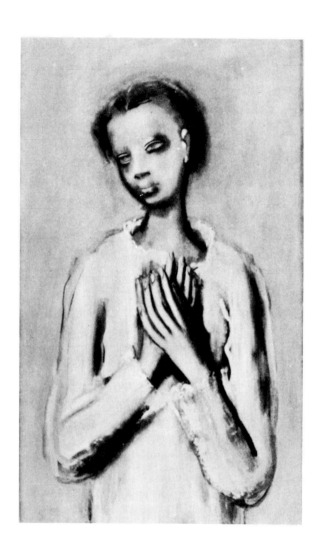

Young Girl, by John Carroll. (By courtesy of Frank K. M. Rehn Gallery.)

art; weakly, as sentimentalism over children, flowers, the sunset, etc. In all these cases, the "treatment" might vary from the idealized (neo-Classic, or pseudo-Classic) to the natural. Romanti-

< 103 >

cism led out into exotic subject-matter: to the picturesque and far-away. Another division of graphic art descended to being little more than ornamentation: the Court painters, and the portraitists to the millionaires. This sort of painting for grandification, in flashy technique, survives fitfully today, along with all the sorts of sentimental and journalistic Realism.

Victorian critics treated these matters as the end and all of the art of painting: writing endlessly of the Classic spirit, the Romantic spirit, technique, composition, subject matter, emotion. When they wrote of form in art, however, they discussed the *forms of things*, as observed in nature, and how those objective forms could be made effective in pictures; or of form as merely mechanical composition.

The Moderns claim that in comparison with form-revelation, in the Expressionist's sense, all those others are secondary values. Without abstract formal-rhythmic support, expression becomes senti-mental reproduction, or mere manufacture of technically brilliant surface ornamentation. The formal-plastic orchestration—shaped by feeling—is recognized as the heart of the pictorial synthesis.

There is a distinction between forms merely as seen in nature—objects transferred in characteristic mass and lighting to the canvas —and forms as synthesized from nature, at a glance of the focus-sing eye: though both sorts are but incidentals to the organizational or abstract form of the Moderns. Mather in *Modern Painting: A Study of Tendencies* distinguishes between the inventoried forms and the fused equivalent thus (in a passage about Manet): "He set himself resolutely to the problem of form. This he conceived in another sense than had the professed realist, Courbet. Form is, for the painter, not what he knows to be, but simply what he sees at a given moment. The eye creates its world not by minute ob-servations, but by swift interpretations of the more significant indi-

< 104 >

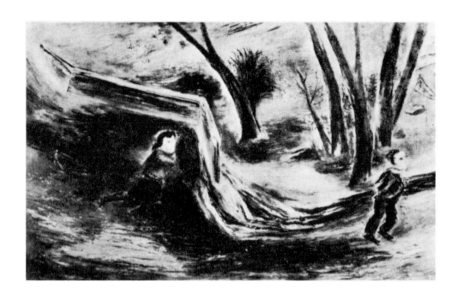

Skating, by Yasuo Kuniyoshi. (By courtesy of the Downtown Gallery, New York.)

cations of mass. Resolve form into its constructive planes, find a reasonable equivalent for these planes in paint, and your picture is done. The eye will infer the mass creatively from such indications with far more zest and conviction than any minute inventory can arouse."

This is, of course, merely a transfer from details of objective natural forms to the summarized characteristic mass: is.still within the understanding and aims of the Realist. It is a parallel to the Impressionists surprising nature in one of her tenderest and fleetingest moods, or catching the model in a "revealing" pose. It is form found outside, not expressed from within.

The form we are talking about here is rather the sum of all the objectively unidentifiable qualities in the picture: it is inner struc-

< 105 >

ture, rhythm, plastic vitality, organic order, architectonics, coiled power—all this plus or shaped by the artist's individual way of revealing his feeling: the distinctive differences that make his painting other than Jones' or Brown's. It is the part of the painting you can't get at, though you know, from your aesthetic reaction, that it is there.

The following chapters embrace my attempt to elucidate what the Expressionists have accomplished in achieving expressive form; and since no exact word-definition is possible, I must leave to those chapters the throwing of whatever specific light is possible. By breaking the subject into two parts, exploring first the gain in plastic form, the revelation out of instrumental means newly mastered, and then going on to feeling and meaning, I may be able to afford the reader glimpses of the elusive quality in its two aspects.* It remains for this chapter only to trace the growth of thought—and controversy—on the subject; and to note some things that expressive form is *not*.

GROWTH OF THE FORM THEORY

Order is a first principle of the universe—"Heaven's first law," modern science's final explanation, and a foundation of all art. There is no finality, no absolute. But man progresses—progresses by setting up some far conception, perhaps some new intuitional understanding of order, and working toward that. The inferences of science precede the experiment and the proof; "ideals" of conduct and social organization outrun attainment; and the artist perspires over a possible revelation he has visioned.

* Herbert Read, in *Art Now*, speaks of form as of two sorts: "abstract form"— illustrated especially in the work of Matisse—and "subjective form," which, in addition to the abstract value, "can be the emergent sensibility of the artist himself."

The farthest thing glimpsed by vision-gifted artists at present is a sort of order that we call form. It may be termed an echo of the finally satisfying cosmic rhythm, a crystallization in little of the universal architecture (the mystic's view); or it may be subjective revelation of an image born to an artist out of the contact of his individual sensitivity with "life."

The Realists admit the importance of order; but limit their tests of it, in the abstract, to arrangement on the surface of the canvas (overlooking the plastic nature of the art, the depth-and-movement dimension); and denying other objective order than can be illustrated from outwardly-seen nature. Through the ages, however, there have been artists unseduced by the Realistic ambition: who have sensed the deeper order, who have intuitively created plastically and beyond-nature. The *theory* of form as the creative summary or essence, of this deeper order, was unknown to the Realists, and is new to the Western World. There has been historic practice—wherefore Giotto, Tintoretto, El Greco and others have entered into our text, and generously among our illustrations—but of theorizing about the quality, in the past, the only rich body of sayings is to be found embedded in the books of far Eastern wisdom.

Since most of the English translations were made in the time when the Western mind understood art only as illustration or interpretation of nature, one cannot be sure that even yet the full significance of Chinese foreshadowing of the "expressive form theory" is clear to us. Centuries ago, in a country now recognized as productive of extraordinarily beautiful paintings, the following statement was set down as "the first law" of the art: *"Rhythmic Vitality, or Spiritual Rhythm expressed in the movement of life."* That this law should have been recorded as basic is a remarkable co-

< 107 >

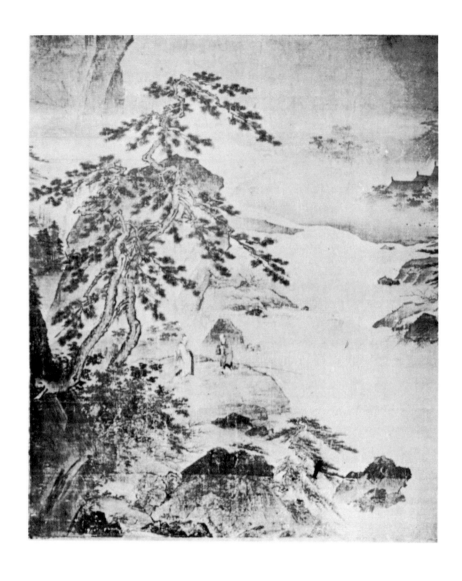

The Emperor Wen Meets the Sage Chiang Tzu-ya: 12th Century Chinese
painting on silk. (By courtesy of the Freer Gallery of Art.)

incidence of ancient Eastern and contemporary Western thought. The words used oftenest by the Expressionists in attempting to explain "form" are here brought together: "movement"—which is the key to the understanding of the "plastic" element (and the subject of several chapters to come); "rhythmic vitality"—there are those who prefer "rhythmic form" to "expressive form"; "spiritual," which is a synonym of "mystic"; and "expression."

Among the other Chinese laws, there is one which is variously translated as "composition and subordination, or grouping according to hierarchic order," and "Correct division of space." A variant reading of the first law is this: "Consonance of the spirit engenders the movement."

The translators have found the same difficulties of statement that beset every modern writer on form, because words are at best bungling in the realm of experience. But, considering the likeness of Chinese paintings and certain Western Expressionistic ones— even to those bugaboos of the Realistic mind, abstraction and distortion—there can be little doubt that the Orientals were getting at the quality we are approaching as expressive form.

So the Modern looks back to intuitive attainment of form, in all lands and in many periods, and to at least one formulation of a theory of art in which the hidden quality is counted fundamental. He goes on his way certain that he is following no "will-o'-the-wisp." He is equally sure that any present-day theory or explanation will take into account certain advances in knowledge accomplished in the machine-age: for instance, the abstract element as realized by Giotto, El Greco and the Orientals will be modified by scientific understanding of the dynamic properties of colors, and the plastic or movement relationships will be clarified by the analogies of modern physics: polarity, tensions, orbital pulls, and other mani-

< 109 >

festations of astro- and atomic dynamics will afford light on the nature of abstract pictorial organization. In short, there is reason to believe that the form-theory of the Modernists is firmly rooted in the traditional creative art of the past, even while reflecting characteristic reaches forward in the thought and experience of our own times.

The progression of theoretical thought has continued from the time when Clive Bell published his treatise on "significant form," through a decade and a half of controversy and downright wrangling. Those who accepted Bell's "discovery" as more or less epochal. found in Cezanne particularly a witness offering constructive testimony. For those who came to enjoy the paintings of the Master of Aix saw that a canvas of his, placed on the walls alongside any representative show of 19th Century works, made the others appear singularly empty, inert, and pictorially lifeless. Here was an object-lesson in paintings with and without vital form —significant, expressive, or what you will. On the one hand, Cezanne with expressiveness of a living truth beyond surface nature, with plastic unity, with rhythmic vitality. On the other hand, pictures copied from surface nature, illusional and reproductive, with plastic elements casually assembled—without pictorial movement, or unity, or dynamic correlation.

Cezanne had done little verbally to clear up the tangle of theory. His famous saying about seeking a "realization" fitted in exactly with the ideas of the mystics, who knew that he meant the crystallizing of a reality that lies within but not on the surface of nature. But the Realists might as easily convert the saying to their uses— and have. Cezanne's works, nevertheless, *exhibited* rich expressive form—and did more than any other easily available exhibit to prove existence of a characteristic creative quality.

< 110 >

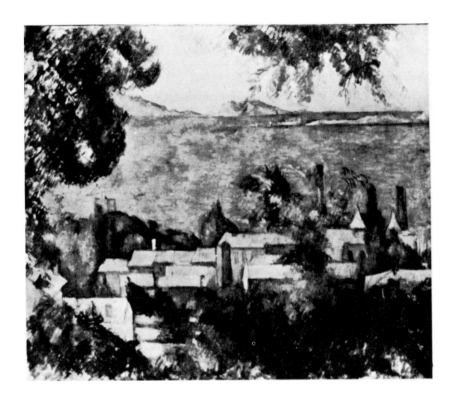

L'Estaque, by Paul Cezanne. (By courtesy of Adolph Lewisohn.)

Barnes was more fortunate than Bell. He failed, to be sure, to
isolate the form so that it could be readily detected—and his own
analyses leave something to be desired in lucidity. But in his book,
The Art in Painting, he did a better job than anyone else writing on
the subject up to this time. He narrowed the conception to abstract
limits, and wrote of *"plastic form."* He posited that this quality
fundamentally gave creative painting its reason for being, affording
to the observer the satisfying aesthetic experience. "Plastic form,"
he wrote, "is the synthesis of the plastic elements or means—color,

< 111 >

light, line, space—in a rhythmic, unified whole." Again he wrote: "The conception of plastic form, as integration of all the plastic means, will be used in this book as the standard and criterion of values in painting." He implied that until observers came to the habit of evaluating a painting (sub-consciously) by the test of plastic unity attained, they would continue to judge superficially, by such secondary attributes as illusional subject-matter, flashy technique, etc.

All this is clarifying; and I am wholly in sympathy with the thought that, in future, appreciation will commonly begin with intuitive evaluation of the plastic synthesis, before other factors "register." If I prefer still to speak of "expressive form," it is perhaps only a difference of approach. It seems to me that my term implies a larger value: expressive form is at once plastic form (the values expressive of the typical painting-means), *and* form expressive of the artist's feelings (the revelation of an image individually conceived, out of the painter's special emotional sensitivity). Dr. Barnes allows for this element, when he notes that the artist's business is to find a plastic *equivalent* for his vision, for his emotional reaction to some human situation or objective scene (these are not his words, but I think a fair summary of his meaning).

R. H. Wilenski, in a book entitled *The Modern Movement in Art,* served to clarify informed opinion regarding the essentials of creative art. Particularly he emphasized the importance of formal order, and deftly deflated the pretensions to importance among descriptive, romantic and other popular painters. But his treatment of form seems to me less valuable than Barnes' because his differentiation of it as "architectural form" leaves out more than it takes in. He points out that the modern movement in painting and sculpture is essentially based on *the idea of architecture as typical*

< 112 >

art. He writes that "the architect as artist makes definite **organized** complete structures symbolizing and epitomizing special instances of his formal experience." He believes that the Modern painter strives to achieve, first of all, an equivalent "structure." In view of the nature of the painter's materials—and the new importance assumed by the "movement" element—it seems to me that his label "architectural form" is less suggestive than "plastic form." I believe, moreover, that Wilenski, who talks a good deal in terms of the old compositional discussions—"balance," "proportion," etc.— fails to penetrate to the secret of integrated plastic orchestration. His illustrations indicate confusion of three-dimensional plastic order and surface-structural order.* Nevertheless, his testimony is to be added on the side of those who count form—plastic, architectural, expressive—basic in the painting art.

I might go on to quote other writers and artists who have come to the use of equivalent terms for "expressive form": Read and his talk about art as genetic, about the expressive synthesis, and structural unity, and abstract form; Davidson, who tries obviously

* It is, of course, a ticklish business for a writer on art to criticize his fellows; and particularly to compare them, as regards the value of their service to students. But I am trying to show how each one cited—Bell, Barnes, Wilenski—has helped to formulate the typical Expressionist theory of what I prefer to term "expressive form." If I believed that any one had brought the whole subject clear, I should feel that there is no need for other books. Bell, Wilenski and others have had their contributive importance; but Barnes summed up better, and had a clearer vision of the plastic synthesis as of basic significance. But his understanding of *certain* of the plastic elements—dynamic color particularly—seems to me incomplete. And so I try to pick up the subject, which is ever growing, at the point to which he advanced it in his book, and I attempt to bring further light from artists who have clarified our knowledge of the individual plastic agencies.

This book, insofar as it treats formal order, is my effort to carry the discussion farther, reshaping the theory which you may consider Bell's or Barnes' by the test of Hofmann's discoveries regarding volume-space organization, and by the post-Synchromist understanding of color,—with perhaps some small personal contribution out of my own study of the expressive synthesis. It seems to me inconsequential who gets the credit, so long as we get on with our understanding, progressively.

< 113 >

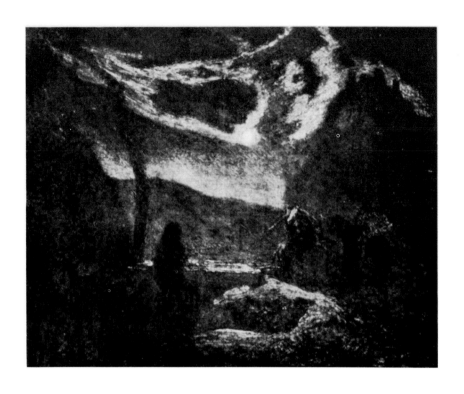

Macbeth and the Witches, by Albert Ryder.　(By courtesy of
Ferargil Galleries.)

—though not very successfully, in his text—to differentiate the
"mystic picture" from the illustrational, and finds in Cezanne a
painter whose landscapes "leap and swell with form," in contrast
with the flat lifeless art of the academists; and Hudnut, who
speaks of the creative sculptor adding "to whatever formal har-
monies he finds in that which he represents . . . other harmonies,
compelling nature to assume whatever new aspects of unity or com-
pleteness he has envisaged"—and again noting that the artist
"strives to realize in patterns of abstract form a symbol of that

< 114 >

cosmic order and unity which must exist beneath the disordered appearances of the world."

I believe that, space permitting, one could bring to the discussion so many quotations and so great a bulk of testimony that it would be obvious that the form advocates are in the majority among vitally interested analysts of modern painting. Living opinion has swung over to belief in a distinguishing formal-expressive quality or property in creative art. Those who oppose admission of a term equivalent to "expressive form" seem to me now on the defensive—a dwindling minority. Abstract form, whether narrowed to a summary of the plastic elements, or expressive of the synthesis of instrumental and emotional values, is understood as the basic excellence and test of the art of painting.

WHAT FORM IS NOT

It remains, for this chapter, to lay one misconception: that expressive form is only what earlier artists and critics termed "composition." There are many books on Composition, but I doubt whether one contains the word "plastic." Certainly I have found none that takes into consideration the depth element, the backward-forward movement.

Poore caught a glimpse of the movement element, and evolved a suggestive theory of the circular observation of pictures, but he traced his path of vision on the flat, with exits for the eye through the canvas—totally overlooking the organic and closed nature of the plastic "structure." Ross, Hambidge and the others seem to have been equally blind regarding recessive movement and plastic design, though very wise regarding the effects to be attained by plane proportioning and linear harmony.

< 115 >

In short, "composition" in painting has been understood, up to the time of the Expressionists, as a system of area organization, with reference to balance, proportion, measure, shapes, etc. "The divine proportion," "the golden proportion," and "dynamic symmetry" are measure-formulas applicable to spacing and object-placing on the surface of the canvas, irrespective of the penetration of linear perspective, or the newly understood tensions of volumes in space, or the dynamic properties of colors.

On the one plane, the composed areas and lines could be made to assume a geometrically stable and superficially pleasing appearance; though the inevitable penetrations and advances of volume, plane, color and texture were left unorganized, or only given a semblance of order, intuitively. Raphael, for instance, was an artist supreme in arrangement of balanced surface compositions, superficially pleasing, although in general his paintings are lacking in compelling plastic rhythms and dynamic unity. (It is for this reason that Raphael was, for the Victorians, "the world's greatest painter," whereas in the 20th Century he has lost stature, until he seems tame and over-sweet beside the plastically rich El Greco and Tintoretto.)

The sense of surface unity and structure gained from observance of the "laws" of composition, as set forth by Hambidge, Poore, Ross, Dow and others, is but a first dimension of the organizational unity or order implied in what I term "the theory of plastic orchestration"; and form, in the Expressionist's sense, is incomparably more than "composition." The test of dynamic symmetry or the divine proportion may even be used to prove the excellence of a painting that is, to the practiced eye, plastically unorganized, and thus expressively defective. The impressive and stirring rhythms of El Greco and Cezanne are possible only through the orchestration of the several plastic instruments in deep space.

< 116 >

Another approach to understanding is in the contrast between *static, balanced* composition, and *dynamic, organic* movement-organization. The discovery of the movement element, of order conditioned by an additional dimension, is typically a modern development, in line with "the new physics" and relativity. Plastic organization is spatial and voluminous, where the old composition was plane and linear. Implicit in the new idea of form are tensions, flow, volume, dynamics—whereas the materials of the old composition were the surface figures of rectangle, triangle, the "S-line of beauty," etc.

Nor can one escape the analogy of "composition" as sufficient for a material world, while expressive-plastic form belongs to art in a world scientifically based but spiritually conscious. Formal pictorial organization, on the instrumental side, accords with the planetary model of the universe, and with the conception of a sort of movement as the basic physical "element"; and, on the spiritual side, with the mystic apprehension of powers and qualities beyond the physical. Let the artist know the latest discoveries of astronomer and physicist, and let him see life with the most transcendent of the spiritual sages; otherwise form in all its fullness and expressiveness may escape him—though he may continue to compass the pleasing effects of the contributive "composition."

< 117 >

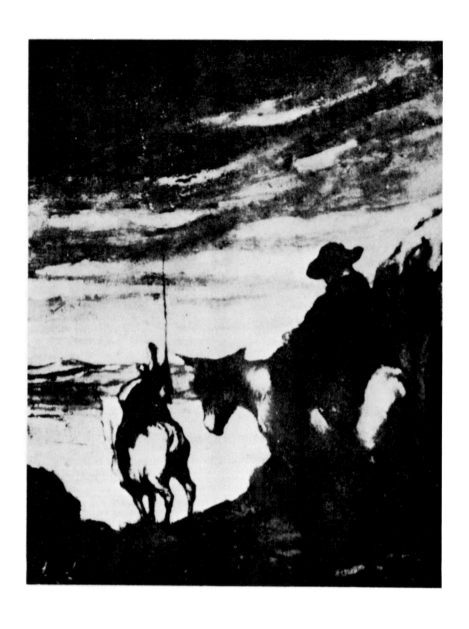

Don Quixote, by Honoré Daumier. (By courtesy of Dr. F. H. Hirschland.)

CHAPTER VI

PICTURE-BUILDING: THE FRAME, THE FIELD,
AND THE MOVEMENT-PATH

ONCE at a solemn meeting of war-service workers and theatre folk, a pompous official arose and said: "I am going to speak on Vice, about which you all know so much." We of the audience greeted this beginning with joyous applause. That we should be treated as experts in that particular field had not occurred to us.

Now I realize that framing formulas for explanation of picture-building became a minor vice of art criticism at the end of the Century; and I am not a little diffident in launching an attempt to explain Expressionist theories of pictorial organization. I should like to place a part of the burden on my readers. Many of them, doubtless, have a more detailed knowledge than I, in regard to the actual systems formulated to explain the "composition" of older works of art. They consort more familiarly with "the divine proportion," "dynamic symmetry," and similar measurable determinants. I have dabbled a little in those dangerous waters, as indicated at the end of the preceding chapter, and I know why artists in general detest all published formulas. But I think that I have explored deeper, to discover not (I hope) a system, but related clues, which go some way to suggest why the older formulas, overlooking the plastic dimension, lead to a mechanical or static sort of art. These same clues are useful, moreover, in explaining why modern Expressionist art is more profoundly affective, on the formal side, than any other group-development since Giotto laid down his brushes.

< 119 >

There can be no doubt that the Expressionists in painting have made more progress in this branch of their profession—in attaining to an understanding of *picture-building*—than in any other of the several correlative means to intense expressiveness. They have rediscovered principles that underlie the melodious-plastic rhythms of Giotto, El Greco and the Russian makers of ikons. Where those earlier artists arrived at intuitive creativeness with their paints on two-dimensional fields, the Expressionists have developed theories to account for the effects gained—and have proceeded with experiments toward intenser pictorial vitality. In short, the most obvious contribution of the Moderns, up to this time, has been in furthering the expressiveness of the pictorial medium as such, and in clarifying knowledge of the potentialities and limitations of that medium.

If, in the end, I slip into the habit of terming my bundle of clues a theory—the theory of plastic orchestration, perhaps—the reader will remember my warning that systems are makeshifts and are dangerous until forgotten, except as background for spontaneous understanding.

MOVEMENT IN THE CANVAS

In any explanation of the new understanding of two-dimensional canvas, paints, and the formal organization to be built with those materials, one comes immediately to the necessity to talk in terms of *movement.*

Movement is at once the most certain "element" in the universe, and the greatest mystery. Modern science traces the order of the spheres and the composition of matter down to movement, but offers not the slightest clue to its origin. Life is movement; all that our senses report as solid, static or material is, we now know, movement poised. Finally we are told that the primary element

< 120 >

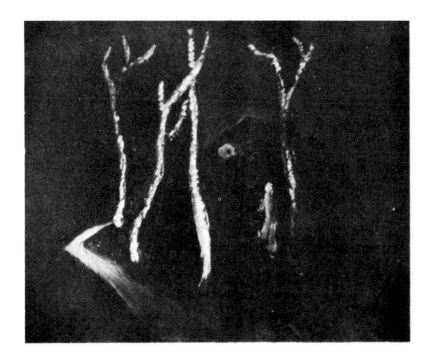

Dancing Trees, by Matthew Barnes. (By courtesy of
Joseph A. Danysh Galleries.)

which pleases the observer in painting can best be described as
"movement in the canvas."

There are many names for the thing, and necessarily none is
exact. "Plastic organization," "spatial vitality" and "dynamic
rhythm" are some of the labels suggesting the movement-factor:
all more or less commonly used in discussion of the modern search
for formal values.

We may approach the subject here by saying that most theories
of Expressionist painting tacitly recognize an element of movement
in the canvas, of a sort unknown to 19th Century painters or theo-
rists; and that study of one or another phase of "movement-

< 121 >

structure" affords the easiest road to comprehension of what are called (with perhaps too strong an implication of finality) "the laws of painting."

The nature of the movement of which Expressionist painters speak is wholly different from the *depicted* sort commonly found in Futurist paintings, and in Realistic battle scenes, dance pictures, sea-pieces, etc. The illusion of pronounced natural movement more often than not destroys the pictorial unity. In the 19th Century, artists recognized only objective movement illustrated, or that sort of pictorial-reportorial shorthand known as perspective. The Moderns think of movement as an element self-contained in the canvas, to which photographed action and perspective may contribute in a minor way. In other words, their sort of *created* movement has nothing to do with the mobility of certain objects and organisms in nature.

In the Modern canvas the "main movement" may often be traced along volumes, colors and textures, offering a guide to the observer's eye: according to a sense of rhythm or formal order experienced by the artist, out of his emotions and his attunement to cosmic order. It is movement within the enclosure of the picture, not illusion of movement in outward life.

Western artists and philosophers after Giotto and El Greco failed to identify or understand this quality or element in painting; and there is practically nothing recorded in our art histories or aesthetics that hints of it. But Chinese books of wisdom speak in terms strangely paralleling the pronouncements of Cubists and other Expressionists.

Regarding the art of China and Japan, Laurence Binyon, in *The Flight of the Dragon,* speaks of "expressive form" and of "rhythmic vitality." He writes: "It is not essential that the subject-matter

< 122 >

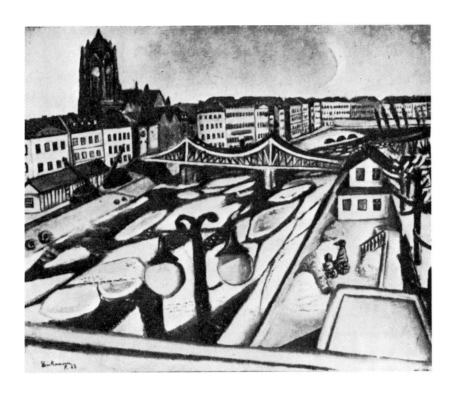

Ice Floes, by Max Beckmann. (By courtesy of J. B. Neumann.)

should represent or be like anything in nature; only it must be alive with a rhythmic vitality of its own. You may say that the waves on Korin's famous screen are not like real waves; but they move, they have force and volume. We might in dreams see waves such as these, divested of all accident of appearance, in their naked impetus of movement and recoil."

Again he makes this "movement" even more integral to the picture, and less of outward nature, and identifies it with "the rhythm of the spirit." He continues: "Every statue, every picture, is a

< 123 >

series of ordered relations, controlled, as the body is controlled in the dance, by the will to express a single idea. A study of the most rudimentary abstract design will show that the units of line or mass are in reality energies capable of acting on each other; and, if we discover a way to put these energies into rhythmical relation, the design at once becomes animated." He records, of the Chinese: "It was felt that the true artist, working when the mood was on him, was brought into direct relation with the creative power indwelling in the world, and this power, using him as a medium or instrument, breathed actual life into the strokes of his brush." The rhythmic vitality in the picture is thus interpreted as *creative* movement, a bit of the cosmic rhythm.*

There is, the Moderns point out, physiological reason for placing movement first among elements making for sense-satisfaction in paintings. The human eye cannot see either a comprehensive scene in nature or a complex picture as a whole, with equal attention to all the parts. The eye naturally roves, explores, focuses and re-focuses, before coming to rest (temporarily) at a center of interest. There is, in short, movement along a path of vision. In nature this results, usually, in selection of bits that hold the attention of the mind, pleasing the intellect. At other times, there is a fortuitous conjunction of elements in "a naturally beautiful" scene: masses of trees bordering a winding road, or a "composition" of lawns, shrubs and buildings—satisfying, in terms true to nature, some sense of compositional order. When pictures are made, the painter can transcribe such "effects" discovered in nature, or he can, creatively,

* See *The Flight of the Dragon*, by Laurence Binyon, New York, 1911, in the series "Wisdom of the East." It is an admirable brief introduction to the art of the Orient. In Vernon Blake's *The Art and Craft of Drawing*, Oxford, 1927, the first of the Six Laws of Chinese painting is translated thus: "Consonance of the spirit engenders the movement (of life)."

< 124 >

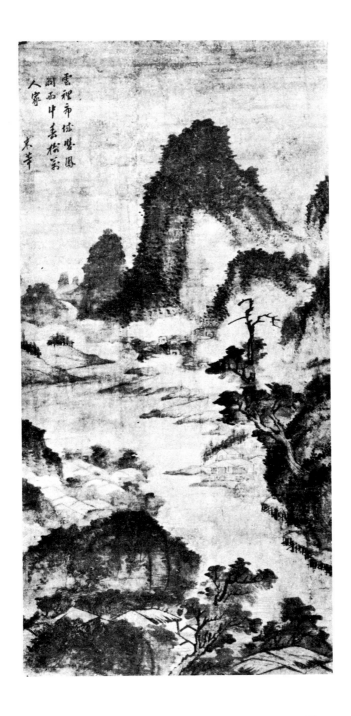

云裡布城磐鳳
間而中丟松筆
人家　米芊

Chinese Landscape Painting of the 12th-13th Centuries.　(By courtesy
of the Freer Gallery of Art.)

set out to fix, in the materials particular to his art, an organic complex of forms, perhaps along a traceable "path of vision," that will afford more intense satisfaction, speaking not only in terms of casual arrangements but rather in a deeper counterpoint understandable to the soul.* The eye no longer translates to the mind alone: it is consciously stimulated to convey a manifestation of order of a super-natural character.

Even in Realistic painting there is some recognition of the habits of the eye. Objective materials are selected, and arranged to bring one object to the center of attention. It is easy to see that if all objects or units in the picture are equally stressed, there is division of interest, resulting in confusion and restlessness. The corners of the painting are darkened or summarily treated. But the Realists are generally innocent of any intention to provide a carefully designed, carefully enclosed, path of vision or complex of forms. Particularly, they are oblivious of action inward and outward, having studied only superficial proportion, on the surface: plane movement, not plastic.†

* Laurence Buermeyer has a wise word to say about the way in which the artist goes beyond nature: "This design or form or vision is a grasp or understanding of what *is*, but it is creative in that the illumination is one which nature, unassisted by the artist, is powerless to provide." See the chapter "Art as Creative" in Buermeyer's *The Aesthetic Experience*, Merion, 1924. Gauguin once wrote: "It is said that God put a piece of clay into His hand and created all that you know. The artist, in his turn, if he wishes to create a really divine work, must not imitate nature, but use the elements of nature to create a new element."

† H. R. Poore, in *Pictorial Composition*, New York, 1903, written for and largely about Realists, includes a chapter on "the circular observation of pictures," and another dealing with the "ways of getting into and out of the picture." There is stimulatng material in the book; but the author sees composition as static, and "movement" as a relationship of surface objects, not as a plastic organism, with depth relations. His insistence upon an "exit" for the eye, and the leaving of openings therefor, negates the first principle of plastic order: that there shall be movement in a *closed field*, a final equipoise of dynamic elements.

< 126 >

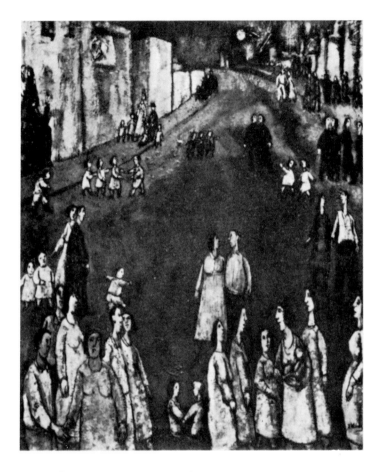

Spring Is in the Air, by Frank Kleinholz. (By courtesy of the Associated American Artists Galleries, New York.)

The Expressionist considers that a "skeleton of movement"—a necessary perversion of terms, where a quality beyond measurements is concerned—is his first consideration. An order in arrangement of his materials is presupposed. Order may best be come at as a structure of thrusts and counterthrusts. Where composition, for the Victorians, was static, a thing of balance on the surface

< 127 >

of the canvas, varied only by depth as understood through the laws of perspective, it is to the later painters dynamic and recessive. To the surface movement is added back-and-forth thrust and return. Equilibrium is construed less as balanced objects, more as related paths of tensions between volumes. Just as cosmic speculation and exploration outgrew the model of fixed stars and pendant earth, in favor of planetary order and orbital progression, so the artist gives up static compositional models, and reads into organizational painting a reflection of the dynamics of the perpetually moving but poised cosmic system (an analogy to be considered later).

SEEING——UNDERSTANDING——CREATING

Since he is dealing with a visual art, comprehensible through the same eye that sees nature, the Expressionist grants that oftener than not the quantitative materials of his picture will be drawn from objective nature; though he insists that there may be intenser expression where the outward appearance is abandoned, in favor of a summary or abstraction. The eye recognizes not by the actual shapes of objects, but by appearances under cast light. After the eye-report, the mind's understanding is re-inforced by memory of reports brought, at other times, in regard to like-appearing objects, by the more fundamental sense of touch (by which we know thickness, roundness, etc.). Movement, as developed in the canvas, will have at least vague reference to these sense-experiences.

It will be related also to stored experience of weight, gravity, balance, etc. But most important—the Expressionist claims—it will link with the deepest rhythms, arising from universal order: with the cosmic machine, the flow of the worlds, the tensions of galaxy, star and planet. It is, he believes, an echo of that deepest,

128

most fundamental ordered movement that gives satisfaction to the observer—in Chinese paintings, in El Greco, in the typical Modernist.

Understanding is an adjustment of what we see at the moment, what we know from past experience, and what we deeply "feel." A work of art is a crystallization of understanding—and its vitality lies in the livingness of the movement-summary. The artist, then, parallels nature, in creating movement; and he is instinctively careful not to negate certain of nature's laws as illustrated in the phenomenal world. He must keep within racial comprehensions of equilibrium, gravity, etc., acquired through immemorial sense experience. It is not his business to transcribe to the canvas observed illustrations of the working of those laws, but rather to liberate in the picture other movements not directly revealed by nature. Ordinarily materials from objective nature are used, as Glenn Wessels puts it, "to build the bridge from ordinary experience into the pictorial world." But some abstractionists, while keeping within felt natural laws, have been able to reveal the deeper form-value with only the slightest reference to objective appearances.

We are dealing here with three orders of materials: what the eye sees physically, an "appearance"; what the mind images, three-dimensional reality, "appearance" plus knowledge gained from past experience through the other senses, and through having seen the same object from all sides, by walking around it, touching it, etc.; and the deeper intuitional image, after penetration to "the soul" of the object, an image conditioned by the artist's sensitivity to it as microcosm, as the universal rhythm in little. In expressing, by plastic means, the last image, the appearance may be distorted. In fusing the elements out of his feeling for nature and the elements out of his feeling for picture-building, the artist intuitively respects

< 129 >

certain laws underlying both categories; but since the picture is his primary concern, he violates the casuals of nature with impunity if thereby he attains a greater intensity of plastic movement and formal order.

The "plastic" is, by dictionary definition, that which is capable of being molded: that which can be worked in a third dimension. In painting, the essence of the plastic is penetration, relief, depth. "Plastic orchestration" implies the projection of the canvas plane backward, creating an understood box-like "spatial field," and the organization, within that field, of all relief or movement elements, in organic relationship.

BACKWARD-FORWARD MOVEMENT

Up to the time of the Expressionist development, artists had attained no clear understanding of backward-forward movement in the picture, as distinguished from linear or side-to-side and up-down movement. The movement across the canvas or up-and-down embraces only a beginning of the dynamic or plastic complex, which gains profoundest effect through mastery of thrust and return, within space beyond the picture "front." The one is two-dimensional, the other three-dimensional. Even superficial Realistic painters, such as Sargent, Bouguereau and Gainsborough, gained catchy effects with two-dimensional rhythms (and these formed the basis of many of the older treatises on composition). But the Expressionist theories, while beginning always with emphasis upon the inviolability of the picture plane, deal with movement in and out, backward and forward, as the fundamental means to pictorial effectiveness. The expressive form is fixed according to an imagined order of movement, linear, recessive, and contrapuntal.

< 130 >

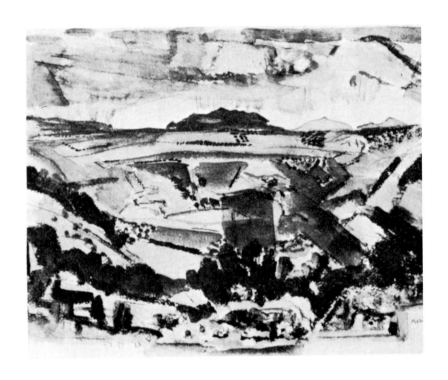

New Mexico: Water-color by John Marin. (By courtesy of
Alfred Stieglitz.)

The Moderns point out that the Realists inescapably created
such movement, without understanding it, without order. The
moment a volume is placed in space, movement of the eye is
induced, forward or back; the moment a color is applied, there is
a physical sensation of recession or thrust forward; and texture
may be insistent or neutral or backward-pulling. The Realist's
painting is, so far as these plastic values are concerned, a chance
agglomeration, a hodge-podge—however engaging the linear sur-
face rhythms and static balance of objects may be.

< 131 >

The Expressionist builds his picture by the movement values of those several elements. From a point of stability in the established picture plane, he creates his plastic rhythm, backward and forward, with the materials of volume, plane, color, and texture. Usually there is a dominant path of movement, varied with oscillations in smaller measure: main "way" and counterpoint. The rhythm has become consciously symphonic: not merely a harmonic arrangement amid the random, and ignorantly combined, thrusts of nature.

THE MATERIALS OF PAINTING: THE SURFACE PLANE

Once the insurgent painters at the beginning of the Century had gained glimpses of movement in this sense—finding the actuality without explanation in Cezanne, and then going back to El Greco, Tintoretto and Giotto for comparison, and perhaps to the flood of Oriental art just then released in European museums—they found themselves driven to a reconsideration of the materials of the painting art. If one starts expression with honest regard for one's medium, one may discover forgotten laws based on the nature of the materials used. Perhaps Cezanne had served to break into a new era by returning his art to a more direct and expressive use of the picture field, the plastics of volume and space, plane, and color movement. A considered search began for "laws" which would afford a clue to form-revelation and essentially pictorial "movement."

The first law of painting—insofar as one can find agreement in any group of Moderns—is that *the picture plane shall not be violated*.

Albert Gleizes was perhaps the first and certainly the most illuminating of writers advocating this law. His summary is still the

< 132 >

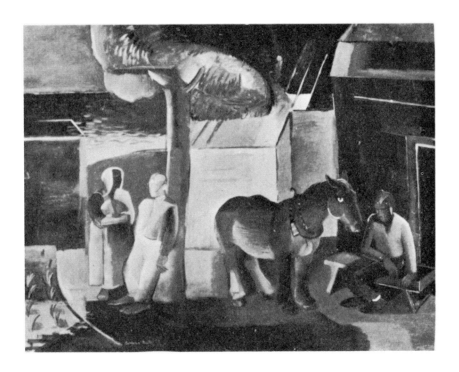

Clam Bay Farm, by Cameron Booth.

most suggestive: "Painting is the art of giving life to a surface plane. The picture plane is an organism of two dimensions. Its truth lies in its two dimensions."

By violating the two-dimensionality of the pictorial plane, by letting the movement escape from the prescribed and framed field, the Realist destroys the picture as a unity, as an art-organism.

The painter's problem is to vivify the picture-field: to build a picture which affords a living experience, within the laws of the two-dimensional unity—and not to make a picture merely reflecting an experience of nature's exterior world. Architecturally speaking, wall-sense is preserved: holes not pushed through.

< 133 >

Maxwell Armfield has said that "movement in art has no meaning apart from stillness." As I see it, in plastic organization, the sense of the picture plane preserved affords meaning to the thrust and return, the recessive rhythm. The plane provides the stillness that gives significance to the movement.

When one accepts the flat plane as conditioning the painter's problem, one uncovers a new set of principles, unknown to the 19th Century artist. Everything entering into the design must be organic to the picture, not to nature: must be pictorially authentic, not "natural." The artist no longer considers the canvas-frame merely a window upon nature, with picture beyond; he begins with a sense of a fixed surface, bounded by a frame integrally related to every unit within the enclosed field. This sense of the two-dimensional picture as removed by its nature from all else in life, subject to its own laws, is the beginning point of all understanding of Expressionist painting. (And, one might add, of early Egyptian and Chinese painting.)

That movement in the canvas shall be controlled, in relation to the flat, is fundamental. Expressive form is destroyed by uncontrolled movement, escaping the picture enclosure, or tracing purposeless representations upon it. The canvas field, complete in itself before the artist touches it, must remain complete when the painter has finished, when he has vitalized it: as a pictorial organism, its two-dimensionality must still be felt, its movement-elements enclosed and firmly anchored to the original plane. This law is implicit in the picture format.

Preserving the picture plane does not mean that the painting cannot have depth: it does mean that every thrust backward, by means of plane, color, texture or other agency, must have compensation, must be ultimately counteracted to restore the sense of

< 134 >

poise in relation to the two-dimensional field. The elements by which movement may be started, inward from and outward toward an established two-dimensional field, are planes, tilted, bent, etc.; volumes in space; colors, forward or recessive; line (which is usually shorthand for boundaries of plane or volume); and texture, fading or insistent. The design is an ordered complex of the movement values of these several elements, sometimes in the nature of main movement and support or accompaniment, sometimes one utilized as corrective of another (as a forward-pushing volume may be neutralized by a recessive blue, or negative empty space brought forward by heavy texture or live red).

In short there is room for complex backward-forward movement, in addition to the up-down and right-left movement on the surface; but, so to speak, that deeper movement must be anchored in the picture field. The constant play of penetration and return must be stabilized in relation to the original chosen plane: the plastic weight balanced within the closed, recessed field.

The infinitely difficult task of the creative painter is to marshal these elements, each in itself and at every move threatening the two-dimensional unity, into a vitalized formal expressiveness, without destroying the integrity of the flat.

There is, then, the *sense* of a third dimension in the expressive painting; the danger is that this will be instead an *illusion* of movement, an imitation of the third dimension of objective nature. Sensed pictorial movement, offering a way for the observer's eye, is at the heart of picture design.

Glenn Wessels writes that "to contrive a destruction of the essential flatness of the picture would produce a deception. One of the reasons that easel painting has fallen into disrepute and disrespect is because its purpose has been mistaken as the production

< 135 >

of such deceptions. Such lying expression is untrue to the nature of the medium and is in the same category as any other hoax." This is perfectly true from the standpoint of the *creator*; though some of us might argue that there is a minor place for "illusion-art," for reproductive illustration. But here we are dealing exclusively with expressive, creative art; and we should keep clear the distinction between the authentic pictorial creation, conditioned by the two-dimensional plane, and the casual, imitational, surface-of-nature thing.

The truth, in summary, seems to be that the artist accepts a convention of two-dimensionality, when he undertakes to create within the painter's medium; in introducing a certain type of movement into his canvas, he utilizes a three-dimensional element, this being only incidentally related to the third dimension in objective nature; and his profoundest aim is to liberate a sense of four-dimensional rhythm or order. If this statement seem muddling and vertiginous at first glance, there is behind the confusion a solution of some of the most difficult problems posed by modern art for the observer trained in the imitative tradition.

THE PATH OF MAIN MOVEMENT

In creating a movement-path and the various counterplay of plastic elements, then, the painter keeps before him the sense of a complete organism, of which the picture plane is the first conditioning, inviolable factor. In initiating movement in the canvas, he will be careful not to partition space, or drive deep beyond the surface, or push toward (or beyond) a border, in such way or to such degree that the plastic equilibrium or tension-poise cannot be restored. He will have before him at every stage of design the

< 136 >

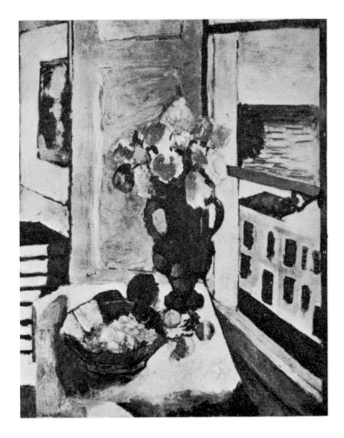

Still Life, by Henri Matisse.

image of the movement equipoised, the path enclosed and centered, the pictorial unity preserved.

The secret of the variations lies in the fact that while the entire movement structure (so to speak) is designed to be in equipoise, one sort of movement will be irregular, far from symmetrical, with a vigorous main "drive"; with another movement element entering to counter-poise thrust or pause, or to "fill the holes." Thus a track of movement may be created by overlapping planes, leading off into one side of the field, and a cunning gradation of colors

< 137 >

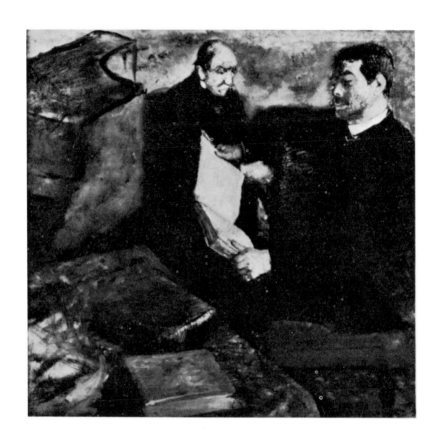

The Elder Degas and His Secretary, by Edgar Degas. (By courtesy of Durand-Ruel.)

compensate for its steep inward thrust, or a heavy textured area or a volume-buffer stop its drive and turn its direction. Line is a less fundamental element, but is commonly used for variation.

In some paintings the movement of volume-space elements is so strong—the color-texture elements affording mere accompaniment —that it is possible at first glance to mark a vision-path. In others, the elements are so fused, or combined with such subtlety of counterpoise, that the complex counterpoint, the rich play of oscillating color and texture and minor melody, seems to be the characteristic element in the design. The practiced eye, however, will soon detect the larger movement beyond the variations: will mark the dominating volume or "sun," will note where the eye enters the picture, its main direction, where it comes to rest—without losing the sense of the enriching counterpoint.

Perhaps the greatest painters are those who learn to accentuate the main movement even while intensifying the emotional effectiveness by a constant play of fluctuating color-planes, small-volume complexes, etc. El Greco and Cezanne, masters of contrapuntal effects, seldom leave the eye in doubt as to a main rhythm. Matisse, perhaps the greatest living master of decorative color and texture, is, on the other hand, weak in understanding of the profounder rhythm; whence arises the criticism from many Expressionist painters that he is "only a light-weight," or "a mere decorator." * Even so the main movement path can be satisfyingly felt in many of his canvases, although the recessions are less deep, the plastic intervals less pronounced. Rouault, Schmidt-Rottluff, Campendonk, Carra, Picasso, Marin, Kandinsky, offer better material for a study of the more vigorous rhythm. Although I shall leave

* My own partiality toward the paintings of Matisse will be sufficiently explained, I hope, in following chapters.

< 139 >

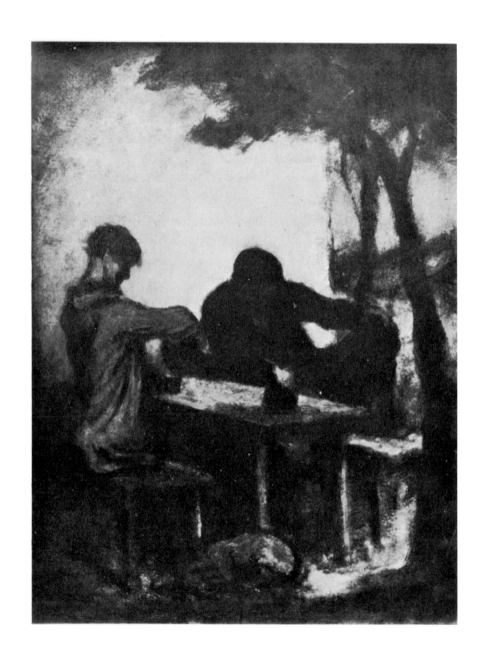

The Drinkers, by Honoré Daumier. (By courtesy of Adolph Lewisohn.)

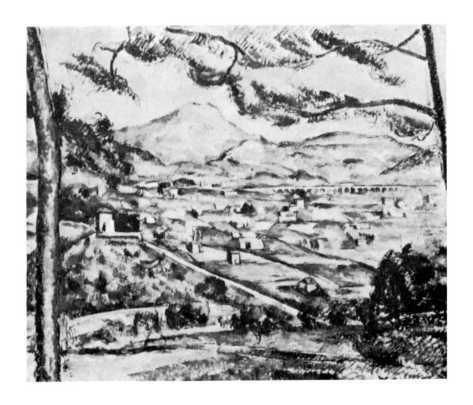

Mount Sainte Victoire, by Paul Cezanne. (By courtesy of the
Phillips Memorial Gallery.)

analysis of the movement-path as such to later paragraphs, I am
introducing here two pictures, to illustrate the plastic rhythm
strongly accentuated, with little subtlety of counterpoint, and, on
the other hand, the main rhythm easily traceable but richly varied,
re-enforced, and answered by a multitude of minor rhythms.

OPENING THE PICTURE

When certain painters speak of "opening the picture" they
usually are referring to initiation of the main movement. The

< 141 >

moment a line is drawn across the virgin picture field, or a color plane laid upon it, movement is initiated and requires compensatory action. Once started in this way, the work is not complete until the structure has been poised, every tension anchored, every recession brought to return.

It is doubtful whether a creative painter ever begins a picture where the path of vision seems to the observer to take its rise: the artist jots down his main tension lines first, in all likelihood—sketches the forms with strongest pull—and works the path both ways, back to an opening point, and forward to a point of final stabilization. But for us who can study these matters not in the doing but only from the finished product, it is more convenient to consider the painter as opening his picture at that point from which the observer's eye seems to rise along a main path.

As if to afford validity to this approach, it is a fact that in an extraordinary number of modern paintings (and in many examples of the work of El Greco, Tintoretto, Giotto and others among master picture-builders of the past) the point of entry is along the lower border to the right or left of center. The internal structure of the picture is such that the movement, from there, pushes inward and up, and so into a more or less complex path.

We do not want to make a formula of this thing, either for guide to appreciation or—far less—for a system of creative picture-building. The path of vision varies as the emphasis on the several formal elements differs, and as the subjective or emotional elements affect the structural composition. But we may be sure that no creative painting is haphazardly built; and that all artists following the Cubist-Expressionist period will be profoundly indebted to Cezanne, Seurat, Braque, Gleizes, Hofmann, and others who served to make clear the nature of movement in relation to formal ex-

< 142 >

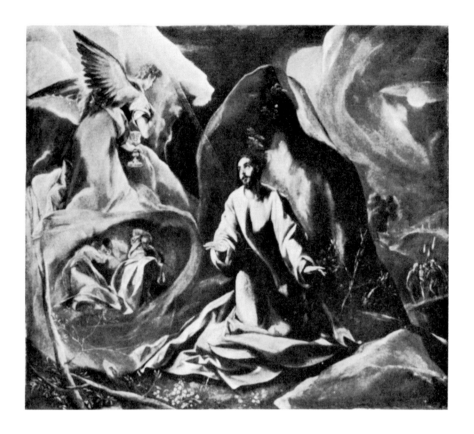

The Agony in the Garden, by El Greco. (By courtesy of Arthur Sachs, Paris.)

pressiveness. We can, moreover, learn a great deal, I think, by studying the movement path in a typical manifestation—just as if it could be disengaged from the other elements within which it is fused.

This, for instance, is the commonest noticeable type of plastic structure, as I have found it in ancient and contemporary paintings: the eye is drawn into the composition somewhere in the right

< 143 >

half (observer's right) of the lower edge of the canvas; it moves, perhaps by artificially overlapping planes or by a sweep of terrain, upward and inward toward the left; above center it is turned across the canvas, perhaps by a buffer specially placed in the corner of the picture; comes down and forward on the right; is turned inward to the pictorial center—and comes to pause there.

Almost needless to say, no example exhibits so bald a structure, so *direct* a line of movement. The eye passes from volume to volume, takes in a minor complex of elements at one point, is attracted by a color or an angle or a face to another; and even the so-called point of stabilization may be the nucleus of a complex, or the tension-point *between* two weights. In short the vitality of the plastic structure lies largely in the variations and incidental enrichments, in the contrapuntal rhythms and the fluctuating fullness; and yet the expressive form suffers if the main line of movement is too long obscured or inadequately felt.

It may be that the path of vision is a secondary consideration, in that the observer's eye may be drawn first to a dominating form or volume, and only after "taking that in" drops to a point on the designed track, to continue from there the "round" of movement. There is, moreover, the probability that even observers somewhat trained to plastic appreciation have developed differing ways of approach, so that to suggest any absolute rule of observation is dangerous. Nevertheless, study of the most creative Moderns, beside El Greco and other early masters, indicates that the plastic order is oftener than not marked out visibly along a rhythmic path.

If the "line" were stripped of all incidentals, the typical path described above would be a spiral: but a spiral which cannot be diagrammed on the flat, because the plastic element in its essence supposes penetration. In trying to "read" the vision·track in any

< 144 >

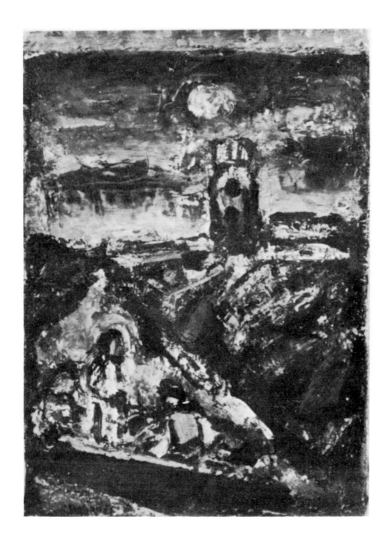

Christ and the Fishermen, by Georges Rouault. (By courtesy of
Pierre Matisse Gallery.)

given painting, the spiral should be felt as pushing *inward* from
the lower border, and returning outward, then inward, in the oppo-
site half of the picture. Inexact and variable as it must be, the test

< 145 >

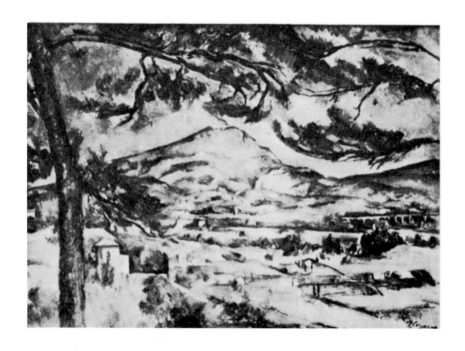

Mount Sainte Victoire, by Paul Cezanne. There is close likeness to the third preceding plate, but significant variations in plastic manipulation, for movement effect. (From *Cezanne*, by Tristan L. Klingsor.)

may serve the reader as one clue to the actuality of the vision path in innumerable creative canvases.

For instances I am introducing here a landscape by Cezanne, a "Primitive" interpretation of *The Agony in the Garden*, El Greco's version of the same theme, and a composition by Rouault. The in-and-out movement can be traced in all of these with very little departure from the type form; though in the El Greco and Cezanne paintings there is extraordinary variation and enrichment all the way; whereas the compelling linear accentuation in the

< 146 >

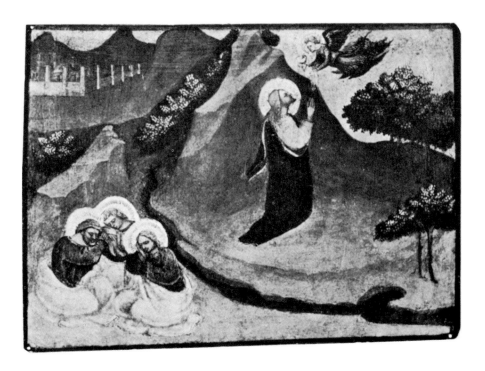

The Agony in the Garden, in the manner of Andrea di Giusto. (By courtesy of the Gallery of Fine Arts, Yale University.)

Primitive and the Rouault make the coiled path stand out in almost naked relief.

Even in the most obvious of the examples, the Italo-Primitive, however, the line is varied, the nodes become complexes, and interest is enriched by minor elaborations. The eye, **drawn** in by the linear lift of the upflowing river, pauses momentarily at the group of Disciples; continues left and up, is turned from the corner by a complex of vaguely recognizable natural forms—mountains, town, wall; is carried along the heavily accented valley of foliage; is

< 147 >

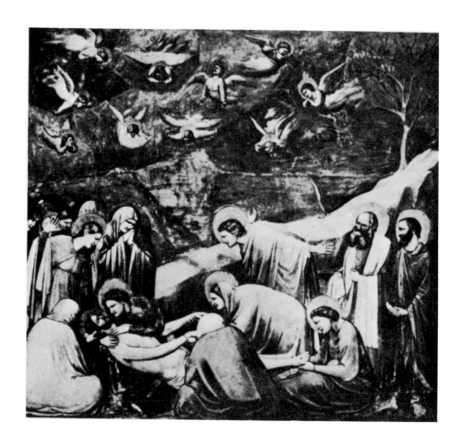

The Lamentation for Jesus, by Giotto. (From *Giotto*, by Louis Gielly.)

drawn around the central peak by the bit of bush beyond; is pulled forward and right by the Angel; falls to the trees, turns inward again, and centerward, to come to rest at the head of Jesus. So varied is the most obvious example of what I have variously termed the way of vision, the tension-path, and the skeleton of the plastic structure.

I confess that I dislike this sort of analysis of creative works of art. But in the circumstances it seems justified: for the recog-

< 148 >

nition of some such underlying plan of structure, or designed movement progression, may afford to the student a key to the basic differences between casual Realistic and designedly Expressionistic painting. Remember, please, that any formula or diagram is a makeshift, a means to first recognition; get on, as soon as possible, to direct feeling of the thing we have been discussing. But if you still have doubts about the nature of the main plastic outlining of the picture, take time to trace out the paths of vision in these four works. The spiral form as given may be tested also, in only slight variations, in Georges Seurat's *The Parade* (page 194), in Kandinsky's *Landscape with Red Spots* (page 155), a perfect example, and, with greater concessions to nature, in Roerich's *The Unknown Singer* (page 159). Practically every illustration in this chapter "declares" its plastic order.

That the movement is not always to be diagrammed so simply, even in a painting with extraordinarily marked recessions, is made apparent by study of Giotto's *The Lamentation,* reproduced here. The first sweep of movement, by means of stepped-back figures, and inward-right instead of left, is strongly re-enforced by the oblique push of the wall. The path is then carried across by tree and angels, and ultimately downward and outward, almost to the corner of the canvas.

MOVEMENT AND THE SPECTATOR

There are principles concerning the origin and direction of pictorial paths of vision, which can be put down with some assurance of scientific sanction. Due to the way of seeing—this being a visual art—the point of opening the picture is somewhere at the base. The painting is conceived with reference to an imagined

< 149 >

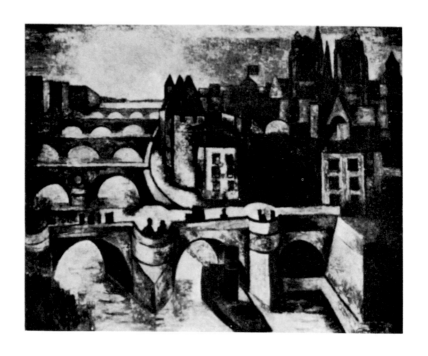

Bridges, by Marcel Gromaire. (By courtesy of J. B. Neumann.)

observer. The spectator is thought of (at a varying focal distance) as facing the central portion of the picture. But the line of his vision is picked up practically never at the center of the frame. The picture opens from the bottom, at his right, leftward; or, less often, at a point to his left, rightward—and always *with relation to the ground where he is (in imagination) standing.* Because subconsciously the observer carries over to his attitude toward pictures his sense of gravitation and equilibrium, the artificial created world of the picture must seem founded on stable ground, and must move away as the eye rises. Through establishment of the observer's position, by the apparent point of origin of the path of vision, these matters are related to his own foundation

< 150 >

and uprightness. The structure of tensions, between volume-axes, relates through him to order and stability in the universe. The new creation is integrated to the existing world.

Applying the principle to the movement path described above, the spiral has mathematical relationship to the ground upon which the spectator stands. The first movement is a sweep away from the frame before him at right, deep into pictorial space before him at left. The lower curve is the broader, aiding the sense of stability. It rises from a frame-edge paralleling the ground.

A group of Cubists were the first to promulgate a theory of the picture as related gravitationally to the spectator's standing-ground. And it is easy to see why we sometimes speak of the way in which the planes of a Cubist picture are "laid up." They seem to rise from a heavy base, close to the observer, and the skeletal lines or axes move up and away (though ultimately brought to poise, into integral relation to the other plastic elements and to the pictorial field).

In an illuminating essay on Cubism, Andrew Dasburg explains that there are "two considerations fundamental to the understanding of rhythm. One is the force of gravity, the other, the upward impulse in living things." * Certain it is that the path of vision *rises.* There is, in plastically satisfying paintings, the feeling of a heavy base. The picture is a *building,* on a foundation, not a random scattering of objects and accents.

Wessels adds to our understanding of the observer's standpoint when he writes: "We live visually in that part of space which is between the horizon and our toes. Unless special evidence to the contrary is brought into the graphic symbol. we assume all things

* "Cubism—Its Rise and Influence," by Andrew Dasburg. In *The Arts,* November, 1923.

< 151 >

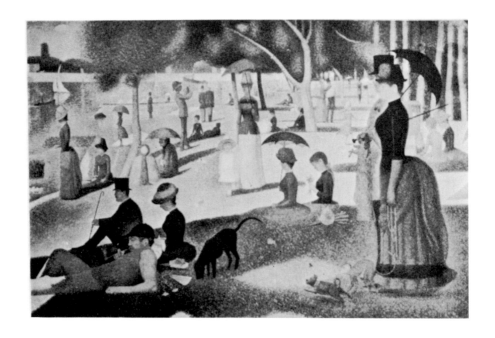

Sunday on Grande Jatte, by Georges Seurat. (By courtesy of the
Art Institute of Chicago.)

seen to be below us." We begin by looking from the ground
upward and back.

Pictures are asymmetrical.* The picture field is partitioned,
the movement initiated, and immediately there is disturbance of
the balance. From then on, in creation, there is a series of proc-
esses, one element checking another, weight roughly balanced by
counterweight, movement turned, enclosed, tied in—but never does
the original static balance return. The life of the picture is in the
adjustments, the varied thrust and return, that hold the movement
stable, without symmetry.

* Symmetry is a condition of ornament or pattern, as distinguished from picture.

< 152 >

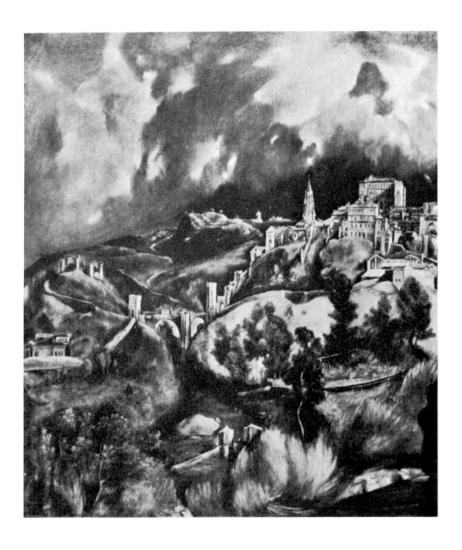

View of Toledo, by El Greco. (By courtesy of the
Metropolitan Museum of Art.)

In fact, there is quite commonly a general division of the picture
into a space side and a volume side. That is, in one half of the
design the path of vision seems to run off into deeper space; in

< 153 >

the other, it pushes out toward the spectator, before turning in again to a point of rest (not *too* far back) at the pictorial center. Only thus could a sweep of movement be accomplished, in the vision-path: only thus strong plastic rhythms be created.

The voluminous side of the picture, in the examples considered above, with one exception, is at the observer's right. It is at the foot of the volume, so to speak, that the spiral line takes its rise, swinging away into deep space leftward. In the Rouault and the Primitive, the matching of volume side against space side is very obvious. Even in the flatter Cezanne landscape, the practiced eye will detect the bulge forward of the hills at right. The Kandinsky landscape shown here perfectly illustrates the "displacement" of the two sides.

As one moves toward decorative painting—Gauguin, Matisse, the Russian ikon-makers—the recessions are less deep, the plastic rhythms less strong, and therefore one detects less easily the space side and the volume side; but illustrations might be cited from all these sources. Further examples of marked contrast between the deep space in one half, and forward push of volume in the other, are shown in nearby pages: Seurat's *On Grande Jatte*, and El Greco's *View of Toledo*.

Again let me say that the "principle" is variable, subject to almost infinite manipulation. If in many cases an entire half of the picture seems to be pushed away from the spectator, the poise being restored by the pull of important "volume interest" in the other half, more examples could be brought to illustrate a subtler counterpoise: the path almost obscured by minor counter-play of volume, plane, color and texture. Sometimes the sweep is almost wholly a matter of movement by complexes of planes leading up and away on one side, "returning" by other combinations to the

< 154 >

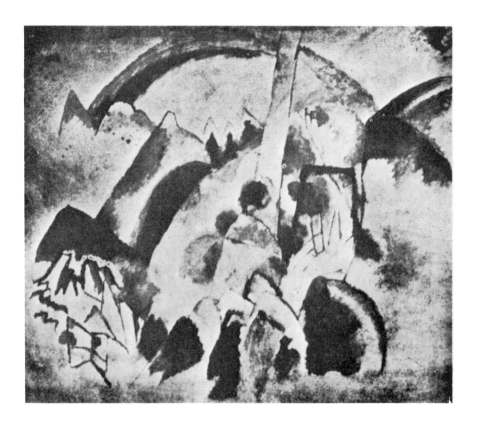

Landscape with Red Spots, by Vasily Kandinsky. (By courtesy of
Der Sturm Gallery, Berlin.)

other—with volumes difficult to detect in any strict sense. Or else
the interplay of oscillating color-areas all but obscures the linear
vision-path and volume-space contrast. Yet here is a clue to the
secrets of designed and completed plastic rhythm.

I have said that no artist would think of building a picture by
consciously following the spiral (or any other) formula, from the
beginning point of a path of vision, through logical progression
to the pictorial center. The formulated theory is useful only as

< 155 >

a test, for appreciative and recognitional purposes. The artist's sense of planned movement, during creation, is more than half intuitional. It is none the less certain that the painter *feels* some such plastic structure, in its main outlines, as the picture grows under his hands. He senses the living movement, the lift and thrust and return, and final settling to poise; and is conscious of the effect upon the unity of the organism as he introduces each recession or advance, by line, plane, volume or color.

MOVEMENT START AND MOVEMENT CONTROL

Hans Hofmann notes that there is no way in which one can draw a line across a virgin canvas, partitioning space, without starting movement. The first line makes for the sense of two planes: there is departure from the absolute flat, from perfect balance, from symmetry. Let us say that the field is divided thus (A):

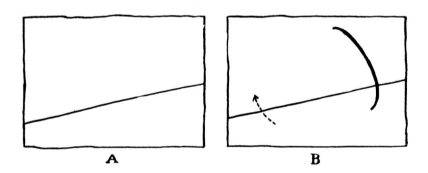

A B

Due to automatic action of the eye, and relationship to observer's standpoint, there is the impression of movement from the area below the line upward and back; and in this case, due to the tilt of the line, leftward (as indicated by the arrow in B). Immediately the artist is faced with the necessity for further movement, for

< 156 >

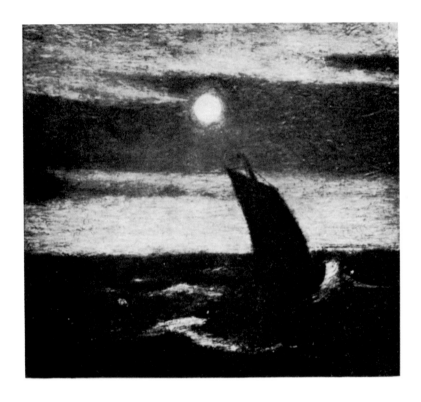

Outward Bound, by Albert Ryder. (By courtesy of the Corcoran Gallery
of Art: Loaned by the Estate of James Parmelee.)

compensation. It may seem to come (if he is thinking at the
moment without reference to any but the line-and-plane element)
by means of an arc as in B—which indicates a sort of skeletal
equilibrium, but immediately opens the way to other compensatory
steps.

Hofmann speaks of the partitioning of space as the "first anima-
tion of the picture plane," of reciprocal action, and of "spatial
unity" restored. He is insistent that in the end the picture shall
be "closed." The sense of completion and enclosure is what some

< 157 >

others have in mind when they insist above all else that the picture shall be considered as an organism: all parts related in movement, in harmony, in variety within unity, in completeness. Joseph Sheridan, who speaks more in terms of forces and tensions—(we shall consider plastic movement as the summary of tension paths, later)—states the thought thus: "The sum of all the forces must form a closed figure."

Cezanne, who has not been surpassed by any later artist in surety and richness of plastic orchestration in painting, worked deliberately to adjust the weights, tensions and directions of his planes of color, from first laying-out to final stroke. His paintings, which seem at first, to the observer trained in detailed Realism, so like an artistic shorthand, so summary and even careless, represent extraordinary labor: not so much in *thinking* through to the perfect relationship, and certainly not in order to catch a photographic effect, but in bringing each brush-stroke into consonance with everything gone before and everything planned to come after. We are told that not uncommonly he would, after filling the brush with color, hold it poised for a quarter-hour before laying it to the canvas: meantime he was feeling through to the movement relationship of that color plane to main plastic rhythm and contrapuntal effect. No later painter stripped himself more naked of casual detail; no one fixed formal rhythms more directly and more cunningly in paints. Those who made theories of his incidental idioms and abstractions, failed usually to approach his mastery of *all* the movement elements in controlled relationship.

I have said enough of movement by plastic means to indicate the importance of the plastic orchestration, the completed dynamic rhythm, as a factor in Expressionist painting; and I will remind the reader again that this factor was wholly overlooked by Realistic

< 158 >

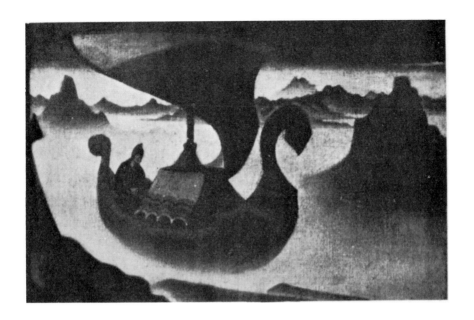

The Unknown Singer, by Nicholas Roerich. (By courtesy of the
Roerich Museum.)

painters and by 19th Century academic critics. The formulas
developed by the intellectuals of the Century-end, to explain har-
mony of design—Dynamic Symmetry, etc.—fail in regard to paint-
ing because they accept static composition as the type excellence.
They make no allowance for backward-forward movement: over-
look the plastic element that gives intensest life to Modern painting.
They content themselves with static balance, linear rhythms, and
"proportion": failing to guess movement in depth as the deter-
mining element in endowing a painting with pictorial vitality. Let
the student know the geometry of the thing miscalled Dynamic
Symmetry, but let him understand it as contributory to a mastery
of surface effects, in no wise explaining the dimension that counts
most.

< 159 >

Since mine is not a technical treatise, I will end my discussion of the movement path as a whole, except to summarize thus:

In creative painting, control of movement, of interrelated plastic means, is the first secret of formal design. From the opening of a picture with a partitioning of the field, through a main thrust into deep space, back to a stabilization or equipoise, with innumerable minor thrusts, tensions, recessions and returns along the way, the artist must foresee how the movement skeleton will be coiled within the picture enclosure.

The theory of plastic-spiral movement in recessed pictorial space happens to be a bit of the puzzle that I worked out myself; perhaps with memories of Hambidge's surface figures, modified by the knowledge of plastics brought in by Hildebrand, Hofmann, Gleizes, and Wessels. But I should add, here at the chapter end, that once upon a time there was in my town a teacher-painter named Vaclav Vytlacil, who developed a theory of picture-building under a name suggestive and illuminating. He called it "the Fifth Line theory." He postulated that a painting is conditioned by its two-dimensional field *within four rectangular border lines.* In relation to these four, the movement developed by the main slope into the picture constitutes a determining *fifth line.* This is, perhaps (as illustrated in the examples considered above) the beginning sweep of the way of movement—which I have oftenest termed "the path of vision," because treating it from the observer's standpoint. It may aid the student to comprehend the organic nature of the enclosed movement if he tests some examples as "resting on" a skeletal "fifth line," and through it related to the four.

The crystallization of my own thoughts upon plastic vitality and movement correlation came through reading the particularized essays of Albert Gleizes and Hans Hofmann; and I found con-

< 160 >

firmation in the more generalized writings of Dr. Barnes. But occasionally students have checked my statements, by their understanding of Vytlacil's teachings, and I cannot know how much of his theory I may have woven into my own—or Professor Hofmann's. The credit is perhaps unimportant. To be able to *feel* the structural line, in a Cezanne *Mount Sainte Victoire*, or a Giotto *Lamentation*, or a Kandinsky improvisation, is comparable to development of the ability to "hear" the architectural relationships underlying the counterpoint of a Bach fugue. And ordered movement is of the essence in both cases.*

* In the years since this chapter on the movement-path was written, scientists have conducted fruitful experiments in the observation of children's eyes while "touring" pictures. Their findings prove that the eye moves through the picture, and that Modern painters and such earlier painters as Giotto, Tintoretto and El Greco seem to provide a guiding path through pictorial space. The commonest path, moreover, is said to be the spiral one here suggested. But at least one scientist has reported that the majority of the observed observers of pictures makes the tour in the reverse direction from the inward and upward one here described. That is, the average person looks first at what I have termed the point of rest or pictorial center, and proceeds along the spiral path and *out* of the picture at the bottom—before repeating the round. This is probably correct. I have no reason to maintain that my theoretical way of "reading" the painter's composition is superior, for all observers. For analysis and technical discussion, however, with due regard to the observer's position in looking into the picture, the treatment here may stand; it seems to make clearer the method of organizing (intuitively) the spatial elements, with regard to the surface plane, the initiation of movement, and an orderly plastic rhythm. The Vytlacil mentioned is a well-known painter and teacher in New York.

< 161 >

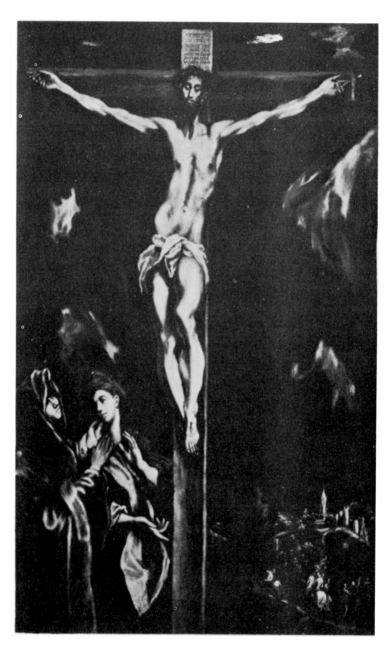

Christ on the Cross, by El Greco. (Photo by courtesy of the Art Institute of Chicago, from the original in the Johnson Collection, Philadelphia.)

CHAPTER VII

PICTURE-BUILDING: HOW MOVEMENT IS CREATED

I F creative painting is now considered a matter of plastic-dynamic
rather than static design, if talk about the mysteries of composi-
tion centers no longer on balance and proportion but on spatial
vitality and plastic form, what key can one find to the all-important
movement-control?

There is no *master* key. The profound beauty of the paintings
of El Greco, Cezanne and Kandinsky is so fixed in a fusion of the
several formal elements that to pick one for analysis brings danger
of undervaluing the interplay. Movement in the canvas exists by
virtue of the perfect adjustment of such differing "materials" as
colors, planes, textures, etc. Each aids the other by checking,
neutralizing, re-enforcing, etc. In the end, plastic orchestration,
the sum or result of all movements, is of supreme import.

Nevertheless there is light for us in discovering the actual means
by which each element contributes to the movement. The listener
gains from a symphony more rather than less if his ear is trained
subconsciously to hear when the wood-winds come in, when the
strings dominate, and so on. The knowledge sharpens rather than
dulls the appreciative faculties (unless one fall into the degenera-
tive habit of staying awake intellectually). The observer will lose
nothing by recognizing the recessive values of colors, the thrust and

< 163 >

return of arranged planes, and the tension values of volumes in space; and he may thereby find unlocked the major mystery of plastic orchestration in painting.

And so—though there is no master key—we shall take one item out of the array of "movement materials," and see exactly how it contributes to the visual progression and the counterplay. We shall review briefly a number of incidental factors; but from the major ones we shall select *planes,* and investigate their movement-potentialities, dynamic slopes, etc. In the end the reader should understand why Expressionists grant that the artist-group known as the Cubists made one of the cardinal historic advances in knowledge of the technique of painting.

<center>MOVEMENT BY "NATURAL" MEANS</center>

The painter's problem goes so much deeper than a mere depiction, or interpretation, of something casually seen in the phenomenal world, that there is almost inevitably distortion of the surface appearance; and not infrequently there is total departure from objective nature, into a region of abstractions. When I first introduced the subject of movement in the canvas I stated—perhaps too emphatically—that the student must be careful not to confuse the plastic element with depicted natural movement. As a matter of fact, since totally abstract paintings form only a small fraction of creative work, objective materials enter into design in great quantity; and occasionally the manipulator of plastic movement utilizes the *direction of natural movement* as an item contributing to his plastic "structure." Thus one can discover examples in which the direction of motion of a horse, or the slope of land, or the pushing of a crowd, gives direction to the path of vision in certain segments.

< 164 >

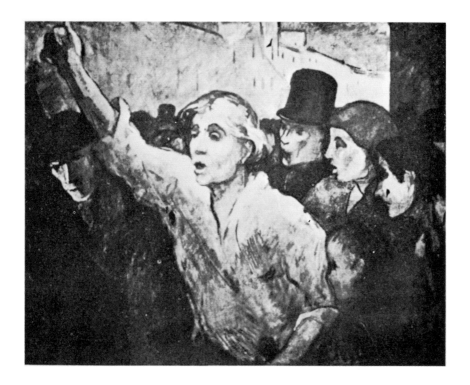

The Uprising, by Daumier. (By courtesy of the Phillips Memorial Gallery.)

It is notable that the majority of paintings do not depict, even incidentally, objects in motion. In a large number of the minority, the movement is in the nature of casual photographic illusion, without relationship to a designed plastic rhythm. But in a few cases, painters who have attained mastery of plastic organization utilize objective elements.

Daumier exhibits many examples of combined natural and compositional "direction." *The Uprising*, reproduced here, shows the main figure accentuating the first long sweep of the path of vision, from lower right base to upper left corner. But note how the painter

< 165 >

artificially uses the darkened left edge of the canvas as a buffer; this, with the slight backward turn of the hand, serves to bend the track of sight rightward along the building wall (simplified into hardly more than a sloping plane); until the darkened block, in the opposite top corner, acting as buffer, pulls it forward and bends it down—to be picked up by the complex of heads, and brought to pause at the pictorial center. Others of Daumier's compositions incorporate moving animals in the same way. The point we should remember is that in utilizing these effects incidentally, the artist never forgot that his complete movement design, not the depicted figure, was the prime consideration: he artificially adjusted, counterpoised and ultimately stabilized within the pictorial enclosure the thrust "naturally" created.

El Greco made extraordinary capital of hands and limbs and draperies in furthering the essential rhythm, and in building up his flame-like theme-variations. Realistic-minded critics see in his "contortions" only a result of astigmatism, or an arbitrary departure from the natural. But El Greco literally twisted nature to his own uses. It is noteworthy that he dealt to an exceptional degree with elements that were "natural" to his public, yet could be endlessly rearranged for abstract purposes; draperies and clouds and rocks. He thus filled in with materials that could be "distorted" without offense to Realistic-minded observers. At other times he took refuge in combinations which could be "excused" because the miraculous subject matter had divine sanction. A man might arrange Biblical apparitions and the Kingdom of Heaven according to his fancy.

Thus El Greco could moderately satisfy an audience trained to Realism, and yet accomplish the miracles of plastic organization that place him among the very greatest painters of all time. The

< 166 >

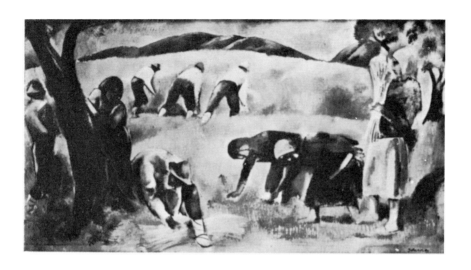

The Reapers, by Maurice Sterne. (By courtesy of the
Phillips Memorial Gallery.)

figures in his canvases are not so much moving, in the usual sense,
as artificially energized—by attenuation and exaggerated gesture—
to carry out a preconceived plastic orchestration.

Much commoner is the utilization of the *implied* movement of
a slope of ground, or the directional effect of a figure facing left
or right, in or out. A bit of terrain leading inward is a common
device of the Realists as well as the Expressionists, for getting the
eye into the picture. But it is in the canvases of the Moderns that
one finds every natural slope incorporated into a closed rhythmic
design. Cezanne's landscapes illustrate at times an amazing com-
plexity of ground slopes entering into the intricate counterpoint of
color, plane and volume. In the early and less abstract work of the
Cubists—Braque and Picasso particularly—there is over-conscious
utilization of such "directions": it may be fields and roads, or table

< 167 >

top or bar. As classic examples one might study Chinese landscape paintings; and the famous *View of Toledo* by El Greco offers masterly material for test of the relationship between apparently natural topography and dramatically moving pictorial rhythm.

We are here on the verge of a consideration of "natural perspective." The reader trained to recognition of right or wrong perspective in pictures probably found himself thinking, when I first began speaking of recessive values and spatial depth, "Why, he is talking of the effect of perspective." On the contrary, nothing could be more confusing than to mistake plastic rhythm for merely a cunning manipulation of appearances in perspective. This factor, like depicted motion of animals, may be one item contributing (at points) to the main rhythm or to the plastic variations. But its rôle is incidental; and in great numbers of creative paintings there is conscious distortion of what are inaccurately known as "the laws of perspective."

These laws are merely a convention. Slavish observance of them, and playing with the resultant "natural effects," all but ruined Western landscape and genre painting from the time of Masaccio, "who was the first artist to attain to the imitation of things as they are" [Vasari], to Manet and Monet and Menzel and Sargent. (Perspective vistas even crept into sculpture—so help us God!) Chinese painting of the same period is incomparably richer in plastic values, in the profounder values of pictorial art.

PERSPECTIVE: MECHANICAL LAW OR CREATIVE INCIDENTAL

There is a supposition, among those who put a special value upon "natural" art, that a knowledge of scientific perspective enables a painter to fix on canvas views of nature exactly as the human eye

< 168 >

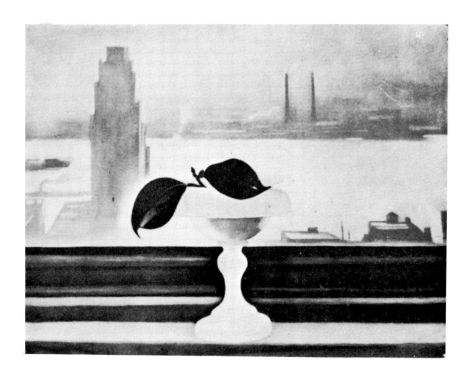

Pink Vase and Green Leaves, by Georgia O'Keeffe. (By courtesy of
An American Place.)

sees them. On the contrary, the eye sees in patches, each clear patch
shading off into blurred surroundings. The Realist sometimes ap-
proximates this effect in a small painting, as when he places a por-
trait head in a field darkened at the corners. In most larger pictures
he spreads over his canvas a series of views of adjoining bits of
nature. By observing "the laws of perspective," he brings them
into a composition which is true to nature as the human eye would
see it *if* it could be focussed over many times the territory it actually
does cover. It is a mistake to believe that we see "in perspective."
The "laws" are really an intellectual working-out of mechanical

< 169 >

truths—and were superstitiously adopted and observed, in an era when materialistic and intellectual forces came together.

The Western system of perspective is *one* convention. Today a great many people are coming to believe that the Chinese convention is truer pictorially, permitting a greater intensity of that sort of beauty pertaining essentially to the painting art. That the method of "laying up" the objective elements of a picture, in Chinese art or in Italo-Byzantine, violates the rules of natural perspective, no longer seems to argue inferiority in the product.

It is seen to be an unwarranted assumption, on the part of material-scientific minds, that perspective-art is true to appearances, and that transcription of surface appearances results in the highest art. In the Far East, painters seldom aspired to the triumphs of literal representation, and scientific perspective was not discovered. In the West, the student should learn the rules and quite consciously forget them.* The wise revolutionist knows thoroughly what he is rebelling against.

The rhythmic structure or plastic organization is, indeed, of so much greater significance than the observance of the mechanical rules, that the majority of paintings produced by the Moderns ignore or distort linear perspective as known to the conscientious 19th Century artist. This is not to say that there is never use of the formula, for incidental gain in primarily plastic design. What used to be called atmospheric or aerial perspective—almost independent of the rules of linear representation—is the greater source

* Vernon Blake, in *The Art and Craft of Drawing*, writes: "The visible universe, the terms of plastic art, are (or were) to the Chinese artist no more than the means of bodying forth abstractions. If the rhythm of pattern in a composition require it, that is, if one of the most important aesthetic factors require it, a Chinese artist does not hesitate to change the direction of a receding perspective line; rhythm is more essentially important, on account of its aesthetic suggestive value, than is exactitude of appearance."

< 170 >

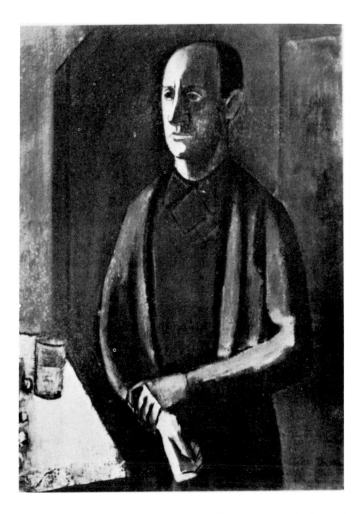

Self-portrait, by Joseph de Martini. (By courtesy of the artist.)

of contributory "effects." The way in which a landscape seems sometimes to be laid up in stepped-back atmospheric planes, could not but be suggestive to the artist interested in all the resources of recession and return. The contrast between forward-dark and lighter-back, and the projection-value of succeeding edged planes

< 171 >

are items not to be overlooked as means to plastic movement. All this, however, is quite apart from the code of laws of linear perspective, which are framed with the stated purpose of making transcriptive art "look natural."

Linear perspective, indeed, presents exceptional dangers when incorporated into plastic design. The convergence of architectural lines toward vanishing points often starts movement that is never "headed"—the pictorial structure thus being destroyed. The museums are full of vaunted paintings which illustrate how the eye can be carried impossibly far back into space, or clear off the edge of the picture. Personally I find the extravagantly praised *Madonna with St. Francis and St. George* by Giorgione badly marred by the duality of focus. The front plane with its distributed points of interest accords to the best canons of static composition: but there must be a violent jump of the eye to embrace the two perspective inserts beyond. There is cunning surface design, almost architectural in its rigidity: though mechanical and dull as compared with the plastic architectonics of much of Tintoretto and El Greco. But the point of the illustration here is that only by an effort can vision be held in the picture proper. Titian is guilty of "breaking" several of his compositions similarly.

Linear perspective appears seldom in El Greco's work. Note, however, in the *Feast in the House of Simon,* how the architectural lines weave into the larger design; and how the artist has pulled in the pillar, spire and dome to close the arched space at back: stopping up what in another's painting would have been a "hole."

It may be of interest to the reader to note how seldom perspective backgrounds appear in the illustrations by contemporary painters, in this book—as compared with any representative series of 17th-19th Century pictures. No work was excluded *for* its perspective: it

< 172 >

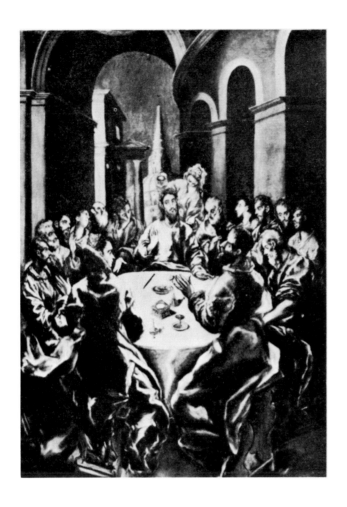

The Feast in the House of Simon, by El Greco. (Photo by courtesy of the Art Institute of Chicago, from original in the collection of Mr. and Mrs. Joseph Winterbotham.)

is simply a fact that a strict regard for plastic unity demands the elimination of many of the deep vistas and sharp linear descents that graced shallow Realistic paintings, as added tidbits of reproductive fidelity.

< 173 >

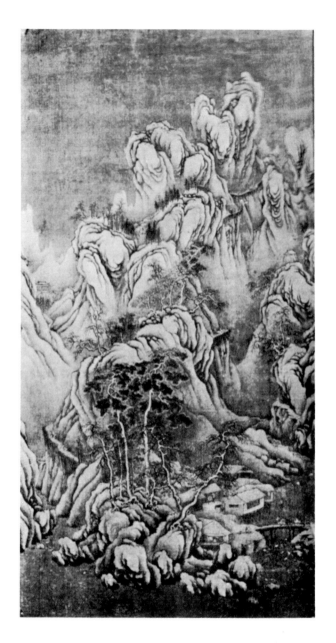

Chinese landscape painting on silk, illustrating utilization of overlapping planes for movement effect. (By courtesy of the Freer Gallery of Art.)

Leaving the natural or objective means, let us see how the *formal* means for creating movement are commonly manipulated. In general it may be said that there are two large groups of formal elements, the one more directly plastic in that they can lead the eye in and out of the canvas by indicating shapes and slopes, the other with the properties of backwardness or forwardness but not "fluidity." The first category includes plane and volume. The other includes color and texture.

When plastic values are under discussion, it is too commonly assumed that color and texture are only secondary and corrective: as if design in painting could be complete without those elements: they being in the nature of added decorative values. Cezanne was the first Western painter to fuse the processes of drawing and coloring. Before his time almost all painting existed as colored drawing: the composition was built up by delineation, chiaroscuro, etc., and then color was superimposed objectively—grass green, sky blue, apple red, etc. The Expressionists in general have now learned the creative properties of colors, and commonly use them for recessive values; but very few have attained to the mastery of Cezanne in fusing this element with the other means to movement.

There are difficulties for the reader here: we can study these matters only by pulling one element free from the others—without which, perhaps, it cannot truly exist—and yet the end of our quest lies in the synthesis, the indissoluble unity of all elements. Thus color cannot exist independently: can be evident only in color-areas —which are essentially color-planes. In the same way line cannot be said to exist as a separate element: it occurs where planes meet.

< 175 >

Of the first group of elements, Hofmann writes thus: "The formal elements of painting are the line, plane, volume, and the resulting formal complexes. These are the elements of construction, and result, when properly utilized, in form." *

Hofmann has written elsewhere that the artist conceives his image in terms of volumes, but that he creates formally in planes. As a matter of fact, volumes are visually existent only as composites of planes shown out by light. The Cubists discovered this truth, and the related one that every solid in nature can be summarized by— "reduced" to—a cube; and they played with planes, wholly abstract, or disassembled from objective nature, or near-natural, until the world wearied of their endless packs of shingles, and patch-work mandolin-players and block landscapes.

But out of their researches came the first easily intelligible clue to the mastery of plastic movement—as exhibited long before by

* The quotations from Hofmann are from two exceptionally meaty articles entitled "Painting and Culture" and "On the Aims of Art," published in *The Fortnightly* (San Francisco) in the issues for September 11, 1931, and February 26, 1932. The one is set forth "as communicated to Glenn Wessels"; the other in a translation by Ernst Stolz and Glenn Wessels. I have quoted, scrupulously, only from these articles, though some of Hofmann's ideas are summarized from his unpublished work *Creation in Form and Color*, of which I read one volume in manuscript. It is to be hoped that this will soon be made generally available to students. The diagrams in following pages, "after Hofmann," are based on his originals in the manuscript, with his permission. The quotations from Gleizes are my own translations from his *Du Cubisme et des Moyens de Le Comprendre*, Paris, 1920. Quotations from Wessels are from a multigraphed syllabus entitled *Principles of Pictorial Composition*, generously put at my disposal. Quotations from Adolf Hildebrand are from *The Problem of Form in Painting and Sculpture*, translation and revision by Max Meyer and Robert Morris Ogden, New York, 1932. This essay, first published in Germany in 1893, was a remarkable reaching forward toward the present theories of plastic organization. Hildebrand wrote particularly of "the relief conception of painting," of the picture "spatially alive," and of "planes and depth." It was left to later artist-teachers to clarify the theory, and to co-ordinate knowledge of the several plastic elements; but Hildebrand's book is still one of the most suggestive and useful works on the subject of Picture-Building. The quotations from Kandinsky are from his essay *On the Spiritual Element in Art*, published in an English translation as *The Art of Spiritual Harmony*, London, 1914.

< 176 >

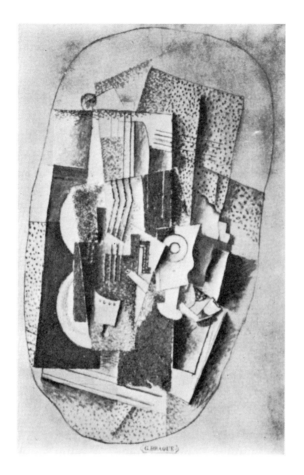

Music, by Georges Braque.　(By courtesy of Katherine S. Dreier.)

their prophet, Cezanne.　And the Cubists themselves rose at times to intense plastic expressiveness, with their best plane arrangements.

In learning to "read" planes in a canvas, the student should make sure that he is not merely following tracks from edge to edge, but rather feeling the tensions from axis to axis.　Every plane has axes, meeting at a center of weight; and "planetary movement" may be said to be engendered by the tensions between axial' points.

< 177 >

The following diagrams, after Hofmann, illustrate the commonest (and type) method of building in a path of vision by plane manipulation. Simple planes (considered, for the moment, as parallel to the picture surface) are set one behind another, with overlapping edges. The eye, due to the way in which the observer automatically looks *into* the picture, inevitably steps back from plane to underlying plane, sensing the weight-tensions from axial point to axial point.

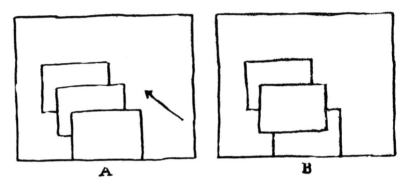

A B

Figure A illustrates the basic principle of movement engendered by planes. There can be no doubt that visual movement is induced by this formal means; nor doubt that the direction is changed by any rearrangement of the overlapping, as in Figure B. A different and less elementary set of figures, below, illustrates how movement

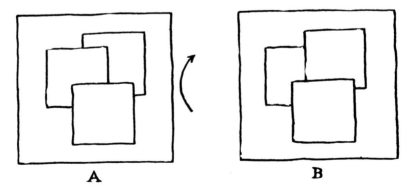

A B

< 178 >

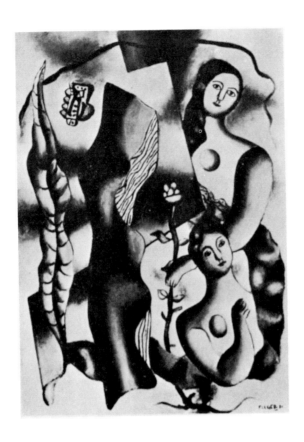

Composition with Figures, by Fernand Leger. (By courtesy of A. E. Gallatin and the Gallery of Living Art.)

can be reversed by lifting one edge from back to front. The arrow beside figure A indicates the path natural to the eye. In figure B the direction, though still inward, is reversed as regards right-left.

Such are the phenomena of planes manipulated to create movement. Seldom will they appear as bald as here; but the basic principle illustrated underlies the practice of one whole wing of the Cubist school. There are few Expressionists who do not utilize

< 179 >

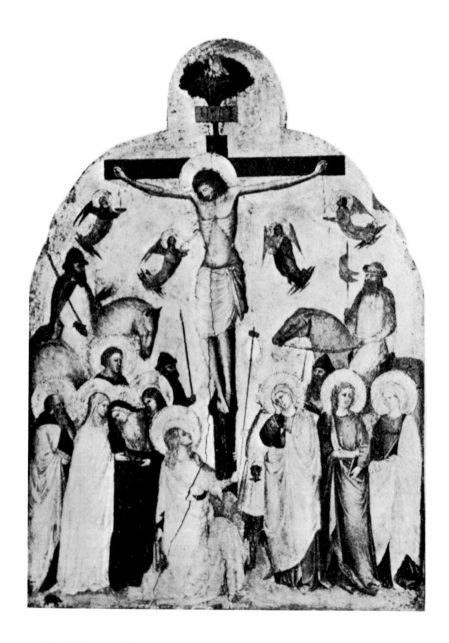

Crucifixion, in the manner of Bernardo Daddi. (By courtesy of the
Gallery of Fine Arts, Yale University.)

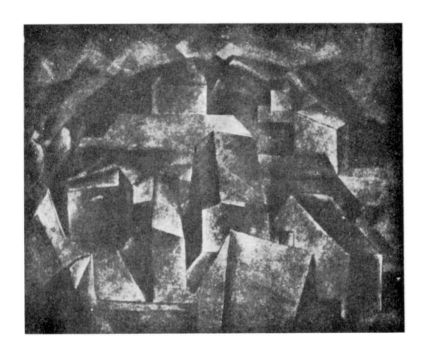

Houses in Horta, by Pablo Picasso. (From *Picasso*, by Maurice Raynal.)

the device, more or less abstractly, in correlation with the other dynamic elements.

The effectiveness of overlapping planes in engendering movement was felt, if not intellectually understood, by Giotto and by many of the "Primitives" of his time and earlier. Duccio, Masolino, Daddi and Taddeo-Bartoli spread on their gold grounds rhythmic compositions, with definite backward-forward movement (though within shallow depth limits) ; and no element contributed more to accentuation of the vision-path than the stepped-back halos and the parallelism of figures of horses and men. As examples I am reproducing here a *Crucifixion* in the manner of Daddi, and (page 208) Giotto's *Crucifixion*.

< 181 >

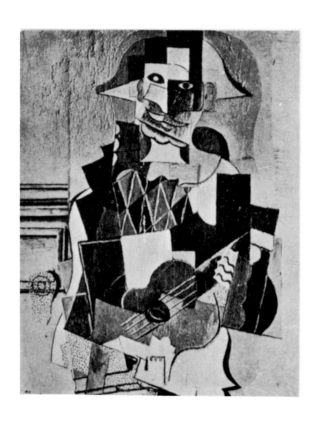

Pierrot, by Pablo Picasso.

The Picasso *Houses in Horta* shows how, even when the device of overlapping planes is used very obviously, to carry the eye in and out, there is continual variation: edges accented, complexes formed to indicate volume, planes turned from the parallel, etc. This is an example, of course, from that period when the Cubists had first reduced to a formula the new knowledge of plastic values and of the mechanics of planes; and the device is self-consciously used.

The effects of parallelism are better studied in the works of those doctrinaire Cubists who, for a time, insisted that the integrity of the picture "flat" could be preserved only by ranging every element in

< 182 >

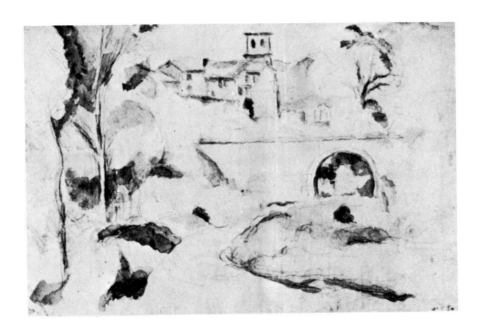

The Bridge: Water-color by Paul Cezanne. (By courtesy of the Museum of Modern Art: Bliss Collection.)

the painting parallel to the canvas surface. They banished movement that carried the eye deep into the picture, even though that plastic movement could—as Cezanne, Picasso and others had proved —be anchored by tensions to an established pictorial plane. Gleizes, Marcoussis, Ozenfant, Braque, Gris and Metzinger all passed through periods of flat patch-work composition, of the sort illustrated here in a painting by Picasso.

One of the sub-groups of Cubists proclaimed that the recessive values of *colors* also offered disturbance of the flat effect, and proceeded to compose exclusively in natural browns and grays. When they had discounted plasticity and denied color, it seemed to some outsiders that they had effectively denatured the painting art. And

< 183 >

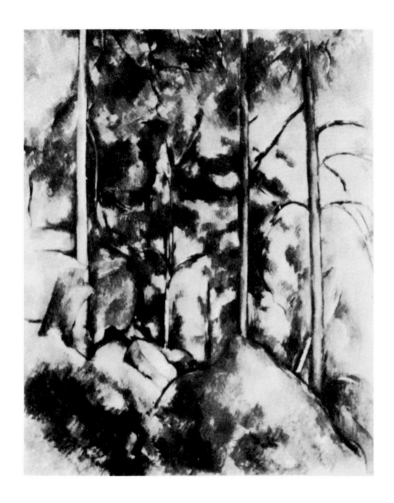

Pines and Rocks, by Paul Cezanne. (By courtesy of the Museum of
Modern Art: Bliss Collection.)

mind you, these Cubists had started from hints found in the works
of Cezanne, the pioneer master of plastic counterpoint and creative
color.

Cezanne had utilized plane-arrangements more cunningly, I be-
lieve, than any painter in the earlier history of the art. Some of

< 184 >

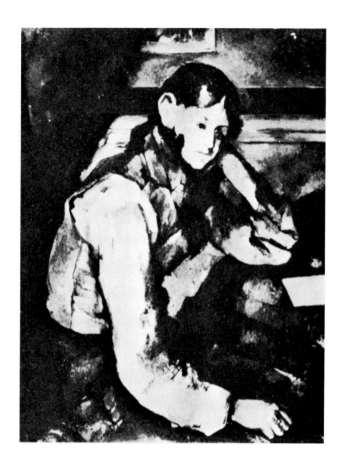

Boy with a Red Vest, by Paul Cezanne. (From *Cezanne*, by
Julius Meier-Graefe.)

his more abstract water colors seem to the unpracticed eye little more
than pleasingly matched squares of color. In the more objective
Boy with a Red Vest, shown here, the artificial "playing with planes"
is evident; and in *Pines and Rocks*, opposite, the method is obvi-
ously the same, but with the typical mature Cezannish variations and
enrichments.

< 185 >

We must leave to Hofmann, Wessels, and other artist-teachers the task of elucidating ways of changing direction and indicating tension; explaining how the principle of overlapping planes is varied for outward rather than inward movement, at a distance from the painting's base, where the eye more naturally "moves in"; and the special effects to be induced with rotating planes, bent planes, interpenetrating planes, etc. My own brief treatment is introduced, first as one more proof of the reality of this newly explained element of plastic movement in painting (about which the reader may still be harboring skepticism); and then to suggest how much more significant this formal means may be than is the easy depiction of actual objects in motion in nature. In that part of the study of Expressionism dealing with the medium, with the technique of picture-building, a comprehension of the movement-values of planes is fundamental. I omit also treatment of that technical device known as "the light plane": the carrying of a consciously manipulated plane, at a certain depth, and with a uniform "value," through separated portions of the canvas, as a binding element.

As a last word on the difference between designed plastic movement and depicted natural movement, I suggest a comparison between works of a true Expressionist, Orozco, and one of the later objective Realists, Benton. The latter is praised for the fullness of his canvases and the extraordinary sense of motion conveyed to the spectator. But to those who expect pictorial as well as representational values, and a sense of aesthetic stability and completeness, Benton's murals often are restless, formless and confusing. We may appreciate his work intellectually, for many unusual qualities: intense liveliness, courageous satire, and—God save the mark!—a sense of bustling mid-Western Americanism. But the virtues are illustrational; the picture as an organization often falls to pieces—

< 186 >

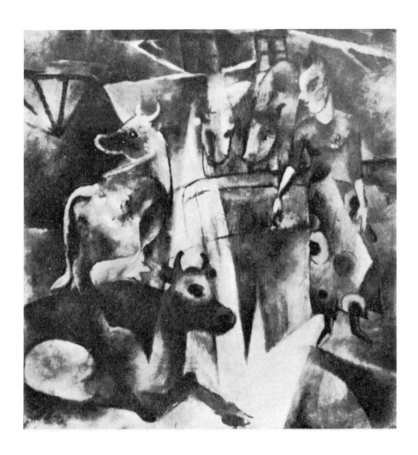

Cow Barn, by Heinrich Campendonk. Illustrating interpenetrating planes. (By courtesy of *Der Sturm* Gallery, Berlin.)

figures seem in imminent danger of tumbling out of the wall to the floor at one's feet, parades march through the border-frame, the eye jumps from prize-fight to locomotive to cabaret.

Orozco, on the other hand, handles material of equal human and social significance with competent and sometimes inspired mastery of plastic design. He confines natural movement within a rhyth-mically closed field, makes it contributory to spatial design; and he

< 187 >

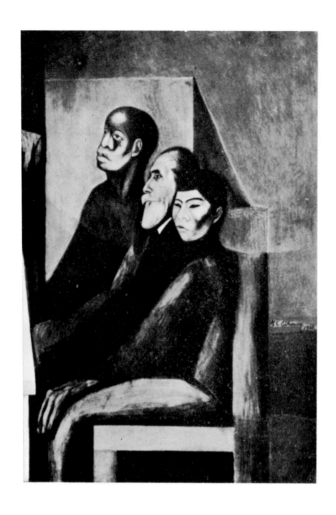

Detail of Mural by José Clemente Orozco. Illustrating utilization of planes for plastic effect. (From original at the New School for Social Research, New York.)

utilizes adroitly that particular formal element just analysed—overlapping planes.

It cannot be recorded too often that mastery lies in the synthesis of elements, in effects gained by manipulating the *several* formal "means" in harmony, in contrast, in fusion. A too obvious and exclusive reliance upon plane-arrangement makes for thin results— and a good deal of Cubism seems, today, pinched and meagre. Having given so much of space to the matter of planes, let me say, then, that the most expressive painters hide their parallel arrangements beyond a continual play of harmonizing and corrective elements. Plane movement is balanced not only by color and texture, but by arbitrary introduction of other abstract elements. There is wilful overriding of planes.

An artist will seem to lay down a complex of planes, starting a thrust, only to cut across it arbitrarily, with a strongly linear element an arc, a mast, or whatnot. The design, outside the main movement track, as fixed perhaps by planes, may be strewn with corrective accents, pointing angles, and minor "points of interest." These may be in the nature of objective features, or they may be merely smears of color, or an area emphasized with lines equivalent to heavy texture.

Pascin's paintings, for instance, seem often to present a clearly defined face or figure or volume, against a background of improvisation in fluid colors. The artist seems to strew mere "smears" through the space portions of his pictures. But where these have not a definite place in an arrangement of planes for recessive and return effects, they act as individual correctives. The careless

< 189 >

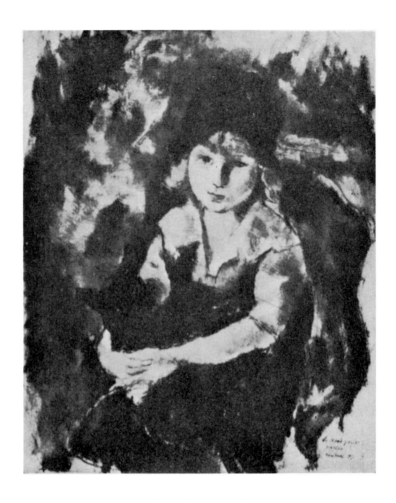

Child with Cat, by Jules Pascin. (By courtesy of the
Downtown Gallery, New York.)

"look" is deceptive. Note in the *Child with Cat* how the arc that
swings down along the left edge completes the main composition
(even in the black-and-white reproduction). In the original this is
accomplished by a long wedge of red-madder, running into a com-
plex of greens darkened with reds and purples. The entire "back-

< 190 >

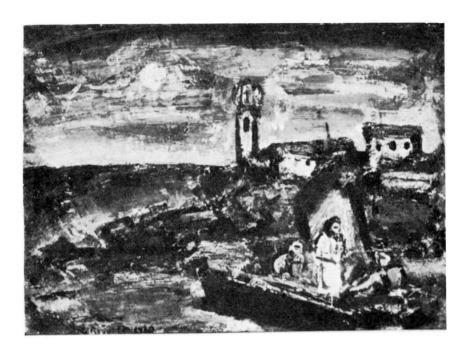

Christ and the Fishermen, by Georges Rouault. (By courtesy of
Pierre Matisse Gallery.)

ground" vibrates with rich color contrasts—but all within a scheme.
(What I see as a "smear," in a picture by Rouault or Pascin, may
be a carefully graded agglomeration of color pellets in Seurat's
work—placed arbitrarily, without objective reason.)

When I write of these smears and accents as correctives, I do not
mean to suggest that the artist sits down and considers intellectually
what effect is needed to balance or close the design. The process
is nearer intuitive. Nevertheless, the "feel" for the right plastic
relationship is there, is orderly.

In the matter of impromptu accents, Marin is a master. You may
read in so good a book as Pearson's *Experiencing Pictures* that
Marin understands only one of the plastic means, color—the inti-

< 191 >

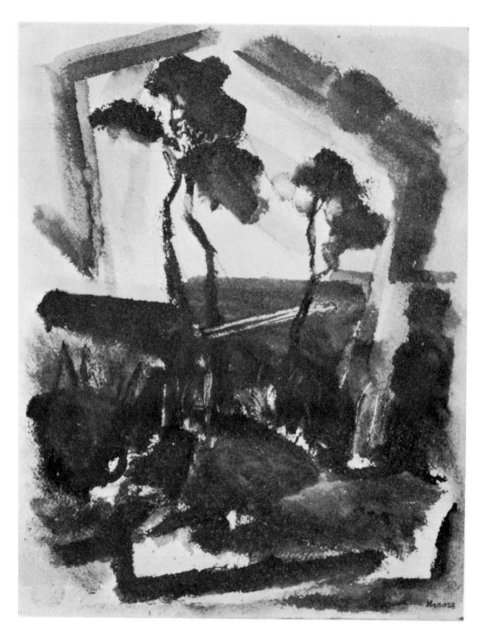

Maine, 1928: Water-color by John Marin. (By courtesy of
An American Place.)

mation being that he is weak in design. I should say, on the contrary, that he has few peers as a creator of organic plastic designs. These are seldom tied up neatly in static linear compositions. But where he seems careless with one element, another is intuitively brought into play. All things recognized, the design is closed, the rhythm poised in relation to the pictorial field. Other artists whose apparent carelessness has puzzled the Realists—but producing work richly repaying study for the variety of counterplay—are Rouault, Schmidt-Rottluff and Kokoschka. Many observers who are confused today by the apparent carelessness of "handling" in Rouault's paintings will progress, as their understanding grows, to enjoyment of the gorgeous orchestration of elements in a work such as *Christ and the Fishermen.*

Note how the plastic design is carried sometimes by the objective factors, sometimes by arbitrary "unreal" bits: the position of the figures and the direction of the boat initiating the movement, a faintly discerned arc of color carrying the vision across the horizon at the left, the sun placed to pick up the attention, then mere color planes "carrying on"; and so to the objective elements again. Rouault packs more of pictorial movement into a canvas like this than was ever created by the Futurist painters, "inspired to reproduce in their art the dynamic movement of modern life."

Seurat was a painter who went to the opposite extreme of meticulous neatness of handling. He used every brush-stroke in its exactly appointed place. Sometimes his design is almost static—rigidly architectural—rather than richly plastic. There is little of the fluid counterpoint that distinguishes Rouault or Kandinsky or Cezanne. But, without being profound, his achievement of thrust and return is sure, his carefully controlled recessive values integral to the pictorial structure.

< 193 >

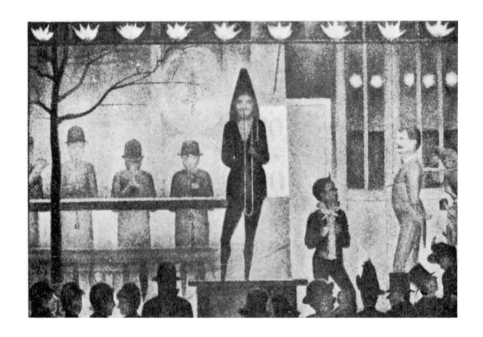

The Parade, by Georges Seurat. (By courtesy of the Knoedler Galleries, from the original in the collection of Stephen C. Clark.)

Seurat, indeed, was one of the pioneer masters of picture-building, in the Expressionist sense—if a little removed from the group that carried along the main current after Cezanne. That he understood the plastic values inherent in stepped-back planes could hardly be doubted, after examination of the two reproductions here, and the *Sunday on Grande Jatte* on page 152. But like the flat-wing Cubists, he stuck by parallelism of planes, limited the depth of recessive elements, and achieved a gently melodic counterpoint.

A sort of flawless architectonics can be found in these canvases; and no summary of the advance in knowledge of picture-building could be written without attention to Seurat's work. But it misses

< 194 >

Port en Bessin, by Georges Seurat. (By courtesy of the Museum of Modern Art: Bliss Collection.)

something alike of the full-blooded emotion characterizing the best Expressionist art, and of the plastic richness of typical Expressionist handling of formal materials.

It is easy to speak of the "architecture" of Seurat's paintings where one speaks of the plastic organization of Cezanne's or Marin's or Rouault's. Pictorial architectonics may be based, so to speak, on a more or a less fluid conception or scheme; and the fact that Seurat sacrifices something of plastic depth for a shallower structure does not remove him from the ranks of freshly expressive

< 195 >

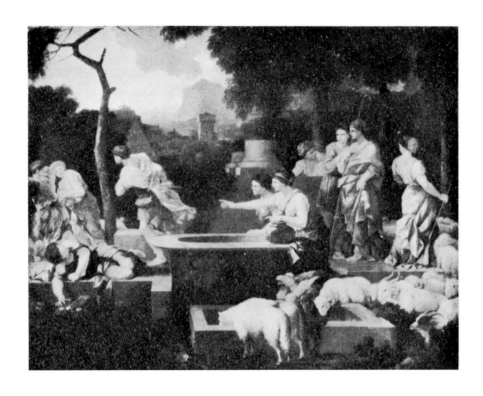

Moses Defending the Daughters of Jethro, by Nicholas Poussin. (By courtesy of the Minneapolis Institute of Arts.)

painters. In all three of the pictures mentioned one can trace easily a designed track of vision; indeed, most of the means and tests of movement already described are illustrated—coiled path, a picture field spatially deeper in one half and voluminous in the other, recession induced by overlapping planes, etc. And yet here is a variation in which the movement is held almost rigidly within a structure with static architectural lines. One can actually see the scantlings holding the architecture together, in *The Parade*, and *Sunday on Grande Jatte*.

< 196 >

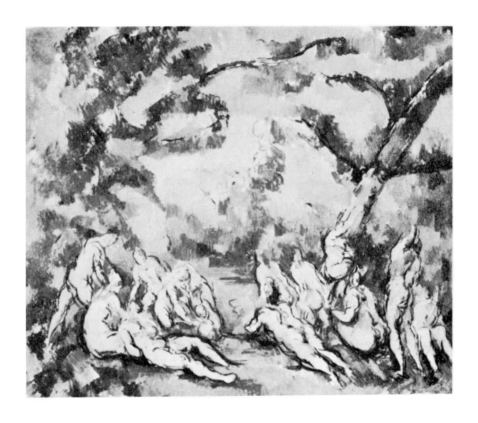

Bathers, by Paul Cezanne. (Photo by courtesy of the Art Institute of Chicago, from original in collection of Mrs. Rutherford McCormick.)

There is a forerunner of this particular sort of conscious picture-building in the 17th Century painter Poussin. He was perhaps a link between the Italian Renaissance artists who achieved an exceptional architectural organization, though more static than plastic—Raphael, Piero della Francesca, Giorgione, etc.—and those Moderns, beginning with Cezanne, who revived monumental structure and added the movement-dimension. It will be illuminating, perhaps, to compare the picture by Poussin, illustrated here, with

< 197 >

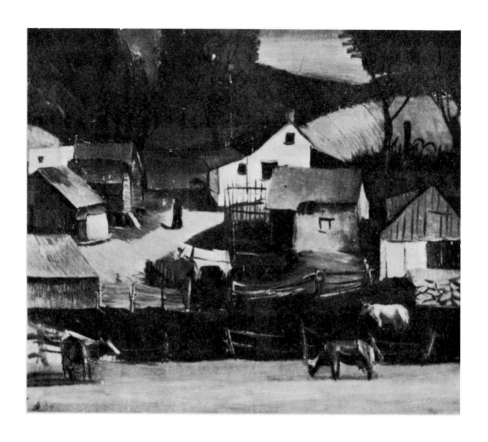

Minnesota Farm, by Dewey Albinson. Illustrating the heritage of plane
Cubism to later non-abstract but plastically ordered painting.

Cezanne's *Bathers* (over-leaf) and the three Seurats. It may be
added that Corot seems at one time to have experimented with this
sort of "architectural" structure.

What I started to illustrate in this chapter was the way in which
a single formal element may be used to carry the main direction
of movement in a picture, or to weave into other elements by
forwarding the thrust or return at certain points. I chose to show

< 198 >

graphically the effects achieved by overlapping planes. Then, recognizing the common vice of overstressing the first understood factor, I showed certain ways in which the experienced artist overrides the plane-arrangements: how he learns the formula for engendering movement by one element, only to be able to cast it aside when some other means will afford variety and deeper enrichment. Leaving to another chapter such other major factors as volume-tension, color and texture, I described some of the minor arbitrary means—accents, improvised linear movement, introduced perspective, etc.

Speaking of "improvised" forms, of what some would call "distortions," in relation to the abstract element in art, Kandinsky points to the numberless assets open to the creative painter: "These apparently irresponsible, but really well-reasoned alterations in form provide one of the storehouses of artistic possibilities. The adaptability of forms, their organic but inward variations, their motion in the picture, their inclination to material or abstract, their mutual relations, either individually or as parts of a whole; further, the concord or discord of the various elements of a picture, the handling of groups, the combinations of veiled and openly expressed appeals, the use of rhythmical or unrhythmical, of geometrical or non-geometrical forms, their contiguity or separation—all these are the material for counterpoint in painting."

< 199 >

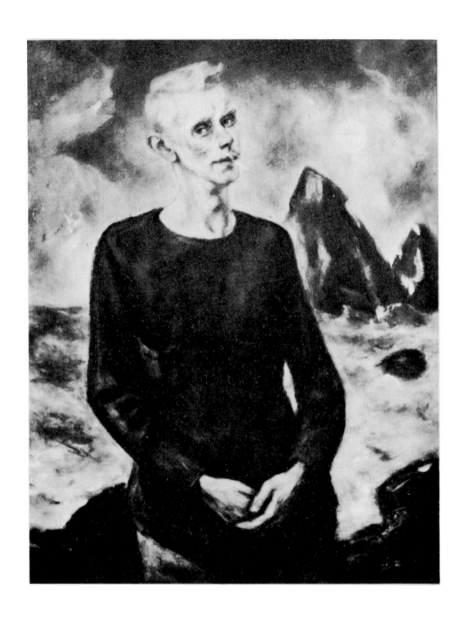

Self-portrait by the Sea, by Henry Mattson. (By courtesy of the Frank
K. M. Rehn Gallery, New York.)

CHAPTER VIII

PICTURE-BUILDING: VOLUME, SPACE AND TENSION

M AN moves forward by progression in two great fields of knowledge. He sheds fresh light on material phenomena, on all that registers in his brain through the senses; and at the same time his comprehension of the intangible grows and matures: his perception of the values that lie beyond sense-reporting and mental reasoning. Today he pushes forward epochally, in discovering laws of the mechanics of matter, and at the same moment millions of men feel a new impulse toward spiritual inquiry, and they sense an underlying principle or cause that will explain the accord or order underlying universe and creative life.

Art bridges the two divisions. A work of art appeals through the senses; but unless it achieve values beyond the material and the reasonable, it fails of the purpose ascribed to it by every prophet and seer through the ages.

Some people avoid both extremes: dislike the purely physical and mechanical at one end of one range, and the mystic at the far pole of the other. They ask explanation in a middle range. And so, having first written, in my exposition of a newly formulated theory of movement in pictorial art, about the most mechanical element or means—the plane—I will now approach the same subject from a viewpoint less isolated from objective life. The plane is an abstraction. The human eye and brain are more accustomed to deal with volumes.

< 201 >

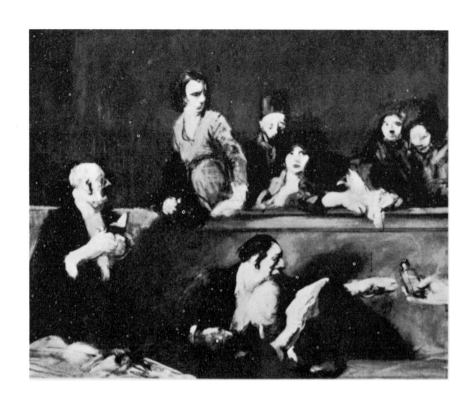

Court Scene, by Jean Louis Forain. (By courtesy of Adolph Lewisohn.)

The eye itself, to be sure, has but slight stereoscopic powers: man is enabled to see only a little the roundness of objects, close by, by reason of bi-focality—through being in possession of two eyes. But the brain reënforces the sense of roundness, out of past sensory experience of like-appearing objects in nature. Even a one-eyed man, whose vision is not at all stereoscopic, who technically sees nature laid up in bounded planes, experiences an instantaneous impression of a head or a house as a volume: the limited two-dimensional sight impression, on the flat, is projected automatically into a three-dimensional image, because the observer has previously

< 202 >

touched those objects, and viewed them from other sides, often enough to *know* them as volumes. The trained artist will purposely view them as planes, breaking up the impression, against the time when he will re-arrange those planes for summary expression, stripped of the insignificant. But while the rest of us see "almost flat," we mostly comprehend nature as volumes in space.

Volumes related in space may also be reduced to abstractions, to geometrical equivalents: cubes, etc. But volumes may as easily be angels and cows and apples, and the other representational materials of picture-making. And so we come to an approach that offers fewer obstacles to the abstraction-shy mind.

By this other approach we shall, I believe, arrive at the same conclusions regarding the all-importance of plastic design, the existence of detectable movement in the canvas, the necessity of anchoring the complex of movements in relation to the rectangular picture field, etc. The painter's formal problem remains the same whether he thinks in terms of plane-manipulation or volume-space organization: the aim is preservation of the sense of two-dimensionality of the picture field, while affording an experience of pictorial-plastic movement, attained, formally, through orchestration of the several dynamic elements available to the painter.

VOLUMES IN SPACE

It might be said that all design begins with forms moving in space. There is here some relationship to the shift in scientific thought which makes the planetary-solar system a basic model of all that physically exists. The planets spinning in their orbits around the sun, held in space by a complex of reciprocal tensions, afford an analogue to the objects held within the picture limits by

< 203 >

felt tensions. The old conception of the picture as static, with its individual objects compositionally balanced, gives place to a dynamic conception: poised taut movement, fixed by the relationship of volumes in pictorial space—with a complex movement-path traceable along the invisible lines of tension.

A writer upon spiritual philosophy once noted that "Everything we see, or imagine, or dream, we have to perceive in space." Objects, or volumes, are anchored in a world of space. But where those objects used to be regarded with a sense of individual finality, as if set out separately and terminally, there is now a tendency to put first, as basic truth, the relationship between all objects. Relativity is a fundamental not alone of modern physics, of all that materially or organically exists in the universe, but also of that little stabilized world which each picture is.

The scientist or artist attempting to identify or explain the binding element, talks in terms of forces, energy, tensions, stresses and polarity. Glenn Wessels opens his syllabus on *Principles of Pictorial Composition* with this statement: "The world outside ourselves is a complex of forces interacting and continually shifting their relationships. We are equipped with senses which bring to our minds different aspects of this cosmos in flux. . . . Consciously or unconsciously, we arbitrarily divide the cosmos of qualities outside us into units, focal points, pieces of experience of convenient dimensions for comparison and differentiation. The world for us has primarily: mass, shape, measure, texture, color, movement, smell, taste, sound. No form can be clearly defined without recording by means of symbols of its perceptible characteristics." He goes on to differentiate between the "primary" characteristics, which are quantitative, have measure, shape, extension in space; and the secondary—texture, color, etc. Later he notes that the voluminous

< 204 >

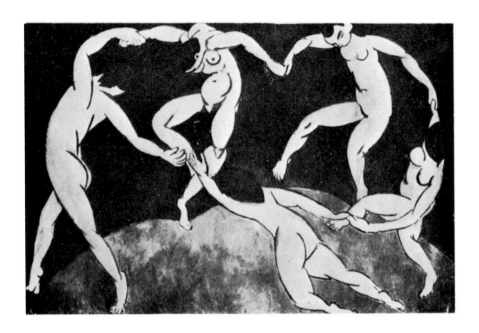

Dancers, by Henri Matisse. Illustrating linear rhythms and volume tensions. (Photo by E. Druet.)

primary materials are held "in certain relations due to their relative tensions on each other."

In short, man's sense-equipment being what it is, there is no more basic approach to the formal problem in art than by consideration of surrounding space, quantitative object or volume, and the relating, interacting forces. Sight and memory, acting together, bring first recognition by contrasting volume and space, with an understood web of forces between volumes.

In shifting from consideration of planes to study of volume-space organization, we might seem to be abandoning certain artists whose works entered importantly, as illustrations, in the preceding

< 205 >

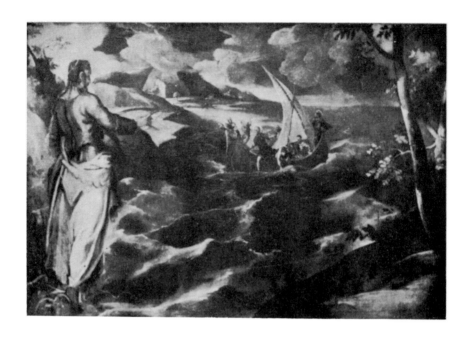

Christ on the Lake of Galilee, by Tintoretto. An early example of
manipulation of planes for plastic enrichment, and an interesting analogue
to Cezanne's painting. (By courtesy of Arthur Sachs, Paris.)

chapters, and turning to others—perhaps more "solid" and "volum-
inous." This is true, I think, only in regard to those Cubists
whose paintings rather self-consciously proclaimed reliance upon
parallel planes. Most of the deeply creative artists earlier con-
sidered—Rouault, Kandinsky, Seurat, etc.—can be tested as easily
for volume-organization. And as for the historic forerunners of
the contemporary plastic-conscious painters, Giotto, El Greco and
Daumier, all exhibit the solidest sense of related volumes. In
characteristic works of each one, the employment of planes as an
instrument to step the vision backward or forward can be marked,

< 206 >

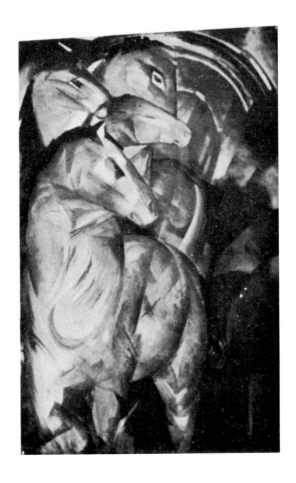

Blue Horse Composition, by Franz Marc. (In the
National Gallery, Berlin.)

with the usual accenting of edges to speed the movement; but no
less there is the detectable and effective "structure" of volumes in
tension, the felt web of polarity and attraction.

Nothing could offer a better tangible beginning point for under-
standing of the finer adjustments of volumes in space than this

< 207 >

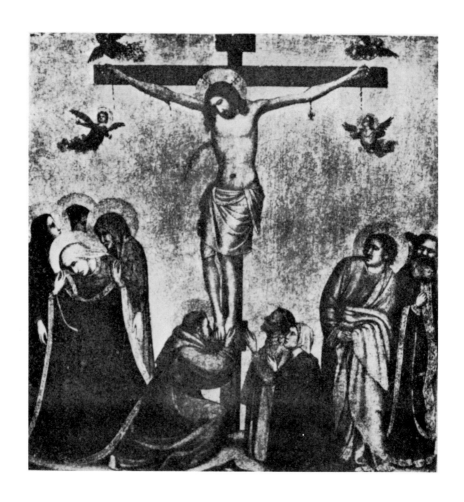

Christ on the Cross, by Giotto. (In the Pinakothek, Munich.)

Christ on the Cross by Giotto. Nor is the Rouault *Christ Mocked* less an exemplar of the two means in combination: activated planes, and volumes interacting. For similar orchestration of the two elements see also the El Greco *Crucifixion* at page 220, and Franz Marc's *Blue Horses.* Note, too, the way in which Cezanne, using

< 208 >

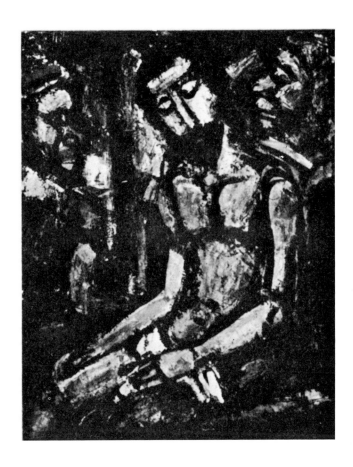

Christ Mocked, by Georges Rouault. (By courtesy of
Pierre Matisse Gallery.)

separated planes more effectively than any other painter, still
affords the feeling of voluminous roundness, in a landscape as
shown on page 141, and in a figure composition, page 251. Just
here I add also one of Georgia O'Keeffe's near-abstractions based
on flower forms, in which there is rich intermixture of plane and

< 209 >

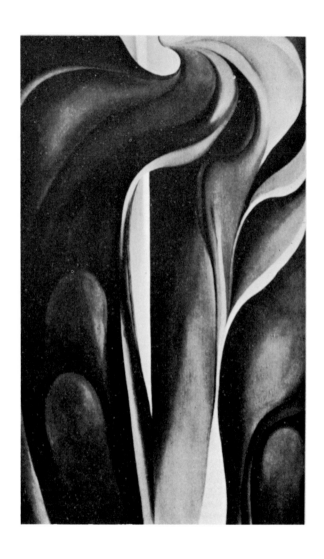

Jack-in-the-Pulpit, by Georgia O'Keeffe. (By courtesy of
An American Place.)

voluminous rhythms. The painting is in the truest sense an orchestration of the plastic elements.

All volume study, like all plane study, must be undertaken with full realization that the beginning point of picture-building is the bounded two-dimensional field. What violates the flat, destroys the unity of the picture. In relating volumes in space, the artist builds a *system*; and this collapses if any solid escapes out of the tension holding it to other solids, out of the adjusted poise. But it escapes also if the system is not fully enclosed in the picture field, if the focal point is not fixed in relation to the established picture plane. Volumes may be presented as deep in space or as close to the observer, but the successful final adjustment is such that the weight as a whole rests firmly within the field. Just as a movement engendered by overlapping planes may carry the eye too deep beyond the focal plane, so the pull of a volume along a tension path may draw the vision so deep into space that the return to equipoise is impossible. All depends on the complex of tensions holding so that the path of vision is fixed, the plastic weights distributed, and the observer's eye never drawn into so deep penetration that the serene sense of equilibrium is upset.

In short, the aim of volume-space organization is to afford the pictorial experience *upon the two-dimensional field*. The tension organization is at rest only in relation to an enclosing frame.

It is necessary again to qualify my generalizations about *one* movement element or instrument, by reminding the reader that what I describe as typical of volume or plane alone is really true only when that element is adjusted or related to all others, primary

< 211 >

or secondary, that contribute to the movement. Thus the painter can and often does place a volume too deep in space, or too close to the observer plane, for the poise to be right while the structure is still stripped of color and texture. He can bring the too-deep volume forward by the advancing properties of certain colors or by insistent pattern, or he can set back the volume (to a certain extent) by the use of withdrawing colors and lack of texture interest. I have preferred to postpone consideration of these "corrective" agencies, in the array of movement materials; in order to attempt first an explanation of the main *structural* means.

No one else has written quite so clearly as Hofmann, I think, regarding the matter of basic volume-composition. He points out that volume and space as materials may be conveniently considered as filled space and empty space: as positive space and negative space. In *The Aims of Art* he writes:

"Form must be balanced by means of space. We differentiate the animated form and the space pervaded by energy. Form exists because of space, and space exists because of form.* A work of art which expresses only the objective form always has an over-emphasized naturalistic effect. The spatial counterbalance being omitted, the painting misses the inner rhythm."

Relating the element of volume-space organization to color rhythm, and the whole movement in the picture field, Hofmann writes, in the same article, thus: "From the depth-sensation, movement develops. There are movements into space and movements forward, out of space, both in form and in color. The product

* Hofmann here uses—or perhaps his translators make him use—the word "form" interchangeably with "volume"; though in the only other published essay, the text explicitly relates space and *volume*. For data about sources of these quotations, see footnote on page 176.

< 212 >

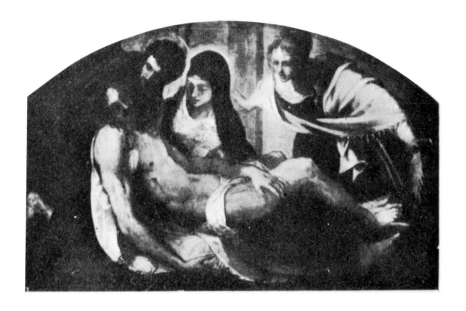

Lamentation over Jesus, by Tintoretto. (In the Brera Gallery, Milan.)

of movement and counter-movement is tension. When tension—working strength—is expressed, it endows the work of art with the living effect of co-ordinated, though opposing forces. Tension and movement, or movement and counter-movement, lawfully ordered within unity, paralleling the artist's life-experience and his artistic and human discipline, endow the work with the power to stir the observer rhythmically to a response to living, spiritual totality. The picture swings, oscillates, vibrates with form-rhythms integrated to the purpose of spatial (and volumnar) unity and it resonates with color rhythms balanced, focussed and so ordered as to produce the richest intensity of light contrast. It is not the contrast of two or three, but the contrasted balance of many contributing factors, which produces the paradox of life within unity."

< 213 >

Wessels notes that "objects must be given their due of space surrounding them. It is a common failure to pass over the space between objects as unimportant. When we are cognizant only of objects and draw them unrelated to their surrounding space, the composition is crowded." It might well be added that, obversely, volumes can be lost in space. Objects are less often crowded, in too little space, perhaps, than separated in too much. There is such a thing as an economy of space: a perfect adjustment of the negative element to the positive. The early Expressionists had a slogan that summed up the idea: "Banish the dead spots in the canvas." Realistic paintings are brimming over with dead space. (A notable parallel exists in one of the principles of the Imagists, who determined, in their poetry, "to use absolutely no word that does not contribute to the presentation." Ezra Pound comments that free verse "has become as prolix and as verbose as any of the flaccid varieties that preceded it. . . . The actual language and phrasing is often as bad as that of our elders, without even the excuse that the words are shoveled in to fill a metric pattern or to complete the noise of a rhyme-sound." Meaningless space is less shoveled into the casual-Realistic picture than left negligently there. It no less makes the picture tedious and thin.)

AXES AND STRESSES

The living axial relationships of volumes across space cannot be reduced to law. For one reason, there are those other elements to enter in and modify or correct: color, texture, etc. The task of creation is bound up in almost intuitive counterpoise of the several movement-means. But this much can be recorded confidently: the Moderns as a group recognize main movement and counterplay of

< 214 >

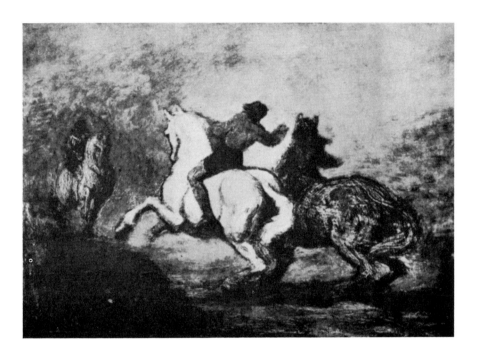

Three Horses and Two Riders, by Honoré Daumier. Illustrating masterly
volume-space organization.

movement as resulting chiefly from tensions between related vol-
umes; and what is sometimes termed the focal point of the picture
is where the coiled power of the tension system centers.

The new philosophies start with two essentially Modern concep-
tions: that life is not static, perfectable and statable, but an evolu-
tionary growth, change, a progress; and that relatedness rather than
isolated individuality is basic. The new physics begins not with
solids, the tangible, but with movement, spurts of energy; and it
recognizes a basic relatedness of all phenomena, material or or-
ganic: the fields of investigation, electrical, gravitational, etc., tend
to merge into one. Modern painting, on the formal or instrumental

< 215 >

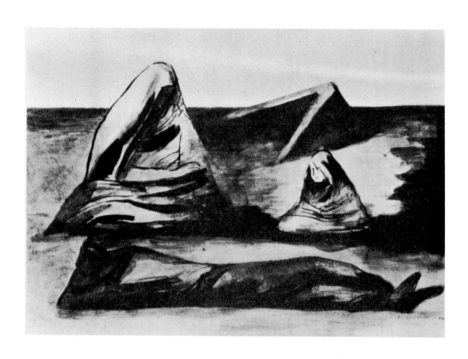

Ruined House, by José Clemente Orozco. (By courtesy of the Delphic Studios, from original in the Albertina, Vienna.)

side, likewise arrives nearer to understanding of basic principle by study of dynamic relativity. The unity of the creative picture grows out of a poised inter-relation of potentially energetic volumes, each with weight and direction exerting stresses on all the others— they in turn exerting a combined pull on it. The paths of tension are from axis to axis (the axial center being determined by the crossing of the two rotational axes of the volume).

To restate our fundamental thesis in still another form: the vitality of the picture depends upon the completeness of the movement-function within the limits allowed by the axial pulls. The

< 216 >

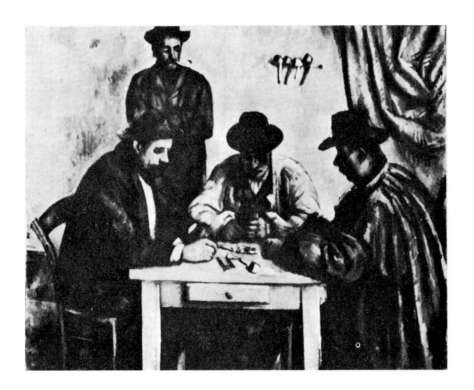

The Card Players, by Paul Cezanne. (Photo by courtesy of the Knoedler Galleries from the original in the Stephen C. Clark Collection.)

sense of completeness is achieved when the movement has been strongly initiated, curbed, brought to poise: the stresses equilibrated.

The galleries of recent favorites are full of paintings illustrating how little the Realists guessed the existence of volume-tension and axial relationship. The fashionable portrait painters—Sargent, Lavery, de Laszlo—concocted pictures as superficially organized as those of Besnard, Bonnat, Henner and Bouguereau. Even Manet, who helped to rescue painting from "mere" Realism, exhibits practically no understanding of volume-attraction. I have chosen a Metropolitan Museum masterpiece by Courbet to illustrate 19th

< 217 >

The Young Bather, by Gustave Courbet. Illustrating the Realist's entire neglect of plastic correlation and volume poise. (By courtesy of the Metropolitan Museum of Art.)

Century neglect of fundamental plastic-formal principles: to exemplify mishandling of weight and space. There is nothing in the canvas to hold the so-forward woman to the picture field. She is suspended, a naturalistic physical-culture exhibit, and beyond her is painted a pretty, naturalistic landscape, pictorially unrelated to

< 218 >

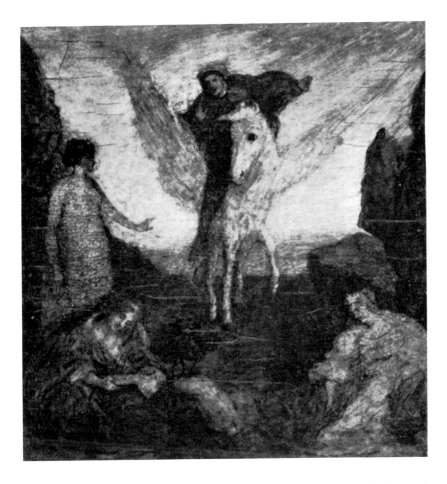

Pegasus, by Albert Ryder. (By courtesy of the Worcester Art Museum.)

the figure. The Moderns might analyze this typical painting with
regard to many other principles, and find it equally unsatisfying:
its only "movement" is illustrational, its color is pictorially de-
structive, etc.

On the opposite page I have reproduced Ryder's *Pegasus*, as an
example of volume-placing by an artist with a strong sense of func-

< 219 >

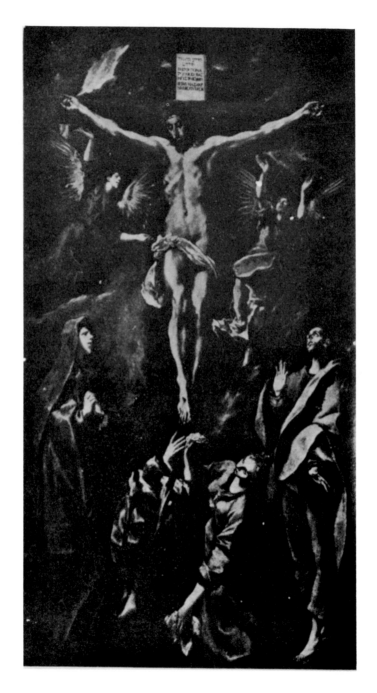

Crucifixion, by El Greco.

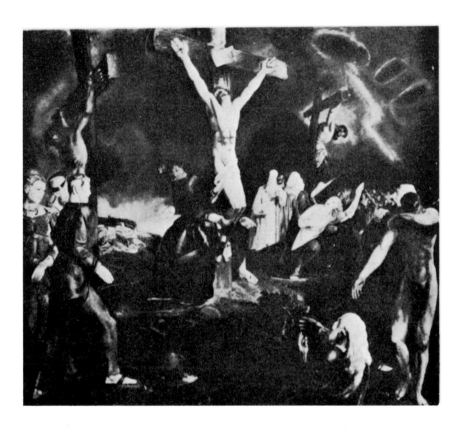

Crucifixion, by George Bellows. (Photo by courtesy of the Art Institute of Chicago, from the original owned by Emma S. Bellows.)

tional design. More powerful tensionally, is the *Crucifixion* of El Greco, with its intricate but consciously related arrangement of many figures. Against the "structure" of axially related volumes in space, there is a gorgeous counterplay of fluctuating planes and flame-like undulations: a sort of enrichment too often overlooked, perhaps, by the Moderns who doctrinairely practise the new theories. No other artist, I believe, ever energized the space in his canvas as does El Greco: he vitalizes the spatial intervals through which pass

< 221 >

Landscape with Red Spots, by Vasily Kandinsky. (By courtesy of
Der Sturm Gallery, Berlin.)

the tension lines from volume to volume. The rhythm is dynamic
and vibrant throughout.

In the dwarfing company of El Greco, indeed, the paintings of
most of the present-day Purists and belated Cubists seem meagre
and over-precious. Only a few of the avowed Abstractionists have
been able to present a full pictorial portion: adding to their care-
fully adjusted balances of weights sufficient counterpoint to enrich
the field satisfyingly. Kandinsky (who seldom is *absolutely* ab-
stract) escapes the fault. The main movement is commonly an-
swered by multitudinous minor patterns of recession and return:

< 222 >

heavy weights poised against complexes of minor weights, the tension paths between main volumes crossed and varied by minor stresses. The "Landscape" shown here is a variation of the pictorial arrangement illustrated on page 155: with greater weight, deeper recession, added solidity.

In these two pictures by Kandinsky there is a perfect illustration of two different pictorial means used to the same end; and a reminder that we are considering planes and volumes, in two consecutive chapters, not as mutually exclusive formal materials, but as related devices, really inseparable—but, studied separately, affording convenient *approaches* to the plastic-form problem. The movement is strong in both canvases, and the vision path is identical. The too obvious regularity of the movement is daringly checked by the same thrust-in shaft. But in the example shown here the movement is engendered mainly by volume-space manipulation, by a rich complex of axial relationships. In the flatter version at page 155 the vision track is traced primarily by means of overlapping planes and color areas. But neither is the plane wholly absent as an instrument in the one, nor the volume in the other.

VOLUME-SPACE AND "MERE" PROPORTION

There can be no doubt that critics and teachers who have talked about *proportion* in painting have had in mind some of the weight effects inherent in adjusted volume-organization. But the understanding has generally been intuitional, and published statements have invariably evaded the issue of recessive values. In short, all formulas for proportional "space division" have dealt with relationships on the flat, as if the movement never pushed beyond the surface plane. "Dynamic symmetry" seems to the Moderns mis-

< 223 >

named, so far as application to painting goes: because it provides a test for design up-and-down and right-left, but totally ignores the plastic forward-backward thrust and return—the dimension in movement that affords the sense of power and dynamic vitality. There is a less deep sort of harmonic vitality, appertaining to pattern and pleasing decorative design, which can be charted by the space-division systems.

Painters with an exceptional sense of static balance and flat geometric relationship—Raphael particularly—seem to have proceeded with a strong intuitional or theoretical knowledge of the laws of harmonic proportioning (as since codified by Hambidge); but those laws are incidental to whatever mathematical truths may underlie the powerful dynamic effectiveness of the paintings of El Greco and Cezanne. That such truths will ultimately be mechanically explained, I have no doubt: that is, they will be codified to "explain" the satisfying mathematical relationships of weight, tension and volume which underlie plastic unity or formal dynamics; but they will go only so far as the so-called "dynamic symmetry" theory has gone to explain surface design—that is, they will offer a test of framework only, leaving out of the case the variations and complexities by which the artist enriches and individualizes the picture.

Hambidge developed his system in such ways that one or another of his formulas will fit almost any average pleasing pictorial composition: conversely, any painter trained to the usual surface-compositional principles will arrive at a result conforming to the coded laws. Raphael or Sargent, Hokusai or Harrison Fisher—their diagonals and root-rectangles will prove to be mathematically right. And yet it is possible that El Greco and Cezanne will often fail, on the surface, to pass the test: because what is a violation of the rela-

< 224 >

Painter in the Landscape, by de Hirsch Margules. (By courtesy of the
Feigl Gallery, New York.)

tionships of surface harmony will be corrected by effects resultant
from manipulation in a deeper dimension, by the plastic element.

It may come to be recorded, ultimately, about Cezanne, that he
totally revolutionized painting in the Western world by turning the
current of theory and practice away from Realistic recording of
nature, and also away from static surface composition. He under-
mined the centuries-old faith in the importance of reproductive art,
with its superstitious regard for anatomical truth, light effect, and

< 225 >

mechanical perspective; he abandoned that faith to express the deeper realities of universe and self. Equally he exposed the shallowness of surface design: initiated the modern search for dynamic movement and symphonic fullness: for the powerful pictorial rhythms that had been all but lost out of painting for centuries— though still enduring in the works of unnamed Orientals, in Giotto, in El Greco, in Tintoretto, and even, rather uncertainly and flamboyantly, in Rubens. It was in the passionate effort to understand and capture the profound plastic values, that Cezanne "distorted" the anatomy of man and landscapes, telescoped natural perspective —and so far departed from orthodox practice that he was execrated by every guardian of respectable painting. Today, nevertheless, he emerges as one of the historic revolutionary and creative figures.*

* There would be little point in calling attention to the total lack of understanding of Cezanne's contribution, on the part of the dwindling group of reactionary Realists, except that certain critics with Victorian standards still hold command of the commoner channels of education: schools, libraries, "art news" columns, museum lecture-series, etc. So recently as 1925 Royal Cortissoz wrote, in *Personalities in Art*, that Cezanne was "commonplace, mediocre, a third-rate painter." Thomas Craven is even more dangerous, because he makes a pretense of understanding Modernism, and grudgingly accords a certain significance to Cezanne's "meagre and unfulfilled art." Craven actually exhibits no comprehension of the values restored or discovered by Cezanne, and he remarks in 1934 (*Modern Art*), that "his influence on the leading American painters of today is imperceptible"! His summary and dismissal of later critics is illuminating: "I am aware of the hundred and one theories put forth to explain the finality and indefectibility of Cezanne's art: the crooning praise of his plastic form, his functional color and his logical consistency—as if these abstract properties were the end of art; the strange descriptions of his little world as a microcosm in which every patch and particle, every distortion, plane, and indefinite contour, was preordained by the omniscient creative wisdom of God Almighty; the comparisons of his worst things —those 'figure compositions' of deformed, slanting females differentiated from the other sex by the ungainly prominence of buttocks—with Raphael's *The School of Athens*. I can only account for such aberrations by mentioning once more the muddled condition of modern art: originality in painting is so rare an article that the presence of a little of it in a slow-witted French provincial is enough to cast a spell over artists and critics and to deprive them of all sense of values." It might have served toward clarification if Craven had paused, just once, to attain to comprehension of plastic design.

< 226 >

Again we must leave to artists and schoolmasters exposition of the more recondite principles and facts involved, as they relate to the placing of volumes in pictorial space. Contrast of volumes, while still preserving equipoise; how a scale of volumes is established, the relativeness put within limits; the mathematical methods of figuring or feeling axes: these are problems proper to technical books—outside the field of a book aimed to establish only the point that there *is* a revolutionary theory of picture-building, sketching enough of the formal means to emphasize the reality and aesthetic vitality of the effects attained.

THE CUBED VOLUME

The Cubists doubtless made more *theoretical* progress than any other group of Modernists; and while we are dealing with volume, it is as well to note that they were given the Cubist name because one step in their advance was marked by the discovery, or re-discovery, that all solids in nature can be reduced to a few geometrical equivalents, of which the cube is basic. They over-did the cubing at first— as is natural when artists have become dissatisfied with mere fact-reproduction, and have glimpsed a means of moving nearer to revelation of universal truth.

Critics and artists who fail to understand the importance of the reach after plastic unity, who wish therefore to destroy the whole edifice of Expressionist attainment, have been quick to herald the shallowness of an art that *merely* cubes objects out of nature; and they have elatedly unearthed diagrams by Leonardo da Vinci, Dürer and other early painters, to prove that "the masters" knew all about this geometrical business, but rejected it as worthy of no more than passing interest.

< 227 >

Hills, by Bernard Karfiol. (By courtesy of the Downtown Gallery, New York.)

Such critics miss the entire significance of the Cubist contribution to the advance of painting: a new theory of formal creation, of plastic structure; and an advance in understanding of the instrumental means, embracing not only geometrical equivalents of solids, but methods of breaking solids into planes (or building by complexes of planes to afford a sense of related volume-weights)—the whole resulting in a conception of plastic movement or organic rhythmic organization as the fundamental compositional factor. The student must know why the Cubists played with cubes—and cones and spheres—at one stage of their explorations; but to pretend that Modernism stands or falls by proof of the newness of the statement of cubic equivalents is childish.

< 228 >

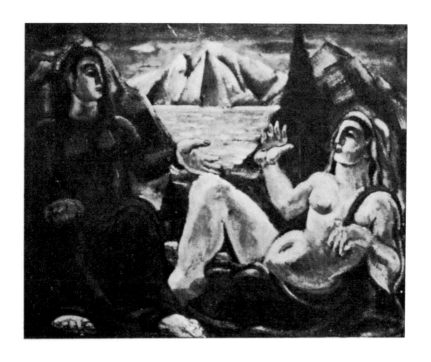

Gesture, by Max Weber. (Photo by courtesy of J. B. Neumann, from collection of Dr. F. H. Hirschland.)

The rest that need be said here about volume-space organization can best be presented in relation to illustrations. In these two pages and overleaf I have juxtaposed some examples suggesting how compactly the volume structure may be compressed into the picture field, and how widely "distributed" it may be in other examples. The Max Weber *Gesture* contrasts strangely with the *Hills*, by Bernard Karfiol; but each painter has proceeded with a sense of volume-placing which will be apparent to the trained eye. The simple balance of weights in Beckmann's *Artist at Beach* is a sort of elementary statement of a principle that finds complex expression and rich variation in Rouault's *The Crowd*. In the latter

< 229 >

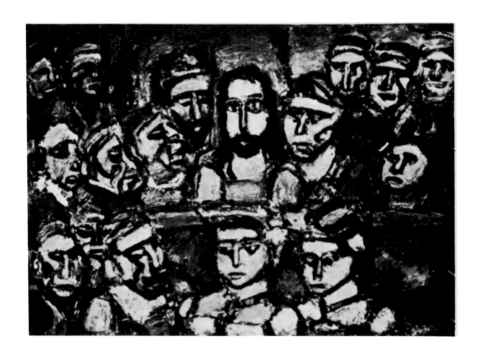

The Crowd, by Georges Rouault. (By courtesy of Pierre Matisse Gallery.)

the separation and distribution of certain volumes, their weight emphasized by comparative isolation, and the combining of others into inseparable weight-complexes—these are details of volume-space adjustment worthy of serious study.

In the Karfiol *Hilda* and Marguerite Zorach's *Hound* there is evidence of a different approach to the problem of volume in relation to picture field. A single volume dominates the canvas; but is, in a sense, cradled back into pictorial space by means less voluminous than plane and linear. In the one, the figure would fall from the field if the draperies below or the sofa-back above were removed. In the other, the dog is plastically "set" in relation to the frame by the "filling" before and behind. In both cases it might be claimed

< 230 >

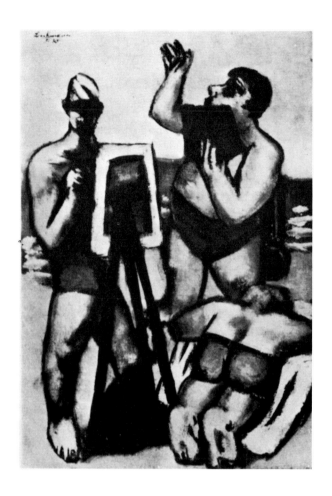

Artist at Beach, by Max Beckmann.　(By courtesy of J. B. Neumann.)

that the plastic effects are not very deep—though the painters are obviously working creatively, pictorially—not merely realistically. The counterpoint is, perhaps, too generally linear.

Immediately one has "discovered" volume tension as a separately distinguishable means to plastic understanding, the temptation is to

< 231 >

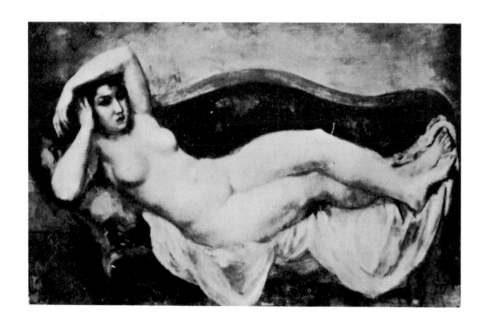

Hilda, by Bernard Karfiol. (By courtesy of the **Downtown Gallery,** New York.)

look for actual solids with traceable stresses between. But few artists deal with volumes so baldly as, occasionally, do Weber and Rouault and Karfiol—as did El Greco and Blake and Daumier. Balance may be achieved by other than tangibly weighty objects. Sometimes the old device of balanced chiaroscuro becomes more important than any detectable equipoise of volumes. Some Moderns have been ready to dismiss Rembrandt as summarily as they do superficial painters like Murillo and Gainsborough. But the best of Rembrandt's paintings seem to this student extraordinary examples of calculated plastic organization; seldom with the depth and richness of an El Greco, but with cunning placing of volume in space, made more effective by light-dark contrast. What is the

< 232 >

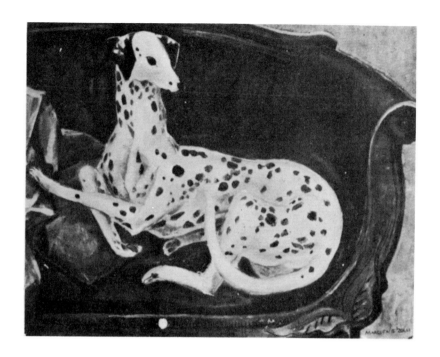

Hound, by Marguerite Zorach.

exact relationship between light-heavy and light-dark as plastic instruments, no one, I believe, has yet pretended to demonstrate.*

It would be easy to read axial relationships into Rembrandt's *Old Woman Cutting Her Nails:* with tension lines traced between the

* Investigators of this particular relationship will do well to go back to a book published nearly a half-century ago: *Practical Essays on Art,* by John Burnet, New York, 1888. From the Moderns' point of view, Burnet would seem to approach the problem backward: how to place volumes for a pleasing composition of light and dark. But the text and illustrations both are richly suggestive. There is a thought, too, in Kenyon Cox's contention, in *The Classic Point of View,* that "Modelling does, indeed, insist upon the body—true chiaroscuro conceals it." Again he writes: "Just because light and shade is so mysterious and absorbing, because it tends to take the place of design and drawing and even color, it is a dangerous tool." If Cox had guessed that all the formal elements might be approached as factors in a deeper synthesis—a fullness of plastic design—he might have seen the "dangerous tool" as an enriching asset. But he was right in believing that misuse often resulted in "a rather paltry picturesqueness."

< 233 >

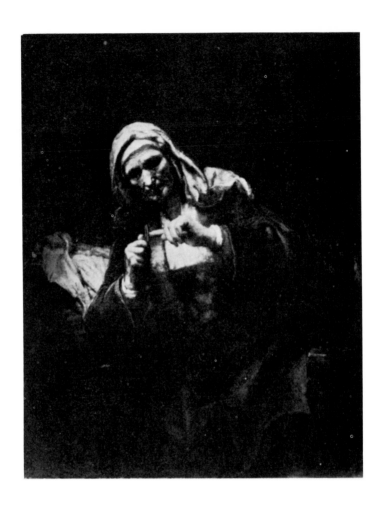

Old Woman Cutting Her Nails, by Rembrandt. (By courtesy of the
Metropolitan Museum of Art.)

figure, the chair arm, and the background mass of drapery. But
the more natural approach is by a study of the lights characterizing
these "objects." The painting is voluminous, with plenty of plastic
fluctuation; but as in most of Rembrandt's major works, whether
painted or etched, there is exceptional capitalization upon the move-

< 234 >

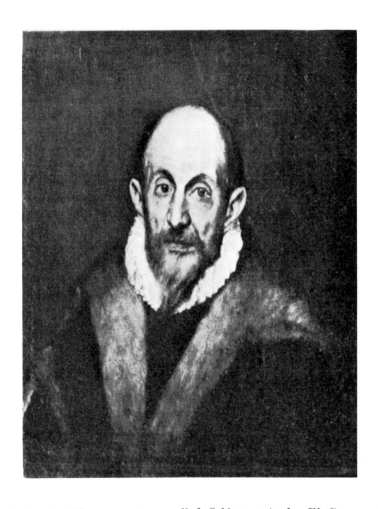

Portrait of a Man—sometimes called Self-portrait, by El Greco. (By courtesy of the Metropolitan Museum of Art.)

ment values of light-dark contrast. Considered as volume-space organization, the positive volume structure seems perfectly fitted into the enveloping negative space. The spatial portions are of the organism, living. If you doubt this, cover a quarter-inch strip of what you may consider dead space at the top of the reproduction;

< 235 >

and note how the composition loses as a formal pictorial organization. Plastically speaking, half a Sargent or half a Gainsborough may be as good as the whole. Not so the organisms built by Rembrandt, El Greco, Cezanne. It would be instructive to test *The Anatomy Lesson* or *The Descent from the Cross* for volume dynamics and the livingness of space.

TENSION BETWEEN VOLUME AND FRAME

The most puzzling question, when one has begun to sense the volume-space structure in plastically rich paintings, arises in connection with canvases wherein a single object appears. One of the earliest principles sensed is that a volume well forward can be anchored, so to speak, by a network of tension lines to other volumes deeper in space. But what of a single volume? The answer is that the entire structure within the picture field is built in relation to the frame: the volumes have tension-relationship not only to each other but to the enclosing borders. It is obvious that there cannot be the rich voluminous counterplay in a portrait bust which one detects, for instance, in the El Greco *Crucifixion* or the Cezanne *Mount Sainte Victoire*. But certainly El Greco's *Portrait of a Man* has, within its limitations, essential plastic weight and spatial depth. The satisfying sense of fullness with perfect poise is accomplished by a cunning adjustment of volume to field. Perhaps the axial center of the single solid is made to coincide with the understood focal plane (of which more in a later chapter).

It would almost go without saying that when the volume structure is limited to one main motive in relation to adjusted frame, the plastic elements other than volume-space are likely to assume increased importance. Additional functions of balance and correc-

< 236 >

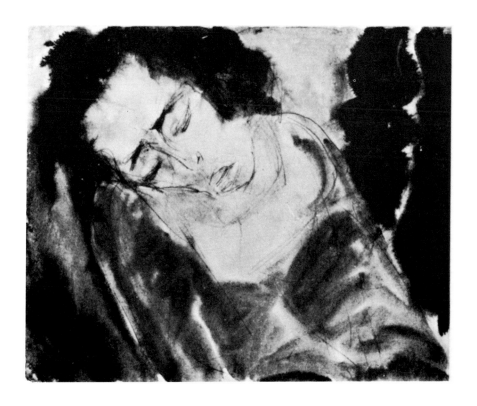

Woman Sleeping: Water-color by Max Kaus.

tion are exercised by color and texture. The *Woman Sleeping* by
Max Kaus is an example in which the single volume would be in
danger of falling forward if not held in tension by the extraordi-
narily heavy texture interest or "streaks" introduced into the upper
right corner of the picture field. This texturing has the effect of a
weight with tensional pull upon the woman's head and figure.

This same painting illustrates the way in which strength is at-
tained by filling the frame almost completely with the single volume.
Obversely, a single volume placed deep in space may appear weak,

< 237 >

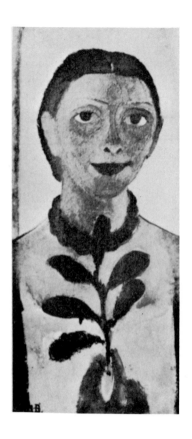

Self-portrait, by Paula Modersohn-Becker. (By courtesy of
J. B. Neumann.)

lost, though perhaps with a gain in restfulness. There is, of course,
a place for strength, and a place for restfully remote isolation.

The strengthening of pictorial impression by cutting down the
space in the field, to "gain volume," is a device not uncommon to
Oriental art; and the Expressionists have been quick to sense cer-
tain possibilities in relation to the pace and timbre of modern life.
Picasso went through a period of sculpturesque largeness of volume

< 238 >

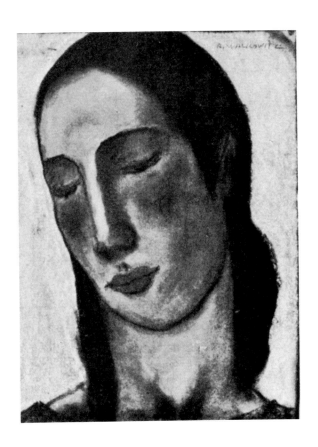

Oriental Head, by Abraham Walkowitz. (By courtesy of the
Downtown Gallery, New York.)

design. The earlier German "radicals"—Pechstein, Paula Moder-
sohn, Schmidt-Rottluff—by this means filled their galleries with
such a show of unaccustomed power and drive that the public edu-
cated on Boecklin, Menzel, Liebermann and Thoma all but fled in
terror. And a great many artists have occasionally utilized the
device with excellent judgment: as Walkowitz has in this pastel
Oriental Head. It is instinct with structural understanding. Modig-

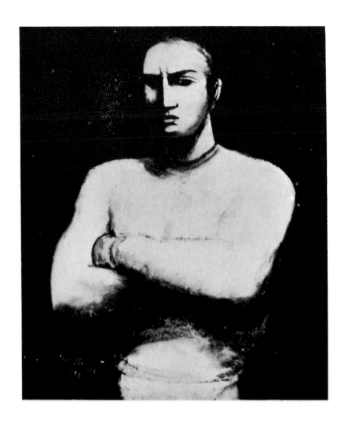

Acrobat in White, by Walt Kuhn.

liani was an Expressionist with an uncanny sense of volume-equilibrium in restricted space. Walt Kuhn often places a dominating single object solidly in framed space, as in his *Acrobat in White*.

In these examples the artists in bringing the volume forward, in relation to frame (and therefore to observer), have not permitted it to fall out of the picture. Hofmann devised what he calls the plumb-line test for volumes "sticking out." A projection too far forward is as destructive of the always understood two-dimensionality as is

< 240 >

a "hole" too deep. If, Hofmann says, a plumb-line dropped from any point on the frame to the corresponding opposite point apparently cuts through a projecting volume, then the plastic structure is defective. In other words, the tensions have not been adjusted to hold each unit in its appointed place in the equipoised structure. One sticks out.

I chose to criticize the murals of Thomas Benton, in the preceding chapter, partly because there is too often the effect of volumes spilling out. The essential fiat of pictorial integrity—that the field enclose the initiated movement—is violated. One no more wants figures to be pushing from pictures into the room, than one wants pictures to simulate windows upon nature, like holes in the wall. Pictorial volume and pictorial space must live, but in their own pictorial character, not as illusion: must preserve an identity of their own, separate from nature, within pictorial limits.

< 241 >

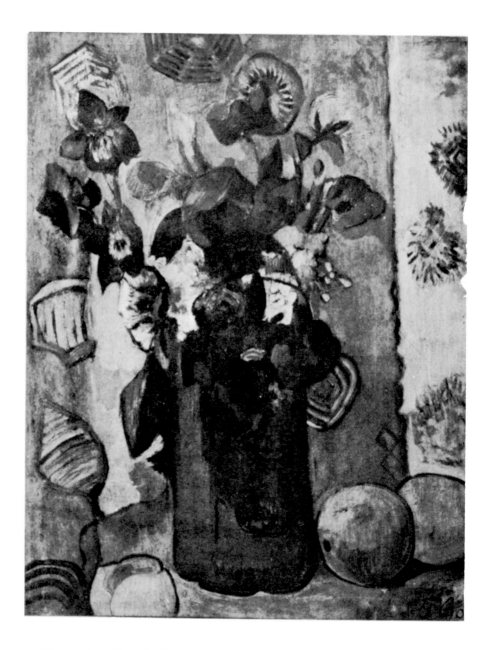

Flowers in a Vase, by Paul Gauguin. (Photo by courtesy of the California Palace of the Legion of Honor, from the original in the collection of Mr. and Mrs. W. W. Crocker.)

CHAPTER IX

A PICTURE field is established. The theory of plastic orchestration posits that the observer's eye will travel a constructed but hidden track winding from the framed front plane back to, and beyond, a focal plane fixed within that field. The "structure" is mainly determined by the weights and axial relationships of volumes in space; though the eye may be led on partly by complexes of planes artificially overlapped, bent, etc. All this is stated as though the design were an organism without that characteristic asset of painting, color. (And there is, indeed, a picture-art of black-and-white.) But, in painting, it is discovered that each color has in itself a movement value. The hue, at its established pitch or intensity, tends to push forward from the surface upon which it is applied, or to draw away. If the plastic structure is adjusted without allowing for the recessive or advancing colors, the rhythm is bound to be distorted or destroyed when color is added.

Until Cezanne fused the processes of drawing and coloring into one operation, practically all picture-making in the Western world had been a matter of arranging the other factors satisfactorily, and then adding color. The Modern affirms that the other formal elements cannot be fitted into the organism unless the living color finds its appointed place at each step of creation. Few have come to Cezanne's deliberate and unerring delivery of stroke and color

< 243 >

effect together; but the best have learned constantly to *see* the color with the structure.

Today one knows, for instance, that a red is insistent, comes forward, and that a certain shade of blue-green is retiring, recedes into distance. Suppose, then, that the painter has been cunning enough to build a certain amount of plastic rhythm into the skeleton of his picture—(and many an artist has outgrown loyalty to other surface aspects of nature, but remains a Realist in his loyalty to objective coloring—fails to guess that colors too have individual dynamic properties). He has somehow balanced his black-and-white picture so that the voluminous cow in the foreground is anchored within the field; nor does the bit of landscape vista at the back recede too far and carry the eye out of the canvas. Then he adds "natural" colors: the cow red, the field vista green. Immediately the combined effect of volume and red color pulls the cow forward, while the green pushes the vista hole deeper: the balance is upset, the plastic rhythm stretched awry—because the colors have not been taken into account as movement elements. The point is that, whether designedly or not, the color *will* have inward-outward motion effect. Added ignorantly to a composition which is already "right" without it, it destroys the rightness. Used constructively, in co-ordination with other motion means, it furthers and completes the plastic unity.

THE NEWNESS OF THE THEORY OF PLASTIC COLOR

If you will look into any of the older treatises upon the art of painting—up to 1900, say—you will find learned and true observations upon certain of the properties of color; but nowhere will you find mention of these recessive values. The subject usually

< 244 >

has been treated according to certain coded principles: harmony of colors; tonality, or the unification of the picture by relating all colors to the chosen "tone" of one; and values, or the harmonizing of the degree of black-and-white in the colors. Many books begin with still another problem: reasonable conformity to nature. How can we, the painters and critics asked themselves and each other, endow the picture with harmony, tonality and a proper scale of values, and still not noticeably violate nature?

In a day when study of the art begins with a flat declaration that the painter's business is creation of an organism distinct from nature, subject first to its own pictorial laws, there is less talk about the problems of truth to natural coloring. But books on design and composition continue to appear, and to discuss tonality, values, etc., without even suggesting that there is a dynamic property of colors, entering constructively and vitally into the modern plastic synthesis.

Repeatedly, in the chapters on picture-building, I have been at pains to remind the reader that no one of the instrumental means treated—whether plane or volume or color or texture—appears independently, in any richly creative or plastically complete painting. What are sometimes termed the *structural*-formal elements can be separated, perhaps—they can at least be isolated, for discussion, theoretically—these being the truest plastic-formal materials, for building in positive-negative space. A picture can be wholly conceived for expression without color. But it is questionable whether any important black-and-white picture escapes exhibiting some suggestion of color and texture. Even the most nakedly posteresque woodcut is likely to take on variety and fullness by the enrichening of grained cutting; the simplest etching gains by the cross-hatching of the shadows or the tonal wiping of the plate. And the painting in wash, from which true color has

< 245 >

been scrupulously excluded, will gain "colorfulness" from devices of shading, stroking, etc.

But exceptional cases and non-color arts aside, the revolutionary truth is that color and texture have been discovered recently as harboring properties of "movement" totally unrecognized in the preceding era. Important as may be the principles codified by the adherents of tonality and scaled values, this other matter of the dynamic properties of color is incomparably more important to the student of Expressionism. The discovery and conscious utilization of the dynamic effects of advancing and receding colors is one of the major phenomena of the Modernist advance.

MATISSE AND COLOR ORCHESTRATION

Probably the surest manipulator of color today, for plastic effect, is Matisse. Whatever else may be lacking in his art—and there are some who scoff at him as a "mere decorator"—he is a master of rich but perfectly balanced color-orchestration. The charge of "lightness" arises from his repeated use of the same emotionally inconsequential materials: flowers, a couch, an Oriental woman, a rug, a bowl of goldfish, etc. Aside from values of feeling and meaning, moreover, the plastic rhythm is ordinarily shallower than in El Greco, Cezanne and Rouault. Matisse is distinctly on the decorative side: historically allied with the Orientals; in the contemporary advance, with Gauguin and Rousseau. Whatever his "place" in Modernism, he offers the perfect example of color expertly used for plastic effect.

Matisse ordinarily relies upon texture values to complement his color-design—no other Western artist uses richly textured areas so abundantly—and it is difficult to analyse his employment of color

< 246 >

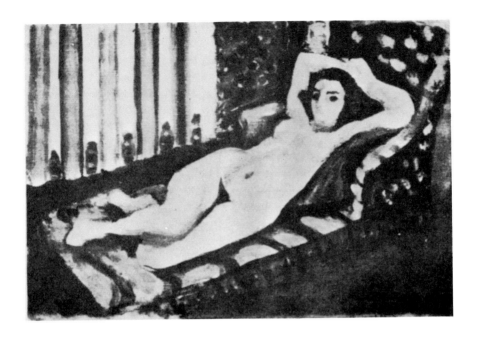

.Reclining Nude, by Henri Matisse. (By courtesy of
Pierre Matisse Gallery.)

without reference to this other factor. (Black and white repro-
ductions are make-shifts at best; but I have tried to present illus-
trations of paintings that suffer least distortion of values in the
transfer.) In the example on this page, it might be claimed that
the initiated movement from front-right to left-back is stopped and
turned by the extraordinarily heavy texture of the wall (in con-
junction with the slight natural perspective effect); and that it is
the large-spot texture of the sofa-head that draws the track of vision
around, down and in to the figure. But examination of the original
would show that the wall-texture is lightened by just the recessive
colors proper to modify the "insistence" of the stripes. Similarly

< 247 >

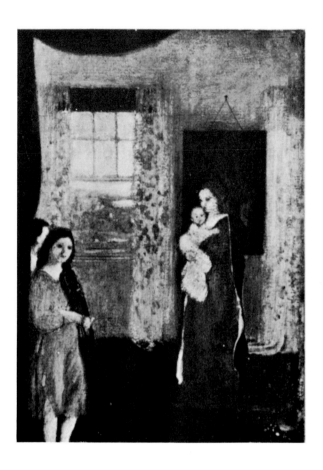

Interior, by Arthur B. Davies. (By courtesy of the Minneapolis Institute
of Arts, from the collection of the St. Paul Institute.)

the "weight" of the sofa is a resultant of the combined volume,
texture and color values.

More strictly an effect of color correction alone, the space around
the couch, which would be in danger of fading out to a deadness,
leaving holes in the plastic composition, if painted a receding color,
is filled with reds, that "bring up" the "space around." Obversely,

< 248 >

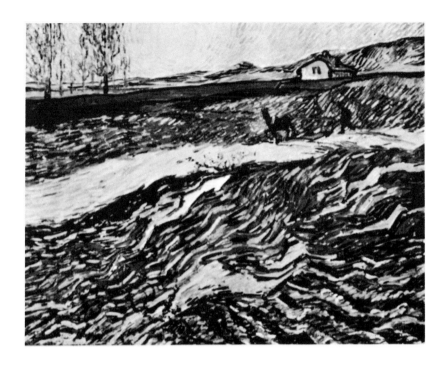

Ploughing, by Vincent van Gogh. (Photo by courtesy of the California Palace of the Legion of Honor, from original in the collection of Mr. and Mrs. W. W. Crocker.)

the body, the weightiest element in the canvas when regarded as volume alone, is "brought down" by recessive colors.

Again and again in Matisse's pictures the student will find this device of space filled with reds, and figure or other dominating solids set back with colors chosen from the receding half of the scale. At times the bodies almost assume a grayness—if a rosy one. Since Matisse conceives the plastic play as held strictly within limits, kept at all times within a range close to the focal plane, his pushing back of volumes and his pulling forward of space are more pronounced: his use of color and texture for cor-

< 249 >

rectives of too deep or too advanced volume-space elements more obvious than in any other leader among the Moderns. He seldom avoids the single dominating solid as do several of the most distinguished practitioners in the decorative group: Rousseau, Klee, Bonnard, etc. Therefore, having chosen strong volume-space contrasts, he must use color and texture strongly for correction. To put it another way, having chosen to be a decorative practitioner, avoiding the deeper plastic rhythms, and yet utilizing voluminous figures and objects that otherwise would imply deep recessions and strong axial pulls, he builds up heavy weights of the less usual plastic means, texture and color—counterpoising weighty volume with heavy color, or "pulling down" volume-emphasis by modifying color.

In Cezanne and El Greco the volume-space organization ordinarily reaches deeper into space, the fluctuations before and beyond the focal plane occupying a less limited range: and color-texture values carry less obviously the burden of plastic oscillation and balance. It is easy to find in Cezanne, nevertheless, examples of the more decorative, shallower-range organization. His work, indeed, afforded a main instigation to the researches of the Fauves, the group with which Matisse first came into prominence. There is, for instance, this *Portrait of Mme. Cezanne* to indicate Cezanne's understanding of the compensating values of texture. His color orchestration is as sure as Matisse's, but more delicate.

There are few things more pleasing to the eye, as sheer decoration, than the best of the Matisse canvases—in the entire range of art. Don't let me give you the impression that I consider them merely superficial arrangements of color and texture. Matisse knows the principles of plastic design as thoroughly as any living artist. If he practically denies the importance of subject-matter—

< 250 >

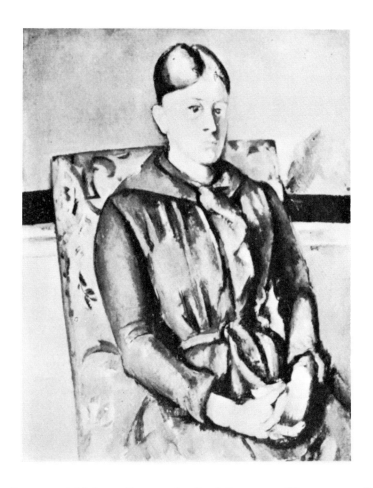

Portrait of Madame Cezanne, by Paul Cezanne. (By courtesy of
Adolph Lewisohn.)

carrying to extremes his reaction from the over-literary picturing
of the 19th Century—he has made himself the unchallenged master
in a medium that will continue to delight generations of men not
too sophisticated to enjoy melodic music and sensuously rich verse.
Nor is his reliance upon color and texture values quite so bald as
this brief analysis may have suggested.

< 251 >

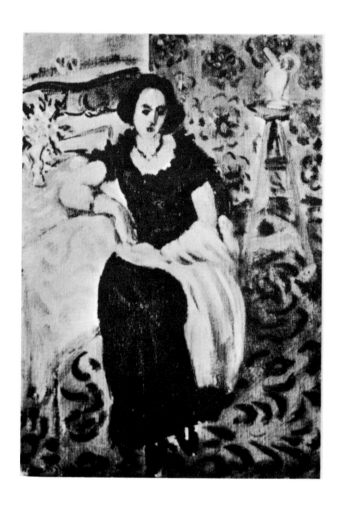

The Taffeta Dress, by Henri Matisse. (By courtesy of
Pierre Matisse Gallery.)

In the picture here, for instance, every one of the formal means
so far described is utilized: the stepping back by planes, the volume-
space adjustment, the axial pulls (figure, bouquet, vase and stand),
color, and texture. But the interplay of elements is all-important.
The bouquet near the upper left corner is at once volume, color

< 252 >

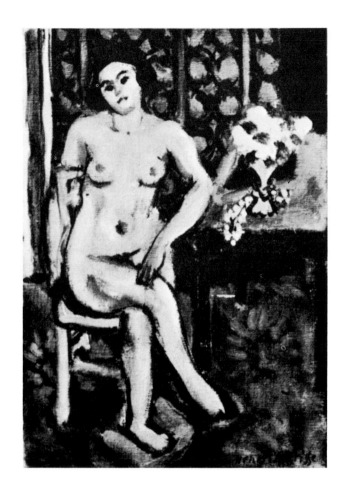

Nude with Flowers, by Henri Matisse. (By courtesy of
Pierre Matisse Gallery.)

and texture—cunningly fused, as you will realize if you ever
happen to see the original. Note how line is utilized, too, just
beyond: to prevent the eye from travelling out the window—
instead, directing it across to the next strong item in the plastic
chain.

< 253 >

The amusing and vigorous water-color by Roger de la Fresnaye, shown opposite, from the original in the Gallery of Living Art, New York, illustrates the play of color, against plastic movement engendered by a structure of overlapping planes and poised volumes. If one studies the three faces, in the original, one will find the nearest head grayed down—otherwise it might tend to push forward of the understood plumb-line—while the face farthest back is, in color, the most "advancing" of the three.

One of the puzzling facts, when the dynamic potentiality in color is understood, may be stated thus: color movement may be capitalized independently or dominantly, in certain parts of a picture; or it may serve, throughout, a merely *corrective* rôle. Perhaps the highest point in creative painting is touched when, as in certain works of Cezanne, the drawing or modelling is fused with the color application. The several movement instruments are then manipulated together in the grip of one plastic intention.*

THE THEORY STATED

The theory of recessive colors, in brief statement, is this: All color effect is the result of broken-up light. (Scientists no longer study the subject by means of colored materials, but primarily through phenomena of light-rays and light-waves.) All that exists visually is made known to man as illuminated forms in space. Whether material object or living organism, light makes it comprehensible to man's brain through sight, by means of radiant energy. The surfaces have no color in themselves: they have

* Some of the later Purists exactly equilibrate their planes or volumes, and leave to contrasting colors the whole task of dynamically vitalizing the organism. This is possible, I believe, only in a starkly abstract painting—of a sort to be mentioned in a later chapter. The commoner method is to let the space-volume structure carry the main burden of movement, color merely re-inforcing, answering, or correcting.

< 254 >

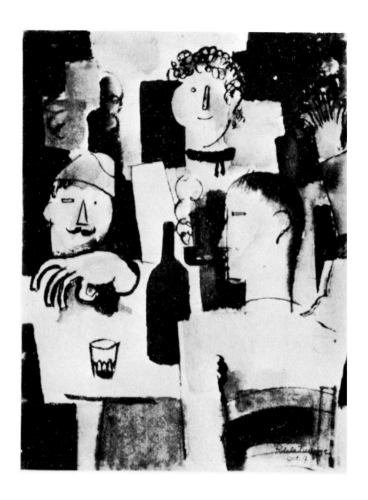

La Madelon, by Roger de la Fresnaye. (By courtesy of A. E. Gallatin
and the Gallery of Living Art.)

properties of reflecting or absorbing rays in such manner that the
resultant radiation induces a sensation in the beholder. According
to the degree of reflection—measured on a wave-length scale
called the spectrum—man judges the object as colored red, green,
violet, etc., though more properly the color resides in the reflected

< 255 >

light. Amount of reflection vs. absorption determines hue, or place in the spectrum. Other modifying factors enter when colors are "used": values, from the degree of lightness or darkness, and intensity, because in pigments the purity of light cannot be attained. But the modern revolutionary fact about color, in relation to the art of painting, arises from the discovery that it is not primarily a static property of objects, but a living activity, with dynamic potentialities.*

The conception of color as a portion of light returned to the eye in vibrations, opened a new world of possibilities to artists already exploring the field of plastic design, of "relief" effects. If color determination was to be a matter of certain vibrations being absorbed, and others reflected outward, there must be in color composition a factor potential in developing the plastic unity or synthesis. In short, as color varied, the eye would push deep into the picture or be brought out. Scientific investigation determined the values of recession and return. Roughly, the red-yellow range advances most insistently, corresponding to positive volume in the volume-space organization; while blue-violet recedes farthest, having retiring effect comparable to negative space.

Knowing this much about the movement values of colors, the Modernist was able to go back and discover one more reason for lack of plastic unity in the works of great numbers of historic painters. If the average Realist between 1600 and 1900 had not effectively destroyed the integrity of his picture field in manipulation of the other elements, he was pretty sure to have used color—copied objectively from nature—with damaging rather than unify-

* My terminology accords, I believe, with that developed by Rudolph Schaeffer in formulating his *Theory of Rhythmo-Chromatic Design*." The material of the entire paragraph is more or less paraphrased from notes taken at Schaeffer's lectures.

< 256 >

ing effect. The theorists of that period had not even guessed at dynamic values. But through the ages there had been a very few painters who felt, intuitively, the relationships of plastic structure and dynamic color. During most of the history of Western art, the destructive possibilities of dynamic colors had been limited because painting consisted largely of dark-light compositions slightly colored over. But since the Impressionists had driven the blacks, grays and browns even out of shadows, this factor of recession or advance by color seemed destined to prove a primary asset when constructively utilized, or a violently destructive agent when ignorantly used. One had only to look in at any academy show to note the disorganizing effects.

Willard Huntington Wright long ago pointed out that study of color in the painting of the past, since the Renaissance, would show that it had been used *naturally*, to increase the illusion of appearance-reality; *ornamentally*, to add to the pleasing aspect of pictures as decoration—this trailing off into the voluptuousness of court painting, etc.; and *dramatically*, to heighten the feeling of the spectator by color-contrast. The Impressionists might be said to have deified color for its own sake, wresting it free from the other elements of design; and certainly they paved the way to discovery of its independent plastic-dynamic properties. It was left for the Expressionists, led by Cezanne, to pick up color thus purified and fuse it constructively with the other plastic elements: to recover the volume-organization that had been thrown away by the Impressionists, and to co-ordinate it with color orchestration.

The Synchromists, Morgan Russell and S. Macdonald-Wright, were the first, I believe, to codify the recessive values, a service summarized by Willard Huntington Wright thus: "With him a yellow, instead of meaning an intense light, represented an advanc-

< 257 >

ing plane, and a blue, while having all the sensation of shadow about it, receded to an infinity of subjective depth. The relative spatial extension of all the other colors was then determined, and a series of color scales was drawn up which gave not only the sensation of light and dark but also the sensation of perspective. Thus it was possible to obtain any degree of depth by the use of color alone, for all the intermediate steps from extreme projection to extreme recession were expressible by means of certain tones and pure hues." *

Wright further says: "At an early date artists had recognized that blue and violet were cool and mournful colors, and that yellow and orange were warm and joyful ones. They applied this primitive discovery with the feeble results to be found in Neo-Impressionism. That these colors had any further character they never suspected. Their insight extended only to the emotional and associative characteristics of the colors; the physical side was overlooked. Had the painters been more scientifically minded they would have known that these characteristics, which were the feminine traits. could not have existed in isolation; they would have searched for the colors' dominating and directing properties which represented the masculine traits. Such a search would have led them to the meaning of colors in relation to volumes, that is, to colors' formal vibrations which alone are capable of expressing plastic fullness. . . .

"The ambitions of the Synchromists went deeper. They desired to express, by means of color, form which would be as complete

* *Modern Painting: Its Tendency and Meaning*, by Willard Huntington Wright, New York and London, 1915. See pages 286-304, embracing the best available exposition of Synchromism. As with so many self-consciously revolutionary groups, the Synchromists ran on to the shoals of an art too scanty and empty, because they overcapitalized their one epochal discovery to the neglect of other elements.

< 258 >

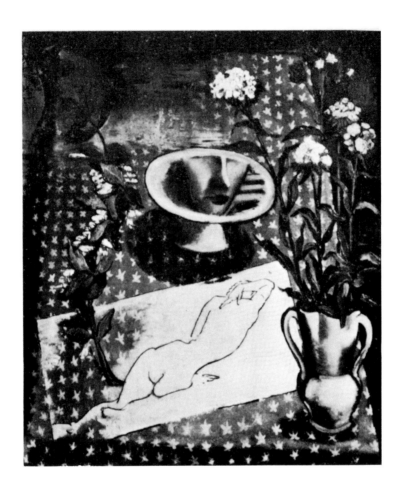

Still Life, by Morris Kantor. (By courtesy of A. E. Gallatin and the
Gallery of Living Art.)

and as simple as a Michelangelo drawing, and which would give
subjectively the same emotion of form that the Renaissance master
gives objectively. . . . The Synchromists' chief technical method
of obtaining this abstract equivalent for materiality was to make
use of the inherent and absolute movement of colors toward and

away from the spectator, by placing colors on forms in exact accord with the propensities of those colors to approach or recede from the eye."

There is in the Yale Gallery of Fine Arts a long panel-painting by the 15th Century artist Sano di Pietro, which establishes a rhythm with a series of foreground hills, mostly in receding dull greens. In the background appears a series of answering forms, comprising the hills seen between, painted in advancing colors— with castles in madder, and figures in reds and yellows. One would swear that the painter consciously "brought up" the far hills with forward colors; that he had insight into the dynamic values of colors, and intentionally stopped the holes in his picture field— in the best manner of the Modernists trained to plastic design. This painting, in short, has a definite affinity with Matisse and the Cubists and Synchromists.

But the history of Western painting forces the conclusion that such understanding was intuitive, and usually uncertain. In general the painters before Botticelli and Leonardo da Vinci had more instinctive feeling for preservation of a plastic balance in the picture field, with color considered, than had the later generations who became entangled in the search for exact equivalents of surface nature. In the rich and glowing paintings of the school and time of Giotto—fertilized by the influences of the Orient—the shallow volume-space rhythms often are accentuated and vitalized by structural color. It may be said, in general, that artists working in the less profound reaches of space, like Giotto—with what is sometimes termed a decorative flatness—have been more fortunate in

< 260 >

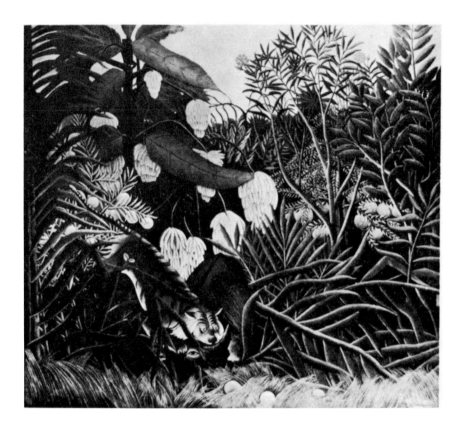

The Jungle, by Henri Rousseau. (Photo by courtesy of the Art Institute of Chicago, from the original in the collection of Mrs. Patrick J. Hill.)

their "feel" for the dynamic effects of color. Some of the others attained to the negative virtue of seldom destroying the picture by wrong use of color, because they approximated monotint painting.

El Greco, the great master of spatial rhythms, used color less creatively than the other elements. Many a later artist who came to be known as a brilliant colorist totally overlooked recessive values, gaining his title for a factitious natural glow or for dra-

< 261 >

matic heightening of emotion. But after all, it was not until the Impressionists had purified color, in the late 19th Century, that ignorant misuse of the palette invalidated whole galleries of pictures.

One does not like to criticize painters who may be serving very laudable purposes, who have evident faith in their own methods. But it will help to clarify our study of constructive color if I record that many of the so-called "progressives" among practicing artists today—even men exhibiting at the Museum of Modern Art, and termed "Moderns" by the newspaper critics—have only an imperfect comprehension, if any, of plastic-dynamic coloring. These painters obviously please large educated audiences, and therefore perhaps will the more easily forgive my personal opinion that they fail in one direction. I have noted, for instance, at recent exhibitions, that the coloring seems to push certain objects out of the canvas, or to dig holes, in paintings of Bruce, Burchfield, Benton, Brook, Beaux, Speicher, Hopper—and many, many more.

Whatever the other accomplishments of these eminent artists, they fail at mastery of the plastic synthesis which is increasingly recognized as the basic excellence of painting on its formal side. They fail worse than many a "Primitive," who could not have known the theory of dynamic coloring: because the Primitives often *felt* the color weights, and endowed their paintings with a plastic unity later lost, when art slid into Realism.

SUMMARY OF THE THEORY OF PLASTIC COLOR

The Expressionists, then, are certain that they have shaped a new and epoch-marking theory of the art of painting—which I have termed the theory of plastic orchestration, or the theory of

< 262 >

dynamic correlation—based on the conception of counterplay of the movement elements as basic; and they consider color as most important in respect to the dynamic values it contributes to the formal synthesis. Colored pigments have been found to possess properties of advancing toward the eye or receding therefrom: positive and negative properties corresponding roughly to those of volume and space. Movement may be engendered by colors in series. Colors in balance or in contrast may be made to create effects of weight and tension—by manipulation of the dynamic-recessive values—comparable to those achieved by adjustments of volumes in space. The movement, weight and tension effects of color may be used directly or dominantly, in parts of the plastic organization; or to clothe and reënforce the plastic-volume structure. In the former case, it may "lead" in the orchestration of the movement elements, or it may "answer" the play of volume-space melodies. While the dynamic element is supremely important among the properties of color, it is an asset only as it correlates with the other plastic instruments in the formal synthesis.

Of the technical refinements that have been worked out in accordance with the theory of plastic color, this book cannot treat; though the chief framers and practitioners have pointed out new subtleties of relationship between coloring plastically considered and the other formal agencies. To mention only one instance, a plane when colored not only "takes on color," in the old sense, but actually appears to the eye as enlarged or contracted, according to the thrust or return value of the pigment. In the future any artist working without a definite comprehension of such dynamic influence, of a recession scale, opens the way to disunity and confusion.

Joseph Sheridan puts down this summary: "Each color has its own rate of vibration. Hues in juxtaposition, vibrating at different

< 263 >

rates, create tensions. They repel or attract one another. . . . Atmospheric color is distributed with regard to a certain advancing and receding character." Again Sheridan has written: "Universality in art exists in the picture. As in poetry the meaning lies not in the words, but in the flow along over the words." He speaks of the flow-elements as forces, adding that "the sum of all the forces must form a closed figure." Color has at last been analysed as dynamic force, a part of the "flow along over": entering integrally into the plastic rhythm, the coiled movement-figure within the picture enclosure.

In closing the section it is not inapropos to add an often-quoted saying of Cezanne: "When the color has the greatest fullness, the form attains the greatest richness."

<div align="center">TEXTURE AS PLASTIC WEIGHT</div>

There is no need to repeat regarding texture the theory of plastic correlation and contributive animation. Texture "vibrates" as color does: except that the painter directly creates the degree of vibration desired. An area can be made to push forward or "disappear." The observer's eye can be unerringly—even violently—drawn to a corner or to center. An otherwise weak spot can be strengthened by building-in vigorous texture. Volume poise, tensions, weights, can be corrected with this factor.

And yet it is the least profound of the major plastic instruments. It remains, when obviously utilized, something added. If one cares to insist that everything existing has texture—smooth or rough, retiring or insistent—then all painters traffic in it. But of the positive thing we more commonly term texture, adding "interest" or frankly drawing the eye's attention, the average Expressionist

< 264 >

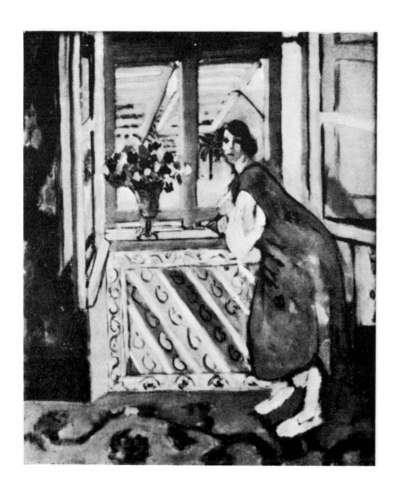

Girl in Green Dress, by Henri Matisse. (By courtesy of the Museum
of Modern Art: Bliss Collection.)

is chary. He wants the quality built in, so integral that it won't
be noticed until after the main plastic rhythms have registered:
like the fluctuating color-spots on a Cezanne hillside. But a lesser
group of Moderns has capitalized texture frankly, compellingly—
and, within a strictly limited range, beautifully. Gauguin, Matisse,

< 265 >

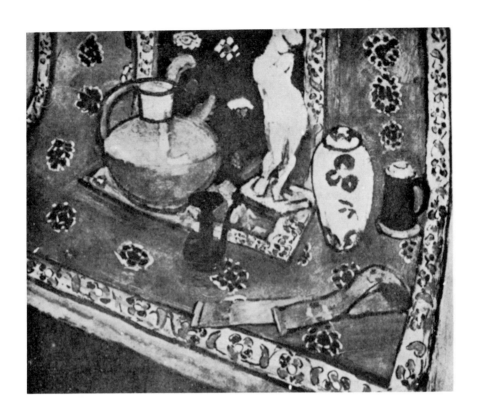

Arabesque, by Henri Matisse.

Leger, Klee, Chagall, Severini, Kandinsky—these all have experimented with the element, since Cezanne brought it significantly into the plastic synthesis.

In the arabesque-like pictures of the mature Matisse, texture enters strongly, gorgeously. In Klee there are likely to be shy little patterned patches, cunningly devised to pick up a rhythm dropped by some other instrument. Among the Cubists who eliminated or ruthlessly subordinated colors, texture is often set to do the work of the missing hues in building up another sort of "color-

< 266 >

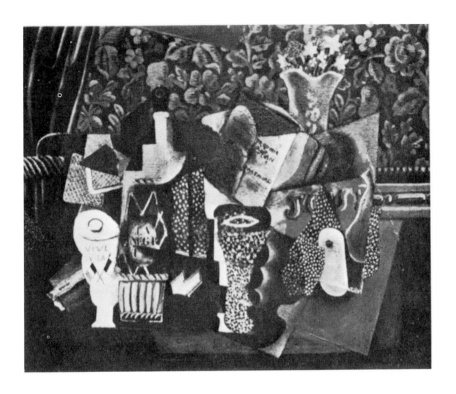

Vive La France, by Pablo Picasso. (By courtesy of Sidney Janis.)

fulness"—as in the Picasso panel illustrated here. The problem was primarily a plastic one, and certain parts are obviously pushed forward by the applied pattern.

But Matisse again offers the richest material in illustration of the principle. In the run of five reproductions in nearby pages, the reader can note the large number of areas frankly enriched by repeat and all-over patterns. Seldom are the volume-space element and plane relationship so subordinated to the Arabesque effect as in the reproduction opposite. It does indeed approach the estate

< 267 >

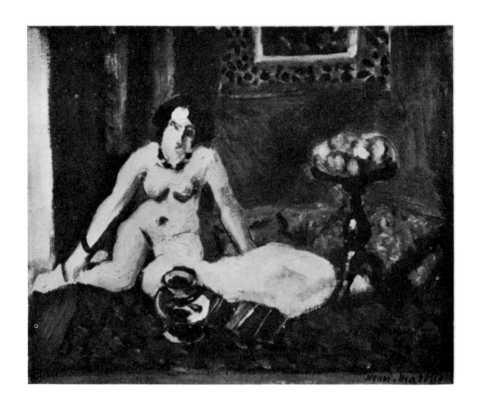

Nude with Goldfish, by Henri Matisse. (By courtesy of
Pierre Matisse Gallery.)

of "mere decoration" which the more intellectual critics and the
emotional-mystic painters alike frown upon. But in its field it is
richly successful.

The *Girl in Green Dress* seems a transitional example between
that sort of "Oriental" composition and a later Matisse type of
volume-color-texture synthesis (still with little subject interest).
The *Nude with Gold Fish* illustrates the texture values more cun-
ningly fused with the other elements, less insistent on their own
account. And yet in the carpets and in the wall behind the figure,

< 268 >

the color is strengthened, and the otherwise negative space brought toward the positive by half-concealed pattern.

Texture in pictures, however, need not be interpreted as merely depicted pattern, where in nature pattern would be: as in introduced carpets, wallpapers and Arabesque hangings or grills. In the nicer sense, every surface suggesting nature has distinctive texture, whether skin or wood or jewel or flower. Matisse is master of the one sort as of the other. There are bits in his canvases, if one cares to fix attention momentarily upon a segment—like listening intently for a certain passage in music—which give back intense pleasure for the sheer sensuous beauty of surface handling. And beyond all individual bits of texture, there is a further achievement, a harmonious conjunction of sensuous values, an achievement that might be termed inter-texture. I feel that if it could be isolated it might have a contributive excellence similar to the marvelous enriching counterpoint of Cezanne's fluctuating color-planes. It endows with recognizable *character* the paintings of Gauguin, Matisse, Rousseau, Klee. It need not be merely glamorous, though it often degenerates to that, in painters less masterly in command of the other plastic means.

There is, also, the device of arbitrarily organizing light-dark for texture effect. The departures from natural chiaroscuro in Rembrandt's paintings might be considered less as distortions to emphasize volume, than as thrusts toward a compelling pattern. El Greco is, of course, the outstanding master of dark-light manipulation for contrapuntal enrichment. The textural or patterned effect is often opulent, but seldom by reason of patches of applied ornament; rather the rich grain or light-dark variation is integral to the flow of voluminous elements.

< 269 >

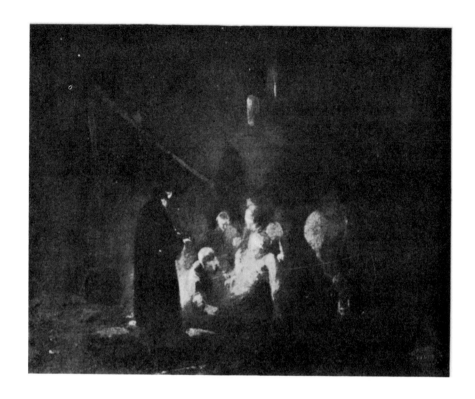

The Good Samaritan, by Rembrandt.

For further study in the field where chiaroscuro and texture meet, Rubens and Tintoretto are historically important—as witness the illustration on page 206—and among the typical Moderns, Cezanne, the Picasso of the so-called Blue Period and of early Cubism, Kokoschka, Heckel, Vlaminck. In these painters there has been, at times, an apparently conscious effort to arrange the effects of light-dark in a surface play approximating the weight-values of texture, within the plastic synthesis.

The painter, then, beginning with respect for the inviolability of the picture plane, and knowing that the first disturbance of equi-

< 270 >

librium, the first initiation of movement, must be compensated through a complex interplay of the dynamic elements—the painter so grounded will add the weight values or plastic properties of texture to his repertoire of force-creating instruments: to volume-space adjustment, plane arrangement, and color dynamics. If he is wise, he will study texture for attainment of all that its rather limited capabilities can contribute; then return to the truth that ideally all the elements will work together, in a harmonious fusion from which no one element stands out: in a plastic orchestration.

< 271 >

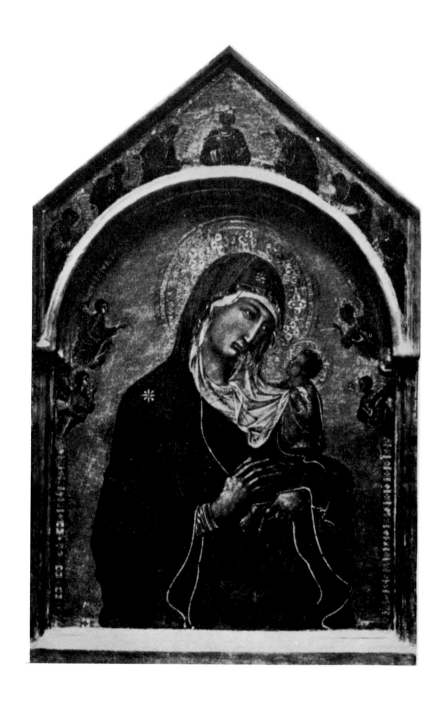

Madonna and Child, by Duccio.

CHAPTER X

PICTURE-BUILDING: DECORATION "FLAT"

THERE are the cathedrals and temples of painting, and also the pleasant pavilions and intimate meeting-rooms. The vast reaches, impressive spaces and profound contrasts of the larger monuments need argue no deficiency of essential art-of-painting virtues in the lesser and "lighter" structures.

Some of the most enlightening critics have utilized the architectural analogy in explaining the formal composition of modern painting: Hildebrand finding "the architectural structure of a work of art the paramount factor," and Wilenski pitting the new "architectural" against the old "descriptive" art. I too have utilized the figure: have grouped the five chapters dealing with the instrumental side of Expressionism under the sub-title "Picture-Building": believing that only a knowledge of the organic *structure* of the picture can bring understanding of the typical expressive form. In distinguishing "decorative" painting from a more profound sort, here at the opening of the last formal-technical chapter, I believe that the thought of spacious cathedral and intimate colorful living-house will be suggestive and illuminating.

El Greco was the great cathedral builder among picture-makers. Cezanne aspired to similar monumental building, and was the first master to use modern materials for profound and spacious creation. But the other range has its prophets and masters too: less deep in intention, less stirring and less likely to dwell in memory; but

< 273 >

certainly no less ingratiating and inventive and companionable. The builders of the pleasant pavilions and colorful houses of modern painting are Gauguin, Rousseau, Matisse—and a smaller group of followers than one would expect, considering the easily comprehended loveliness bequeathed to the world by these masters.

The "decorators" accept a lesser problem, conceive their sort of creation as filling out a lesser framework; and the excellence of their contribution should be judged in relation to the limits consciously acknowledged.

There is more than mere metaphor in the thought of the structure of decorative painting as less spacious and less deep. In the theory of plastic orchestration, it is the actual extent of the thrust into space that determines the profundity of the plastic rhythm. Decorative painting is an arbitrary division of examples within which penetration is deliberately curbed, and a different sort of fullness achieved, usually with larger reliance upon melodious linear rhythms, sensuous color-harmonies, and texture interest.

THE UNIVERSAL CREATIVE ELEMENT

There is no painting without depth. Decorative painting merely *approaches* the flat: does not exclude recession values, but only holds them within shallower limits.

Realistic and expressive-formal artists alike initiate movement into space. The Realist copies the casual movement and space effects of nature, and recognizes no need to control the plastic thrusts and returns. He affords the illusion of natural movement. The Expressionist starts movement in the canvas with the conscious intention of controlling every plastic element. He knows that the first partition of the picture area creates the "feel" of plane beyond

< 274 >

plane, every volume implies recession, every color pushes toward the observer's eye, or withdraws, into space. Depth is an inescapable actuality in all painting. The decorative sort is that in which the depth is purposely limited, the play of plastic elements controlled within a shallow depth-range. In short, decorative painting is not flat, but merely flatter than the other sort.

I am frank to say that I did not see the matter in that light until recently. Not many years ago I wrote, ignorantly, of "the flat composition approaching pure decoration" of Gauguin, as follows:

"If its essential quality is to be called form at all, it is form dependent on surface organization of lines, masses and colors; it is not voluminous form, dynamic poised form."

Insofar as I had comprehended the idea of plastic form, I was attempting to apply it solely to the complexly structural painting of El Greco, Cezanne, and similar but lesser "symphonic" practitioners. I had not arrived at the truth that in the nature of men's way of seeing, *every* painting has depth; that every completely designed picture gains something of its satisfying formal unity by plastic orchestration. Today I believe that the so-called decorative canvas of Gauguin or Matisse or Klee, no less than the profounder things of Cezanne or Rouault or Kandinsky, must be equilibrated according to the principles of correlated dynamic elements. The sole difference is in the depth or shallowness of the plastic range.

When I say "sole" difference, I am thinking at the moment in terms of the formal elements: not emotional or subjective. I am postponing—since we still are concerned with structure—the question of a lessened importance of the life-content, in a decorative work. For the moment, we will leave aside also the question of a possible accord between the decorative and the abstract. Some commentators mark decorative painting as close to ornament:

< 275 >

imply that it merely adds to the elegance of a place—and that abstraction may serve such a secondary ornamental purpose, although a drawback to more "serious" painting. But we are concerned here with the formal means, not with the elements of feeling and meaning.

When one gets clear the truth that plastic correlation is a fundamental of all creative painting, one no longer tries to classify painters in mutually exclusive pigeon-holes. One may say that there is more of the cathedral or symphonic element in El Greco, whereas Giotto is over toward the decorative group. There is no dividing line. The plastic synthesis is no less attained in the best of Gauguin than in the average work of Cezanne; but the one conceived his compositions *nearer* the flat, while the other delighted in seeking realization through the play of forms and colors reaching deep into space. The one sort of painting is, we say, "decorative," for lack of a more definitive word: as against the other sort—for which we have no distinguishing name at all. Some critics and artists would call that other sort "serious painting": implying a lack of significance in the decorative. We can best meet that by asking a question: "What then of Giotto?"

Giotto's murals, indeed, exhibit most of the "decorative" earmarks: recession values held within a strictly limited range, background "interest" suppressed, large-area coloring, melodious surface rhythms, parallelism of planes, even flattened volumes. And yet Giotto retains "significance"—apparently for conservatives and radicals alike.

There is extant a "curtain theory" which is suggestive of the special qualities considered proper to decorative painting. It found its origin, perhaps, in the speculations of certain Cubists who, in the search for flatness, denied validity in the picture to anything

< 276 >

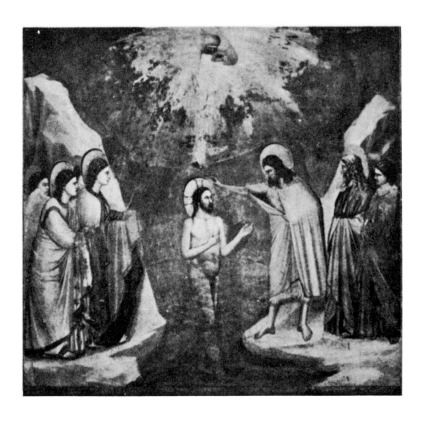

The Baptism of Jesus, by Giotto. (From *Giotto*, by Louis Gielly.)

inappropriate to a rug or wall-hanging. Some of the old tapestry-makers had arrived at a compromise of pictorial aim and architectural purpose which ranged them with the most accomplished pictorial-plastic creators in history. Their respect for the curtain as such was comparable to the Moderns' respect for the two-dimensional integrity of the canvas. Their tapestries can be compared to the works of the decorative group of Expressionists, because they sensed that a deep plastic play into space would destroy architectural wall-sense.

< 277 >

Some readers doubtless will find their comprehension of the aims of Gauguin, Matisse and Rousseau sharpened by thought over the disposition of volume and space in relation to "the curtain." The problem may be stated thus: how to animate the surface, without recessions disturbingly deep.

PLASTIC DEPTH AND THE FOCAL PLANE

In decorative painting, then, a knowledge of plastic orchestration *in relation to an established picture field* is fundamentally important. There is one principle, in connection with the stabilization of the movement-complex in the field, which has not been elucidated— so far as I know—by Hildebrand, Gleizes, Hofmann, Wessels, or other artist-teachers. I have termed it tentatively the principle of the focal plane.

What most commentators speak of as "the picture plane" is meant to be understood as the actual field bounded by the frame: the plane from which the movement "into the picture" starts. Too often this *front* plane is by implication identified as the plane in which the plastic movement "centers," the plane in which the eye is brought to rest after travelling its pictorial journey. Confusion of front-plane or picture-field with focal plane can only serve to puzzle and disconcert the student.

From the nature of the painter's means, and of the human eye by which the observer "takes in" the picture, space seems to open away from the base of the frame. The eye is drawn in; and the plastic orchestration starts—"the picture begins"—at a point in the plane established by the bordered canvas. From there it travels back, from plane to plane (volumes being considered here as complexes of planes), until at some point it touches deepest, and is turned across and outward.

< 278 >

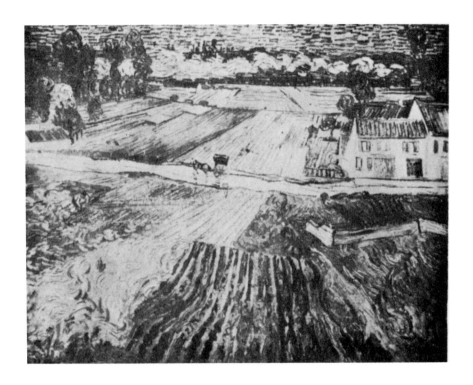

The Railroad, by Vincent van Gogh. The main planes clearly stressed.

But a return movement never pushes forward to the full extent of the recession. *The eye never returns to the front plane.* If we visualize the eye-track, for instance, as the organic spiral (pushing into space, and winding back, not merely traced on the front plane), we see the movement initiated at the picture border, stepped back by the several dynamic means, reaching deepest point on the large far sweep, then rounding forward toward the picture-front, and finally settling back to a focal point where the eye is (temporarily) brought to rest.

When artists insist that the flat must be respected, the picture field never be violated, they do not mean that the observer's eye is

< 279 >

Head of a Tahitian, by Paul Gauguin. Illustrating a very shallow plastic range, as compared with the El Greco portrait opposite. (By courtesy of the Museum of Modern Art: Bliss Collection.)

to be held in the front plane. No power on earth can keep the picture from being three-dimensional in effect, once the first line is drawn or color-plane applied. The observer's eye inevitably pushes in, and stays in (if the design is truly organic). The crux of the

< 280 >

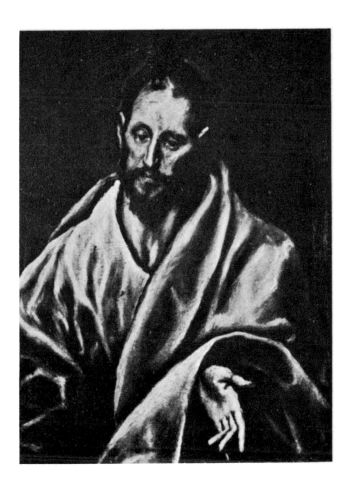

St. James the Less, by El Greco. (Photo by courtesy of the Art Institute of Chicago, from the original in the Charles Deering Collection, lent by Mr. and Mrs. Chauncey McCormick.)

matter, it seems to me, is that a focal plane be established *part way back*. It is in that plane that the pictorial equilibrium will seem to be stabilized. There the final focus will be established. That plane will be mathematically related to the front plane or original picture

< 281 >

surface, from which the movement started, and thus equally related to the frame.

Too often, I think, when the main picture plane is mentioned, meaning the front plane, and the idea of recession and advance is added, the student tries to visualize the movement as to and from the actual canvas. But obviously any movement forward from there would bring the object out of the picture. It is rather what I term the focal plane which affords the *mean* of movement backward and forward. This is the plane in which pictorial center, or the focal point of the plastic rhythm, is to be located. It is an inner plane fixed in relation to front plane and to point of deepest penetration. Once the eye is in the picture, it is from this plane that the backward-forward elements seem to act, into depth or toward the frame: whether recession and advance of color, or draw and push of volume in space, or slopes of planes, or forceful textures.

We are accustomed to say that colors advance and recede. From what? Except at the bottom edge of the canvas, they do *not* act from the picture surface. Visual phenomena are such that they act, pictorially, from planes at certain depths within space, determined by volume organization. In the average, all movement elements considered, the action is from the inner focal plane.

The *spatial* field is space between framed front-plane and focal plane, plus space between focal plane and the plane touched by plastic penetration at its deepest. Pictorial center, in the focal plane, is the point of stabilization of the axial pulls through space. The plastic "structure" seems to "rest" there.

After the plastic element has entered, when the picture is first animated, the front plane, the fixed canvas surface, actually disappears. The nature of three-dimensional design is such that the eye and the attention are carried beyond. The problem has become

< 282 >

Winter Landscape: Snow Effect, by Henri Rousseau. (From *Rousseau,*
by Christian Zervos.)

spatial, and whatever "anchoring" is necessary, of forces inward
and outward, will be accomplished in direct relation to a plane in
mid-space, not to the front plane. In short, the plastic organism,
moving in space, acts entirely beyond the frame. In the paintings
and prints of the Far East, the front plane is often emphasized by
a panel containing title or signature, obviously on the "picture sur-
face." This marks the beginning point of observation, and, as the
Japanese artist says, "gives depth." Whistler experimented with
the device when he was working in arranged receding planes.

How far back from the frame the focal plane is "normally" fixed
cannot, I believe, be arbitrarily established. The limits might be

< 283 >

Coronation of the Virgin, by El Greco. (Photo by courtesy of the Art Institute of Chicago, from the original in the collection of Max Epstein.)

determined, perhaps, by the analogy of the observer looking into a mirror. Automatically he will find the proper "range" for shaving or tying a tie, or what-not. There is a considerable latitude of satisfactory focus, as one approaches or recedes from the mirror; or, if the observer remains fixed, a considerable range of image planes beyond the glass that can be comfortably realized. There are rough limits of the area of visual clearness, from any given observer-standpoint.

Certainly there can be no *one* normal depth for the focal plane, for all picture-making. Otherwise, there would be no difference of

< 284 >

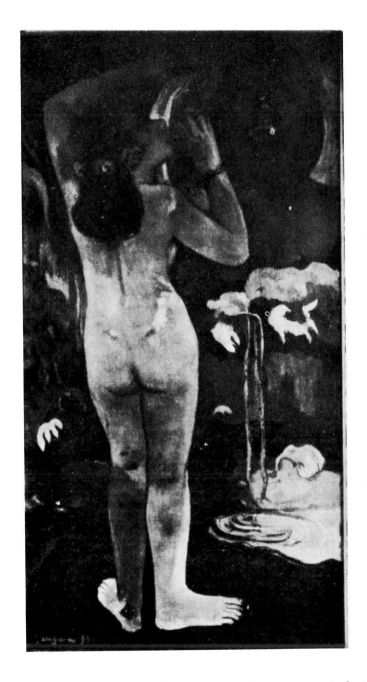

Hina Tefatu, by Paul Gauguin. Illustrating plastic depth strictly limited, as compared with the El Greco opposite. (By courtesy of the Museum of Modern Art: Bliss Collection.)

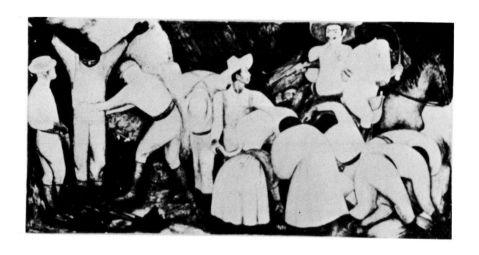

Mural in the Social Chaos Series, by Diego Rivera. (From *Das Werk des Malers Diego Rivera.*)

recessive penetration between an El Greco and a Gauguin. If the focal plane of any given picture is, to put the thought another way, at the average depth of focuses demanded of the observer's eye, as it travels the vision-path, the distance of that focal plane beyond the frame will be established by the pulls of all dynamic elements; an El Greco thrusting figure beyond figure into space, will establish his mean of focuses farther back than Gauguin, who seldom ranges solids in recessive series, who flattens bodies and tree-trunks, and spreads color not in fluctuating waves and turned planes but in simple areas.

It is a temptation to suggest that a picture might be simplified down to the point where its focal plane could be demonstrated as half-way between front plane and plane touched by deepest thrust; but there are so many movement agencies contributing to the plastic

< 286 >

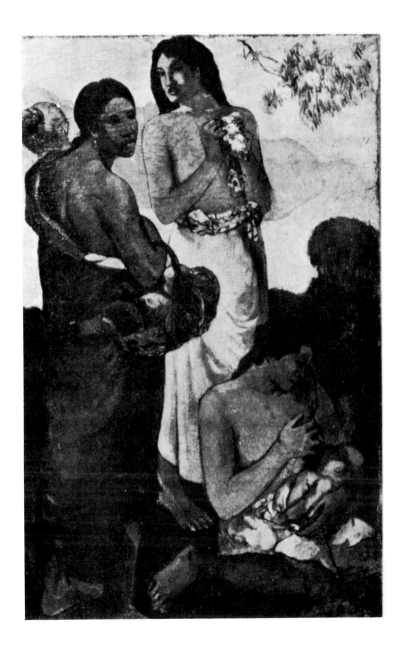

Maternity, by Paul Gauguin. (By courtesy of Adolph Lewisohn.)

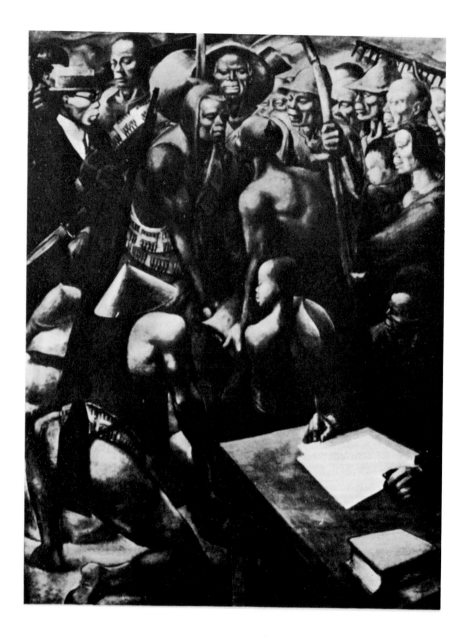

The Chinese Red Army—Distributing Grain: Mural by Jacob Burck.

synthesis, that any such summary statement would be extremely hazardous. One sort of thrust is modified by another instrument, and it is the total "effect" that creates a center of stabilization, of focus. Nor would "half-way back" be an accurate designation, since we are dealing with the organic spiral (in the one suggested example of eye-path), and the longer recessive swing is in the front space, the lesser in space beyond the focal plane. All we can conclusively say is that the artist initiates movement into space, and utilizes several interacting dynamic means; and that the web of plastic animation is poised between front plane and back plane, with a felt median of vitalization in what I am naming the focal plane.

DECORATIVE PAINTING AND MURAL SENSE

What is termed decorative painting, then, is simply a sort in which the focal plane is established especially close to picture-front, and the total recessive depth thus deliberately shallowed. This is accomplished in two ways: by keeping *all* elements near the flat, as in Rousseau's tapestry-like jungle pictures—where there is no violent movement of any sort, no "bright" colors, no insistent texture, no strong axial pull of volumes or precipitately descending planes; or by immediate *correction* of any strong movement in one element by the forward or backward properties of another, as in Matisse's rich interiors-with-nudes, where the dominant solid is "toned down" in color, or potentially deep space is brought forward by advancing color and texture. In both cases the artist has worked toward an equilibrium centered near the frame.

All the decorative painters are likely to close the background against perspective effects (the commonest cause of the "hole-in-the-picture" fault of even eminent Realists), and many are accustomed

< 289 >

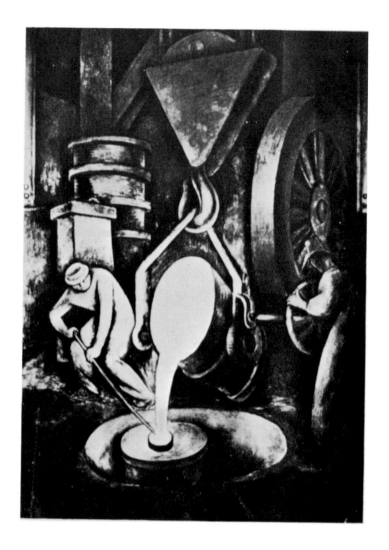

Pouring Steel, by Diego Rivera. Illustrating flattening of volumes in a
mural painting. (From *Das Werk des Malers Diego Rivera*.)

to make more than usual capital out of frankly linear rhythms.
Thus what is lost in deeper rhythms is partially gained on the sur-
face. There are other compensations: a general enrichment by

< 290 >

sensuous means—texture and color both leaning to the sensuous; there is less of volume-space manipulation, which works by axial attraction through space, and more reliance on the dynamics of color and texture, acting from surfaces.

It is easy to see why "decorative painting" and "mural painting" are accepted as synonymous terms. If the artist has a wall to paint, and begins with the obligation to preserve the sense of a flat plane bounding the room, he will automatically exclude the deep recessions: will work with a sense of the focal plane only slightly recessed. The "extra flatness" becomes a concession to architectural fitness. The great modern muralists from Puvis de Chavannes to Orozco and Rivera exhibit many of the idioms already ascribed to the decorative easel-painters: Gauguin, Rousseau, Matisse. (The distinction is, of course, an artificial one. Gauguins and Matisses and the Cubists are bought by those who feel that such pictures will not "disturb the architecture," as would compositions with profounder plastic rhythms, extended into deep space.) Broader areas, flattened volumes, parallel planes (preventing the extra movement of slopes), restrained color, linear harmonies: these are typically "mural."

There are Moderns who deny any validity to Puvis de Chavannes. But I think they argue, in general, from a restricted viewpoint, that of the Cubists or the Abstractionists or those insistent upon art as a social stimulus. Certainly there is, in the murals at the Sorbonne and in the Boston Public Library, a sustained loyalty to the wall, and at times a complete animation of the picture-surface within a controlled plastic unity. The coloring and the disposition of forms both indicate a possible fear of upsetting an equilibrium attained instinctively rather than through conscious knowledge of dynamic values. There is here none of the vigor or intensity of Orozco

< 291 >

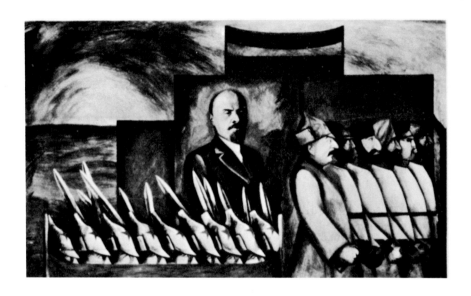

Part of the Russian-Oriental Panel of a Mural Series by José Clemente Orozco, in the New School for Social Research, New York. Typical shallowing of plastic elements.

and Rivera. Perhaps it is Expressionism at its lowest intensity, in its most delicate manifestation—at a time when expression would seem, on its emotional side, to demand drive and strong contrast. But since we have accepted the attainment of plastic unity as the type earmark of Expressionism on the *formal* side—and have not yet ruled out abstract and "unmeaningful" subject art as insignificant—there is reason to mark Puvis de Chavannes as a pioneer experimenter in plastic-decorative organization.

He lived in a time when the Realists ruled, and it is noteworthy that he resisted the melodramatic devices and superficially clever light-effects by which his contemporaries were enlivening their canvases—even while destroying any plastic order. He did not

< 292 >

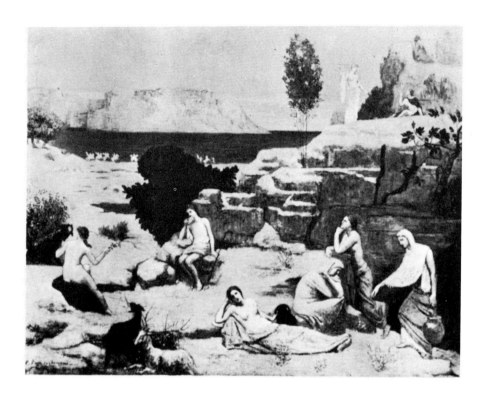

A Vision of Antiquity, by Puvis de Chavannes. (By courtesy of the Department of Fine Arts, Carnegie Institute, Pittsburgh.)

escape a rather pale literary yearning; but he was the first muralist in many generations to preserve wall-sense and create ordered plastic movement. There were many artists among his contemporaries—and even a few critics—who called lustily for a return to architectural painting, to the wall unviolated and flat pictorial effects. But most of them went on strewing their murals with casual movement patterns—because they neither understood the principles of dynamic volume and color, nor possessed Puvis' intuitive plastic

< 293 >

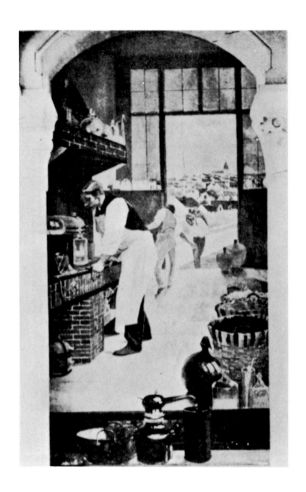

The Laboratory,. Mural by Albert Besnard in the. *Ecole de Pharmacie.*
Illustrating how wall-sense is destroyed by Realistic perspective pictures.
(From *Albert Besnard,* by Gabriel Mourey.)

sense. I reproduce here one of the murals of Besnard, for example
of all the effects that destroy the wall and negate plastic order and
expressive form.

Confusion has arisen in many quarters out of the fact that an
artist *can* establish the feeling of wall-flatness and yet compose

< 294 >

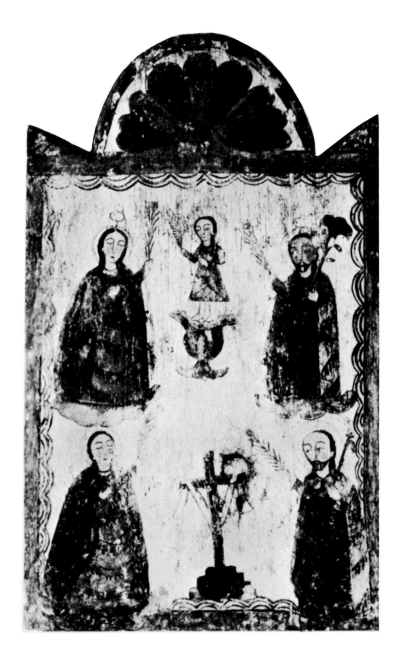

A Santo from the American Southwest. (By courtesy of J. B. Neumann.)

spatially, with plastic depth. It cost the Parallelist group of Cubists many years of near-futile experiment, after they had enunciated the principle of flatness, of integrity of the two-dimensional field, before they returned to volume-space organization and dynamic colors. In a chapter on "Decorative Painting," a leading aesthetician writes: "Yet most of the great decorators have been satisfied with very moderate concessions to flatness. . . . Giotto, who has been more highly praised for flatness than anyone else before Puvis, has been praised with equal enthusiasm for the solidity and rotundity of his figures!" He adds the exclamation mark to register his own amazement that anyone could claim a "flat" value for any picture in which solid and rotund figures appear. Such criticism is based on ignorance of the nature of the plastic element in painting, common to teachers of the old school. The fact is that solid items are not at all denied to muralists: the flatness is a matter of the adjustment of *all* the movement factors—the holding of the several recessive elements within a shallow depth-range behind the canvas.

A study of Orozco's compelling murals will indicate some of the ways in which a fine solidity of figures can be achieved without destroying the sense of flatness. Sometimes Orozco flattens the figures—as indeed did Giotto on occasion—in the manner common to Gauguin's later work. But a voluminous effect can be prevented from going too deep, by color correctives, volume buffers, etc. It is because he seems to me to lack a knowledge of these dynamic adjustments that I have freely criticized, in earlier pages, the murals of Thomas Benton. His insistent figures, which might be "relieved" by the other plastic elements, are given high objective coloring, and

< 296 >

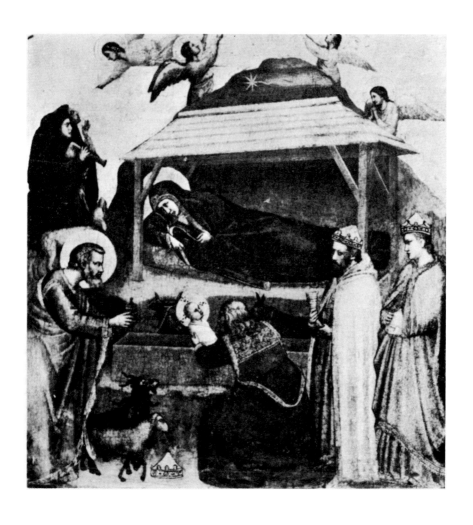

The Nativity: attributed to the School of Giotto. (By courtesy of the
Metropolitan Museum of Art.)

spatial effects are deepened by naturally recessive hues: till the figures spill out of the picture, and the wall is punched with holes. Nothing but a knowledge of plastic correlation can bring richness plus flatness to decorative painting, whether on walls or canvas.

ORIENTAL AND WESTERN DECORATIVE PAINTING

The Orient has been more successful than the Occident in attaining to the lighter loveliness of sensuous decorative painting. Persian art is a delight for the way in which the shallow plastic range is animated with eye-filling color, delicate texture, and restrained movement from plane to plane. It is only with the coming of Expressionism in the West that recognition grows of the superior decorative achievement in the East, whether in the "deeper" paintings of the Chinese, or the "lighter" achievements of the Persians, Hindus and Japanese.

It would be well if, in the histories of European art, more emphasis were laid on the influences that came into Italy from the Orient before the Renaissance. The Italo-Byzantine painters afford the most pleasurable exhibition of sensuous-melodious painting in the whole pageant of Western art. This group were called "Primitives," by the critics and historians of the long Realistic era, because the formal conventionalizations and distortions—necessary for the achievement of the plastic rhythm—were mistaken for crudities of artists who would have been Realists if only they had known enough. It is more likely that, like the Orientals (and many true Primitives too), the Italo-Byzantines were content if they created pictures with complete formal expressiveness: it did not occur to them that accurate copying of nature would come to be considered art. In any case, they are taking a belated revenge today, when the early Florentine

< 298 >

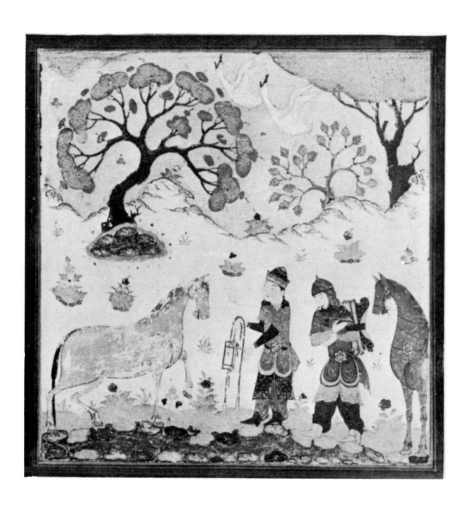

Rustam Capturing His Horse Rakhsh: Persian painting of the early 15th
Century. (By courtesy of the Metropolitan Museum of Art.)

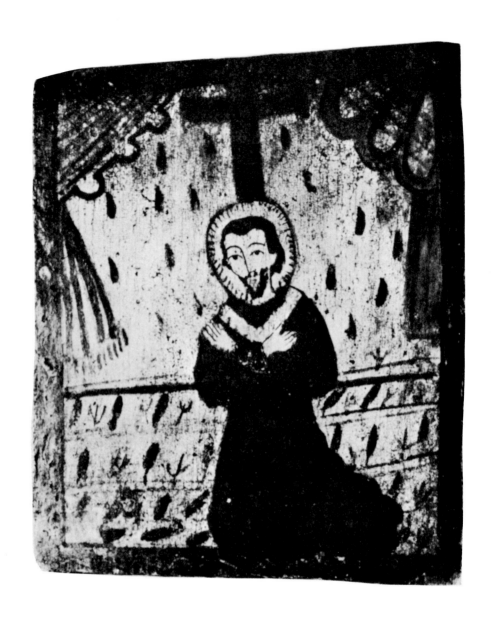

A Santo from the American Southwest. (By courtesy of J. B. Neumann.)

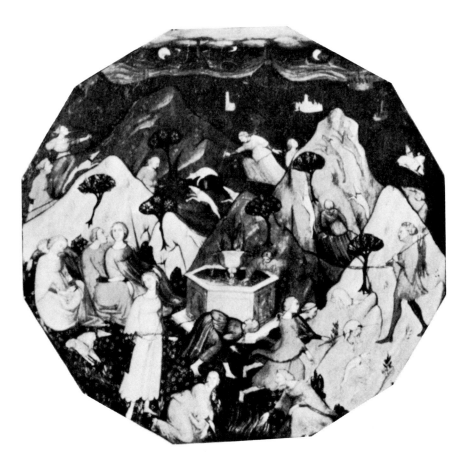

Painted Marriage Salver, Florentine, Early 15th Century. (By courtesy of the Metropolitan Museum of Art.)

and Sienese panels are being brought up from museum basements, to displace the illustrative painters of the three Realistic centuries. Our galleries will be infinitely richer, aesthetically, for the change.

The Byzantine tradition as such persisted in Russia till our own time. The ikons, even those of the 19th Century, surpass in rich decorative effect any other products of Europe since "natural" painting came in. Curiously enough, there is a parallel achieve-

< 301 >

ment in the "Santos" of the American Southwest and Mexico. Native artists, by some intuitive return to the Byzantine directness of expression, swung Catholic church painting back to formalized decorativeness.

Even the historians of Post-Impressionism and Fauvism are likely to forget the significance of the inflow of Oriental influence during the formative years 1870-1900. Some of the root-nourishment of Expressionism can be traced to the treasures imported from the East. If Whistler made rather superficial application of the decorative principles of Japanese art, in most of his later work, he again attained to an exquisite adjustment of shallow plastic and delicately sensuous elements. His small contribution to Expressionism is rather more secure than some of the intolerant historians of Modernism admit.

But this is not the place to attempt ranking of the various artists concerned in the transition from Realistic to Expressionist art. We are interested in learning what it is that constitutes the progress, the revolution, during the fifty years past, and we need summon the artists and their work only as light may thus be thrown on the special qualities of Expressionist painting—just here the formal-decorative qualities. Whistler is useful to the student for evidence of a cautious return—revolutionary in his time—to an ideal of what he termed "arrangement," as against the current obsession with observed natural effect; and for his preservation (in the best of his work) of the two-dimensional integrity of the canvas. If often he let that regard mislead him into an art too flat and linear and slight, he again attained an ordered synthesis into which the plastic elements entered.

Another lesser but still significant figure was Hans von Marées, within whose mural compositions the geometric-plastic structure is

< 302 >

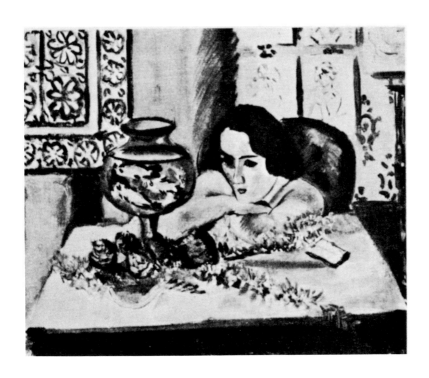

Girl and Goldfish, by Henri Matisse.

implicit. One might go on to other border-line figures, to Manet—
who seems to me, despite his praised "good painting" and "styliza-
tion," to exhibit less of expressive form than Whistler, to have less
pictorial sensitivity, in the Expressionist sense—and Degas, and
Hodler. But it is more to the point that we return to the artists who
summarize the decorative phase of the Modernist advance.

"Exotic" is the adjective applied to Gauguin more frequently
than "Oriental." And there is no profit in laboring the matter of
this source or that. Gauguin is allied to the Orient, to Africa, to
the South Seas: to all places where art has remained a formal-
decorative exercise rather than illusional transcription. In this one

< 303 >

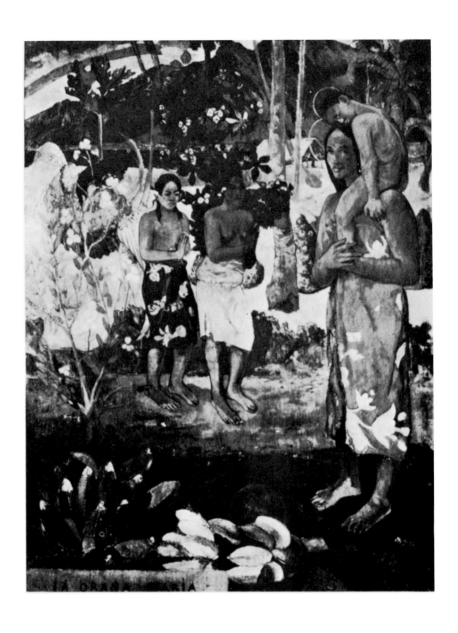

Ia Orana Maria, by Paul Gauguin. (By courtesy of Adolph Lewisohn.)

man's work there is illustrated the sum of the Modern decorator's likeness to the other Expressionists, and of the differences between decorative and other "wings."

Gauguin is of the Expressionists because, within limits, he attains to a formal-plastic orchestration; because he is essentially colorful, revelling in sensuously-compelling color-harmonies—"expressing the paint" with a new intensity; and because he expresses his emotional self in relation to life, freely distorting the actuality of nature —anti-Realistically.

He is of the decorative group, rather than the Cezanne-Fauve-Rouault succession, because the plastic range is deliberately limited: the flatness consistently affirmed, by broad color areas, by flattened volumes, by linear rhythms, by parallelism of planes. Patterned texture is frequent, and color harmonies are utilized for exceptional sensuous loveliness.

All of these characteristics are illustrated in the plates in nearby pages.

Where Gauguin arrives at a simplification out of long study and many influences—less out of the savage isles than out of the civilization he sought to escape—Rousseau the Douanier was lifelong the incorruptible child. It is said that he longed ardently to achieve the academic fatuities of the popular painters. Fortunately he seldom got beyond being himself.

It seems a miracle that an artist supposedly untutored could so often achieve the plastic effects so consciously labored after by other Moderns, could so unerringly avoid the deep unstopped recessions of the Realists, and their piling of advancing objective colors on prominent volumes. Again, it is that a very few artists through the ages have been born with an instinctive sense of plastic co-ordination. Rousseau is the true modern intuitive-Primitive.

< 305 >

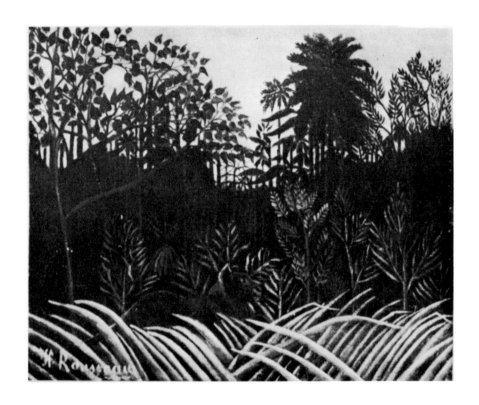

The Jungle, by Henri Rousseau. The "curtain" idea illustrated. (By
courtesy of the Museum of Modern Art: Bliss Collection.)

Note how backgrounds are brought forward, men and tigers naïvely
conventionalized, the botany stylized, the houses flattened: and all
brought into relation within the slightly recessed spatial range.

Of other artists who have chosen (usually) to renounce the deep
plastic rhythms, but have attained to organic expression by correla-
tion of the movement elements, I am illustrating Paul Klee, Marie
Laurencin and Pierre Bonnard.

Klee has an uncanny way of making every canvas "live," no mat-
ter how slight the subject-matter, and the formal means. Almost

< 306 >

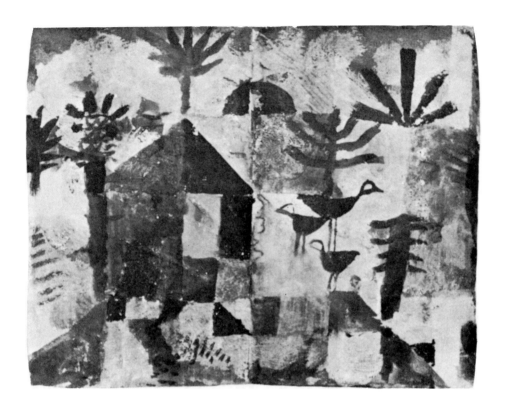

Landscape with Blue Birds, by Paul Klee. (By courtesy of A. E. Gallatin and the Gallery of Living Art.)

invariably there is a satisfying "adjustment"—which I take to be a plastic unity achieved. People complain that his paintings are like the scratchings and daubs of children: and yet there is "something they like." It is, perhaps, the hidden plastic structure. This patch-work picture is engagingly decorative. It is hardly more than a fluctuating pattern of turned planes of color, with accents to indicate trees, birds and house.

Marie Laurencin seems to me less sure pictorially; though you personally may find her pale paper-flat ladies and cool colors more

< 307 >

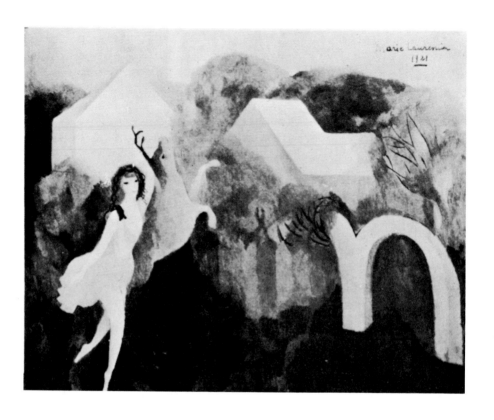

The Huntress, by Marie Laurencin. (By courtesy of Adolph Lewisohn.)

to your liking than Klee's near-abstractions. She falls back on linear rhythms to an extent that removes her a little from the builders of plastic organisms. The art of line is only incidentally the art of the painter.

In emphasizing that (in general) the decorative Expressionists move away from the plastic-symphonic technique of El Greco and Cezanne, toward a territory where sensuous values help to compensate, we have moved still another notch away from seriously "meaningful" art. It is not difficult to hear certain readers—the

< 308 >

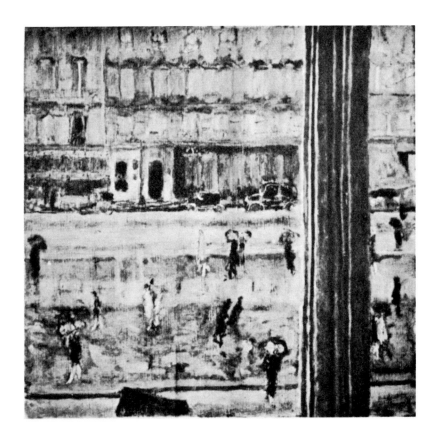

The Boulevard, by Pierre Bonnard. (From *L'Art d'Aujourd'hui*, Autumn, 1927.)

mere Realistic illustrators, the intellectualist followers of Craven, the crusading Communists—muttering "Does the man mean to claim that decorative art is self-sufficient, just because it is decorative?" It happens that I do. But I postpone the arguments to the chapter on Feeling and Meaning. Here we are arbitrarily limiting discussion to the instrumental phase, the plastic skeleton, if you will. For

< 309 >

that reason, too, we will put over all treatment of the mural painting
of Rivera, Orozco, Siqueiros.

SUMMARY

Decorative painting, no less than the other sort, finds its formal
vitality in an achieved plastic order. Within a pictorial, not an il-
lusional, unity, there is movement: engendered of volume-space
tensions and planetary thrusts, modified by strong or weak texture,
and color (with hue and intensity both considered in relation to
depth of recession). When movement is poised, and fills the closed
spatial field behind the frame, the plastic orchestration is complete.
The aesthetic experience of the observer is more poignant and more
intense, as the pictorial-plastic organism is achieved with this vitality
and fullness.

In the Orient, up to the recent invasion by Occidental "ideals,"
abstract-formal values have been at the core of creative art. Once
upon a time Western art, open to Byzantine currents, was rich in
the same values, as one may realize by going back to the Sienese
and Giotto and the ikon-makers. But with the dawn of the Renais-
sance, Europe proclaimed its independence from the East, and
Western artists began that glorification of superficial appearances
which culminated centuries later with the Impressionists. During
the reign of Realism the abstract values, the skeleton of expressive
form, almost wholly disappeared.

Expressionism—speaking still without regard to feeling and sub-
ject—is the beginning of the rebirth of creative formal painting in
the West. It derives impetus, on the traditional side, from a return
to study of Giotto and those in Giotto's line. At the same moment
there is a spontaneous reaction against accumulated shallow Realistic

< 310 >

art; and again, it happens, currents are flowing in from the Orient and have their influence—due to a new familiarity with the East, possible only to the age of instantaneous communication and easy machine-transportation. History will, I believe, mark the first fifty years of Expressionism as the beginning of an art revolutionarily different from that of the 17th-19th Centuries: due to its abstract-formal core, which is partly a recovery and partly new evolutionary development, in consonance with the times.

The theory of plastic orchestration tries to explain the gain of this art on the formal or instrumental side.

< 311 >

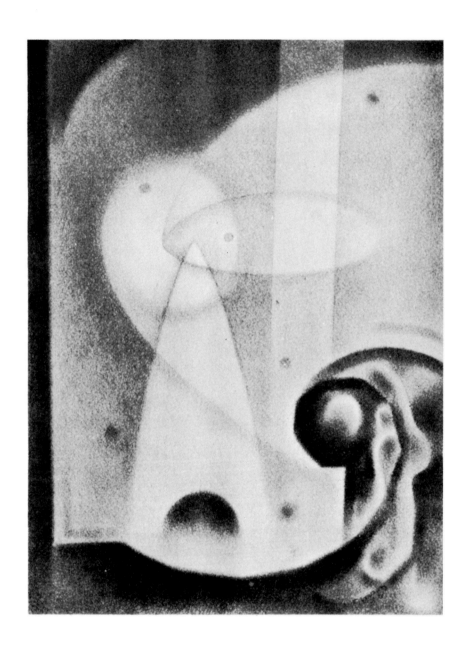

Orbits: Pencil Drawing by Raymond Jonson.

CHAPTER XI

THE chapters on picture-building have been concerned with a certain way of use of the *materials* of the art: with orchestration of the several plastic elements, for achievement of an ordered movement within the closed spatial field, a dynamic unity, an organic pictorial vitality. In those chapters I have attempted an elucidation of the methods employed to attain one part of expressive form: an intensification of the potentialities and properties of the specialized medium of painting. This might be termed the formal achievement out of masterly use of the instrument. But form-organization in this sense, as a plastic organism, is but one part of the larger creative synthesis, the full pictorial expression. The instrumental orchestration—harmonizing, correlating, organizing the tensions of volumes in space, axial pulls, movements of planes, dynamic colors, etc.—is but one important unity achieved within a larger unity. It is the mastered means of expression, not the end of expression.

Continually in those and earlier chapters the implication has been that subject-matter drawn from surface nature had, in Expressionism, receded in importance, as mastery of ordered plastic design increased and the "hidden" elements of expression became intensified. It was even suggested that, where creative art is concerned, distortion of objective nature might be "natural"; even to a point where the recognizable visual aspect disappears, in total abstraction.

< 313 >

If the values of photographic or selective imitation of nature—of Naturalism and Realism—are thus discounted, one may ask, what is it that enters as the primary value of painting? If depiction is dropped for expression, what is it that is expressed?

The answer "Form" is not enough, if we continue to consider form merely as a capitalization of the instrumental means: as a plastic achievement, a mechanical-dynamic order fixed in the canvas. Where does the instinct come from that impels the artist to formal creation? What is the *feeling* inseparable from form-conception and image-fixing? Form is revelation—of what?

It is revelation not merely of a plastic organism, but *through* the plastic of something that might be termed universal or cosmic truth, and, commonly, of human emotion.

Leaving out of consideration here the human or "subject" aspect, we are seeking clues to the reality of the cosmic or universal value that lies between the mastered means of expression and the human-feeling content.

In truth there is no separating the values, in either creation or appreciation. When the Expressionist claims that the attainment of a structural order, a plastic unity, is basically important, he doubtless is thinking of the order or synthesis both in the mechanical, measurable aspect (which can to a certain extent be diagrammed mathematically) and in an abstract-mystical aspect. That is, he creates a little world with a living order and vitality of its own; and at the same time an image of the macrocosm, echoing the relatedness and order of all that is. We have explored the nature of the immediate pictorial order. Now we are asking to what extent the universal enters in.

There are those who see all abstraction as merely a mathematical and mechanical thing, explainable by its surface aspect of geomet-

< 314 >

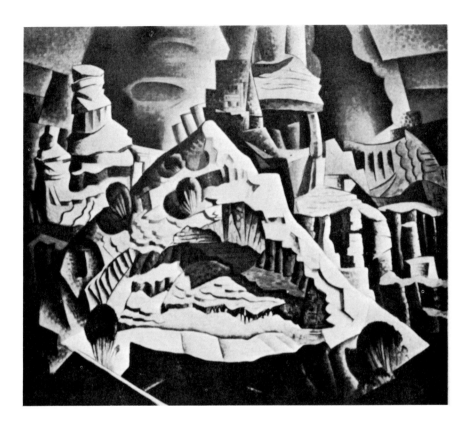

Earth Rhythms, Number 9, by Raymond Jonson.

rical relationships. There are others—the majority now, I think—
who link the abstract with the mystic: who consider it an expression
at once of the mathematical and of the spiritual or cosmic. Whether
the painter feels that he is, in "turning abstract," instinctively ex-
pressing what is only a mechanical-physical order, or is proceeding
in accord with a mystical aesthetic philosophy—apperceiving a
deeper meaning in objects and relations than those explainable
mechanically through senses and intellect—in either case, he is
furthering a main advance of modern art: the march *toward ab-*

< 315 >

straction. Whether one grants or not that *pure* abstraction in painting is possible or desirable, there can be no doubt that the world of art has recently moved in the direction of intenser capitalization of non-objective values.

It is my belief that the greatest art compasses form in the three aspects: as plastic-mechanical, as abstract-universal, and as expression of human feeling. I believe, moreover, that the increasing abstract significance in art is one phase of mankind's contemporary advance in spiritual apprehension. In other words, I take the mystic's view of the artist as creator, and count the mystic artist the true Modern.

If I am right, we shall see, in the 20th Century, a phenomenal increase in abstract art. I might put it better by saying that there will be both an increase in the amount of totally abstract art, and enlarged emphasis upon the abstract element in art which, in "content," still deals frankly with the objective world, with symbols, with events. In the Expressionist advance so far, there have been two easily-marked divisions: a small but challenging group of artists abandoning objective reality, to seek expression in the absolute abstract, and a larger group who inform their "more natural" work with an abstract "structure" or design. When I speak of abstraction in painting, I include both those pictures in which abstract "meaning" is the central content, and those in which the human-subject values lie over a support or core of the abstract. In the latter case, it is the support or core that gives most significance, aesthetically, to the picture.

It seems to me, moreover, that the art of the ancients will survive for future generations, as vital expression, largely because of the intensity of the abstract realization. I have noted that many artists, Western and Eastern, have achieved, perhaps intuitively, those very

< 316 >

formal values that the Expressionists are consciously striving to attain. And while the subject-matter—of, say, Christian legendry —may register with observers still, it is less the personal or human expressiveness than the abstract expressiveness that makes the pictures "live" for us of today. Therein is the explanation of the return to popularity, within your lifetime and mine, of El Greco, the Chinese landscapists, and the Italo-Byzantines—in all of whom the abstract skeleton is obvious, the cosmic implication evident. If there is a universally valid "quality" in graphic art, it is on the abstract, rather than on the "subject" side. It is this value more than any other that links Cezanne, Rouault and Marin with Giotto, El Greco and the Persians—or Lehmbruck with Michael Angelo and the Romanesque carvers.

IS PAINTING NORMALLY ABSTRACT?

For those who still cannot see significance in pictures from which objectively recognizable nature is wholly or practically excluded— Kandinsky, O'Keeffe, the "flat pattern" Cubists, etc.—there is solace, perhaps, in the fact that most of the "great" painting preserved from the past compasses objective content as well as abstract-pictorial form; though, as just noted, that art in which the abstract element is strongly emphasized tends, in the 20th Century, to displace "merely objective" painting. This point may well lead us to the question whether there is, possibly, a *reasonable norm of abstraction* in each art. I am not ready to admit that a picture entirely innocent of the camera-symbols of the phenomenal world, divorced from sense-known nature, is necessarily without meaning, reality and aesthetic validity. But for those who cannot experience abstraction except mechanically, it may be illuminating to inquire

< 317 >

about the balance of objectivity and abstraction in the other arts.

Music is widely considered to be cheapened when the actuality of nature is introduced: as in program pieces wherein one can hear the babbling stream, the lion's roar, the storm, etc. Hardly less contemned is the subject piece, built not around actual sounds but limited to emotional-interpretive equivalents of living: as too often in the works of Tschaikovsky or the Impressionists. But take a composition of Bach, that we all might admit as great, and immediately it is clear that creation has been arbitrarily divorced from anything heard in nature: is primarily an exercise in the abstract. (It is not, as so many Victorian commentators averred, *intellectual* music, but richly abstract-expressive—or as I would say, abstract-spiritual and cosmic-expressive.) In other words, it is almost universally accepted that music is essentially an abstract art; that it departs from abstraction only at cost to its highest aims and potentialities.

The Expressionist inquires, then, why the materials that are detected by sight cannot be utilized to afford stirring aesthetic experience as readily and purely as the materials addressed to the sense of hearing. Sight and sound afford many parallels: why should the one be bound, as art, to portrayal of objective nature, the other freed for absolute creation? It may be answered that a picture *can* reproduce a view in detail, or tell a story circumstantially. But that is no conclusive argument against there being a department of painting aiming at a degree of abstraction as advanced as that normal to music.

Literature seems to be in different case, because the prime material of the art, words, came into existence as a set of intellectual symbols for sense experience. Words primarily stand for things. Inventorial, descriptive and story-telling aims are natural to the

< 318 >

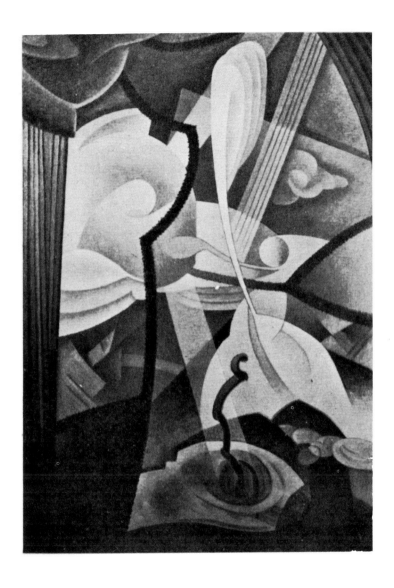

Composition Eleven: Rain, by Raymond Jonson. Considered by the painter "fairly Realistic," this is, like the preceding plate, a far step from illusionistic painting, but less abstract than the chapter frontispiece.

word-art, and abstraction may here be a will-o'-the-wisp (though one cannot dismiss offhand the experiments of Gertrude Stein and James Joyce). Certainly abstract elements exist richly in the highest literary form, poetry, in which the sensuous values of words, and formal structure, enter expressively. But there may be a bar to absolute abstraction in the very nature of words. There are, however, no such medium-limitations upon the art of painting—of line, plane, volume, color, texture.

Architecture and dancing are other arts on the abstract side. The one became imitative in the Realistic era—imitative not of nature but of the outgrown but sanctified forms of the past—but under Expressionism, architecture returns to abstract creativeness, upon a foundation of expressiveness of use, function and materials. Dancing purges itself of descriptive and story-telling accretions, and returns to abstract creation. The lesson of these arts, as of music, would seem to be that the painter is being modernly Expressionistic in pushing the search for abstract-pictorial effectiveness just as far as he can without losing his "public." Certainly no one would deny that Kandinsky and Braque and O'Keeffe and Klee have an audience today; though there are critics who stand off and jeer at that audience as deluded and self-hypnotized.

In all this I am trying to ease the way for those who are still afraid of abstraction. To me, as appreciator, the question is beside the point. I derive a real and direct enjoyment out of certain purely abstract painting; though that is but one small division of the range of pictures from which I gain aesthetic pleasure. It seems to me that the measure of a certain sort of expressive form is perhaps greater in the abstract picture, say an O'Keeffe or a Jonson; but when I turn to a Cezanne or an Orozco, the lessened

< 320 >

expressiveness on that side is matched by the gain on the subjective-expression side.

I honestly believe that man's aesthetic-appreciative faculty grows with individual use, and, in the mass, with the evolution of the race. It is no assumption of a special sense of superiority when one who has lived intimately with manifestations of the arts claims to experience the values of abstract-pictorial form. It is merely an earlier arrival at a sort of sensitivity that will be universal—as the present generations outgrow their false education to Realism, and as the opportunity increases for living with varied sorts of art. At the present stage of comprehension—retarded by education —a few people but an increasing group are sensitive to absolute abstraction, which they may or may not consider a sort of mystic revelation of harmonious cosmic order; and a larger group turn to partially objective painting in which the abstract skeleton or core is richly dominant. They will detect the quality in greater purity as understanding and sensitivity grow; perhaps the individual will march on till he commonly demands abstraction washed of the last remnants of objectivity. In any case I ask the reader to grant me the possibility that this is not mere self-delusion: to go on with me, probationally, to an examination of the mystic significance attributed to abstract pictorial form by many Expressionists.

ABSTRACTION AS MYSTIC REVELATION

The commonest explanation put forward by the Expressionists, regarding the mystic element, is that the abstract form fixed in the picture is a direct revelation of cosmic architecture, of the rhythmic order of the continuing universe. That is, the plastic organism, or coiled and poised movement in the spatial field, is

< 321 >

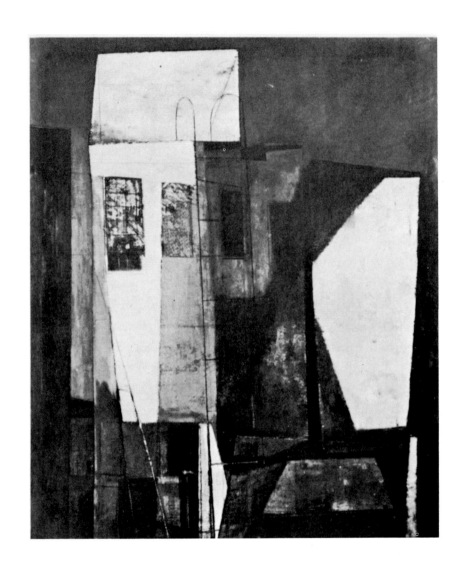

Majestic Tenement, by Arthur Osver. (By courtesy of the Pennsylvania
Academy of the Fine Arts, Philadelphia.)

not merely of the sort that geometrically pleases the eye—as an old armchair fits the body—but carries with it cosmic and spiritual implications. The order created by the artists is an echo—rather, an implicit part—of first creation, a manifestation proceeding from the Center of all that is, a pulsation in little of the rhythm self-perpetuated at life's Source.

Formal expression, at its intensest and most significant, embraces, in this view, cosmic and spiritual revelation: the artist touches upon final unknowable truth about life, crystallizes a fragment of the beauty and order that lie beyond the field of sense knowing and intellectual explanation.

The Expressionist's business, then, in creating the plastic synthesis, is to reveal through it the ultimate hidden principle, the all-relating harmony, the sense of cosmic unity. In Realistic art the surface of nature is reproduced or portrayed, and neither the hidden universal value in the object nor the cosmic emotion of the artist enters into the product. But in Expressionist art the two sorts of hidden value primarily determine the excellence of the work. The painting partakes more of the reality of the spirit than of the commonly accepted reality of outward nature.

The picture, with a vitality of its own sort, determined physically by the nature of its materials and means—flat field, spatial sense, voluminous organization, dynamic colors—is in itself a universe in little, yet exhibiting the laws of original creation, and the rhythm and poise of celestial movement. In its finite way, it echoes, in one more manifestation, in one further push of evolutionary achievement, the harmonious order of the infinite. A bit of the equilibrium, of the utter clearness, of intuitively divined Perfect Order, is fixed, beyond any incidental copying of disordered outward nature.

< 323 >

We have been talking here in terms common to mysticism—a word demanding definition wherever it is used, so great are the differences between one man's and another's interpretations of it.

The mysticism which enters into the conception of Expressionist art is not the playing with veils that too often cheapens the word, and confuses the uninformed public. It is a philosophy of life and a release into richer living.

The mystic believes that the world as known to senses and intellect is only one phase or manifestation of the universe and experience: that there is a world of the spirit, more directly connected with, or expressive of, first principle or Divinity. Each man is potentially divine, and through his consciousness maintains a link with original Spirit. The individual can purposely develop his consciousness of relatedness to creative Spirit, and can illumine every object and event on the immediate material plane of living, by bringing light and understanding to bear from the deeper plane. He may even withdraw occasionally from the surrounding disorder of human-physical life, into blissful self-identification with the divine Spirit, experiencing the rapture of perfect realization of harmony and order. Whether one prefers to term this identification with God— in the Christian mystic's words—or merely elevation into a region of harmonious accord of spiritual and physical living, there is presupposed a realm beyond the comprehension of the senses, but open nonetheless to human experience: where there is total release from the bondage of material and worldly things, where the individual partakes of the life of the Spirit.

The Expressionist in art believes that he brings material or "meaning" from that realm beyond, when he endows the picture with form affording experience of an unexplainable harmonious

< 324 >

order; and that he does this by means of the abstract elements, not the objective, with which he works.

The "scientific" materialists of the late 19th Century—when the Spirit, and love, and art, were all in line for explanation by test tube and chart—denied reality to everything unexplainable by sense experience and reasoning. They rejected the idea of divinity, denied the Spirit, and ridiculed the mystic. They set up sense-Reality as the only truth, and reason as the only guide to living. A later generation of scientists have helped to discredit materialistic philosophy; but mankind had already descended into that excess of animalism, cupidity and will to power that brought the earth to its present disordered state. The pendulum swings back; the interrupted continuity of spiritual-material expansion is re-affirmed —and the world of man will inevitably resume the march toward order and perfect understanding. But there are artists and critics still who would interpret Modernism from the crassest materialistic viewpoint. There have even been books on 20th Century painting that belittle the mystic implication, that make out Expressionism as largely a by-product of scientific-mechanical discovery, and material—even fleshly—living.*

* The rise of Modern painting is ascribed to Parisian Bohemianism, and more particularly to freed sexual impulses, in at least one widely advertised book on Modern Art published this year. In the opening chapter the words prostitute, whore, harlot, tart, strumpet, pimp, bawd, procurer and the like appear at least twenty times, and the politer cocottes, grisettes and mistresses as many more—with mention also of fornication, cohabitation, brothels, Lesbians, etc. It implies no sense of aloofness or assumed superiority, I believe, when one criticises a writer who thus sensationalizes or animalizes the subject of art. Certainly we all have learned to live, in these realistic times, without wincing at the mention of prostitution on its own grounds. But why, in the larger view, should that way of facing life and approaching art be considered superior to—or more realistic than—the one which involves talk of the spiritual, the mystic, the formal, etc.? The men who write such books, denying the mystic overtones and the abstract significance of Modern art, are obviously of the surviving group of scientific materialists. Having failed to establish any spiritual orientation with life, they deny the possibility of spiritual experience, and they carry the negation over into their statements in the field of art.

< 325 >

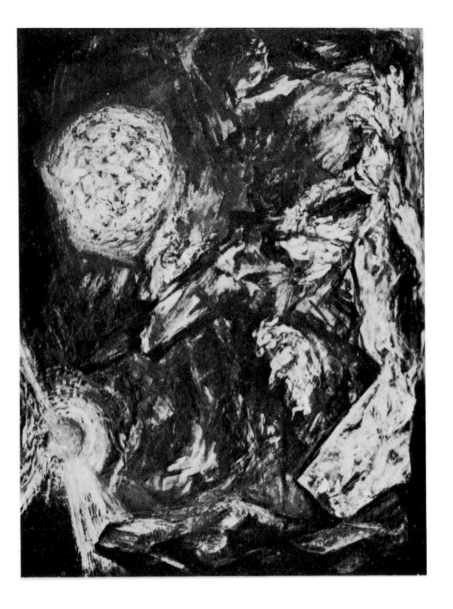

Vital Storm, by Kenneth Callahan. (By courtesy of the artist.)

The Realists having so recently been in the ascendancy, popularly, and my own position being so far distant, at the very pole, I think it wise to state, briefly but with some exactness, what sort of philosophy of life lies behind my linking of the Expressionist artist with the revelation of spiritual tru·h and the opening of four-dimensional vistas. If there is validity in the suggestion, made in another chapter, that there is in process today a regathering of spiritual forces, a push toward a possible universal belief, my own statement of its outlines may be serviceable precisely because I speak for no sect or church or system. What I think has become the belief of millions is this:

There is a unity of all that is, life undivided flowing from a single principle or source, of which man can feel but not explain the nature. This is the great well of Spirituality, the creative Center, and all phases of life known to man are manifestations in the finite of that infinite and universal power or flow. The wise individual recognizes the relatedness of all that is; and he attempts to shape every detail of his living in the light of the intuitive guidance of Spirit. The only particularization of creative Spirit functioning on man's plane is in his own consciousness: the only divinity is in man—but he is, exceedingly slowly, escaping animal bondage, as evolution proceeds. As he recognizes his own creative power, his oneness with the universal whole, himself as channel for expression of the divine, he puts himself in position to advance evolution by creation of new manifestations of order and grace. There is no other way out of the disorder and the accidents of casual nature, than by returning first to the sense of in-forming divinity— of God in man, if you will.

This is how the modern philosophy so stated applies to the creative work of the artist:

< 327 >

Life is a progression, originating from a *Creative* principle or power, and proceeding, by manifestations of that Spirit or power, in new designs of order and beauty. Each individual may make himself the instrument of creation, in the measure of his awareness of the oneness of all life and his realization of Spirit. Knowing himself a particularization of originating Spirit—with, therefore, control of material and thought in immediate surroundings—the artist is enabled to push forward creatively, originating manifestations of order beyond any accomplished theretofore, taking the step that advances evolution toward ever-purer crystallization of Spirit. The creative march, in art as in every department of man's activity, is toward intenser expression of order, relation, union, and unity.

Far from limiting expression, identification with Spirit affords the artist at once the inspiration of universality, of inexhaustible harmonious forms, and absolute freedom of creation on his immediate plane, up to the limits of his mastery of his chosen artistic medium. The artist's creative faculty both lives in the originating Spirit or power at the center of all-related life, and continually becomes a fresh center of creative manifestation.

The intellect is but a tool along the way, as the technique of one's art is a tool. Sense knowledge and mastery of one's instruments are necessary; but the greater understanding and power must be from the spiritual center, if one is to illumine life movingly.

In short, the artist is God and man, Creator and creator, drawing from the center of all life and creating new life. For the work of art is itself a living thing, manifesting vitality, order, growth, rest. The greatest art is that which expresses the apprehension of Source, Spirit, Cosmos, and at the same time expresses the creating, feeling self of the artist. Form in art is at once the expression of this dual power or origination, and expression of the poten-

< 328 >

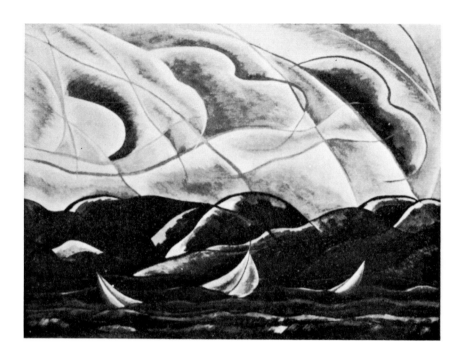

Wind, Clouds and Water, by Arthur G. Dove. (By courtesy of
An American Place.)

tialities of the particular medium employed: as manifested in the
living plastic organism in painting or the typically theatric flow of
the stage art.

I might quote from endless books and articles to support my
own view in these matters: but it hardly seems necessary to bring
varied testimony, when so many artists and critics have turned or
are turning to the mystic view. There is an excellent chapter on
"Art and Mysticism" in Barnes' *The Art in Painting*. Hofmann,
despite his usual preoccupation with the methods of plastic organi-
zation, goes back continually to the affirmation that creative art is
spiritual and transcendentally revelatory. Claude Bragdon is the
most prolific writer on the relationship of art, mysticism and four-

< 329 >

dimensional mathematics; and the reader is urged to search out his several books. Farther afield, but richly suggestive, are the works by Troward: from which my own summaries are derived, more than from any other source. But the few quotations I am adding here—not for corroboration, but because they seem to open further vistas—are from practicing artists.

Kandinsky speaks of the artist as having "a secret power of vision," and of art as "belonging to the spiritual life." He avers that "that which has no material existence cannot be subjected to a material classification. That which belongs to the spirit of the future can only be realized in feeling, and to this feeling the talent of the artist is the only road. . . . In dancing as in painting we are on the threshold of the art of the future. The same rules must be applied in both cases. Conventional beauty must go by the board and the literary element of 'story-telling' or 'anecdote' must be abandoned as useless. Both arts must learn from music that every harmony and every discord which springs from the inner spirit is beautiful, but that it is essential that they should spring from the inner spirit and from that alone."

Joseph Sheridan has expressed the whole relationship of artist, cosmos and rationalization in a few sentences: "Man the microcosm is endowed with the attributes of that, all that, which lives; the pulsing of the macrocosm, the oneness with the universe, that which makes man the part of the whole, and so sensing that there is a whole—and so endowed he has no choice, would he move upward, but to seek to create, for creation is the activity of the macrocosm. . . . The futility of creation out of rationalistic endowments, the incurring flow, during their exercise, of confounding intuitions or whispers out of the ether, awaken a new sense in a degree free from matter: a sense which catches vibrations of the Eternal, and

< 330 >

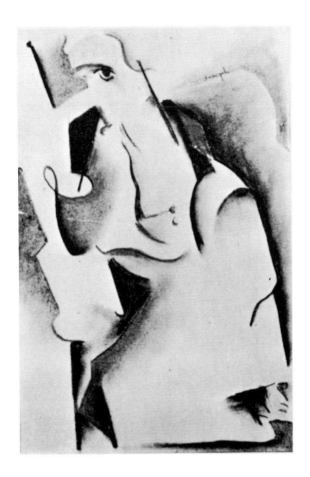

Figure Abstraction: Crayon Drawing by Joseph Sheridan.

re-expresses them in the matter-organization in which the recipient
works, a re-expression attaining to that degree of clarity to which
this vehicle styled 'artist' has himself achieved, through the elimi-
nation of worldly enchainments or weightments. Let this be named,
if one will, mysticism. Or let it be called sensitivity."

Herbert Read quotes Picasso as having said (to his biographer,
Zervos): "Whilst I work, I take no stock of what I am painting

< 331 >

on the canvas. Every time I begin a picture, I feel as though I were throwing myself into the void." Read counts this subjective method—or as I would say, "intuitive" method—revolutionary in its significance. Read adds: "We have to realize that we are now concerned, not with a logical development of the art of painting in Europe, not even with a development for which there is any historical parallel, but with an abrupt break with all tradition, with all preconceptions of what the art of painting should be. . . . Let us realize, however, that all links with the objective world are broken; that that love of the concrete which has characterized the art of Europe for centuries, and which has become inseparable from the very concept, is deliberately renounced. The painter instead turns all his perceptive faculties inwards, to the realm of his subjective fancies, his day dreams, his preconscious images. He replaces observation by intuition, analysis by synthesis, reality by symbolism."

As a footnote to this description of Picasso's subjective-intuitive method, let me add Bragdon's observation that *the intuition works mathematically.**

We may go back, for the sake of those who possibly are wearied by so much unaccustomed talk of the Infinite, the Source, and intuitive creation, to the fact that there are artists who admit the

* A bit culled, I believe, from Bragdon's *The Frozen Fountain*, New York, 1933. The quotations from Read and from Kandinsky are from books already cited: bibliographical details will be found in earlier footnotes. The quotation from Joseph Sheridan is from a letter. The volume by Troward which touches closest the artist's problem and method is *The Creative Process in the Individual*, by T. Troward, New York, 1917. I may add that, having quoted freely from the Chinese "Six Laws" in earlier chapters, I have forborne to cite again those ancient maxims that so strangely parallel "Modern" mystical theories of the painting art; but the student should not omit Binyon's *The Flight of the Dragon* from any list of books illuminating the subject-matter of this chapter.

< 332 >

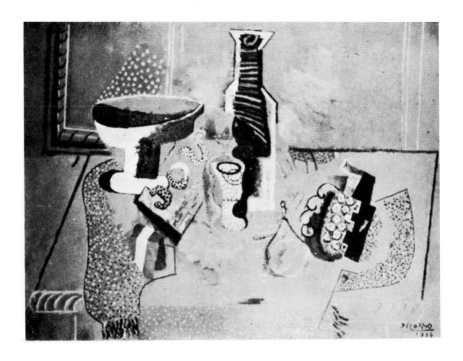

Green Still Life, by Pablo Picasso. (By courtesy of the Museum of Modern Art: Bliss Collection.)

value of the abstract but discount the mystic meaning and the cosmic significance. It is just natural, they say, that man craves the *feeling* of mathematical order: he gets the same satisfaction out of certain pictorial arrangements, designs, that he does out of seeing a tree depicted upright, with a sense of firm rooting; or out of the artificially ordered elements of a sweetly functioning machine. "And that's all there is to this talk about echoes of a universal architecture, and identification with the harmonic pulsation at the heart of life." Just crystallized geometry or mechanics: a matter of mathematical ratios, proportioned magnitudes, and pleasingly measured adjustment. One critic has posited that the

< 333 >

key to all creative Modern art is to be found in the *ratios* between the different parts of the picture.

And by way of further relief, we may return the rest of the way, and remind ourselves of those who oppose abstraction and mysticism as meaningless, in a society of intellectually emancipated men. We find a curiously mixed company in this grouping of "antis": the academicians holding to the sanctity of "normally" depicted nature; the Realist-Intellectuals; and the one-object Communists, barring abstract art because it bears no message, puts forward no promise of a workingman's world. Thomas Craven, in *Men of Art*, has summed up wittily and perfectly the intellectual-academic view: "Art at last was pure, perfect, abstract, absolute—and intolerable."

THE VARIOUS APPROACHES TO ABSTRACTION

If there is a sufficiently general and unified advance toward abstraction to warrant the claims that this is a main path of Expressionism, there is still a very great variety of approach. I have scattered through nearby pages illustrations of many sorts of example: absolute, near-abstract, and objective with strong abstract emphasis. Notes on the methods, and sometimes the intention, of the individual artist may help to illumine the points already theoretically made.

Kandinsky, of course, is the type exhibit of the mystics who state flatly that creative painting comes from the soul. In most of his mature work the objective element has been so slight that there can be no doubt that his aim is to crystallize some other-worldly order. And yet there is the point that seldom does his work lack, somewhere, a minor link with recognizable objectivity. Kandinsky

< 334 >

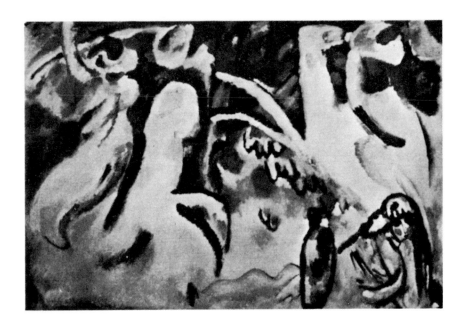

Improvisation, by Vasily Kandinsky.

is an avowed mystic, seeking to bring the light of the spiritual
realm to the illumination of earthly life. There was a time when
he studied painting by the analogy of music. But he seems to many
to have arrived at a point as near pure creation in the terms of
his medium, without dragging along suggestions of the other art,
as any living painter.

In the paintings of Nicholas Roerich, another frankly mystic
artist, there is a suggestive contrast: in that he commonly uses
subject-matter to stimulate thought upon an imagined world; though
he considers the creative design-elements of his pictures a revela-
tion direct from the soul. I must confess that I find Kandinsky's
works richer in spiritual or four-dimensional implication or feeling.
It may be that the difference is due to Kandinsky's superior formal

< 335 >

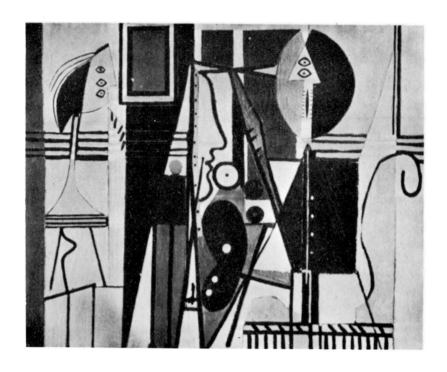

The Artist and His Model, by Pablo Picasso. (By courtesy of
Sidney Janis.)

mastery; or perhaps awakening the intellect does definitely inter-
fere with intuitive-spiritual response. It seems to me that Roerich
seldom touches upon the creative intensity of that Far Eastern art
from which his best qualities seem derived. The serenity is there,
and often a richness of coloring, but the rhythms are not compelling,
the plastic depth and adjustment lacking. Farther down the scale—
and illustrating a sort of vagueness that is too often miscalled
mystic, because reality is poetically veiled, are the shallow har-
monies of Arthur B. Davies. As a matter of fact, the abstract
element is only weakly expressed in most of his canvases.

< 336 >

Of those who seem to approach abstraction without mystic intention—with a mechanistic understanding of order, perhaps—there is a considerable group centering in Paris; another that worked fruitfully, before Germany was purged of "radicalism," at the Bauhaus, Dessau; and a considerable number of scattered painters here in America. I have chosen to illustrate, as representative, works of Jean Hélion and Raymond Jonson. These are as stripped of objective materials and symbols as the extremest purist could ask. As it is not within the province of this book to push out into the manifold theories—but only to record the generalities of the advance toward abstraction—I will put into a footnote some references to published statements of the Purists and Mechanists.*

The Cubists were the most significant "school" in the long progression between Cezanne and the abstract-Expressionists—or Purist-Abstractionists. They returned painting definitely to a search for the nature of the abstract plastic organism; and the compositions of Braque, Picasso, Gris and Marcoussis are likely to rank high among the early accomplishments of non-objective Expressionism. Their works lean to the mechanistic side, rather than the mystic-formal. They seldom attain to anything comparable to the profound rhythms of El Greco and Cezanne. Their range is as lim-

* The A. E. Gallatin Collection in the "Gallery of Living Art," at New York University, leans strongly to the most advanced abstractionists. The instructive catalogue contains an essay by Jean Hélion, on "The Evolution of Abstract Art," which is an excellent summary of the progress from the time when Cezanne broke the tradition of "submitting the picture to the model," to the "free treatment of elements" in Arp, Mondrian, etc. Hélion believes that "the artists do nothing but indicate the paths for the eyes through the surface of the pictures. Whether this path follows the known line of a nose or the anonymous trajectory of a parabole, is of no decisive importance in itself." His own work is concise, balanced, clear—he wants it to be "as clear as a sign." The same catalogue includes an excellent essay by James Johnson Sweeney, on the development of the plastic organization under and after Cubism. One of the best books on the "Functionalist" theory is *The New Vision*, by Moholy-Nagy, New York [1932].

< 337 >

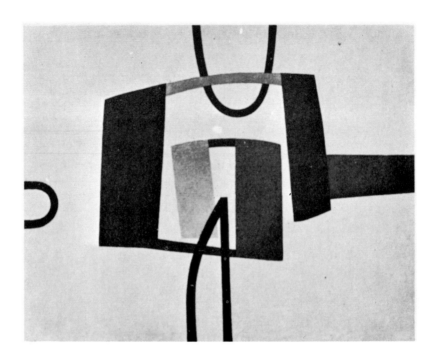

Construction, by Jean Helion. (By courtesy of the Becker Galleries.)

ited as that of the "decorators," Gauguin and Matisse—and for the
same reason: they consciously hold the spatial field to a constricted
depth, with planes closely paralleling the front "surface." The
illustrations of Cubist work indicate their virtues within those limits.

The approach to abstraction in painting by definite parallelism
to the qualities or "effects" of music, is illustrated in the portrait
of Dr. Savadsky—himself a musician—by Katherine Dreier. The
subject of the portrait has written thus: "This form of art is the
result of the acuteness and vigilance of the spiritual insight rather
than of the sharpness and keenness of the eye. Katherine Dreier's
enigmatically interwoven lines, forming here and there geometrical

< 338 >

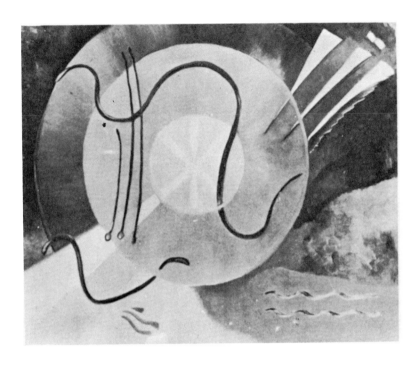

Abstract Portrait of Savadsky, by Katherine S. Dreier.

proportions, resemble combinations of harmonic chords of music.
These crossing rays of light, throwing different colors on fantastic
unknown forms . . . are reminiscent, in music, of a masterly
design of the contrapuntal order. . . . Thus, like music, these
paintings compel us to join in the process of their unfoldment,
stimulating our senses and directing our emotions. This property
of abstract painting brings about the co-ordination of emotional
vibration and gives it the music-like quality of fluidity."

Georgia O'Keeffe in one series of abstractions was obviously in-
fluenced by meditation upon the comparable elements in musical
creation. I have chosen to illustrate here, however, other phases

< 339 >

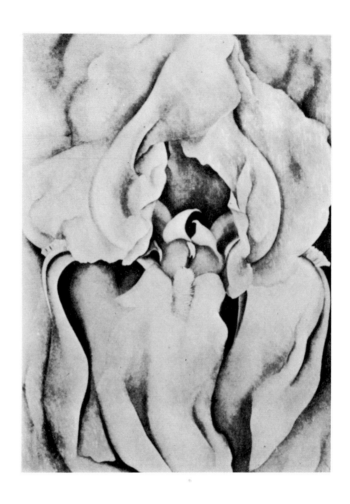

White Iris, by Georgia O'Keeffe. (By courtesy of An American Place.)

of her work—which is, to me, strangely potent and beautiful. The two plates of a white iris, the one retaining strongly the objective "natural" forms, the other a pictorial-formal organization "abstracted from" the natural object, afford an illuminating lesson in the way in which nature may *serve*, without enslaving, the artist.

< 340 >

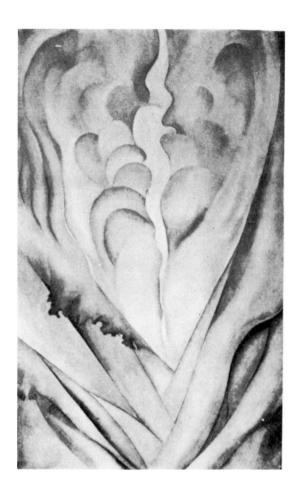

Abstraction—White Iris, by Georgia O'Keeffe.

There are few painters whose work would so well repay study for detection of the intensified abstract element: whether "absolute" or as pictorial skeleton or core. (Though I doubt not that O'Keeffe would deplore "study" of paintings for any such outside purpose: she creates her pictures, out of her own special understanding and

< 341 >

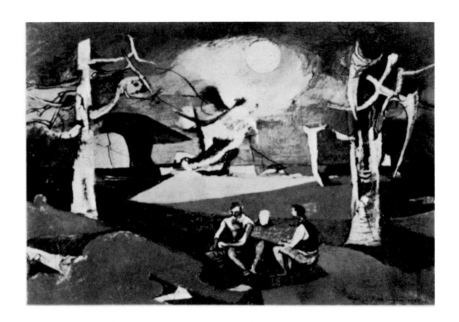

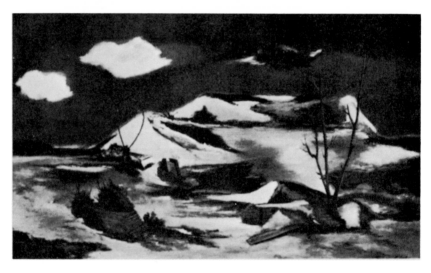

The Gale-swept Orchard, by Keith Vaughan (above); Near Somewhere, by Karl Fortess (below). (By courtesy of the American British Art Center, New York, and the Associated American Artists Galleries, New York.)

urge, and if they speak to people with like aesthetic sensitivity, that is enough. But I add a wide range of her expressions, abstract and otherwise, for the benefit of those still in the period of intellectual groping: who are trying to find mental comprehension, that they may the more freely dismiss the mind.)

We might have come at this whole question of abstraction by two approaches, differentiated as the attempt at inner subjective expression, with practically no reference to, or stimulation from, the phenomenal world of objects—Hélion, Mondrian, Arp, etc.—and the attempt at expression of the deeper structural or four-dimensional secret divined in the object. The latter approach—suggested by the *White Iris* compositions of O'Keeffe—reminds one of the dictum of Troward, not specifically directed to artists but nonetheless apropos, that: "The great duty incumbent on all who have attained to this knowledge is to impress on their fellow men that there is an *inner side* to things, and that until this *inner* side is known, the things themselves are not known."

Abstract expression in art may be revelation of something detected as a deeper value or hidden truth in the object, or it may be a manifestation direct from the well of truth beyond all objects. In either case the artist, in being creative at all, inevitably creates a world nearer final truth and cosmic harmonious order than is the casual one of outward visible nature.

ABOUT SUR-REALISM

I have left out of consideration one exhibit that many another commentator would bring prominently into view, in any exposition of the position of the Abstractionists—if only because the "school" is currently very much in evidence. I refer to the Sur-Realists, and

< 343 >

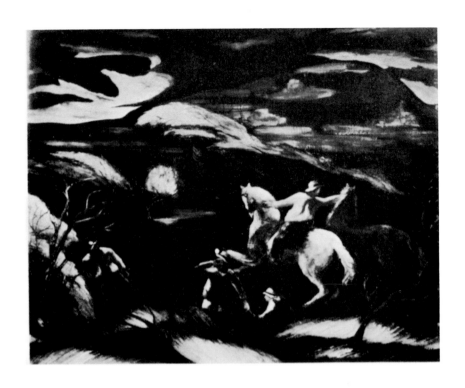

The Apparition, by Revington Arthur. (By courtesy of the Joseph
Luyber Galleries, New York.)

I dismiss them thus casually because only confusion can result
from mistaking the retreat into fancy, and into dream-symbolism,
for a true escape into free creation. The Sur-Realists, as a typical
group, substitute the images of the sub-conscious for the object
portrayed (by the Realists) direct from nature; and they juggle
these familiar images in new and "unreal" combinations. But
oftener than not the images carry so great a burden of intellectual

< 344 >

(and perhaps Freudian) significance, that the mental response precedes and nullifies the aesthetic.

This is not to say that the group affiliated under the Sur-Realist banner includes no artists endowed with rich plastic sensibility, and no creators who place attainment of abstract expression first. But these latter are in general accessions from other schools—Klee from the German Abstractionists, some graduated Cubists, etc.—claimed by the Sur-Realists, but better explained with their earlier affiliates. Giorgio di Chirico cannot be overlooked as a creative force, and even the dream-fantasy group, Miro, Ernst, Masson, etc., rise above their Sur-Realistic fetters at times: forsaking dream symbolism and intellectual baiting for absolute plastic aims. But the typical Sur-Realist credo is as essentially opposed to the main current of Expressionism as is the so-called "New Objectivism." I may add that my chary use of the word symbol or symbolism—which is occasionally employed to explain the values beyond the objective aspect—is due to the fact that most so-called symbolism in art has been a matter of placing one *intellectual* concept to suggest another. Symbolism remains on the objective and mental plane. If in Sur-Realism the artist rises above casual reality as visible in nature, it is only to re-arrange the objective symbols of nature according to a fanciful or dreamed arrangement. This is not an approach to abstraction in the chapter-meaning of the word.

< 345 >

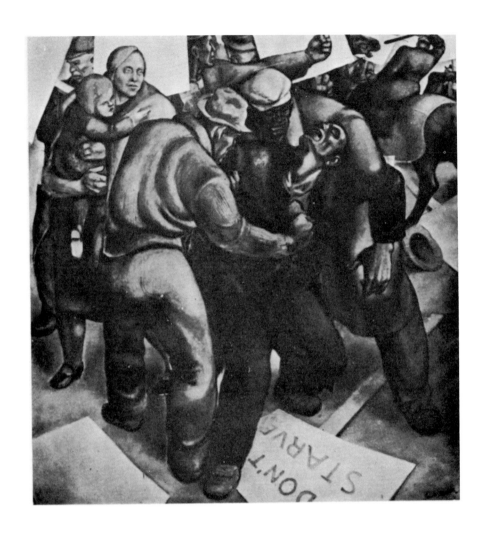

The Death of a Communist: Mural by Jacob Burck.

CHAPTER XII

FEELING AND MEANING

SINCE Realism was discredited, and the tyranny of the object destroyed, art has re-spread its wings. It now covers a territory wide and varied, from absolute abstract to purposefully meaningful. There is no authoritative warrant for claiming that one sort is exclusively valuable, or superior. The view that all serious painting is message-bearing seems to me to grow out of a narrowness, an intellectual bigotry. The counter-claim that the "highest" art is purged of objective elements, innocent of the language of phenomenal nature, is brought without the confirmation of history —and the contemporary evidence, though compelling in its narrowed field, is hardly of a volume or of an intensity to warrant dismissal of the several sorts of non-abstract art as inferior.

In the preceding chapter I affirmed my faith in abstract values: both in the occasional absolutely non-objective picture, and in the basic importance of the abstract element—skeleton or core—in the "content" picture. I have marked the swing toward apprehension and capitalization of abstract factors as a typical and healthy part of Expressionism. But this is not to say that painting is through with human or social content. I think only a few fanatics among us would insist that today the major portion of our enjoyment out of paintings is derived from purely abstract examples. Most of us will be quick to report that it derives from pictures where there is obvious understanding of the *underlying* abstract elements. But

< 347 >

we admit human-feeling and social-meaning values as still commonly entering, and valid. Without returning to Victorian preoccupation with the camera-subject, we oftener than not expect a fusion of the formal-abstract and feeling-meaning factors.

When I state that subject-matter importantly exists in the bulk of Expressionist works, it is necessary to add that *more* progress has been made in establishing a norm of abstract-formal expressiveness —in an understood plastic correlation—than in attaining a main road of human or social expressiveness. The reason lies perhaps in the confusion of contemporary life: the disorder in the spiritual and economic fields, the lack of conviction regarding purpose in present-day living, the inability of the mind to cope with the surface disorganization of a material world transitionally deranged and involved. Where subject matter exists, there is no social focus, no common agreement as to what is significant.

In approaching this matter of subject and meaning, we should by this time be free of the misconceptions and limitations that turned an earlier generation aside from an evaluation—or enjoyment—of typically pictorial expressiveness on its own account. We are happily released from the belief that there is an uplift in being "classical," insofar as that term implies devotion to the conventions and lifeless symbols of an intellectually idealized Greek-world. Nor are we seduced by the Realistic-Romantic offering of a detailed exotic world, to carry our thoughts out of our own too pressing surroundings: as a "relief" from life, rather than—what art should be—intensification of one of life's most precious experiences. When we Expressionists turn to the human and social content—the part of the picture beyond formal expressiveness and spiritual or cosmic connotation—we insist that the materials be of life as lived today, a reality of the present world. Only we dis-

< 348 >

count, in picture-making, the photographic view of that world: the depictions and inventories easy to the camera, and the longer descriptions and narratives natural to the literary art. The "realization" sought alike by Cezanne and Kokoschka and Orozco, escapes the definitions of Classicism and Romanticism; it escapes, also, both naturalistic and selective Realism, but is of the essence of the familiar world and common living.

THE CASE FOR CONTINUING OBJECTIVE CONTENT

I imagine that I hear our Abstractionist friends still asking why there is this confession of attachment to concrete subject-matter, after so complete an affirmation of the *basic* importance of the plastic-abstract and spiritual-architectonic elements. The answer of the "subjective" Expressionists is this: in the nature of Evolution, men cannot swing so quickly from an art with centuries-old traditions of human-life content, to an art purged of every element of objective reality.

Progressively man attains to spiritual awareness achieves new manifestations of order on the immediate material plane. The artist renders himself a channel of creativeness, bringing the life of the Spirit to the pictorial organism. The picture, or the expressive form in the picture, is from the central well of all-creativeness; but the manifestation is here on earth, to be "lived in" by men whose awareness is still largely conditioned by what they have experienced in the phenomenal world. The projection of the universal or cosmic is therefore still—-at this stage of progress—clothed more often than not in the symbols of life as objectified for the earth-bound human faculties.

In other words, men's grasp of the spiritual is weak—though strengthening; and the trammels of the immediate concrete world

< 349 >

are still numerous and strong. Creative geniuses arise, to speak more directly than ever before, out of the Source of life, to the spiritual consciousness in upward-struggling man. In another field —of absolute wisdom, shall we say?—Jesus, Buddha, Lao-tze, and a very few others, were such seers and prophets. But even they, so eloquent of the divine, so clear-seeing in regard to human life— even they must bring their revelations to humankind in terms of accustomed objective understanding, manifesting within an order natural to the plane upon which man has his day-by-day existence. The impulse of art is to the higher plane, toward realization of the vitality of the Spirit; yet most of us climb but laboriously to grasp of the cosmic and the abstract, out of the consciousness of a conditioning natural world. For a time yet the comprehending faculties will demand that the images of objective experience serve as carriers of the purports and suggestions of formal and spiritual order.

In time, the concrete, the lowest form of manifestation, may be burned away, as man's faculties become alight with spiritual truth. But we are not in an era when the individual man can more than illumine material living—not escape it—by devotion to the inner being. And it is likely that our artists yet awhile will subordinate, not deny, objective nature.

WHAT IS MEANING?

I will attempt to set up no boundary lines between feeling and meaning: between the emotion of the artist and the stimulus to the observer. Most of the writing on the relationship of perception, emotion, expression, and communication seems to me more confusing than clarifying. The fusion of processes is fundamentally important; the synthesis of expressive elements the prime requisite

< 350 >

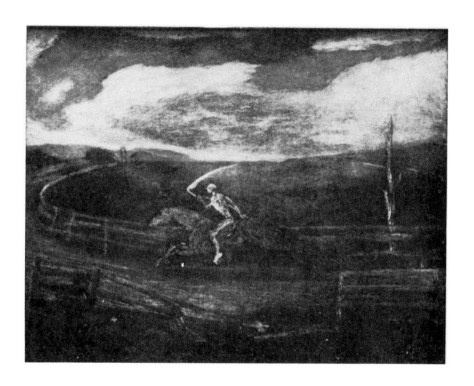

The Race Track, by Albert Ryder.

for the creator, and the conditioning achievement for appreciation.

We may, however, profitably remind ourselves of the many senses in which the two words "meaning" and "feeling" are commonly employed by artists and critics; trying, then, to delimit their application under Expressionism. I have doubtless, in pages past, used the terms "aesthetic meaning" and "mystic meaning"; but these are extensions of the word beyond the implications intended in this chapter. When the Abstractionists and those opposed to abstraction use the word, they are talking about human and social

< 351 >

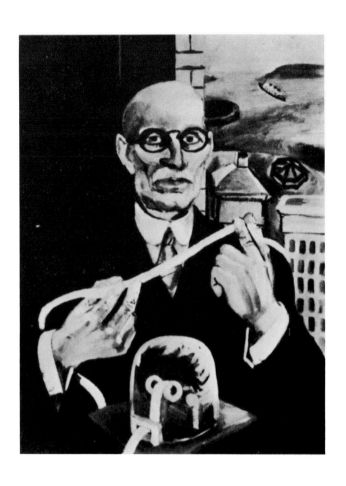

Modern Inquisitor, by Philip Evergood. (By courtesy of the A.C.A. Gallery, New York.)

significance as distinguished from formal and possibly fourth-dimensional substance or suggestion. Particularly meaning is that which stimulates, by stirring recollection, sympathy, moral sentiment, etc. Meaning may be a stimulus to the observer's feeling: cheaply and shallowly, as in popular sentimental art, or profoundly, as in deeply religious art. It may further be a stimulus to action,

< 352 >

through arousing feeling—and that is what the extremer Communists demand of "typically Modern" art today.

Meaning is the thing that stirs the artist to creation, and it carries through to the product and the effect on the observer. In the end it is compelling in measure of the intensity of the artist's feeling.

The artist "sees for others." Because his sensitivity was exceptionally keen, Cezanne penetrated through to meanings of nature hidden from most eyes, beyond the camera aspect. Because his grasp of the plastic medium was extraordinary, he was enabled to present in vitally living pictures his double "realization": of something divined beyond ordinary seeing, and of a new plastic order. He got down to some inner significance and structure of the object, stripped of trivialities and casual detail, and, in intensely pictorial terms, carried a sense of the fundamental character of the thing, its universal import, over to the observer (who, however, first had to be cured of his "educated" taste for the photographically correct or sweetened depiction of surface aspects).

In a true sense, Cezanne created a world in each picture: created, because it was a world not seen by other men, a world of new meaning for them. He offered them the two inseparable experiences of great objective art: enjoyment of a complete pictorial-plastic adventure, and a revelation of essential truth in something they had known before but in lesser significance.

SOCIALLY SIGNIFICANT ART

There are those who claim that we still have not come to meaning of the sort that characterizes the greatest painting. How, they ask, can any deep significance be attached to the endless landscapes and apples and bathing figures in Cezanne's pictures? In short, they

< 353 >

want *socially* significant subject-matter. They want the art that starts the mind to unwonted thinking, that stirs the observer to action. We are on dangerous ground here: for most of the Moderns believe that aesthetic expression can be brought to its intensest when the mental faculties are not unduly aroused. They draw a line between richly formal art and intellectualized art. The literary art, because it deals with the mind's symbols for objective things, words, necessarily is closer to a combined formal-intellectual expression; to carry the plastic art into the realm of intellectual stimulus is to render it unduly literary, mental and objective.

Perhaps the deciding factor here is that contemporary artists find so little in modern life worth re-expressing: that there is no objective-intellectual material that appeals crucially or universally. Let us grant for the moment the claim that achievement of the formal-expressive synthesis is only half the battle: that the plastically complete picture is only a shell, unless an equally moving "content" is provided. What is there in modern art to compare with the religious symbolism and story-telling of the Middle Ages and early Renaissance? Or, for that matter, with the fleshy neo-Paganism and courtly pageantry of the late Renaissance (which endowed the world of the artist and his appreciators with a certain unity and significance—though later generations detect the inherent elements of falsity)? The answer is, mighty little. Today it is a world disorganized, without unity, and a society dangerously divided and without convictions, that present themselves to the artist's social consciousness.

That is not to say that there are no new elements in life, typical of the age, that cry out for re-expression. The magnificent vistas opened by the scientists, upon cosmic glories and marvelously delicate manifestations of order, no less than the epic struggles into

< 354 >

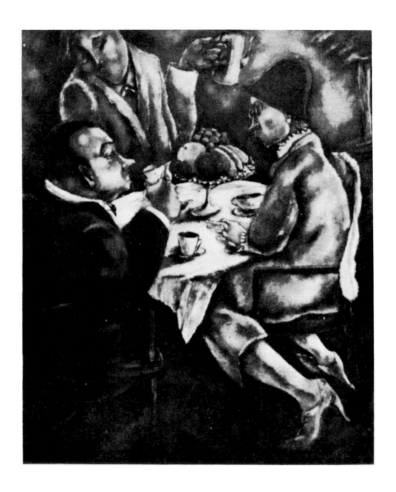

His First Crossing, by George Biddle. (By courtesy of
Frank K. M. Rehn Gallery.)

which mankind is plunged in the search for just government and a
new spiritual vision, afford the artist stirring materials and unique
inspiration. The splendor and stupendousness of the newly dis-
closed universe of nebulae and galaxies, the dwarfing grandeur of
the new physical cosmos, linked with the sweet precision of its

< 355 >

mathematical order; the compelling design of microscopical atomic matter, and its microcosmic echo of a universal dynamic rhythm; the mass struggles of class-divided men, still fighting one another although at last there is abundance for all—with the gigantic irony of persisting ignorance and selfishness and enslavement amid Utopian assurance of physical sustenance, and unlimited tools for intellectual and spiritual study and enjoyment; the collapse of royal dynasties and the march toward world unity; the decay of centuries-old churches—at a time when men crave spiritual experience and release as of old: all these are phenomena of our times, of the essence of life and progress—and so grist to the mill of the contemporary artist. No age has offered more stirring external stimulus to the creative faculties, and the painter or dancer or sculptor is deliberately blind if he fail to place himself in timely and sympathetic relationship with these conceptions and events. The sharp crisis and the cosmic perspective, the penetrating, poignant insight and the epic sweep of human issues: these all are background for the contemporary arts—but largely unexpressed.

Certainly there is little to compare with the way in which, during the Mediaeval era, the symbols and beliefs of the Christ-obsessed painter and builder entered into the mural pictures, the ikons and the idols, even into the church edifice. What is lacking today, to afford the artist grasp of the titanic elements and profound significance of the machine-age world is, of course, a binding faith, a unified attitude, an all-embracing conviction. Instead, a materialistic individualism, a surviving will-to-fight, a wide smattering of superficial education, have prevented the formulation of a world philosophy and the discovery of a comprehensive viewpoint. And perhaps that is natural, just after science has destroyed centuries-old beliefs about the universe and the physics of life; in the near-

< 356 >

The Lynching, by Ben Kopman. (By courtesy of J. B. Neumann.)

chaos when invention has rendered obsolete an economic system built up through all the known ages, and men seek frantically to establish the foundations of another; when the venerable churches are deserted; when nationalism and self-destroying imperialism approach the final phase of break-up and disappearance. In the midst of these changes, man is still too confused to attain to the philosophic belief, to gain a comprehending perspective.

And yet the artist should be prophet as well as reflector or spokesman of a society in the forming. With his special sensitivity and his profounder awareness, he should perceive before others, and give expression in his formal fashion. If there is to be meaning in painting, it should be eloquent of these things of which I have

< 357 >

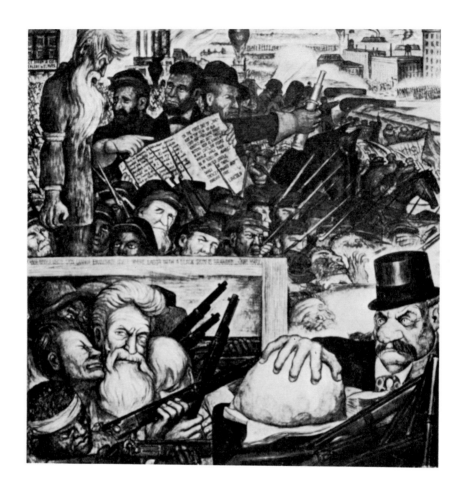

The Civil War, by Diego Rivera, in the mural series at the New Workers'
School. (By courtesy of Covici-Friede.)

spoken. Perhaps it is not too much to ask of the artist that he be
the first focusing agent, the perceiver and the herald of a new world
order, nearer to the spiritual type, underlying all still-chaotic sur-
face manifestations.

< 358 >

There comes to mind the legend of Fra Angelico: that he wept continuously while he painted his pictures of Christ on the Cross. His personal realization of the agony of Jesus, of what he believed to be the supreme tragedy of mankind, was so poignant that he suffered and cried unashamedly as he created his pictorial re-expression of the event. Where among artists today is the comparable example?

Perhaps men feel as deeply. But where is the conviction, the faith, the passion to impel that self-outpouring? Not such is the feeling of the artist for his model, or for a landscape, or for the Republic, the Empire or the King. Artists are lost in individualism, with a plentiful measure of the purely personal emotion, but without the belief that permits a magnificent devotion, an impassioned impulse to express *through* oneself a lived truth.

Not one among us has failed to experience the incitement to expression of a feeling—which perhaps at the moment of flashing into our consciousness seemed clothed in the magnificence of universal truth. Painter, writer, theatre artist, sculptor: we have been afire with the flame of creation; but how often has the result been more than a reflection of limited personal·emotion: turned out petty because our own understanding, desires and penetration were restricted and commonplace? Even when the content was less of ourselves than of a "cause" or a group, we failed of a universal view, an inspired or epic love for our subject.

THE COMMUNIST VIEW

Insofar as there may be forming a main road of human or social expressiveness, based on a world view and an idealistic philosophy, I judge that it is being laid down by those radicals whom we may,

< 359 >

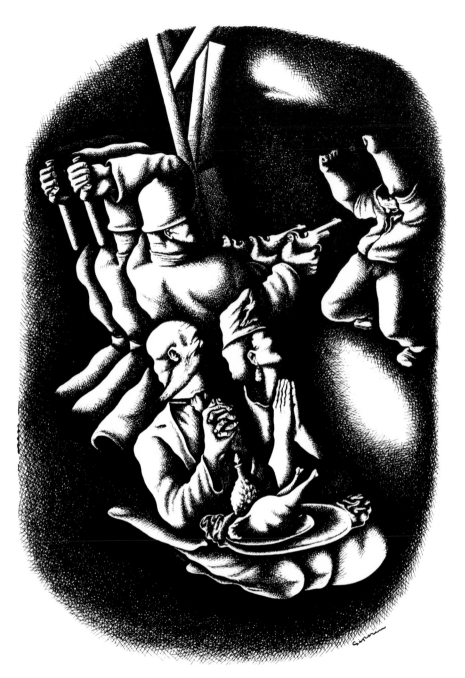

Thanksgiving 1884: One of the Haymarket series of drawings by Mitchell
Siporin. (By courtesy of the artist and *The Daily Worker*.)

in the looser significance, term Communists (this including—in our non-party sense—the Socialists). They are the only world-wide "community" of men and artists inspired by a shared conviction and a passionate devotion. Despite the frequent statements in earlier pages combating the idea—put forward by the most vociferous and extreme Communist artists—that art must serve the immediate proletarian struggle for power, I record my belief that insofar as a social consciousness is today stimulating artistic creation, and social conviction impelling personal expression, Communism is responsible. It is no accident that the theatre arts in the Soviet Union are incomparably more vigorous, vital and interesting than those of the rest of the world, or that in the United States the most stirring graphic art charged with social significance is in the far-left magazines and newspapers.

Communism as we know it, particularly in this country, from its day-by-day works—and more especially from the distorted "news" of it—may seem an imperfect vessel, and a faint promise upon which to pin hopes of a universally valid art of combined formal and human expressiveness. But in its world aspect and its essential idealism, beyond the immediate struggle and compromise and fear, it seems to me to exhibit the only unity to which millions of men are manifesting loyalty—even to that last earthly one of giving up their lives—internationally, as both a "religion" and a form of lay organization. No other ideal of the world reconstructed, no other vision of human-social order, affords the slightest promise of developing a comparable conviction and passion, strong enough to stir determining numbers of men to world action and a widely compelling art.

Perhaps I can re-state here my belief about the whole matter of art as abstract-mystic revealment and art eloquent of a social truth

< 361 >

or conviction. (I am conscious that I have left my position open to misinterpretation: perhaps myself open to the unpleasant charge of "straddling.") I believe the truth lies in these *two* statements:

First, Expressionism has gone far to prove, by progressively wide adoption of a new theory, and by a sizeable body of works, that a totally abstract or near-abstract art of painting can evoke a profound and enjoyable aesthetic response. This art will remain valid and accepted by reason of the intensity and reality of its formal-mystic crystallization of human-craved truths, regardless of lack of objective and social-stimulus content. It will survive as certainly as non-objective music has survived. It seems likely, moreover, that the evolution of man's aesthetic faculties is toward ever-greater sensitivity to the abstract element, so that artists may look forward to more rather than less absolute-abstract art; and to a greater measure of the abstract-formal element in all art.

Second, there is also an art of painting that adds to the formal abstract revelation, revealment of the artist's human feeling, and possibly stimulus to action, over the object or event. This sort of art takes on significance as it moves toward the unfoldment of truths important to group-man, as it partakes of the race-purpose and a common human spirit. In this field, the only achievement that even suggests a possible development of world-wide import is that foreshadowed in—using the term broadly—Communistic channels.

I argue the two opinions, doubtless, out of my own feeling and experience. I have enjoyed abstract art, and I have gained immensely in directness of approach since I learned to apprehend all works of art *first* as achievement of a characteristic formal completeness. Facing also a small body of contemporary art that combines the formally expressive element with subjective and social significance, evoking equally intense aesthetic response, I have found that

< 362 >

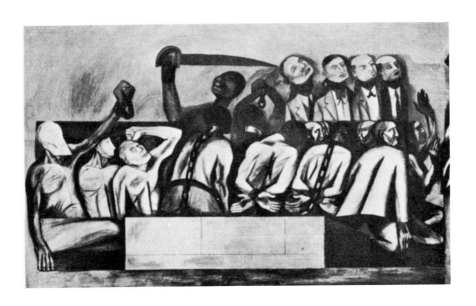

The Slaves: Mural by José Clemente Orozco, at the New School for Social Research, New York.

this oftener than not has connection with the only world-wide social-change current that I have been able to mark clearly in the confusion of the times. Both the abstract works, and the socially significant works with rich abstract core, therefore, appeal to me as phases of characteristically Modern painting. In example, I enjoy —seem to experience with typically modern intensity of feeling— Cezanne and Orozco, Marin and Siqueiros.

Ruling out the directly propagandist thing, frankly or craftily carrying a "lesson" to the beholder—(literature and the cinema, utilizing word and photograph, are better "teacher arts")—one may note that most objective or human-content painting or drawing is subtly propagandist for one social set-up or another. The endless conventional streams of portraits, nudes, sweethearts, landscapes,

< 363 >

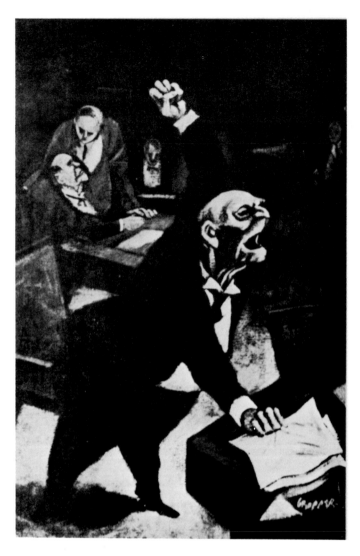

Incumbent, by William Gropper. (By courtesy of the Associated American Artists Galleries, New York.)

battle scenes, Venetian and Algerian travel bits, etc., etc., are really eloquent of a way of living, and suggest by inference the superiority or sufficiency of the life of which they are a part. The flattering

< 364 >

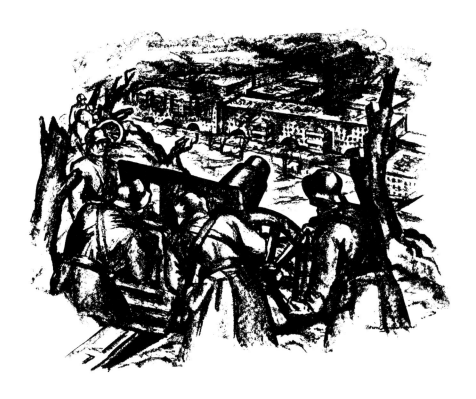

Bombardment of Workers in the Karl Marx Hof, Vienna: Illustration by
Marion Greenwood for *The New Masses*.

portraits of "important" people, the reminders of the delights of
the flesh, the romantic invitations to escape from familiar surround-
ings, the patriotic allegories—all these are indicative of the "so-
ciety" that is: the tired, faithless, materialistic, divided world,
held together precariously, without a ground for common conviction
of artist and any large group of beholders. They "speak for" the
status quo.

If subject-painting must be eloquent of something in life, let it
be—say the social-stimulus advocates—a something worth being

< 365 >

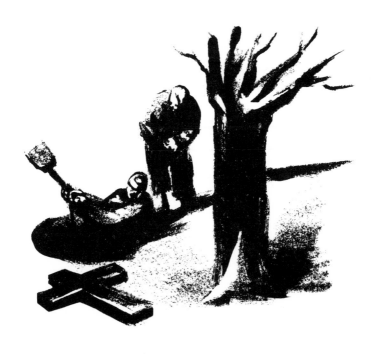

Illustration by Phil Bard, for *The New Masses*.

passionate over, arising out of conviction, and communicating conviction. In other words, let us have Rivera, and those who go farther in that direction, rather than Sargent and Frieseke, and those nonentities who, largely, fill the walls on 57th Street today.

Where I part from the typical Communist critic is, first, in my willingness on occasion to accept as self-sufficient a type of art without the attributes of social meaning; and second—when I come to human-content art—in my insistence that there are sorts with universal values not directly *illustrating* the coming of a world-state and justice for the worker.

It is not surprising that when political dissentients are on the defensive, when every avowed radical is made keenly aware of

< 366 >

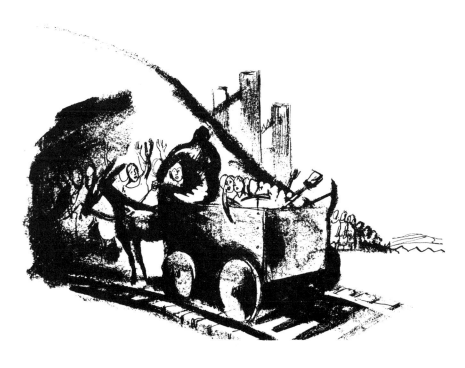

Illustration by Phil Bard, for *The New Masses.*

strife, injustice and opposition, the constituted spokesmen should claim that no art is good that does not directly further "the cause." The world is in an emergency; ergo, art must be drafted with all else, to the one political end. But any observer not blinded by the immediacy of the beginning struggle should see that art can serve better by developing to its own greatest intensity in its own primary terms, not distorted to message-bearing purposes; and if it has become truly Modern, it will then be found to link inevitably with the social Modernism that is of the coming age.

The test, I think, should be that this art will be worthy of the society that will *follow* the immediate inevitable struggle, not merely of service to the participants in that struggle. The very ·extreme

< 367 >

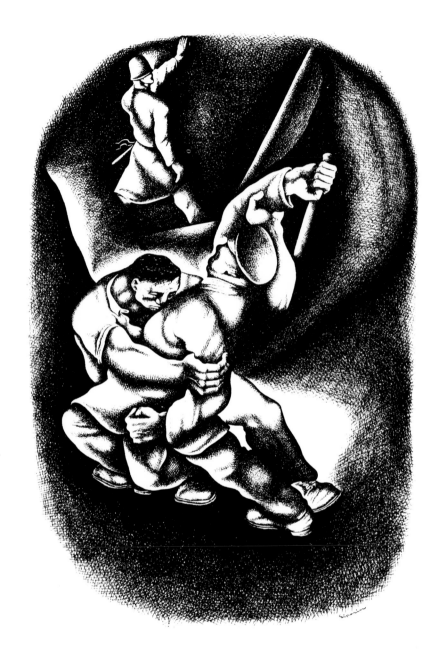

Haymarket 1934: One of the drawings by Mitchell Siporin commemorating the "Haymarket Massacre." (By courtesy of the artist and *The Daily Worker*.)

claim that no art is worth survival that does not promulgate the theses of radicalism—we might substitute Fascism for Communism here—is sufficiently answered, perhaps, by a counter-question: is music, a non-objective, message-free art, not to survive? The Expressionist is likely to claim that any painting as intensely expressive in its own terms as the music of Bach or Beethoven, is bound to override any temporal struggle or interlude of chaos.

The existence of a significant art of painting linked with the radical or leftist social movement, can best be illustrated from the works of those Mexican muralists who have so curiously come to pre-eminence in the United States. Despite the lack of sympathy in high places, Rivera, Orozco and Siqueiros, and their Northern imitators, have pushed forward until they afford the only instance of a group movement, of undoubted creative significance, in the American world of painting. If this were the sole evidence of linked formal-creative achievement and radical social consciousness, no inferences would be in order. But in the kindred field of black-and-white illustration there is nothing in the "regular" press to approach the vitality of the drawings appearing in such newspapers as *The Daily Worker* and such magazines as *The New Masses*. I speak not of the human content alone, but of that joint plastic-formal and human-feeling expressiveness which alone can make this sort of thing lastingly significant. I reproduce examples which the reader may analyse for himself.

Equally, I shall leave the reproductions of the murals of Orozco and Rivera to illustrate without comment the richly formal achievement, linked with socially significant "content," that places these Mexicans in the forefront of American Expressionists.

What I have said in this chapter on Feeling and Meaning might be set down in one-two-three order thus:

< 369 >

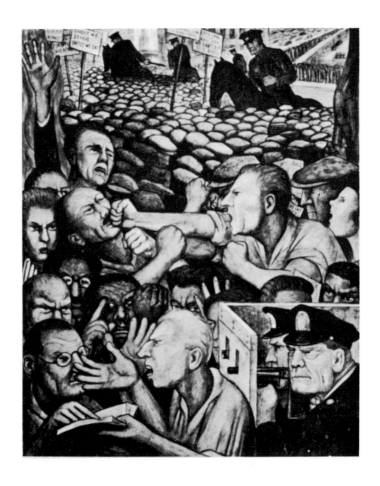

Division and Depression: Mural by Diego Rivera at the New Workers
School, New York, depicting the unemployed, bread lines, and police rule.
(By courtesy of Covici-Friede, publishers of *Portrait of America*, by
Diego Rivera.)

All creative painting is expressive of the instrument and of the
artist's feeling: of his mastery of the specialized plastic means of
the art, and of his image-compelling emotion. The meaning carried
over to the observer may be of three sorts: first, a mystic-abstract

< 370 >

meaning wholly free from images of the concrete world; second, a
meaning both mystic and incidentally objective—as in much of
Cezanne—in which case the abstract-formal core is the truer reason
for the existence of the picture; and third, a combined formal-
expressive and socially-valuable or humanly-stirring meaning—in
the art of immediate subjective appeal, over a formally vital skele-
ton, as in Orozco, and (in black-and-white) Siporin, Gorelick, Gel-
lert, Gropper, Burck, Del, and Bard.

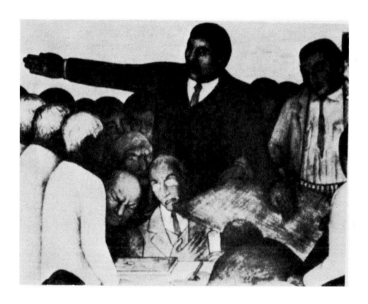

Mural, by Diego Rivera. (Photo by courtesy of Weyhe Gallery, from
original in Mexico City.)

< 371 >

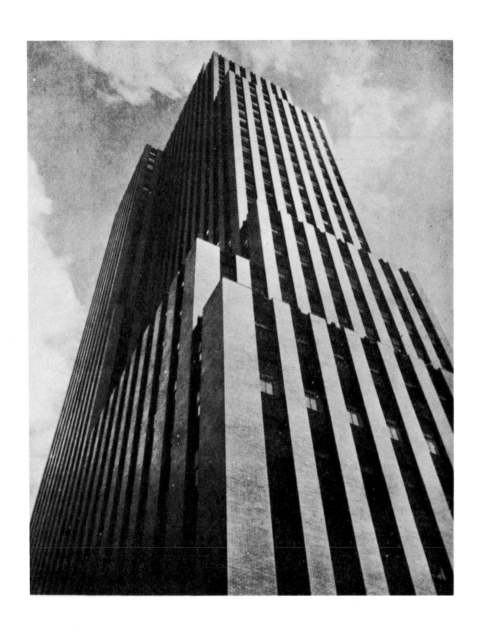

The News Building, New York. Like the Rockefeller Center buildings, this illustrates the bare bones of a new architecture: structurally expressive, but without creative enrichment. (John Mead Howells and Raymond M. Hood, Architects.)

CHAPTER XIII

THE ARTS OTHER THAN PAINTING

HAVING attempted my answer to the unanswerable question, "Are Modern painters necessarily Reds?" I am relieved to reach the comparatively untroubled waters of the other arts. The streams of progress of the several arts flow parallel, and even mingle at some points; but, in general, there is not elsewhere the vexing question of the comparative degree of abstraction, subject-interest and meaning-stimulus.

The pictorial art, as noted in an early chapter, affords the neatest example of revolutionary change from 19th Century Realism to 20th Century Expressionism. The boundary line between an old art and a new is there most distinct: the about-face of theory most cleancut and decisive, the contrast of exhibited examples most unmistakable. I have, therefore, in setting out to illustrate the development of Expressionism, chosen to analyze from several viewpoints the advance in painting, as the type art.

It is of course impossible to treat all the arts in similar detail—in less than a seven-volume work. But it is part of my purpose, in outlining what has been learned of the nature of Expressionism, in its first half-century of development, to indicate briefly how the lines of advance, as illustrated in painting, are clearly traceable in several sister arts. It would be but poor support for my theory of the interlocking nature of the several Modernisms—in art, science, government, the spiritual realm—if I could not show a

< 373 >

common progress, nay revolution, in the several fields within the broad activity termed art. In practice and in theory, indeed, there are corresponding gains in the theatre, the dance, architecture, and on—though less patently—to the end of the list.

The broad shifts which may be expected to discover themselves throughout the range, if there is an all-embracing creative advance, may be summed up as these: negatively, an abandonment, in the graphic arts, of photographic, transcriptive and illusional aims, and in the near-abstract arts, a denial of historic-imitational limitations (such as existed in 19th Century "Eclectic" architecture, or the contemporary remnants of the dance art); and, positively or constructively, a leap forward to intensified expression, in the triple achievement of newly-compelling use of the medium, revelation of profounder implications of order, and subjective crystallization of the artist's feeling or insight. The sum of these gains might be described as the attainment, among the Expressionists, of a common element termed "expressive form," partaking of the three sorts of "revealment"—instrumental-formal, universal, and personal-responsive—but in each art conditioned by the nature of the medium, sculptural, theatrical, plastic, etc.

ARCHITECTURE, THE TIMES, AND EXPRESSIONISM

The art of architecture, next to painting, affords the clearest-cut example of utter revolution, in theory, and in widespread "radical" practice. If the main lines of change were obscured, for thirty years, after being laid down a half century ago, the sudden swing toward "the new architecture," throughout Europe and the United States, since the World War, has made the logic of Modernism in the building art patent to all, and the examples inescapable.

< 374 >

In the Victorian era, imitative, historic-echo architecture was as prevalent as Realistic painting. The Eclectics ruled the profession, the schools, and the channels of criticism and appreciation. The originator was scoffed at. Tradition was praised as something ended and sacrosanct. The "art" consisted in re-arranging bits adapted from past practice. The revolution from this sort of reflective and impotent building, to a truly expressive architecture, started when a few pioneers—most notably Sullivan and Wright in this country, Berlage in Holland, and Wagner in Austria—challenged the historic knickknack sort of thing, and set out upon a course of creative experiment with modern materials and machine-age methods of engineering.

Sullivan promulgated a motto for the "radicals" the world over: "Form must follow function." It is worth while to pause a little over the ways in which functional—or expressive-organic—architecture had been lost to Europe and America in his time.

Architects throughout the Western world had become mere choosers and adapters, in the mid-19th Century. They had decided that all possible styles had been invented. They chose their style and their motifs from the buildings of the past. They taught students that any structure, even railway terminal or hangar, could be properly sheathed within one of the stylistic envelopes hallowed by age.

Even with new inventions in structural methods, and the development of new building materials, steel and poured concrete, the architects covered over the engineering with veneers echoing the old methods and materials—remained faithfully mediaeval or tastefully Renaissance. They masked the steel-frame structures with temple façades and cathedral fronts. They even tortured concrete into forms simulating cut stone. You can see this sort of

< 375 >

architectural falsification in almost any concrete structure in your own town. And surely you will find there banks hiding behind Greek temple porticos, and vegetable markets in Italian palace loggias. A lot of us used to believe that a building with a row of Greek columns on the front was *ipso facto* artistic.

Those 19th Century architects hung up useless cornices on flat-top buildings, attached functionless columns where they cut off light from the windows, and did a dozen other architecturally-dishonest things. They were forgetting the organism that lies at the heart of every true work of art. They were dealing in antiquarian trifles, thinking in terms of unrelated façades, of pretty arrangements of surface ornament. Their structures were generally inexpressive of the engineering within, of the materials employed, and of the spirit of their own time. Their art was a hangover from the courtly age, totally unrelated to any of the deeper social drifts of the era, democracy, industrialism, scientific advance. Architecture had become a museum art—reflective and illustrative, not expressive.

Even during that 19th Century when architectural falsification was almost universal, a few radical artists were laying the foundation of a new sort of building. Today there emerge, in all the countries of Europe, and in every town of our own land, the beginnings of an expressive building art. It is unmistakably new, unmistakably of the machine age; and certainly it is the first great creative advance in the art since the Gothic. Renaissance was just what its name implies, the rebirth of an old architecture. Today the building is new in every phase, engineering, use, design, appearance.

Looking at the styles and motifs, the columns and cornices and ornaments, of the Eclectics and the Beaux-Arts men, the Modernists

< 376 >

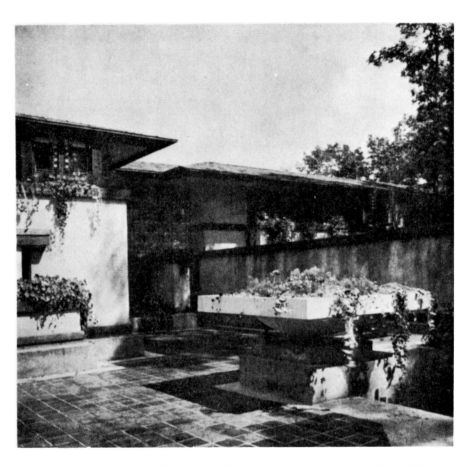

A House in Illinois, by Frank Lloyd Wright. An early work that exhibits many of the idioms later incorporated into European-American expressive Modernism.

say, "sweep it all out." Strip off every vestige of ornament, every column, pilaster, cornice or window frame that has been divorced from its original function, every meaningless escutcheon and cupid and regally decorated ceiling. Shear off every merely "picturesque" addition, every flourish, every atrophied member. Thus the first phase of the new building sometimes seems like a "stripped architecture."

< 377 >

Some people, of course, don't like the stripped look. To them the new architecture seems bare, almost hospital-like. They miss the cushioning, the regal softness, and the Victorian luxuriousness. But enrichment will come, in idioms that belong to our own time—particularly in a greater fullness of color. But in "decoration" too. Only that decoration, the Expressionists insist, must grow out of the characteristics of the type of building men are now doing, and out of the materials they are using. Some critics believe that the stripped look is proper expression of a machine-age directness and mathematical precision. Certainly a great deal of the new architecture so far, whether in the American skyscraper or the functional houses of Germany and Russia, exhibits long, hard edges, surfaces kept smooth and sanitarily clean, and massive proportions. Some of the sense of irresistible power, of mechanical efficiency, belonging to our era, is here objectified.

Beyond the basic simplicity, directness, massiveness, there is, of course, a form appropriate to the skyscraper and another appropriate to the house, and still another appropriate to library or market or gymnasium. But from all, if the architect is true to his materials and his time, the old decorative motives have been sheared away.

The new architecture is Expressionistic in exactly the way of the new painting. The first characteristic is—let me repeat—that it expresses, rather than imitates. There is, first of all—and this is the easiest characteristic to mark—genuine and clear expression of the materials and methods of the art. There is also expression of the life of today: men's ways of living, their activities and thought, and their highest aspirations. Finally, there is—in a small fraction of cases—expression of the subjective, personal, creative genius of the designer.

< 378 >

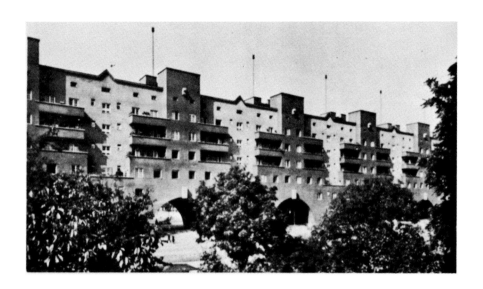

Karl Marx Hof: Modern workingmen's apartments in Vienna.
Karl Ehn, Architect.

The Expressionist architect more than any other artist gains in having at his disposal an enlarged range of physical materials. Instead of the immemorial building by means of stone laid on stone, he is released for new sorts of compositional design, in having steel (and other metals just now being tried), concrete, and glass in large areas and new forms not dreamed possible by earlier generations. The skyscrapers, now that the Classic and Gothic veneers are generally omitted, assert the cage-like steel frame—towering upright, and repeated cross-member; factories, warehouses and stations are eloquent of the heavy block of poured concrete; and not a few houses tell the story of new possibilities of concrete blocks, of stucco, and of wood used for typically wood-like effect.

All these materials are utilized by the Moderns with scrupulous regard for their own natural effects when functionally placed. The

< 379 >

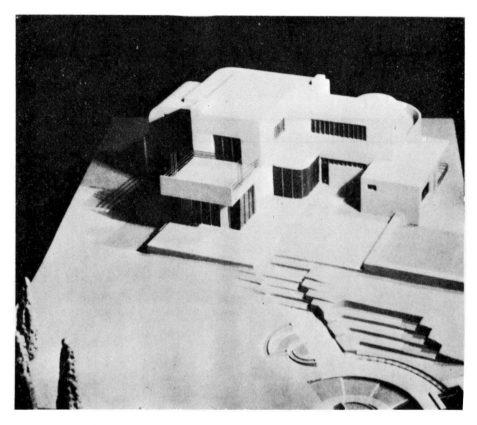

Model for a Functionalist House, by Norman Bel Geddes.

aesthetics of the building art begins here: in the organic truth of
member-parts, and the undisguised attributes and peculiarities of
the materials. It was Louis Sullivan—engineer as well as architect
—who summed this up, back in the 'Eighties, with that now-famous
challenge to the Eclectics, which can hardly be repeated too often:
"Form must follow function." Only thus can the organic unity be
manifested.

Frank Lloyd Wright was instrumental in spreading the "slogan"
to cover the idea not only of material-and-member function but of

< 380 >

use-function—as also he was to provide the first example of out-standing personal creativeness linked with functional design.

Perhaps I can best indicate by example the change in thought on the matter of use-honesty. When I was outlining this book I was living in New Haven and one of my diversions was walking out among that strange collection of buildings which is, physically, Yale University. Day after day I passed what I took to be the Divinity School: a massive truncated Gothic tower, blocks of mediaeval monks' cells with thin infrequent windows, mortuary chapels, and sculpture direct from some ancient Notre Dame. Then something prompted me to step inside, and I found encased in those ecclesiastic walls—the new Yale gymnasium. That is what the Expressionist calls "falsification of use-expression." It is a form of architectural dishonesty that became well-nigh universal in the Victorian era, surviving still in such strongholds of tradition as universities, museums and women's clubs.

The Modernists insist upon an appropriateness of design to occupancy, to use-function. One reason for the stripped and bare "look" of early functional architecture is to be discovered in this: the orthodox architects relinquished to the radicals first such difficult-to-ornament structures as factories, hangars, and warehouses, where use determined sanitarily sheer walls and a generally simple effect. As the modern home, now a functioning machine for pleasant housekeeping, becomes more efficient, the machine-idioms of simple lines and clean surfaces creep also into expressive-functional house-design: where, in the Eclectic era, planning began with choice of the Spanish style or the Italian, or English-cottage or Dutch Colonial. In the later examples the richness and ease of living are expressed also in a greater colorfulness, reposefulness and terraced openness.

< 381 >

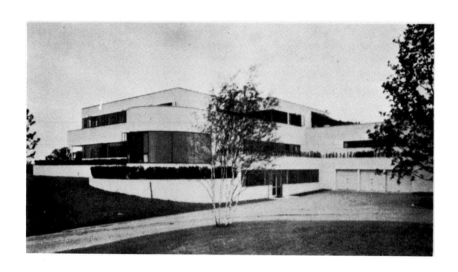

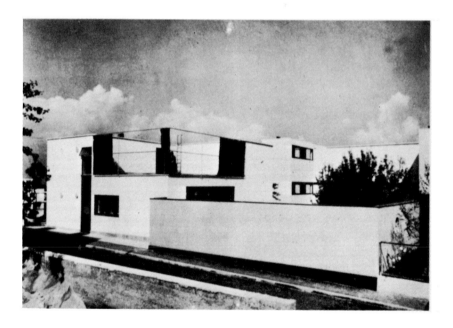

Functional Houses, by Edward Stone and Donald Deskey, at Mt. Kisco, New York (above); and Walter Gropius, at Stuttgart, Germany (below).

Let no one suppose, incidentally, that the true Expressionist will own the current "Century of Progress" Exposition in Chicago as other than a travesty on Modernist architecture. It illustrates practically every violation of creative-expressive principles: every fault of the old Eclectic architecture except the return to borrowed antiquarian surface-motifs. It utterly lacks unity, an organic creative relatedness. The surface forms, instead of growing out of structural methods, material and uses, are in general borrowings from the outward "effects" of recent European exposition buildings. The collection as a whole is a perfect example of the imitative designer's failure to attain to the spirit of creative Modernism. The Exposition, of course, was "done" by Eclectics, who thought they were being creatively Modern because they incorporated the surface idioms of some "early Modern" buildings, as easily as they had previously borrowed Greek, Gothic or Renaissance façades. Expressionism goes deeper than that. It must be organic. It must be expressive. It must be from within.

Of the Moderns who express, over and above those other formal values, a deeply creative personality, the foremost is Frank Lloyd Wright. Through nearly forty years Wright has used the materials of architecture in expressions unmistakably original, compelling and rich. Almost invariably the building can be recognized as Wright's; and yet Wright has no recognizable "style"—because he varies his creative touch with the conditions of materials, use, site, and owner-personality. I am illustrating two of Wright's creations, to suggest that Modernism can be varied in effect, even while true to its own materials and the times. Wright has said that the problem is not to create a "modern style," but to put style into whatever you design—varied by the conditioning purpose of the building, structural characteristics, etc.

< 383 >

Attempts have been made to define a typical style of the machine-age, especially as something termed "the International Style." But only up to a point is this a possibility: the new materials afford certain typical outward effects, and contemporary machined life dictates a frank simplification, a cleanness of aspect—and an openness. It might be argued—regarding the "open" aspect—that architecture has marched fairly straight from dugout, windowless temple and fortress to the openness possible with steel-and-concrete frame and movable glass areas. But no matter how these fundamentals may dictate the negative change of abandoning ancient stylistic detail, and the positive one of building on a frankly age-of-steel framework, the fact remains that the final determining element, the subjective-creative emotional contribution of the architect, is only slightly expressed as yet. In other words, the world has recognized the theory and early basic manifestations of an Expressionist art of building, but the larger part of the creative outpouring, even the fixing of idiomatic enrichment and accent, is yet to come. Masters have been among us already, Wright, Hoffmann, Mies van der Rohe, and a very few others, but the practice is only a beginning of the flowering we shall see in the second half of the 20th Century.

If there is in architecture an analogue to the newly-stated expressive-formal theory of painting—the theory of plastic orchestration—it is to be found in the talk about the "space conception" of the building art. That space enclosed, space used, and spatial proportions are nearer basic than wall-building—even the pioneer Modernists were too thoughtful of walls, perhaps—might be considered the beginning point of a new architectural philosophy: developed first by Wright in his notably "open" buildings, and expressed in varying forms by Oud, Gropius, Mies van der Rohe,

< 384 >

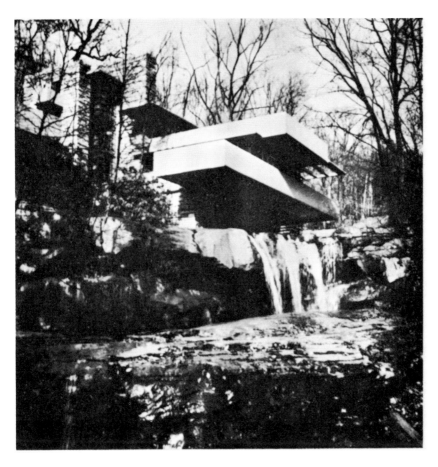

Falling Water House, Bear Run, Pennsylvania, by Frank Lloyd Wright. (By courtesy of Edgar J. Kaufmann, Jr., and the Museum of Modern Art, New York.)

Dudok, Le Corbusier, Kiesler, Neutra, and Geddes. After the façade-adapting during the centuries of Renaissance theorizing and neo-historic practice, this conception of spatial design, of plastic-organic parts, and of machine-efficient functioning, comes as a revolutionary basis, for an epochally new expressive architecture. The crag-like skyscrapers of New York, the functional houses of Ger-

< 385 >

man suburbs, the Soviet factories, the schools of progressive Dutch towns, and the houses by Wright in Illinois and California, are examples, variously creative, of that expressiveness—and by that token truly Expressionistic.

THE DANCE: BALLET, DUNCAN, WIGMAN

In the dance again, there is the perfect parallel: an art expressive in historic times, but brought within strict imitative limitations in the 18th-19th Centuries; then a revolutionary figure appearing, followed immediately by other innovators, challenging conventional practice and orthodox theory, and initiating an epochally different —and richly expressive—manifestation.

The ballet is the immediate background: a type of dance bound up in a strict code of technical regulations, designed exclusively for a small class-audience, restricted to a minor place in another art, opera. Today it is difficult to realize that this court plaything, embedded in an operatic mélange, constituted all there was to the art of the dance, through several generations. Yet the literature of the subject will attest that there was no other dancing "art"—barring sporadic "folk" activity—through centuries.

The revolutionary practice initiated by Isadora Duncan, and then developed in many lands under an assortment of labels—the free dance, aesthetic dancing, abstract dance, etc.—is seen now as a parallel to the painting of Cezanne and the architecture of Sullivan and Wright. There is first the stripping from the art of old aims, old rules, and the accumulation of borrowed features. In this case Duncan swept out not only the tight-binding regulations about steps and patterning, but the tight-binding costume—a heritage from the masquerade-like court ballets. She liberated the body for self-expression, for expression of the prime instrument of the art. In

< 386 >

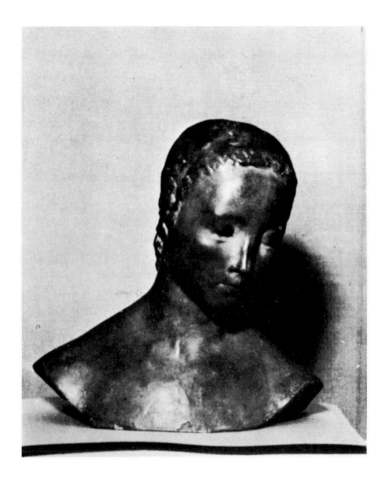

Head, by Wilhelm Lehmbruck. (By courtesy of the Downtown Gallery, New York.)

another gesture she exactly paralleled the Expressionists of the pictorial art: she wrenched dancing free from its literary aims, from the story-telling which had been an inseparable part of the ballet.

In all of this Duncan was travelling the high road from imitationalism to Expressionism. She is the pivotal figure, opening the world's eyes to the way in which an art had been narrowed till

< 387 >

opportunity for creativeness had been all but squeezed out of it; then offering examples of a free art, capitalizing anew the typical medium of expression, offering at the same time an outpouring of herself. With her the *self*-expression element was strong; the grasp of abstract-formal means more intuitive than studied. Her essays on the dance are full of references to nature as an inspiration, offering not ready-made patterns for interpretation, but a mystic urge to further personal revelation of rhythmic order. Duncan, like Cezanne and Sullivan, is ranged with those who seek a realization of unseen overtones, of a unity and a purpose beyond surface nature.

Some critics feel that Isadora failed to divest herself of the last vestiges of Impressionism, even of Romanticism. While granting her the position of the pioneer Secessionist from the rule-encumbered ballet, they think of her as only imperfectly expressive of a new abstract-formal understanding and a contemporary machine-age meaning. They point to the German "abstract" dancers as evidence of an advance beyond anything exhibited or forecast by her. The question is perhaps unimportant, at the point now reached by dance practice and dance criticism. Here there is, I believe, no such clarifying body of theory, on the instrumental side, as the theory of plastic design in the pictorial field. It is easy to mark the epochal shift into new ways of expression. But there are no landmarks, no generally accepted theoretical guide, no authority for ranking the several contributive figures.

All one can record confidently is that Duncan came at a time when the art had crystallized, that she turned the attention of the world to a different sort of dance, by the example of her own self-expression, and that she released new energies in countless directions: sometimes through frank imitators, sometimes by inspiring "schools"—Dalcroze, etc.—sometimes by galvanizing traditionally

< 388 >

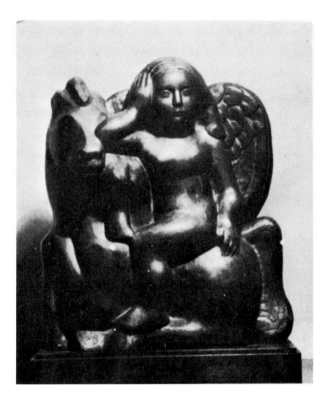

Young Pegasus, by William Zorach.

trained troupes into richer expression, as in the offerings of Diag-
hileff's Russian Ballet, Pavlowa, and Fokine's groups. The
"spread" of her influence and inspiration were truly amazing;
though she herself may have failed to escape wholly from emotional-
interpretive limitations.

Certainly Mary Wigman carries her audience into a realm where
abstract-formal means count for more. Both dancers attained to
an organic unity, in this case a flow, a revealed rhythmic order.
One was subjective, expressed life as she felt it, perhaps a bit pic-
turesquely still; the other delights to sink herself in expression of

< 389 >

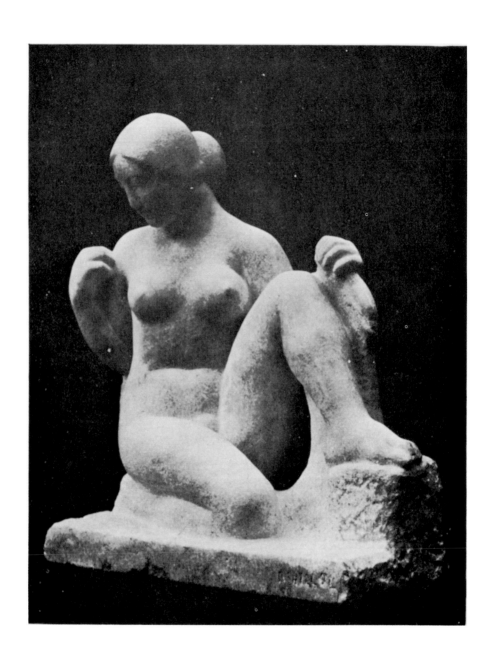

Seated Nude, by Aristide Maillol. (By courtesy of Pierre Matisse Gallery.)

abstractions—machine-age mathematical abstractions. She carries the dance one step farther from Realism, and she affords millions of people an aesthetic stimulus, in terms true to the dance art. She too is a great Expressionist, the greatest in the field today—as Isadora Duncan was in the pioneer days.

Expressive form in this art, as I have noted, has been but confusedly debated by the dancers and critics, and it remains for some future student to formulate the theory of dance Modernism, as helpfully as the new painting and architecture and theatre have been interpreted. But this much is easy to see: the art has returned, substantially, to intensified expressiveness of the means—movement and the human body—of the artist's emotion or understanding, and of life today.*

EXPRESSIONISM IN SCULPTURE

In reviewing the several arts, in this way, I find the revolutions so alike that I am at a loss for words not already overused. And indeed, when I arrive at scultpure, I know that again the revolution is to be explained in only one way: a return, essentially, to expression, from imitation. Again it is a threefold expressiveness that is attained, of the materials and methods particular to the art—resulting in unmistakably *sculptural* form; of a deeper order and structure in the object; and of the artist's feeling.

In this art there is a fairly well-defined theory of formal organization. It not only parallels the theory of plastic orchestration in painting; with allowances for the difference of materials in the two arts, it partakes of the same nature of plastic elements ordered in space. A theory first set forth by Adolph Hildebrand posits that

* Martha Graham, a rare artist and a creative leader in the art of the dance, has taken first place in the Modern tradition in this country, since this book was first written.

< 391 >

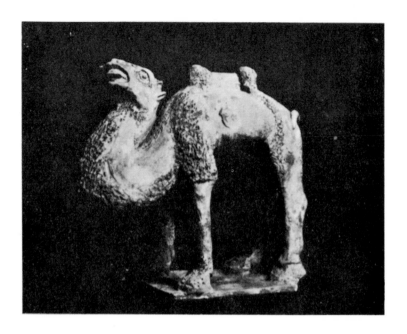

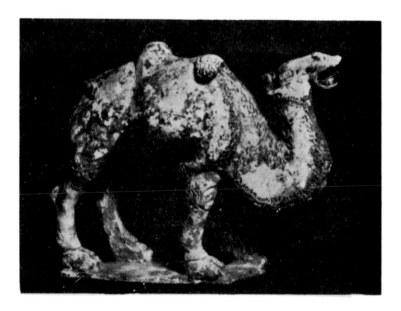

Camels: Early Chinese Sculptures. Richly expressive of a deeper "realization" of the object, and of the potentialities of the medium. (By courtesy of Richard E. Fuller and the Seattle Art Museum.)

a sculptural field is established by the farthest projections or total "relief" of the statue—establishing understood limits or a frame similar to that of the spatial field in painting—and that the sculptural order is created by manipulation of volume and plane with relation to this field. It remained for others to clarify this theory by reference to modern physical law: showing that relation of volume to volume, with felt tensions between axes, is the basic structural factor in the art. This is the art of related mass, of rhythmic-voluminous organization.

Linked with this theory of an instrumental unity, a plastic structure, is the insistence upon a return to essentially sculptural materials. All the early pioneers of Modernism denied validity to modelling as the method of the art, and demanded a return to stone-cutting. The first principles arise from the massiveness of the stone block, the resistance of the stone to the tool, and the glyptic process. The light painty effects possible to modelling belong, the Expressionists believe, to a minor branch of the art, not truly sculptural. They claim that nothing but confusion can result from transferring the modelled figure into stone. There are processes which fix the modelled volumes and planes appropriately—as terra cotta. The clay figure can also be built up with regard to an ultimate casting in metal—the effect of the metal surface being remembered at every step along the way. But the truest sculpture deals with stone, expresses stone-quality, is massive with the density and heaviness of this material. It is partly the return to stone as a conditioning factor that puts Expressionist sculpture into obvious accord with the Primitives of many nations, and with certain periods of Chinese and Egyptian art.

But while there is the usual background of Expressionist achievement, in the far past, the 17th-19th Centuries were even more

< 393 >

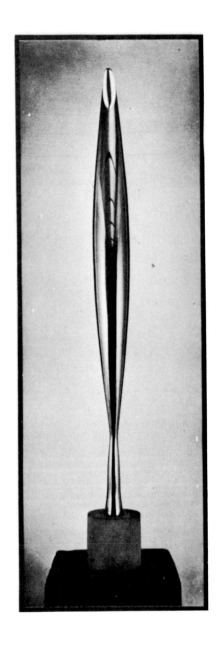

Bird, by Constantin Brancusi. An example of near-abstraction in sculpture.
(From copyright photo by F. S. Lincoln.)

innocent of creative figures here than in painting. Michael Angelo is the sole great Renaissance artist claimed by the Expressionists. After him there was ornamental and naturalistic and selectively Realistic sculpture. In the latter half of the 19th Century, Realism culminated in Rodin, the master-Impressionist. He fixed in clay or stone the arrested gesture, the picturesque pose, the fleeting natural aspect. He also played with light effects, by rippling or stippling his surfaces. A very few times he gave himself over to an expression beyond nature—but in general he is the great Realist.

After Impressionism, Maillol came, to bring back a forgotten largeness, and a sense of solid organizational order. Lehmbruck, however, was nearer to the type Expressionist: distorting nature for the sake of intensified sculptural expression, gaining a sense of fourth-dimensional order, pouring out his own feeling so unmistakably that his statues could never be mistaken for another's. He will rank, perhaps, as the greatest sculptor since Michael Angelo. But then one has to add that the expressive-stone quality is more intensively achieved in the work of Gill or Lachaise; and that Epstein reveals the hidden character of a sitter the more compellingly. William Zorach returns the art nearer to the architectural reposefulness of Maillol, seldom distorting the outward detail of nature, but always subordinating the "natural effect" to the search for sculptural order. In this country, in Germany and France, even in England—a land without a known sculptor in all its history up to 1920—there are creative young artists fired with a new vision of manifestations of order to be characteristically revealed by the sculptural process.

Thus another art, once upon a time expressive in the language of its own materials and methods, declined into Realism, was given up to photographic and lightly ornamental aims, with hardly a

< 395 >

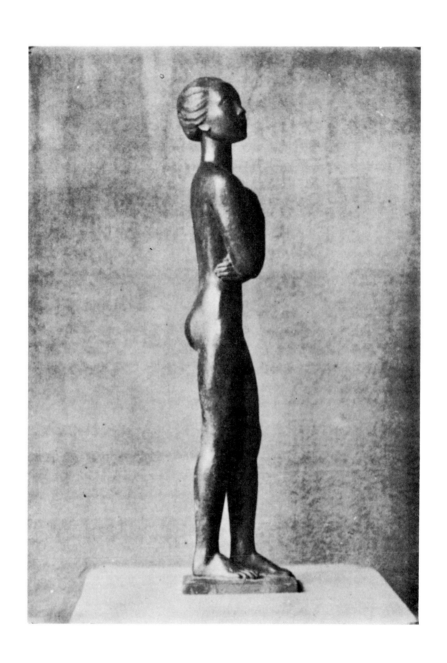

Woman Looking Up, by Georg Kolbe.

trace of Expressionistic achievement through three centuries; but now is brought back to intensified expression, through a revived devotion to the medium, and a new understanding of formal order and art's expressive purpose.

EXPRESSION IN THE THEATRE

The story of the revolution in the theatre art is of another sort, in that the actual shift to Expressionistic practice has been delayed. Realism still rules the day-by-day stage, although the theory of the art has been utterly remade, and certain features of production have been obviously revolutionized.

In other words, the change from Realism to Expressionism is only partial or fragmentary. The reason may lie in the fact that the machinery of the art is very expensive—both the actual machinery of getting a play staged and an audience comfortably seated, and the business framework by which plays are bought, actors hired, rehearsals paid for, etc. In other words, the theatre is owned, administered, and exploited for a profit, by others than the artists concerned. The newly creative figure, the tangent thinker, the visionary prophet, tend to be excluded from the actual theatres. More practical progress has been made in "little theatres"—considered by the "regulars" unprofessional and negligible—than in the fully accredited and fully equipped commercial playhouses; and the two pioneer prophet-theorists of Modernism were all but exiled from the stages of their own time.

Despite the halting progress in actual production, the revolution in accepted theory is, I believe, as near complete as any radical could ask. Even the universities recognize that there is a theatre art, and offer courses of instruction that begin with a consideration

< 397 >

of the relationship of stage forms, settings, acting and play. In 1900 no college or school in the country took cognizance of an art of the theatre. Drama was considered, historically, as a minor branch of literature. Outside the respectable institutions of learning there were to be found a few schools of acting, considered rather "shady"; and a still more distant activity called "scene painting" could be learned by apprenticeship in a commercial studio—a studio that purveyed, usually, a sign-painter's notion of Realistically artistic play settings, to a businessman's order.

Nothing could better illustrate the utter change in theory, the return to a conception of the theatre art as a unity, an organic-expressive medium, than the correction of this separation. Today there are numberless schools of the theatre art, and the universities and colleges build laboratory-theatres, within which courses on the drama, acting and setting—and production—are secondary to a consideration of the stage art *as a whole*.

The separation of functions, of activities, was, of course, characteristic of the actual producing stages of forty years ago. The first great Expressionist rebel, Gordon Craig, cried out against the disunity of the theatre production of the Century-end. In a passage of an essay published in 1905—and since become as famous as Sullivan's dictum about architecture, "form must follow function"— Craig underscored this disunity as the one great weakness of the current production, and demanded that staging be given over to a new figure: the artist of the theatre—or the artist-director. It is largely through the entry of the *regisseur*, in the years since, that European and American stages have seen a return to theatrically expressive production, in examples numerous enough to warrant prediction of a typically Expressionistic stage-art in place of the present average Realism.

< 398 >

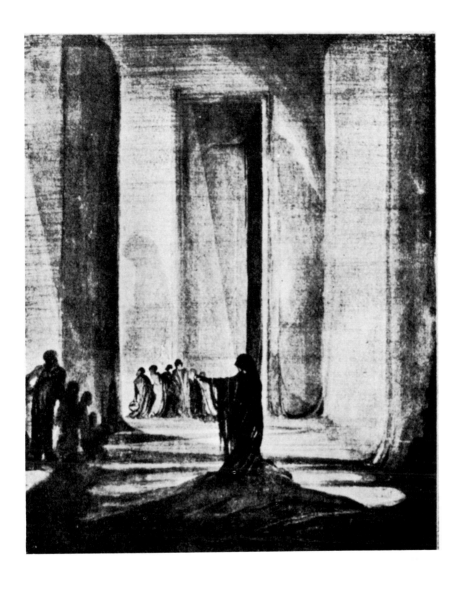

Setting for *Electra*, by Gordon Craig. An early landmark in the modern movement toward simplification and abandonment of the "picture" setting. (From *Towards a New Theatre*, by Edward Gordon Craig.)

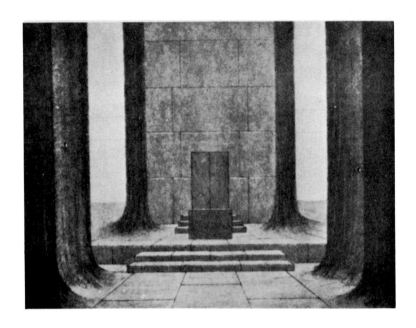

Two drawings for productions, by Adolphe Appia. Above, formalized setting for Glück's *Iphigenia in Tauris;* below, a platform stage for *Orpheus.* (From *Adolphe Appia,* a portfolio privately printed in Zurich.)

Stanislavsky, Reinhardt, Jessner, Meyerhold, and a few other world-known figures, have brought back the lost unity, have restored the theatre to an expressive rôle, in terms natural to the theatre, and in a few cases they have turned the medium to the expression of typically machine-age social meanings. They capitalized the elements—largely lost in the Realistic era—of movement, color, light, with a new intensification out of modern mechanical invention. They brought production as a craft to a degree of theatrical effectiveness unknown in the Realistic centuries. Unfortunately they advanced without carrying with them playwrights of similar vision and mastery.

What we have essentially, today, is a new theatre without contemporary dramatists. Competent playwrights have been drafted to the commercial stage, to repeat the formulas of journalistic Realism. The great regisseurs have been driven, for adequately theatrical-poetic-expressive texts, to the Greeks and Shakespeare. They have achieved productions beautifully Expressionistic—except in contemporary-social meaning. The Russians alone, I believe, are offering, commonly, works in which the new formal unity is linked with an emotionally-significant content out of the life of today.

The theory of a theatric organism, in the nature of a flow, has been built up in the writings of a dozen artists, most notably perhaps by Craig, Appia, Evreinoff and Meyerhold. It remained for Roy Mitchell to sum up—in a book entitled *Creative Theatre*, which seems to me the best single work on the theory of the art—the importance of the artist-director in achieving the synthesis:

"Once we have recognized the miraculous power of the theatre to initiate, and have seen how such a recognition can bring order into the relation of its many parts, we have our first understanding of the function of an initiator who stands nearer to its mystery than

< 401 >

the playwright can and nearer than the actor himself. He is the director.

"Whatever we have achieved these last few years towards a finer ideal and better unified practice has been exactly in the measure of our recognition of the director as nearest the theatre's heart. He can be master of things a thousand playwrights have never troubled themselves to learn, and a hundred thousand actors have despised. We have had playwright's theatre and our miracle has been smothered in turgid debate. We have had actor's theatre and it has been killed by strife or diffused in shabby vanities. Not for a long time have we had director's theatre but we are getting it and at last we seem to be going somewhere. . . .

"This new director is an ordainer of volumes, of massive shapes, of spatial relation, of the cumulative power of motion, of swirl, of interlude, of farandole. He found the theatre doing appropriate things; already he has made it do vital things. I can fancy him making it do divine things."

While the achieving of the synthesis has been the first considera tion of the Moderns—all credos begin with attestation of the importance of the rhythmic organism, the theatric unity—it is possible to examine the parts separately for signs of advance. Contemporary playwriting, as I have implied, has failed to develop co-ordinately with the craft of production. There is no master-dramatist to be named.* There have been stirrings of new life—as in the experiments of the Expressionist playwrights of Germany and

* In early 1948, looking back over the theatre of the last fifteen years, I feel that the most heartening gain has been the emergence of Thornton Wilder as an Expressionist playwright. His plays *Our Town* and *The Skin of Our Teeth* are anti-realistic, creative and deeply significant. One other "new" playwright deserves mention: Tennessee Williams. For the rest, the little and college theatres have continued to make experimntal progress, while the professional theatre, whether on Broadway or "the road," has sunk to shameful depths of commercialism and infantilism. The American theatre is owned by those who have the taste of the realist, the sensationalist, the half-educated; to expect important progress before repertory theatres and other institutional playhouses are founded seems futile.

< 402 >

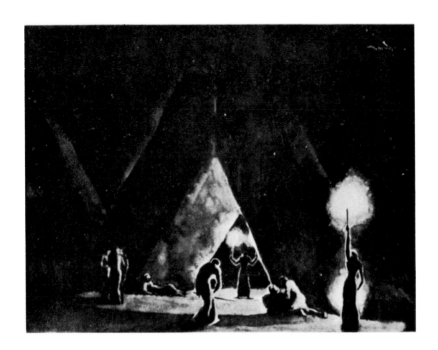

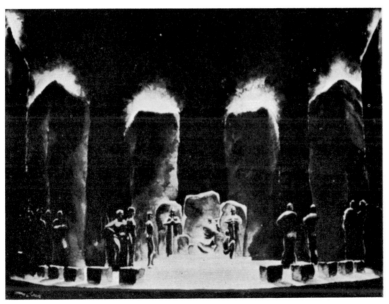

Two sketches for a production of *King Lear*, by Norman Bel Geddes.

America, Toller, Kaiser, Lawson, and a few others, and in the body of recent Russian social drama. But the directors and actors and designers still await the texts which should be the inspirational beginning-point for their organized presentations. Nor is there reason to pause over acting, for signs of revolutionary change. What is to be Modern acting will be recognized largely as a return from naturalistic representation to creative presentation: the actor no longer merely a variation of himself, as natural as your umbrella or your grocer, but expressing overtones of feeling, within the special beauty of words, movement, theatric flow.

In the one "department" of scene design, of physical stage background—or stage space made theatrically living—there has been complete revolution. The disappearance of the old detailed picture-setting, whether artificially painty or naturalistically photographic, is one of the easiest-marked phenomena of the Expressionist advance. The "scene" has been simplified, ordered, made beautiful, with a beauty that furthers the expressiveness of the total production. Not only the progressive theatres but the commercial have benefited immensely in this particular. The Realistic play, as well as the Modernistic experiment, is adequately "set." Craig was the pioneer instigator to this change, though Adolphe Appia had as early made designs which today are recognized as beautiful and prophetic. Both men wrote treatises which still stand among the few books indispensable to the student of the art.

But if scene has been reformed, made expressive in truly theatrical terms, that is perhaps merely incidental to the emergence of the craft of "production" as an organic, vitalizing process. The true Expressionist advance has been in the denial of the Realistic story, naturalistic acting, and romantic or naturalistic "scenery"— a negation of all the merely imitative elements—and the develop-

< 404 >

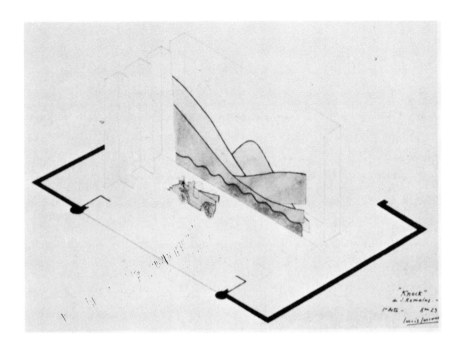

Stage Design by Louis Jouvet, for *Dr. Knock*. An example of the abandonment of picture background or "scenery" for organization of stage space.

ment, in one flow, under one visioning direction, of all the factors that make the play live theatrically.

If I summarize, in a few paragraphs, the parallels in two other arts, it is not because I am less convinced that they are moving forward in a revolutionary change, which can be marked as essentially Expressionistic. In the one—literature—the shifts have been more gradual and inconclusive than elsewhere, and the roots of anti-Realism are hidden much farther back, beyond the half-century range of study that tells the story of a new painting and a new

< 405 >

architecture; and it is a question of suggesting a few main lines of growth, or embarking upon explorations impossible within the compass of this summarizing chapter. In the case of the other art, music, I am frank to say that my knowledge is inadequate: that I will not undertake an exposition because I do not know. It happens that I have studied somewhat in every other art, even compositionally in a small way; but I have no such "inside" insight into music.

I feel that there are analogies between the thing we have been studying and the rising opposition to Impressionistic and other program music; and the continuing growth of Bach's popularity seems to me not unlike the emergence of El Greco as an Expressionist master, rich in formal-abstract realization. There are negative indications too: vociferous challenge of the coded laws, constant quarreling between conservatives and "wild" radicals, and—nearest to the painting case—a decrying of composition that leans heavily on the stimulus of ephemeral natural phenomena. This last leads us back to the constructive: instead of what is taken from nature, impressionistically or emotionally, a greater capitalization of formal values. With that so-brief paragraph, I will end all discussion of music.

If we try to test recent changes in literature by the Expressionist principles, we first run into the confusion of the division into poetry, fiction, etc. Perhaps poetry, by reason of being more rigidly ordered, is always Expressionist to some degree; whereas fiction leans more naturally to the Realistic. And yet in both divisions there is today a welter of experiment; and some critics would say that, on the one hand, there was a master-Modernist seventy years ago, in the figure of Whitman, while, on the other, the first great Expressionist novelist appears in a contemporary, Joyce.

< 406 >

Certain it is that in the art of poetry, which especially capitalizes formal-expressive elements, Whitman two generations ago challenged the academic rules and the orthodox "authorities"—a perfect parallel to Isadora Duncan denying the coded patterns of the ballet-masters, and setting out to express herself in free dance, or Sullivan striking off the shackles of neo-historic architectural practice. I believe that any study of Expressionism in literature would have to go back to Walt Whitman as the pioneer of expression in free verse, intensifying his emotions in new ways, distorting what had been known as normal verse forms, mystically enlarging the art. Of his followers the Imagists were most suggestive of the Expressionist painters: seeking a new concentrated, ordered movement, banishing the dead spots, achieving a typically modern precision and exactness. Their self-discipline to this end often resulted in self-consciousness, but I think no student can overlook them as furtherers of Expressionist-formal ideals. But it is necessary to add that the greatest Imagist lived and wrote and died before the name was invented: Emily Dickinson. She exhibited the directness and concentration and order, with a personal accent of her own, and, like Whitman, an independence from the rules of orthodox rhythm and rhyme; and over it all an imaginative and mystic attitude toward common things. I think there has been no such Expressionistic poet since; but there is an extraordinary range of experiment between her and the latest works of Kreymborg, Cummings, Pound, Sandburg, Jeffers, and H. D.

The fiction writers have advanced in a more oblique direction, perhaps because they move into verse the moment they obviously adopt a formal order as conditioning. The greater advance has been in the abandonment of surface recording of life for reproduction of the total "stream of consciousness"—and this is new, if

< 407 >

hardly more a Modern advance than are the dream pictures and somnambulistic reporting of the Sur-Realists. Joyce may well be the first important artist of a beginning Expressionist era, and certainly Virginia Woolf is breaking new trails. I think, though, that a crystallization of the actualities of the stream of consciousness is not enough; the attainment of a new ordered movement, a freshly expressive orchestration of the elements that go into the "story"—content, words considered sensuously as well as literally, musical rhythms and intervals, etc.—will be the larger part of the gain. In regard to words, one cannot overlook the experiments of Gertrude Stein, aiming at the attainment of abstract but emotionally compelling effects, by arrangement of these prime materials of the art outside their usual significance. It seems likely that a purely abstract literary art is a will-o'-the-wisp, because words came into existence as intellectual symbols for things and ideas. But so sincere an effort to widen their usefulness cannot but add grist to the mill of the literary composers.

In all of this we are studying efforts to widen expressiveness, within the limits of the medium particular to the art. In other words, we are tracing one more parallel to the Expressionism of the painters, who have abandoned imitativeness of older practitioners, and imitativeness of nature, to seek intensified *Expression*.

< 408 >

CONCLUSION

THAT the work of art shall *live* for me, with its own sort of vitality, is my deepest wish. There is a knowing about art, which is secondary, intellectual. Criticism too often concerns itself with developing a talent and a vocabulary for that knowing. It should lend itself rather to clearing the way to an immediate response, to a living with art. The justification for this book, if any, will lie in its efficacy in bringing the reader to the realization, the actual experience, of Modern works of art.

When I have talked to students about these matters, I have urged on them three injunctions, as protection against the critic's tendency to pose as an authority, to codify, and to intellectualize. It is well to warn the reader, in similar danger.

1. *Don't believe a word I say.* That is, unless you have come to the conclusion yourself, after I have afforded you a clue, or have cleared the way to seeing, don't accept the offered idea. Hold it open, pending further experiment, and personal experience. If I have said, "There is in the canvas a plastic organization, a mystic-rhythmic movement, which is more precious than any other formal element in the painting," don't believe me until you have experienced that beautiful hidden thing. If I have said, "Mankind is accomplishing an epochal revolution in ways of living, of which the revolution in art is an integral part," don't believe me—until you too can image the old world that is passing, the civilization dying, and the new world that is being born, with its changed patterns of living, institutions, philosophies, art. Accept my ideas here,

< 409 >

tentatively; for you will know by this time that I have studied into these matters, and that art has come to dwell in my everyday life with an unaccustomed immediacy, as constant enrichment of experience. But make your life a reflection of no man's thinking or teaching. Don't accept any interpreter as a permanent crutch. Be independent, even to that last childish confession, "I know what I like"—rather than like blindly what someone else knows.

2. *Strive for direct response, immediate experience.* Let the fact-finding mind be stilled. Don't intellectualize over Modern art except as preparation for feeling and enjoyment. For most people a period of self-conscious study and judgment is inevitable, due to early mis-education, as a means to dislodge prejudice and open the way to intuitive acceptance. But the objective is to free the vision, to prepare the eye and the inner faculties for the single response. While studying go continually to the works of art themselves, for the aesthetic experience. Better still, practice widely in the arts, not primarily for the works you will produce, but for broadened and intensified creative appreciation.*

3. *Accept art not as a refuge from life, but as an intensification of living.* As such, it will be related to man's environment and associations and spiritual discernment in this machine age. Go occasionally to the art of long ago and far away, not as escape from

* You might be surprised if one brought to your attention the multiplicity of ways in which art already enters creatively into your intimate life. If you are a woman, your personal "make-up," and dress, and the graces you cultivate in your housekeeping —laying the table, arranging harmonious furniture, etc.—are essentially arts. You may be practicing them with none but a Realistic-imitative intelligence, modelling your make-up and your dress on something seen shallowly, from the outside; or you may be creative, taking expression of your inmost self as the beginning point—Expressionistically. But I would advocate that you go farther, if only for the deeper insight it will afford you in regard to these intensely personal arts: I would have everyone draw and paint, practice in the handicrafts, and develop a basic sense of *design in living*, which will extend from the spiritual-creative center to every outward expression of personality.

< 410 >

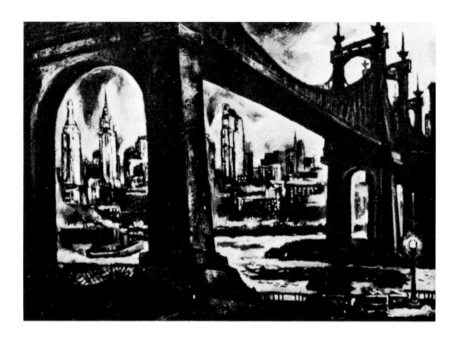

City of Lights, by Umberto Romano. (By courtesy of the Associated American Artists Galleries, New York.)

existence as it is today, but because some artist, far removed in time or space, achieved expression that lives for us, when he recorded and revealed something of himself and of social living in his age, in universally valid plastic and mystic values. Modernist art offers a like creative experience, and one closer to our desires, because the artist reveals his emotions or imagination intensified through his feel for life in our times. This is the art that will be nearest to you if you are living fully.

Remember that true creative art has a vitality of its own, is a separate living thing in the world, offers, in the meeting with it, an experience different from any to be had from nature, or from the secondary, imitative art which affords the illusion of nature. To

< 411 >

find that experience continually is to lift living from the plane of commonplace reality to the plane of the reality of the Spirit.

As the artist is concerned with creation, expression—no longer with illusion, transfer, photography—so the beholder prepares himself for experience, aesthetic response, giving himself to art; not for judgment, thought or diversion. The appreciation of art becomes a spiritual rather than a mental activity. It seems to me that Expressionism returns art to livingness, to aesthetic evocation, to revealment of those values that feed the Spirit.

< 412 >

INDEX

< 413 >

< 414 >

< 415 >